Design to Live

التصميم للحياة

ابتكاراتٌ يومية من مخيمٍ للاجئين

فريق التحرير
أزرا أكشامية، رأفت مجذوب، وميلينا فيليبو

مطبعة معهد ماساتشوستس للتكنولوجيا
كامبريدج، ماساتشوستس
لندن، إنجلترا

Design to Live

Everyday Inventions from a Refugee Camp

Edited by
Azra Aksamija, Raafat Majzoub, and Melina Philippou

The MIT Press
Cambridge, Massachusetts
London, England

تشمل خطوط هذا العمل كلآ من خط أكتيف جروتيسك Aktiv Grotesk وخط نديم Nadeem بواسطة خدمة Adobe fonts، إلى جانب الخط الأميري Amiri من Google fonts. تمت عملية الطباعة والتجليد في الولايات المتحدة الأمريكية.

ISBN: 978-0-262-54287-6

رقم الضبط في مكتبة الكونغرس: 2021930916

This work is set in Aktiv Grotesk and Nadeem by Adobe fonts and Amiri by Google fonts. Printed and bound in the United States of America.

ISBN: 978-0-262-54287-6

Library of Congress Control Number: 2021930916

التحرير والتدقيق اللغوي: لوكاس فريمان، حسين ناصر الدين
الترجمة: ضحى صايل الطلافيح
تصميم الجرافيك: رشا طبلت، زين أقصوي، مجد علاونة، منصة – الأردن
الطباعة: مطبعة Versa Press, Inc، جمهورية الولايات المتحدة الأمريكية

تمّ إنتاج هذا العمل بدعمٍ سخي من عدة جهاتٍ في معهد ماساتشوستس للتكنولوجيا:
كلية الهندسة المعمارية والتخطيط
مجلس الفنون في معهد ماساتشوستس للتكنولوجيا (CAMIT)
مبادرة رواية القصص عبر الوسائط المتعددة
برنامج المنح في معهد ماساتشوستس للتكنولوجيا
جائزة لورانس بيرهارت أندرسون
جائزة الفنون الإنسانية والعلوم الاجتماعية
جائزة J-WELL للابتكار في مجال التعليم
منحة CAST Mellon Faculty Grant
صندوق CAST الدولي للمعارض والإنجاز
برنامج العالم العربي ضمن MISTI برنامج مبادرات العلوم والتكنولوجيا في معهد ماساتشوستس للتكنولوجيا

كما تمّ تمويله جزئياً بواسطة عددٍ من المساهمين:
منحة مؤسسة جراهام للمنظمات
متحف كونستهاوس غراتس
المستشارية الاتحادية النمساوية - شعبة الفنون والثقافة
مجلس شباب قبرص (ONEK) *
* التمويل المقدم من قبل مجلس شباب قبرص (ONEK) لهذا الكتاب لا يعني بالضرورة الموافقة على ما ورد فيه من محتوى.

ساهم في إجراء البحوث لجمع مادة هذا الكتاب في الأردن كلٌّ من:
كلية العمارة والبيئة المبنية في الجامعة الألمانية الأردنية، عمان
منظمة كير (CARE) في مخيم الأزرق للاجئين

إخلاء مسؤولية: الآراء ووجهات النظر الواردة في هذا الكتاب هي آراء المؤلف ولا تعكس بالضرورة السياسة الرسمية أو الموقف لأي جهة أو منظمة أو صاحب عمل أو شركة أخرى تم تضمينها في الكتاب.

جرت جميع المحاولات للتواصل مع المساهمين في هذا الكتاب وللحصول على موافقتهم في ظل الظروف وباء كورونا الصعبة وظروف الصراع والأزمات. وعليه، يقدم الناشرون اعتذارهم عن أي خطأ أو سهو، ويعبرون عن امتنانهم لأي تنبيه يصلهم بخصوص التعديلات الواجب القيام بها وتضمينها في النسخ أو الطبعات المستقبلية من هذا الكتاب.

Copy editing and Proofreading: Lucas Freeman, Hussein Nassereddine
Translation: Duha Sayel Al-Talafeeh
Graphic Design: Rasha Tabbalat, Zein Aksoy and Majd Alawneh', Platform
Amman, Jordan
Printing: Versa Press, Inc. print, United States of America

Produced with the generous support of MIT groups:
School of Architecture and Planning (SA+P)
Council for the Arts at MIT (CAMIT)
Transmedia Storytelling Initiative
MITx Grant Program
Lawrence B. Anderson Award
Humanities, Arts and Social Sciences Award
J-WEL Education Innovation Grant
CAST Mellon Faculty Grant
CAST International Exhibitions and Performance Fund
MISTI Arab World Program

The production of this book was also partially funded with the generous support of the:
The Graham Foundation Grant for Organizations
Kunsthaus Graz
The Austrian Federal Chancellery, Division of Arts and Culture
Youth Board of Cyprus (ONEK)
* The granting of funds by ONEK to this book does not necessarily imply agreement with the content expressed in it.

The research process for this book in Jordan was facilitated by the:
School of Architecture and Built Environment (SABE), German Jordanian University (GJU), Amman
CARE, Azraq Refugee Camp

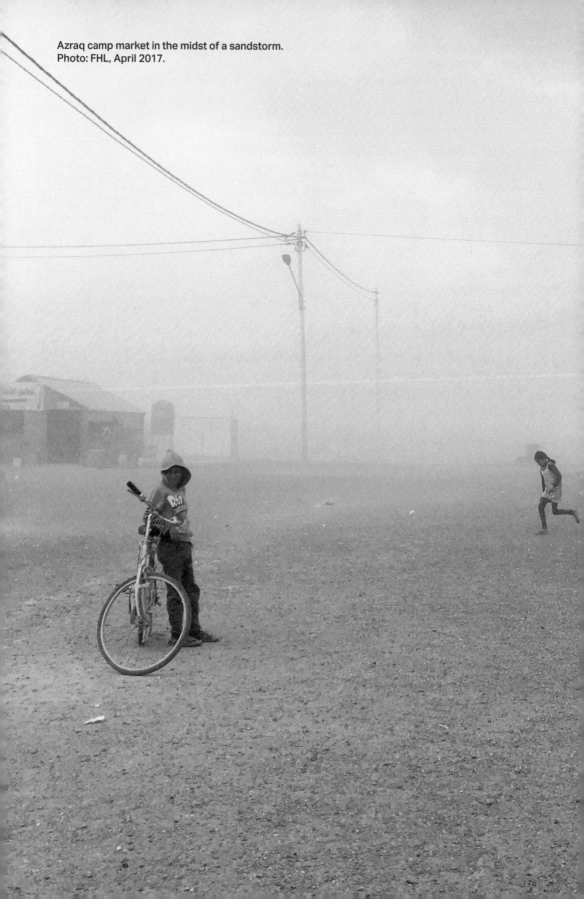

Azraq camp market in the midst of a sandstorm.
Photo: FHL, April 2017.

سوق مخيم الأزرق وسط عاصفة رملية. الصورة: مختبر الإرث المستقبلي.
نيسان 2017.

Table of Contents

*The book is designed to be read in two directions, weaving Arabic and English content side by side throughout.

Perspectives on Humanitarian Design

محتويات الكتاب

وجهات نظر حول التصميم الإنساني

شكر وتقدير

Acknowledgements

We dedicate this book to displaced Syrians around the world who use architecture, art, and design to create a better world and a better future.

The creation of this book was made possible with the support of many students, colleagues, friends, family members, and the generous backing of several sponsoring institutions. We would like to thank them all for their individual contributions.

Numerous students at MIT who have participated in this project's courses and programs contributed notably to the evolution of both the Future Heritage Lab and the larger set of projects informing this book. We are grateful to the students of:

Design for a Nomadic World (spring 2017) Students: Noora Aljabi, Nicole Ashurian, Andrea Baena, Natalie Bellefleur, Manuela Uribe Buitrago, Soumaya Difallah, Ciera Gordon, Rebecca Hui, Anthony Kawecki, Cindy Liu, Hugh Magee, MyDung Thi Nguyen, Alicia Noriega, Reva Ranka, Marco Vinicio Rosero, Danniely Staback Rodriguez, Anna Kathryn Ryan, Brandon Sanchez, Marcas Zacheus Smith, Joseph Michael Swerdlin, Megan Thai, Sera Tolgay, Alaa Zuhra Quraishi, and Calvin Zhong. Teaching Assistants: Martin Joshua Elliott and Raafat Majzoub, and the communications component instructor Cherrie Miot Abbanat.

State of Displacement: A Code of Ethics for Cultural Interventions in the Refugee

Context (fall 2017) Students: Anastasia Farnum, Erin Genia, Luisa Brando Laserna, Hannah Lienhard, Sujin Lim, Katherine Paseman, Homa Ershad Sarabi, Riddi Pankaj Shah, Hazal Seval, Nneka Deandra Sobers, Lavender Rose Tessmer. Teaching Assistant: Nolan Oswald Dennis.

Dynamic Heritage: Art, Culture, and Technology in a Refugee Camp (fall 2017) Students: Lily Bailey, Baian Chen, Gabriel Fields, Beatriz Gonzalez, Kevin Gonzales, Marlo Johnson, Shannon Miller, Ankita Reddy, Pooja Reddy, Rikhav Shah. Teaching Assistant: Pedro Cardoso Zylbersztajn

Culturally Sensitive Design (Spring 2018) Students: Erika Anderson, Sophia Chesrow, Szabolcs Kiss, Catherine Lie, Ellen O'Connell, Riddi Pankaj Shah, Marcas Zacheus Smith, MyDung Thi Nguyen, Stella Zhang. Teaching Assistant: Nolan Oswald Dennis.

MISTI Arab World Program: A group of graduate students helped us deepen our research in Jordan during their extended stay in Amman and at the Azraq Refugee Camp: Catherine Anabella Lie, Akemi Sato Matsumoto Miranda, Nabil Sayfayn. We thank the MISTI Arab World Program for supporting us in hosting these students in Jordan, especially the Associate Director of the MISTI Program, David Dolev, and the MIT International Safety and Security Manager, Todd Holmes.

This book is the product of continuous exchanges among students at MIT, GJU, and the Azraq Refugee Camp. We are

thankful for MIT students' commitment and passion, GJU students' guidance and support, and the trust and powerful contributions of displaced Syrians at the camp. Participants in the workshops and events that took place in Amman and at the camp include Noora Aljabi, Natalie Bellefleur, Soumaya Difallah, Sophie Goemans, Rebecca Hui, Zuhra Quraishi, Marco Vinicio Rosero, Brandon Sanchez, Marcas Zacheus Smith, Sera Tolgay, from MIT; and Lubna Alawneh, Muhsen Albawab, Hasan Hamdan, Linda Mazahreh, Rawan Twal Alexandra Alfar, Rasha Al Sharqawi, Haneen Barbarawi, Samer Dababneh, Christine Sa'd, Taleen Samawi, Reef Qbelat from GJU; and displaced Syrians at the Azraq Refugee Camp: Hanaa Ahmad, Kifah Al-Akil, Ahmad Al-Hasan, Majid Al-Kanaan (Abo Ali), Abdel Karim Al-Khalil Hassan Ghazi Al-Abdallah, Hussein Ghazi Al-Abdallah, Moussa Al-Abdallah, Mohammad Al-Abdallah, Rawan Al-Azo, Fatima Walid Al-Fares, Ahmad Al-Hasan, Mohammad Abdullah Al-Mezael, Jar Al-Nabi Aba Zeid, Omran Al-Mansour, Samer Al-Naser, Abdallah Audeh, Abo Al-Saleh, Hiba Al-Saleh, Nagham Al-Saleh, May Hamid Al-Sharif, Hiba Hamid Al-Sharif, Saba Talal Al Turk, Hob Talal Al-Turk, Saba Talal Al-Turk, Yassin Al-Yassin, Hanaa Al-Hassan, Jamil Al-Hassan, Rawan Maher Al-Haj Hussein, Saleh Khello, Noha Mohammad, Mostafa Hamada, Salem Al-Shalash, Hatem Al-Balkhi, Moayyed, Abo Suheir, Afrah Al-Kayed, Boshra Al-Kayed, Nour, Fayez, Salim, Tarek Al-Eid, Moseb Al-Bosh, Jamil Homeidi, and Mohammad Homeidi and Ziad.

These workshops would not be possible without the invaluable collaboration of professors Omaimah Al Arja, Rejan Ashour, and Mohammad Yaghan from the GJU, the contributions of Amani Yousef Alshaaban of Architecture Sans Frontières and Amani Harhash of the International Art Academy Palestine, the instruction of Muteeb Awad Al-Hamdan at the camp and the administrative support of Malek Abdeen and Jameel Dababneh of CARE Jordan.

We would like to thank the researchers who in different phases of this project worked with us on the content development of this book: Noora Aljabi, Nada Khalid Al Mulla, Rasha Al Sharqawi, Andrea Baena, Catherine Anabella Lie, Mary Mavrohanna, Khan Nguyen, Nabil Sayfayn, Michelle Xie, Stella Zhujing Zhang, Calvin Zhong, Ziyuan Zhu. We note the exceptional work of Stratton Coffman and Jaya Eyzaguirre in synthesizing the work of various student collaborators into the twelve LIFE-themes illustrations. We are profoundly thankful to Zeid Madi, one of our closest collaborators in Jordan, whose social intelligence and critically engaged involvement made our work on the ground more effective and relevant.

Several individuals have helped us reach out to and document the work of the creative community of displaced Syrians at the Azraq Refugee Camp. We are deeply grateful to Hussein Ghazi Al-Abdallah, Mohammad Abdullah Al-Mezael, Mohammad Al-Koeiry, Yassin Al-Yassin, and Mohammad Homeidi of the Azraq Journal, Nisreen Rawashdeh of Edraak, and Duaa Faleh and Malek Abulatif of the CARE outreach team.

To the designers and artists whose work is included in this book, we are thankful to them for opening their households, sharing their stories, and generously allowing the reproduction of their work: Abo Jar Al-Nabi, Majed Shaman Al-Khalifa, Amir Yassin Abo Haitham, Abo Mohammad Al-Homsi, Majid Al-Kanaan (Abo Ali), Ali

Fawaz, Mohammad Khalid Marzouqi, Abd Al-Rahman, Aziza, Issam Ali Abazeid, and others who prefer to remain anonymous.

We thank our interviewees Muteeb Awad Al-Hamdan, Mohammad Abdullah Al-Mezael, Malek Abdin, Mohammad Yaghan, Rejan Ashour, Zeid Madi, Amani Yousef Alshaaban, and Muhsen Albawab for their insightful reflections on the creative production at Azraq.

Over the past three years, we have benefitted from exchanges with colleagues and advisors on the array of projects related to our engagement with the Azraq Refugee Camp. Their intellectual contributions illuminate aspects of this book. Special credit should be given to Natalie Bellefleur, Omar Darwish, Lillian Kology, Raed Suleiman, and Claudia Urrea.

Snippets of this research were presented at the exhibitions *Design for a Nomadic World,* as a part of the *Amman Design Week 2017 – parallel program; The Infrastructures of Care: Housing+* at the Center for Advanced Urbanism at the MIT Media Lab (2018); *Spaces of Displacement & Refuge* at the Bartlett School of Architecture, UCL (2019); The *T-Serai* at the Sharjah Museum of Islamic Civilization (2019); *ARTS & CRAFTS: Between Tradition, Discourse and Technologies* at the Kunsthaus Graz (2019); *Sanctuary* at the Aga Khan Museum in Toronto (2020); and *How will we live together?* at the Venice Architecture Biennale 2021. We are deeply grateful to these organizations and their staff for providing platforms for the international dissemination of our work.

الدولي للمعارض والإنجاز، برنامج العالم العربي ضمن مبادرات MISTI في معهد ماساتشوستس للتكنولوجيا. تم أيضًا تمويل إنتاج هذا الكتاب جزئيًا بدعم سخي بموجب منحة مقدمة من مؤسسة جراهام للمنظمات، ومتحف كونستهاوس غراتس، ومتحف آغا خان للفنون الإسلامية في تورنتو، والمستشارية الاتحادية النمساوية – شعبة الفنون والثقافة.

نتقدم في برنامج الفن والثقافة والتكنولوجيا في معهد ماساتشوستس للتكنولوجيا، بخالص الشكر للمسؤول الإداري ماريون كننغهام، والمساعد المالي كيفن ماكليلان، والموجه الفني غراهام بيغر، على ما قدموه من دعم في سياق التحديات الإدارية ومعالجتها، بما تمثله من هيكلية فريدة تتضمن التعاون العابر للحدود والمواطنة ومناطق الصراع.

ولا ننسى تقديم الشكر لرشا طبلت ورنا بيروتي وزين أقصوي ومجد علاونة من المنصة في الأردن على تصميمهما الجرافيكي المنهج والمدروس لهذا الكتاب، ونشكر أيضًا لوكاس فريمان (محرر النص الإنجليزي) وحسين ناصر الدين (محرر النص العربي) على الجهد

الذي بذلاه في تحرير محتوى الكتاب بأفضل ما يمكن، ونشكر ضحى صايل الطلافيح على دقتها في تنفيذ الترجمة بين اللغتين العربية والإنجليزية.

كما ونعرب عن تقديرنا لشون أندرسون وخلدون بشارة لمراجعتهما النقدية لهذا الكتاب، ولناشرنا MIT Press الذي مثّل شريكًا قيمًا لمساهمته في نشر وتوزيع هذا الكتاب، ونقدم شكرنا الخاص لمحررة التكليف فيكتوريا هيندلي لالتزامها المهني بإنتاج هذا الكتاب.

نود كذلك تقديم امتناننا الخاص لهاشم سركيس، عميد كلية الهندسة المعمارية والتخطيط في معهد ماساتشوستس للتكنولوجيا، الذي آمن بهذا المشروع منذ البداية وقدم الدعم لعملنا طوال هذه المدة. كان لرؤية وكرم العميد سركيس دور كبير في المحافظة على إلهام وشغف طلاب معهد ماساتشوستس للتكنولوجيا، و دفعهم لاستخدام أدواتهم الإبداعية والمهمة من أجل الكشف عن وحشية العالم الذي نعيش فيه، ولإعلاء أصوات أولئك الذين تم إسكاتهم قسرًا.

أزرا أكشامية، رأفت مجذوب، ميلينا فيليبو

The different phases of Design to Live have been funded by grants from various entities at MIT: Office of the Dean, School of Architecture and Planning (SA+P), Council for the Arts at MIT, Alumni Class Fund, Transmedia Storytelling Initiative, MITx grant program, Lawrence B. Anderson Award, the Humanities Arts & Social Sciences Award, J-WEL Education Innovation Grant, CAMIT-Council for the Arts at MIT, CAST Mellon Faculty Grant, CAST International Exhibitions and Performance Fund, and the MISTI Arab World Program. The production of the book was also partially funded with the generous support of the Graham Foundation Grant for Organizations, Kunsthaus Graz, The Aga Khan Museum Toronto, and the Austrian Federal Chancellery, Division for the Arts and Culture and the Youth Board of Cyprus.

At the MIT Program in Art, Culture and Technology, we sincerely thank the Administrative Officer Marion Cunningham, the Financial Assistant Kevin McLellan, and Technical Instructor Graham Yeager for their support in addressing the administrative challenges of a unique structure of collaboration across borders, citizenship status, and conflict zones.

We thank Zein Aksoy, Majd Alawneh', Rana Beiruti and especially Rasha Tabbalat from Platform in Jordan for their thoughtful and meticulous approach to the graphic design of this book. We thank our professional copy editors, Lucas Freeman (English text) and Hussein Nassereddine (Arabic text) for their sharp eyes and excellent work polishing the text, and Duha Sayel Al-Talafeeh for the careful translations from English to Arabic and vice versa.

متحف الشارقة للحضارة الإسلامية في العام 2019، ومعرض «ARTS & CRAFTS: بين التراث والخطاب والتكنولوجيا» في متحف كونستهاوس غراتس في العام 2019، ومعرض «الملاذ» في متحف آغا خان للفنون الإسلامية في تورنتو في العام 2020، ومعرض «كيف سنعيش معًا؟» في بيينالي فينيسيا الدولي للعمارة في العام 2021. نعبر عن خالص تقديرنا وامتناننا لهذه المعارض والعاملين عليها، لتوفيرهم منصاتٍ مكنتنا من نشر أعمالنا على الصعيد الدولي.

تمَّ تمويل المراحل المختلفة من كتاب «التصميم للحياة» من عدة جهات في معهد ماساتشوستس للتكنولوجيا، وهي: مكتب العميد، كلية الهندسة المعمارية والتخطيط، مجلس الفنون في معهد ماساتشوستس للتكنولوجيا، صندوق دعم الخريجين، مبادرة رواية القصص عبر الوسائط المتعددة، برنامج المنح في معهد ماساتشوستس للتكنولوجيا، جائزة لورانس بيرهارت أندرسون، جائزة الفنون الإنسانية والعلوم الاجتماعية، جائزة J-wel للابتكار في مجال التعليم، مجلس الفنون في معهد ماساتشوستس للتكنولوجيا (CAMIT)، منحة CAST Mellon Faculty Grant، صندوق CAST

الحمدان،محمد عبد الله المزعل، مالك عابدين، محمد ياغان، ريجان عاشور، زيد ماضي، أماني يوسف الشعبان، ومحسن البواب.

على مدى السنوات الثلاث الماضية، حققنا الإستفادة من تبادل الأفكار مع الزملاء والمشرفين حول المشاريع المتعلقة بانخراطنا في مخيم الأزرق للاجئين، وتعتبر مساهماتهم الفكرية أكثر ما يسلط الضوء على جوانب هذا الكتاب. من هنا، وجب علينا التعبير عن خالص تقديرنا لكل من ناتالي بلفلور، وعمر درويش، وليليان كولوجي، ورائد سليمان، وكلوديا أوريا.

تم استعراض عدد من مقتطفات هذا البحث في عدد من المعارض، بما فيها معرض «التصميم في عالم الترحال» الذي انعقد ضمن فعاليات أسبوع عمّان للتصميم في العام 2017، ومعرض «+Housing» في مركز العمران المتقدم في مختبر الوسائط المتعددة في معهد ماساتشوستس للتكنولوجيا في العام 2018، ومعرض «البنى التحتية للرعاية: الملاجئ والمأوي» في مدرسة بارتليت للهندسة المعمارية في كلية لندن الجامعية في العام 2019، ومعرض «T-Serai» في

Our appreciation goes to Sean Anderson and Khaldun Bshara for their critical and insightful reviews of this work. Our publisher, MIT Press, has been an incredibly valuable partner in the publication and distribution of this book. Special thanks in particular to the acquisition editor, Victoria Hindley, for her professional commitment to the production of this book.

We wish to express our special gratitude to Hashim Sarkis, Dean of MIT's School of Architecture and Planning, who believed in this project since its inception and supported our work all the way through. His vision and generosity keeps inspiring the passion of MIT students to use their creative and critical tools to expose the brutality of the world we live in and amplify the voices of those who have been silenced.

Azra Akšamija, Raafat Majzoub, and Melina Philippou

العبد الله، حسين العبدالله، موسى العبد الله، محمد العبد الله، روان العزو، فاطمة وليد الفارس، أحمد الحسن،محمد عبد الله المزعل، جار النبي أبا زيد، عمران المنصور، سامر الناصر، عبد الله عودة، أبو الصالح، هبة الصالح، نغم الصالح، مي حميد الشريف، هبة حميد الشريف، صبا طلال الترك، حب طلال الترك، ياسين الياسين، هناء الحسن، جميل الحسن، روان ماهر الحاج حسين، صالح الخلّو، نها محمد، مصطفى حمادة، سالم الشلاش، حاتم البلخي، مؤيد، أبو زهير، أفراح الكايد، بشرى الكايد، نور، فايز، سليم، طارق العيد، مصعب البوش، زياد.

لم يكن من المستطاع عقد ورش العمل هذه لولا التعاون المثمر الذي ساهم فيه كلٌ من الأساتذة التالية أسماؤهم من الجامعة الألمانية الأردنية: أميمة العرجا، ريجان عاشور، محمد ياغان. إلى جانب المساهمات التي قدمتها أماني يوسف الشعبان من شبكة العمارة بلا حدود الدولية، وأماني حرحش من الأكاديمية الدولية للفنون في فلسطين، ومتعب عوض الحمدان لدوره التعليمي في المخيم، والدعم الإداري الذي قدمهُ مَالك عابدين وجميل دبابنة من منظمة كير في الأردن.

نود أيضًا أن نشكر الباحثين الذي عملوا معنا في المراحل المختلفة لمشروع تطوير محتوى هذا الكتاب، وهم: نورا الجابي، ندى خالد الملا، رشا الشرقاوي، أندريا بينا، كاثرين أنابيلا لاي، ماري مافروهانا، خان نجوين، نبيل سيفين، ميشيل شيه، ستيلا تشوجينغ زانغ، كالفن زونغ، زوان تزو، ونقدرُ من جانبنا الجهد الاستثنائي الذي قام به ستراتون كوفمان وجايا إيزاجويري في جمع أعمال الطلاب المتعاونين، وتمثيلها في اثني عشر رسم توضيحي، حول محور عناصر الحياة. ونقدم جزيل الشكر لزيد ماضي الذي يعتبر أحد أهم الأفراد المتعاونين معنا في الأردن، والذي ساهم ذكائهُ الاجتماعي ومشاركتهُ الفاعلة في جعل عملنا أكثر فاعلية وأهمية على أرض الواقع.

قدم العديد من الأفراد المساعدة لنا من أجل الوصول إلى وتوثيق أعمال المجتمع الإبداعي الذي يشكلهُ اللاجئون السوريون في مخيم الأزرق. نقدم شكرنا العميق إلى حسين غازي العبد الله ومحمد عبد الله المزعل ومحمد القعيري وياسين الياسين وجميل حميدي ومحمد حميدي من مجلة مخيم الأزرق للاجئين، وإلى نسرين الرواشدة من منصة إدراك، وإلى دعاء فالح ومالك أبو لطيف من فريق التوعية في منظمة كير.

نشكر جميع المصممين والفنانين الذين يتضمن هذا الكتاب أعمالهم، ونعبر عن تقديرنا لهم لفتح منازلهم لنا ومشاركتهم قصصهم معنا، ومنحنا الإذن لإعادة إنتاج أعمالهم، وهم: أبو جار النبي، ماجد شامان الخليفة، أمير ياسين أبو هيثم، أبو محمد الحمصي، ماجد الكنعان (أبو علي)، علي فوّاز، محمد خالد المرزوقي، عبد الرحمن، عزيزة، عصام علي آبازيد، وآخرون فضلوا عدم ذكر أسمائهم.

ولا ننسى تقديم شكرنا لمن أجرينا معهم مقابلات، على ما عرضوه من أفكار مستنيرة بخصوص الإنتاج الإبداعي في مخيم الأزرق، وهم: متعب عوض

ساعتمل

شكر وتقدير

نُهدي هذا الكتاب للسوريين المُهجرين حول العالم، الذين يوظفون الهندسة المعمارية والفن والتصميم، من أجل عالمٍ ومستقبلٍ أفضل.

هذا الكتاب هو حصيلة دعم قدمه العديد من الطلاب والزملاء والأصدقاء وأفراد عائلاتنا، إضافة إلى الدعم السخي من المؤسسات الراعية. من هنا، نود أن نشكرهم جميعًا على مساهماتهم الفردية.

ساهم العديد من الطلاب في معهد ماساتشوستس للتكنولوجيا من خلال مشاركتهم في الدورات والبرامج التي انعقدت من أجل هذا المشروع في النهوض بمختبر الإرث المستقبلي وتطوير محتوى هذا الكتاب، ونقدمُ امتنانا لكل واحدٍ من الطلاب التالية أسماؤهم:

التصميم في عالم الترحال (ربيع 2017)، الطلاب: نورا الجابي، نيكول أشوريان، أندريا باينا، ناتالي بلفلور، مانويلا أوريبي بويتراغو، سمية ضيف الله، سييرا جوردون، ريبيكا هوي، أنتوني كاويكي، سيندي ليو، هيو ماجي، مايدونج تي نجوين، أليشيا نوريجا، ريفا رانكا، ماركو فينيسيو روزيرو، دانييل ستاباك رودريغيز، آنا كاثرين رايان، براندون سانشيز، ماركاس زاتشيوس سميث، جوزيف مايكل سويردلين، ميغان تاي، سيرا تولغاي، علاء زهرة قريشي، كالفين تشونغ. مساعدو التدريس: مارتن جوشوا إليوت، ورأفت مجذوب، ومُدرسة التواصل شيري ميوت أبانات.

قضية النزوح: مدونة الأخلاقيات الخاصة بالتدخلات الثقافية في سياق اللجوء (خريف 2017)، الطلاب: أناستازيا فارنوم، إيرين جينيا، لويزا براندو لاسيرنا، هانا لينارد، سوجين ليم، كاثرين باسمان، هوما إرشاد سرابي، ريدي بانكاج شاه، هزال سيفال، نيكا ديندرا سوبرس، لافندر روز تيسمر. مساعد التدريس: نولان أوزوالد دينيس.

التراث الحركي: الفن والثقافة والتكنولوجيا في مخيمات اللجوء (خريف 2017)، الطلاب: ليلي بيلي، بايان تشن، غابريل فيلدز، بياتريس جونزاليس، كيفين جونزاليس، مارلو جونسون، شانون ميلر، أنكيتا ريدي،

بوجا ريدي، ريكاف شاه. مساعد التدريس: بيدرو كاردوسو زيليبيرسرزتان.

التصميم الحسي الثقافي (ربيع 2018)، الطلاب: إريكا أندرسون، صوفيا تشيسرو، سزابولكس كيس، كاثرين لاي، إلين أوكونيل، ريدي بانكاج شاه، ماركاس زاتشيوس سميث، مايدونج تي نجوين، ستيلا زانغ. مساعد التدريس: نولان أوزوالد دينيس.

برنامج العالم العربي ضمن برنامج MISTI مبادرات العلوم والتكنولوجيا في معهد ماساتشوستس للتكنولوجيا: ساعَدتنا مجموعة من طلبة الدراسات العليا في تعزيز بحثنا في الأردن، خلال فترة إقامتهم الطويلة في عمّان ومخيم الأزرق للاجئين، وهم: كاثرين أنابيلا لاي، أكيمي ساتو ماتسوموتو ميراندا، نبيل سيفين. كما نشكر برنامج العالم العربي ضمن مبادرات MISTI لدعمنا من خلال استضافة هؤلاء الطلاب في الأردن، ونخص بالذكر المدير المشارك للبرنامج ديفيد دوليف، ومدير السلامة والأمن الدولي في معهد ماساتشوستس للتكنولوجيا تود هولمز.

هذا الكتاب هو حصيلة تبادلات مستمرة بين الطلاب في معهد ماساتشوستس للتكنولوجيا والجامعة الألمانية الأردنية ومخيم الأزرق للاجئين. نحن ممتنون للالتزام والشغف الذي أظهره طلاب معهد ماساتشوستس للتكنولوجيا، والتوجيه والدعم اللذان تلقيناهما من طلاب الجامعة الألمانية الأردنية، والثقة التي منحنا إياها اللاجئون في مخيم الأزرق ومساهماتهم. تاليًا، هي أسماء المشاركين في ورش العمل والفعاليات التي أقيمت في عمّان والمخيم: من معهد ماساتشوستس للتكنولوجيا: نورا الجابي، ناتالي بلفلور، سمية ضيف الله، صوفي غويمانس، ريبيكا هوي، زهرة قريشي، ماركو فينيسيو روزيرو، براندون سانشيز، ماركاس زاتشيوس سميث، سيرا تولغاي. من الجامعة الألمانية الأردنية: لبنى علاونة، محسن البواب، حسن حمدان، ليندا مزاهرة، روان الطوال، الكسندرا الفار، رشا الشرقاوي، حنين بربراوي، سامر الدبابنة، كريستين سعد، تالين سماوي، ريف قبيلات. من النازحين السوريين في مخيم الأزرق للاجئين: هناء أحمد، كفاح العقيل، أحمد الحسن، ماجد الكنعان (أبو علي)، عبد الكريم الخليل، حسن غازي

Azraq is...

a place of the most
creative, inspiring, and
talented people I know

- a place to learn from

~~strength~~
- resilience

هو البيت الذي لجأت إليه
~~بعيداً~~ بعيداً بي عن وطني

لازرق هو مخيم السورية الذي جمع كل
~~القلوب~~ الناس من كل النحاء وهو حلم
جميع الأطفال الذين يعيشون فيها

Azraq is...
from a distance, a sea of
homes made from metal
but close up, an ocean full
of hopes and dream

الأزرق هو أمان للعائلة

الأزرق هو معهم مكان تحقق
فيه جزء كبير من أحلامي
وفنى الحذير ...

~~Azraq is~~
الازرق هو منطقة ~~الجسم~~ الانطلاق إلى
المستقبل بالنسبة لي

هو المكان الذي يحميني ويحمي الناس
جميعاً وروى أصحابات كلها

الأزرق: يعني لي أنه صمود والأمان
والحب المتواجد الذي اجتمع عليه الغني
والفقير بلا تمييز. وهو جعلنا نصنع
من الصعاب مستقبل.

~~scribbles~~
الأزرق هو الرافعة نحو هو حياة أفضل

الأزرق هو...

Exercise from the MIT Future Heritage Lab
storytelling workshop, Azraq Refugee Camp,
January 2018.

إحدى أنشطة ورشة كتابة القصص التي نظمها مختبر الإرث
المستقبلي التابع لمعهد ماساتشوستس للتكنولوجيا في
مخيم الأزرق للاجئين. في كانون الثاني 2018.

Preface

The existential threats of climate change, the COVID-19 pandemic, and the rising numbers of forcibly displaced people make visible a new reality of social, political, and economic inequalities that is impossible to ignore. As an increasing number of people are forced to move and adapt to unexpected life scenarios, they have to find strength, inspiration, and hope in moments and in places where it seems so easy to surrender to hopelessness.

Glimpses of our shared future may well be found in the present-day living situations of displaced people. Shouldered by hope, Syrians fleeing from conflict and crisis find their way across borders into processing centers and camps. Ninety kilometers from the Syria-Jordan border, a two-hour drive from the capital of Amman, almost 40,000 Syrian refugees found their shelter in the Azraq Refugee Camp. It is a centrally planned, closed camp built to address the basic needs of displaced Syrians.[1] Deep in the Eastern Desert, the camp appears from a distance as an endless grid of white containers, bordered by an infinite fence, and surrounded by nothing but sand. The barren landscape extends to the horizon as evidence of these hostile living conditions, with temperatures reaching 118 degrees Fahrenheit in the summer.

Among the 15 other refugee camps in Jordan, Azraq is the most representative example of institutional humanitarian infrastructure. It constitutes what the humanitarian field considers an advancement in governance, security, and design. In our conversations with camp and NGO

officials, Azraq was often referred to as a model camp for the region, designed to avoid the looser, more incremental development approach seen at other camps, such as Za'atari just a few kilometers away. This tightening is evident in local regulations that seep into the daily lives of the residents, from forbidding permanent structures and plantation to limiting customization of interior spaces.

Such an austere environment, one produced by standardization-driven engineering, encourages conformity, disengagement, and despair. This is precisely why we were all the more inspired by the optimistic young people we met in this camp: teenagers who follow their own path to overcome the difficulties of displacement with bravery and creativity. Jar, for instance, feeling that schoolwork was futile, dropped out; but he could teach you how to turn the white metal shelters of the camp into something closer to a home with one of his many creations, like a portable fountain. His friend Wael focused on the camp's Taekwondo program; he will be contending for the upcoming Tokyo Olympic Games. Rawan invented a washing machine out of plastic buckets, hoping to help hundreds of people wash their clothes amid water scarcity and unbearable heat. Hanaa rewrote her life scenario outside the

[1] "The UNHCR Results Framework defines basic needs in terms of access to basic services and assistance in health, nutrition, WASH, food, shelter, energy, education, as well as domestic items and specialized services for people with specific needs." United Nations High Commissioner for Refugees, "Basic Needs Approach in the Refugee Response," UNHCR website, accessed 12 January 2021, https://www.unhcr.org/protection/operations/590aefc77/basic-needs-approach-refugee-response.html.

norms and expectations of her peers by focusing on art and writing courses in pursuit of higher education. Mohammad is the youngest leader of his community. He initiated the first refugee-led camp journal, a platform for residents to express themselves and to be heard. A monument to the destroyed heritage of Syria, Abo Ali's mud version of the famous Palmyra Arch reminds people where they came from. To provide hospitality for his guests, Jar's father made an elaborate coffee set using food cans decorated with carved date pits. To alleviate the sheer tedium that befalls a population deprived of work, another artist carved chess figurines out of a wooden broom stick. Jar, Wael, Rawan, Hanaa, Mohammad, Abo Ali, and other residents at the camp show us the practical and profound ways in which they pursue human and humane lives. Their inventions

and actions tell stories about the strength in people whose quality of life has been pushed near degree zero.

Refugee camps have long been criticized for providing poor living conditions and violating human rights such as the freedom of movement and access to employment. Others point out that the camp is a model that perpetuates dependency, making financial self-sufficiency impossible. In 2014, the UN agency for refugees published a "UNHCR: Policy on Alternatives to Camps."[2] Soon after, in 2015, the International Rescue Committee called for a closure of refugee camps across the world.[3] Today, five years after these calls to action, approximately 6.6 million refugees still live in refugee camps and we are far from actionable steps to render the policy of camps obsolete.[4]

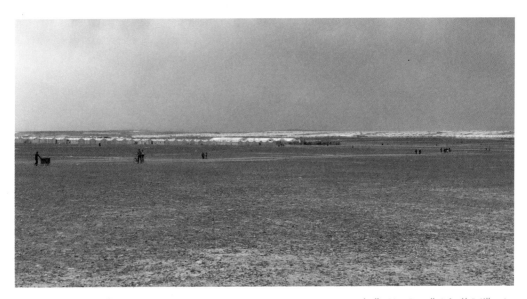

The Azraq Refugee Camp.
Photo: FHL, 2017.

مخيم الأزرق للاجئين. الصورة: مختبر الإرث المستقبلي، نيسان 2017.

Design to Live is not a book about how to create better camps; it aims, rather, to contribute to the body of knowledge on the harms of encampment and advocate for a shift from the paradigm of aid toward self-determination. In the subsequent pages, we invite you to witness how art and design restore humanity within circumstances that deprive it. We invite you to experience the Azraq Refugee Camp not as a marginal moment of encampment, but rather a site full of life, of challenges and dreams that are individual, nuanced, and specific. And through this journey, we hope to take a few steps forward toward a form of knowledge that recognizes the complexity of refugee populations' identities and supports their individual and collective agencies within the harsh and dehumanizing circumstances of forced displacement.

2 UN High Commissioner for Refugees (UNHCR), "UNHCR Policy on Alternatives to Camps," 22 July 2014, UNHCR/HCP/2014/9, accessed 8 February 2021, https://www.refworld.org/docid/5423d-ed84.html.

3 Damien Gayle, "David Miliband: Close the World's Refugee Camps," *The Guardian,* 14 May 2016, accessed 9 November 2020, https://www.theguardian.com/politics/2016/may/14/close-worlds-refugee-camps-says-david-miliband.

4 United Nations High Commissioner for Refugees, "Shelter," n.d., accessed 9 November 2020, https://www.unhcr.org/shelter.html.

الطرق العملية التي يسلكونها للوصول إلى حياة كريمة، فابتكاراتهم وأفعالهم تحكي قصصًا عن القوة التي يمتلكونها في ظل ظروف حياتهم المليئة بالصعاب.

لطالما تعرضت مخيمات اللجوء للانتقاد بسبب سوء ظروفها المعيشية وانتهاك حقوق الإنسان فيها مثل حريات التنقل والعمل، فيما يعتبرها آخرون نماذجًا لإدامة الاعتماد على الإعانات، مما يجعل تحقيق الاكتفاء الذاتي مستحيلًا. نشرت وكالة الأمم المتحدة في العام 2014، مذكرة بعنوان «سياسة المفوضية السامية للأمم المتحدة لشؤون اللاجئين لبدائل المخيمات»2، وفي العام 2015، دعت لجنة الإنقاذ الدولية إلى إغلاق مخيمات اللاجئين في جميع أنحاء العالم3، واليوم، بعد خمس سنوات من تلك الدعوات لاتخاذ الإجراءات، ما زال قرابة 6.6 مليون لاجئٍ يعيشون في المخيمات، وما زلنا بعيدين عن اتخاذ خطواتٍ عملية لإنهاء سياسات المخيمات.4

ليس «التصميم للحياة» كتابًا عن كيفية تحسين أوضاع المخيمات؛ بل هو كتاب يهدف إلى المساهمة في بناء أوجه المعرفة حول أضرار المخيمات، كما ويدعو إلى التحول من نموذج المساعدة إلى أحقية تقرير المصير.

ندعوكم في صفحات الكتاب، لتشاهدوا كيف يعيد الفن والتصميم إحياء الإنسانية في ظروف الحرمان، كما وندعوكم للتمعن في تجربة مخيم الأزرق للاجئين، ليس باعتباره مجرد نقطة نزوح مهمشة؛ بل مكانًا مليئًا بالتحديات والأحلام الفردية والخاصة التي لا يحدها سقف. نأمل من خلال هذه الرحلة، أن نخطو بضع خطواتٍ للأمام في درب التأسيس لأحد أشكال المعرفة الذي يعترف بهوية اللاجئين المعقدة ويدعم الجهات الفردية والجماعية المعنية بهم، في ظل الظروف القاسية وغير الإنسانية التي تسود النزوح القسري.

2 "المفوضية السامية للامم المتحدة لشؤون اللاجئين(UNHCR)، "سياسة المفوضية بشأن بدائل المخيمات". 22 تموز 2014، المفوضية السامية للأمم المتحدة لشؤون اللاجئين، UNHCR/HCP/2014/9، تمت الزيارة في تاريخ 8 شباط 2021. https://www.refworld.org/docid/5423ded84.html

3 دامين جايل، "ديفيد ميلباند: أغلقوا مخيمات اللاجئين في العالم - David Miliband: Close the World's Refugee Camps". الجارديان، 14 أيار 2016، تمت زيارة الصفحة في تاريخ 9 تشرين الثاني 2020، https://www.theguardian.com/politics/2016/may/14/close-worlds-refugee-camps-says-david-miliband.

4 المفوضية السامية للأمم المتحدة لشؤون اللاجئين، "الملجأ"، بدون تاريخ، تمت الزيارة في تاريخ 9 تشرين الثاني 2020، https://www.unhcr.org/shelter.html

تمهيد

تتسبب التهديدات الوجودية المُتمثلة بالتغير المناخي وجائحة وباء كورونا وازدياد عدد المهجرين قسرًا بخلق واقع جديد تسوده مظاهر انعدام المساواة الاجتماعية والسِّياسية والاقتصادية، التي لم يعد بالإمكان تجاهلها. مع ازدياد أعداد الأفراد النازحين إلى بيئات تُجبرهم على التكيف مع سيناريوهات الحياة غير المتوقعة فيها، زادت التحديات التي تتطلب منهم إيجاد القوة والإلهام والأمل في لحظات الضعف والفراغ واليأس التي يسهل الاستسلام لها.

يمكن العثور على لمحات تعكس مستقبلنا المشترك في الأوضاع المعيشية الحالية التي يعيشها اللاجئون السوريون، الذين تحزموا بالأمل وقطعوا الحدود للنجاة من الصراع والأزمات، واتجهوا إلى مراكز الإيواء والمخيمات. على بعد تسعين كيلومتر من الحدود السورية الأردنية، وجد قرابة 40 ألف سوري مأوى لهم في مخيم الأزرق للاجئين، البعيد مسافة ساعتين بالسيارة عن العاصمة عمّان. يمتاز مخيم الأزرق بأنه مغلق ومخطط مركزيًا، وقد تم بناؤه لتلبية الاحتياجات الأساسية للاجئين السوريين.[1] يقع المخيم في قلب الصحراء الشرقية، ويظهر من بعيد كامتداد لا نهاية له من الملاجئ البيضاء المحاطة بالأسوار ولا شيءٍ آخر سوى الرمال. تمتد البيئة القاحلة التي تضم المخيم إلى الأفق، وتبدو معها الظروف المعيشية شديدة الصعوبة التي يعيشها اللاجئون، في ذلك المكان الذي تصل درجات الحرارة فيه صيفًا إلى 118 فهرنهايت (48 درجة مئوية).

من بين مخيمات اللجوء الأخرى في الأردن التي يصل عددها لخمسة عشر، يعد مخيم الأزرق مثالًا واضحًا على البنية التحتية الإنسانية المؤسَّسة، حيث أنه يشكل ما يعتبرُه القطاع الإنساني تقدمًا في الحوكمة والأمن والتصميم. خلال الحوارات التي أجريناها مع مسؤولي المخيم والمنظمات غير الحكومية، غالبًا ما كان يُشار لمخيم الأزرق على أنه مخيم نموذجي في المنطقة صُمم لتجنب النهج التنموي غير المحكم الموجود في المخيمات الأخرى، مثل مخيم الزعتري الذي يبعد بضع كيلومترات عن مخيم الأزرق. تتأثر القوانين المحلية بهذا التشديد، الذي يؤثر بدوره على الحياة اليومية للسكان، ويؤدي لحظر المباني الدائمة والمزارع والحد من تعديل المساحات الداخلية في الملاجئ؛

تُعد هذه البيئة الصارمة نتيجةً للهندسات القائمة على توحيد المعايير، التي تزيد من عوامل الإمتثال المُجبر والإنفصال عن الواقع واليأس. لم تحبط هذه العوامل من عزيمة الشباب المتفائل الذين التقينا بهم في المخيم، وهم مجموعة من المراهقين الذين يسيرون بخطى ثابتة في طريق التغلب على مصاعب اللجوء بشجاعة وإبداع. كان جار أحدهم، إذ شعر بأنّ الواجبات المدرسية عديمة الجدوى، فترك الدراسة، ولكنهُ بالرغم من ذلك، صار قادرًا على أن يحول الملجأ الأبيض المعدني إلى شيءٍ أقرب ما يكون للمنزل، وذلك عبر ما تضفيه اختراعاته، ومنها النافورة المتنقلة، من لمسات على المكان. أمّا صديقهُ وائل، فقد صبّ جُل تركيزه على برنامج التايكواندو في المخيم، وسيكون من ضمن المشاركين في المنافسات القادمة في دورة الألعاب الأولمبية في طوكيو، وروان، التي ابتكرت غسالة باستخدام الدلاء البلاستيكية على أمل مساعدة مئات الأشخاص في غسل ملابسهم في ظروف ندرة الماء ودرجات الحرارة المرتفعة، أما هنا، فقد أعادت كتابة سيناريو حياتها خارج معايير وتوقعات أقرانها، من خلال التركيز على دورات الفن والكتابة، في سعي منها لتحصيل التعليم العالي، ومحمد الشاب القيادي الشخصية في مجتمعه، الذي أسس أول مجلة في المخيم، لتكون منصة يُعبر مِن خلالها اللاجئون عن أنفسهم وتُسمع عبرها أصواتهم، وأبو علي، الذي قام بتشييد نصب تذكاري لتمثيل ما دُمر من التراث في سوريا، وتذكّر النسخة الطينية، التي بناها أبو علي لقوس تدمر الشهير، الناس بوطنهم الذي جاءوا منه، كما صنع أبو جار أدوات لتقديم القهوة بإتقان باستخدام علب الطعام المزينة بنوى التمر المنحوتة، من أجل توجيه ضيوفه وإكرامهم، بينما قام فنان آخر بنحت قطع الشطرنج من عصا مكنسة خشبية لتخفيف الملل الذي يصيب سكان المخيم المحرومين من العمل. يُظهر لنا كل من جار ووائل وروان وهناء ومحمد وأبو علي وغيرهم من سكان مخيم الأزرق للاجئين

312 ⌄ ⌃ 13

[1] يحدد إطار المفوضية السامية للأمم المتحدة لشؤون اللاجئين القائم على النتائج الاحتياجات الأساسية من حيث الوصول إلى الخدمات الأساسية والمساعدة في مجالات الصحة والتغذية والمياه والصرف الصحي والمأوى والطاقة والتعليم، إلى جانب المواد المنزلية والخدمات الخاصة للأشخاص ذوي الاحتياجات الخاصة. المفوضية السامية للأمم المتحدة لشؤون اللاجئين. "نهج الاحتياجات الأساسية للاستجابة للاجئين"، موقع المفوضية السامية للأمم المتحدة لشؤون اللاجئين، تم الوصول إليه في تاريخ 12 كانون الثاني 2021. https://www.unhcr.org/protection/operations/590aefc77/ba-sic-needs-approach-refugee-response.html.

If I could fly...

لو استطعت الطيران لاكانت
الحياة اجمل

If I could fly, I would to do

all my drooms.

كنت سأذهب الى بلدي
الذي لم أره منذ ثلاث
سنوات

أذهب الي البحرين

أساعد الناسي

I would to travel to
syrai to see it
a gane.

~~I would~~ overview or
~~I would~~ fly

watch ches from above
land on hills to have a rest and
continue.

لسافرت وإلى مكة المكرمة ..

لو استطعت الطيران لعشت حياتي بدون
أي متاعب

spread seeds
of growth all around

لو استطعت الطيران...

Exercise from the MIT Future Heritage Lab
storytelling workshop, Azraq Refugee Camp,
January 2018.

إحدى أنشطة ورشة كتابة القصص التي نظمها مختبر الإرث
المستقبلي التابع لمعهد ماساتشوستس للتكنولوجيا في
مخيم الازرق للاجئين. كانون الثاني 2018.

وجهات نظر حول الحياة في المخيم

Perspectives on Life at the Camp

Placed in a Timeless Base

Placed in a timeless base
trapped, yet alive
a living part of the world
here, dignity is invented
inspired by heritage
overcoming scarcity
to exceed your comforts
living memories of home
still human

Poem by: Hanaa Ahmad, Muteeb Awad Al-Hamdan, Azra
Akšamija, Omar Dahmous, Omar Darwish, Raed Suleiman

التمركز في مكان بلا زمن

مكانٌ توقفَ فيه الزمان
رَهينُ الأسْر, لكنه على قَيد الحياة
جزءٌ من العالم ينبض بالحياة
هُنا تُخلق الكرامةُ
مستوحاةٌ من التراث
حيث تقهر النقص والعوز
لتتجاوزَ راحتك
وتعيشَ ذكرياتٍ عنْ وَطنْ
لتبقى إنسان

هناء أحمد ، متعب عوض الحمدان ، أزرا أكشامية،
عمر دحموس ، عمر درويش ، رائد سليمان

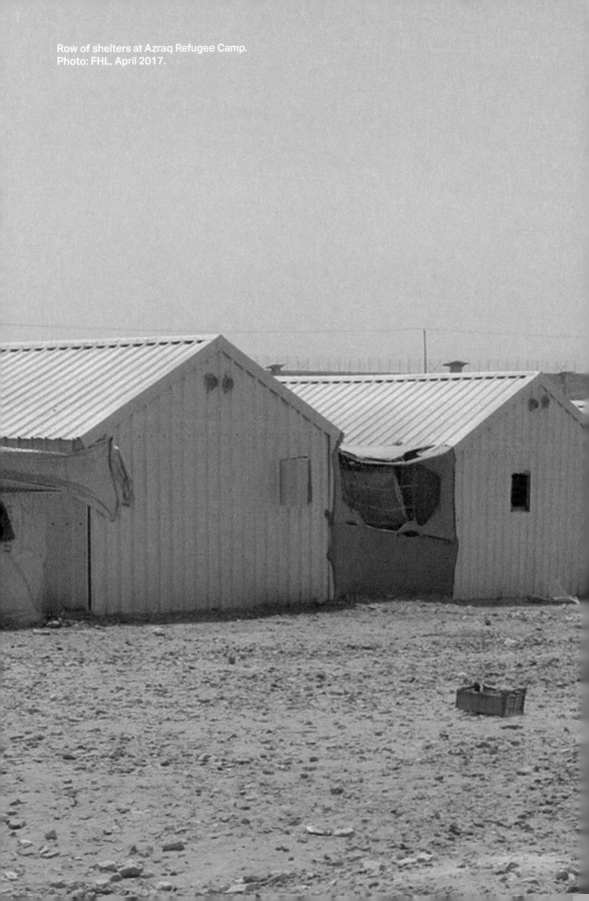

Row of shelters at Azraq Refugee Camp.
Photo: FHL, April 2017.

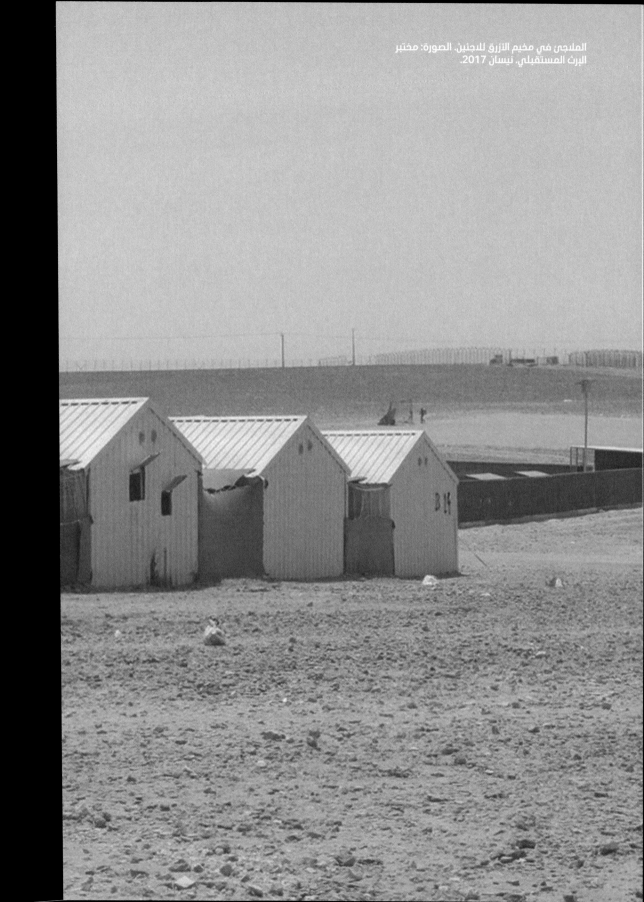

الملاجئ في مخيم الأزرق للاجئين. الصورة: مختبر الإرث المستقبلي. نيسان 2017.

The Power of Writing

Mohammad Abdullah Al-Mezael *is a Syrian youth leader and the founder of the camp's* Azraq Journal. **Muteeb Awad Al-Hamdan** *is a Syrian high school teacher who developed the Tawjeehi exams at the camp, paving the way to university admissions. In conversation with the editors they discuss the value of publishing creative work at the camp and the role of imagination in camp education.*

The interview took place online with participants connecting from Amman and Azraq, Jordan, Tripoli, Beirut, Nicosia, Cyprus, and Boston, Massachusetts on 5 July 2020.

Arriving at the camp

Editors: Mohammad, you've proven yourself to be a youth leader at Azraq. You are involved with community and youth organizing, founded initiatives like the *Azraq Journal*, and led the documentation of the inventions featured in this book. When did you get to the camp and what was your first impression?

Mohammad: That time was tough. It was 2014, I was 13 years old and we had just escaped the war in Syria. My family and I were traveling among a big group of Syrians, and we lost my sister for a day. Upon our arrival to Jordan, we stopped at a point outside the camp to get unit ID cards. During that brief respite, I asked one of the representatives about the Azraq camp, and was relieved to hear that my sisters, mother, and I would be given a shelter that was comfortable and air-conditioned. However, as we entered our assigned

shelter, we were surprised to see no air-conditioning or electricity. I remember thinking: "There's no power but from God. I shall accept my fate and try to move on."

Editors: How did you feel at Azraq?

Mohammad: I felt safe. We had just fled from bombings. This was the first shelter I'd been to in my life. It took me around one year to start acclimating and accepting the environment as my own; it was all so new to me. It wasn't until we started furnishing and decorating the space that we felt at home. We still didn't have electricity, we used solar power for lighting and phone charging.

Leading community initiatives

Editors: When did you start assuming a proactive role in the community? Could you tell us about the evolution of your role in the camp leading to the founding of *Azraq Journal*?

Mohammad: From the second day after arriving at the camp, I started looking for a school; I recognized the urgency of education. After arriving at the school and meeting the professors, they found that I had an inclination to write and recite poetry and started encouraging me to actively pursue writing.

Back in Syria, my uncle, who was a professor of Arabic, used to constantly give me articles and books to read and encouraged me to read voraciously. It became a habit to pick up any journal or newspaper I came

across and start reading. Education, culture, and reading opens minds and doors; it allows one to think with logic. My community and I have been through countless agonies and hardships, which I don't think journalists would be able to capture and relay. The journal was to be an outlet for these intimate stories to be shared.

I started the journal with four of my friends. When I pitched the idea to them, two were opposed because they feared we would not get support, but they reluctantly agreed. We had nothing to lose, so we pitched the idea to CARE. We wanted something for the camp that discussed camp information, stories, education, and tradition.

Today, the journal has a column to welcome and help newcomers socialize, an editorial section with articles and photography, and a portion dedicated to children. There's also a section for people to share topics they'd like to read about, or share texts to expand the scope of readership and the journal team.

Editors: Often you take on the role of representative for your community. You bring people together, articulate shared concerns, and find ways to support them.

Mohammad: I am one of many who take that kind of initiative. I had the opportunity to meet and discuss with people all over the camp during events I helped organize with CARE. I would give speeches in these events and was comfortable with being in the spotlight. It's not unfamiliar in our tradition to be outspoken. As children we grew accustomed to welcoming guests to our homes and socializing in gatherings. Hospitality is part of the Syrian tradition and I believe that prepared me for this role in the camp.

The value of recording design inventions

Editors: Your wide engagement with people around Azraq was also how you got to know and share with us your fascination with the designs, alterations, and mechanical inventions residents create.

Mohammad: With all my activities at the camp, I'm fortunate to know most of the camp residents. As we moved forward with recording these inventions, me being part of the *Azraq Journal* team made them comfortable in opening their household and sharing their creations.

There's something very important about photography, and particularly documentation. These photos were adding value to things that people thought were quite mundane and insignificant. Seeing their work documented gave the makers a sense of pride. When you feature people in a book, you recognize and amplify what they're doing which serves as encouragement for them to keep going. It is also proof that when people are put in a harsh situation, they can still survive, produce, be creative.

Muteeb: People in the camp come from all provinces and districts of Syria, so there's diversity here. These inventions are about the necessity to find ways to adapt and try to resume life. When I worked with the Finn Church Aid I had the chance to visit Villages 3 and 6 and discover some of these inventions. In Mohammad's school, students would talk about the special inventions they had come across. Each person would share their favorite finding, whether in agriculture, knitting, or art; these were things people did back in Syria, adapted to the available materials of the camp. Some of them tried to get grants

to produce items and sell them to make a living and support their families, and others created things from found objects as a hobby.

Editors: Was there a design that specifically appealed to you?

Muteeb: Do you remember the time we paid a visit to the *Majlis* around Village 6? A representative of the village welcomed us. He was very hospitable and happy to receive guests. Well, I'm very fond of Arabic coffee, so the thing I liked the most was the making of coffee using all the tools and accessories he designed for the process.

Creative expression in education in environments of crisis

Editors: About a year ago you facilitated our creative writing workshop with Syrian youth anchored around the fascinating designs of camp residents. From your experience as a teacher at the camp, what do you think is the role of creative outlets in this situation?

Muteeb: I believe creative writing is one of the most important skills a person can have. It's important to express your thoughts and document your ideas. Talented students need mentorship to develop creative interests that will allow them to go places in the future, receive university education. The most relevant university major is journalism, and it's very important to learn to speak on behalf of others, to tackle and shed light on societal issues.

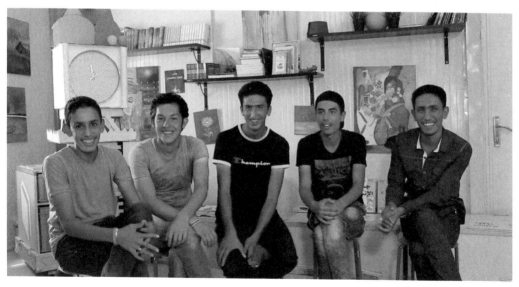

Founding members of the *Azraq Journal*, Mohammad Al-Koeiry, Hussein Ghazi Al-Abdallah, Yassin Al-Yassin, Jamil Homeidi, Mohammad Abdullah Al-Mezael. October 2018.

الأعضاء المؤسسين لمجلة مخيم الأزرق، محمد القعيري، حسين العبدالله، ياسين الياسين، محمد عبدالله المزعل ، محمد عبدالله المزعل ، تشرين الأول 2018.

Editors: You were one of the first teachers to provide education for Tawjeehi at the camp.

Muteeb: When I first came to the camp in June of 2014, I was volunteering as a teacher with an organization for three months, then I worked for three paid months, and throughout this whole time there wasn't a Tawjeehi class, which is the general secondary education certificate examination required in Jordan.

At the beginning of 2015, we started Tawjeehi with four students; and now one of them is studying medicine in France and the other graduated with a business administration degree. It was a new system at the time, and we weren't very sure about the required criteria; it was new to Jordanian students as well.

My colleague and I supported them and taught them Math, Physics, and English. We faced many obstacles with the curriculum. The students found it difficult, especially the ones coming from Syria who had just learned the basics of the language, but they were hopeful and optimistic and able to overcome the obstacles. Five years later, I have many students who graduated from Tawjeehi. One of them is now my colleague.

Editors: Throughout our collaboration you shared some of your students' work in poetry and fiction that showcases the power of imagination as a coping mechanism for learning environments in times of conflict and crisis.

Muteeb: That's right. As you know, I teach boys and girls at Relief International. I

التطور والتكيف مع التحديات. نملك القوة للاستمرار في المعيشة وعدم الاستسلام، ونؤمن بالمثل القائل «الفرص تأتي مع الشدائد»، وفي الاستثمار في الشباب السوري، إذ أنه الضمان الحقيقي لنهضة سوريا.

لديّ رسالة لأوصلها، بصفتي استاذ، ولديَّ الثقة في سكان المخيم، ودعمهم للطلاب ومساعدتهم لإكمال الدراسة في الجامعات وفي مختلف التخصصات، حتى يعودوا إلى سوريا كجيل مثقف متعلم، وإن علمّتني هذهِ الحرب شيئًا، فهو أنَّ الجهل لا يعقد الاتفاقيات، ولا يُحل السلام في العالم.

دور الخيال في هذه الحالة هو موازنة حياتنا الآن مع ما فقدناه وما نأمله.

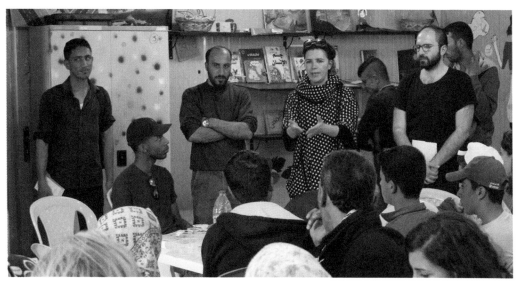

Mohammad Abdullah Al-Mezael, Muteeb Awad Al-Hamdan, Azra Akšamija, and Raafat Majzoub at the first collaborative design workshop with students from MIT, the GJU, and Syria at the Azraq camp. Photo: FHL, April 2017.

محمد عبدالله المزعل ومتعب عوض الحمدان وأزرا أكشامية ورأفت مجذوب في ورشة عمل تشاركية حول التصميم، بمشاركة طلاب من معهد ماساتشوستس للتكنولوجيا والجامعة الألمانية الأردنية والطلاب السوريين في مخيم الأزرق. الصورة: مختبر الإرث المستقبلي، نيسان 2017.

كان أكبرها تعليم الطلاب السوريين أساسيات اللغة الإنجليزية من الصفرِ. على الرغم من كل ذلك، لم يتخلَ الطلاب عن الأمل، وظلوا متفائلين بقدرتهم على تجاوز الصعاب، والآن وبعد مرور خمس سنوات، حصل العديد من طلابي على شهادة التوجيهي، حتى أن أحدهم اصبح واحدًا من زملائي.

فريق التحرير: شاركتَنا أثناء تعاوننا، بعضًا من أعمال طلابك الشعرية والأدبية، وكانت أعمالاً تُظهر قوة الخيال كوسيلة للتكيف في بيئات التعلم في ظروف الصراعات والأزمات.

متعب: هذا صحيح، فكما تعلمون، أُعلم الأولاد والبنات في منظمة الإغاثة الدولية Relief International، من الصف التاسع وحتى الثاني عشر. يشكل الخيال والتاريخ ورواية القصص بعضًا من الوسائل التي يوسع عبرها المرء حدود خياله ويُنميه. يستفيد الطلاب من القصص التي يقرأوها، أو تلك التي يسمعوها من كبار السن، ليأخذوا منها العبر لحل المشكلات، وهذا أحد الأشكال التي يدعم عبرها الأدب الشباب في رحلتهم نحو النضوج.

فريق التحرير: هل لكَ أن تخبرنا، عن الفائدة التي قد تؤثر بها الكتابة والإبداع على مستقبلهم من وجهة نظرك؟ وكيف تساعدهم هذه المجلات على التفكير في الفرص المستقبلية خارج النطاق الذي تفرضه حدود المخيم؟ نهاية، هل تجد في كتاباتهم دلائل على ما يشعرون به؟

متعب: يتذكر أغلب الطلاب في كتاباتهم أحداثًا ومشاهد من ماضيهم في سوريا، مما يعني أنّ أعمالهم تشكل محاولة لتذكر تلك الأوقات واستعادتها من خلال الكتابة. يساعد الخيال الطلاب في بعض الأحيان على التعبير عن رغباتهم في المستقبل، ويربط بين ما خسروه في سوريا، وحزنهم على الماضي، وبين ما يُبذل من جهودٍ لبدء حياة جديدة بمستقبل أفضل في مكان آخر، مثل الدول الأوروبية أو الولايات المتحدة أو كندا. يكمن دور الخيال في هذه الحالة في تحقيق التوازن بين حياتنا الحالية، وما فقدناه، وما نأمل أن يتحقق.

ما قالهُ محمد عن أنّ الاختراعات هي أحد أشكال التعبير الإبداعي صحيح، فالرسالة الحقيقية من وراها تُظهر قدرة الناس على التكيف والتغلب على العقبات حتى يواصلوا حياتهم. يتمتع البشر بمرونة تساعدهم على

have the opportunity to meet students from grades 9 to 12. Fiction, history, and storytelling are some of the ways to expand and support one's imagination. Students can relate to stories they read or hear from elders and even use them to find solutions to certain problems. In that sense literature supports the journey from youth to adulthood.

Editors: Can you tell us more about how you think it could be helpful for their future? How can it help students to think about opportunities and think outside of just being in the camp? What do you see in their writing that hints at how they feel?

Muteeb: In their writings, most of the students recall events and scenes from their past in Syria. Sometimes fiction helps them express desires for the future. Imagination

links what we've already lost in Syria, the grief about the past, with the striving for a better future in resettling elsewhere, like a European country or the United States or Canada.

What Mohammad said about the inventions is also true about other forms of creative expression: the real message is that people have the ability to adapt and overcome obstacles. To live again. Humans have the resiliency to develop and adapt to challenges. We have the power to continue living and not give up. There's a saying that goes as follows: "With adversity comes opportunity." Investing in the Syrian youth is the real guarantee for the development of Syria.

As a teacher, I have a message: I trust in the people of the camp to teach the

تتطلب من الشخص أن يتعلم التحدث نيابةً عن الآخرين، من أجل معالجة قضاياهم المجتمعية وتسليط الضوء عليها.

فريق التحرير: لقد كنتَ من ضمن أول الأساتذة الذين دَرّسوا منهاج التوجيهي في مخيم الأزرق.

مُتعب: عندما جئت إلى المخيم في شهر حزيران من العام 2014، تطوعت كمعلم في إحدى المنظمات لمدة ثلاثة أشهر، وعملت بعدها لثلاثة أشهر أخرى مدفوعة الأجر. لم يتوفر في ذلك الوقت أي إعداد لصفوف التوجيهي، الذي يمثل شهادة التعليم الثانوي في الأردن.

في بداية العام 2015، بدأنا تدريس التوجيهي لأربعة طلاب، أحدهم يدرس الطب الآن في فرنسا، وآخر تخرج بدرجة في تخصص إدارة الأعمال. تمَّ تحديث نظام التوجيهي في الأردن وقتها، ولم نكن متأكدين تمامًا من المعايير المطلوبة، فقد كان الأمر جديدًا حتى بالنسبة للطلبة الأردنيين. قمت أنا وزملائي بدعم طلابنا، ودرّسناهم مواد الرياضيات والفيزياء واللغة الإنجليزية. وقد واجهنا العديد من العقبات في المناهج الدراسية،

العربية كثيرًا، وكان أكثر ما أعجبني في ذلك المجلس، طريقة صنع الرجل للقهوة، والأدوات والاكسسوارات التي صممها لإعدادها.

التعبير الإبداعي في التعليم في بيئات الأزمات

فريق التحرير: ساعدتنا قبل عام عندما أقمنا ورشة الكتابة الإبداعية للشباب السوري، وقد تمحورت الورشة حول التصاميم الرائعة لسكان المخيم. ما الدور الذي تلعبه النشاطات الإبداعية هذه في هذا الوضع، من وجهة نظرك كأستاذ خبير في المخيم؟

مُتعب: أعتقد أنّ الكتابة الإبداعية هي إحدى أهم المهارات التي قد يمتلكها الإنسان، إذ أنها تساعدنا في التعبير عن أفكارنا وما يجول في خاطرنا. يحتاج الطلاب الموهوبين إلى الإرشاد والتوجيه ليطوّروا اهتماماتهم الإبداعية التي تفتح لهم أبواب الفرص للخروج إلى العالم الخارجي في المستقبل، وتلقي التعليم الجامعي. تعد الصحافة إحدى أكثر التخصصات الجامعية صلة بالكتابة الإبداعية، إذ

students and give them all the help and support to continue studying in universities with different specializations so that when they go back to Syria, they go back as an educated generation. If I've learned anything from this war, it's that ignorance doesn't reach agreements or make peace in the world.

The role of imagination in that case is to balance how we live now with what we lost and what we hope for.

جميع محافظات ومدن سوريا، ويعتبر التنوع سمة من سمات المخيم. تعبّر هذه الاختراعات عن ضرورة إيجاد وسائل للتكيف واستمرارية الحياة. أتيحت لي فرصة زيارة القرى 3 و 6 في المخيم، واستكشاف بعض تلك الاختراعات أثناء عملي مع منظمة Finn Church Aid. تحدث الطلاب في مدرسة محمد، عن الابتكارات الخاصة محمد، وشارك كل طالب منهم اختراعهُ المفضل، سواءً في مجال الزراعة أو الحياكة أو الفن، ومن اللافت أن جميع الإختراعات كانت متصلة بأمور اعتاد الناس ممارستها في سوريا، وباتوا يمارسونها الآن في المخيم باستخدام المواد المتاحة لديهم. حاول بعض اللاجئين الحصول على منح لإنتاج السلع وبيعها لكسب العيش وإعالة أسرهم، واكتفى آخرون بصناعة الأشياء كهواية، باستخدام المواد المتاحة أمامهم.

فريق التحرير: هل أعجبك أيّ من تلك التصاميم على وجه الخصوص؟

متعب: هل تتذكرون عندما زرنا المجلس القريب من القرية رقم 6؟ رحب بنا أحد ممثلي القرية، وكان مضيافًا وسعيدًا بزيارتنا. أحب في الحقيقة القهوة

رأسي. كتبتُ هذه المقالة في العام 2014 بمساعدة عمتي، أتذكر أننا أمضينا يومًا كاملًا في كتابتها. تحكي المقالة عن المكان الذي وُلدت وعشت فيه لأربعة عشر عامًا، وهي عزيزة عليّ لأنها تتحدث عن موطني الذي غادرتهُ.

فريق التحرير: تمثل يا محمد مجتمعك إذًا، وتجمع الناس مع بعضهم، وتمنحهم متسعًا للتعبير عن اهتماماتهم المشتركة، وتسعى في إيجاد طرق لدعمهم.

محمد: أنا واحدٌ من الكثيرين الذين تولوا زمام المبادرة، وقد حظيت بفرصة لقاء مجموعات مختلفة من سكان المخيم والنقاش معهم، ضمن الفعاليات التي ساعدتُ منظمة كير CARE في تنظيمها. ألقيت خطابات في تلك الفعاليات، وكنت سعيدًا بالاهتمام الذي نلتهُ، وخاصة لأنّ الخطابة أمرٌ مألوف في ثقافتنا، حيث اعتدنا منذ طفولتنا الترحيب بالضيوف في منازلنا والمشاركة في اللقاءات الاجتماعية، كما ويعتبر حسن الضيافة جزءاً من التقاليد السورية. أعتقد بأنّ كل تلك العوامل قد ساهمت في تهيئتي لهذا الدور في المخيم.

أهمية توثيق الإبتكارات في التصميم

فريق التحرير: إنّ تفاعلك الواسع مع السكان في أرجاء مخيم الأزرق هو أيضًا ما حفزك للتعرف على شغفك بالتصميم واستخدام البدائل والاختراعات الميكانيكية التي نفذها اللاجئون، ودفعك إلى مشاركتها معنا.

محمد: تعرفتُ إلى معظم السكان المخيم عبر الأنشطة التي ساهمتُ في تنظيمها. شعر سكان المخيم بالراحة عندما كنت أوثق اختراعاتهم، لأنني كنت جزءًا من فريق العمل، وكنت واحدًا منهم، لذلك فتحوا منازلهم لنا، وشاركونا المزيد من إبداعاتهم.

ثمة أمرٌ مهم آخر لفت أنظارنا، عندما كنا نوثق الإبداعات في صور فوتوغرافية، إذ لاحظنا بأنّ الناس لم يدركوا قيمة اختراعاتهم حتى رأوا أحدًا يقوم بتوثيقها. أضافت هذه الصور قيمة للأشياء التي اعتقد الناس أنها بسيطة وغير مهمة، حيث أنّ رؤيتهم لأعمالهم وهي تُوثق بثت فيهم إحساس الفخر. إنّ توثيق إنجازات الناس في صفحات كتاب ما، يمكن أن يضيف قيمة على عملهم، ويشجعهم على الاستمرار بالإنجازات، كما يدل أيضًا، على قدرتهم على التعايش والإنتاج والإبداع في أصعب المواقف.

متعب: ترجع أصول اللاجئين في مخيم الأزرق إلى

قوّة الكتابة

محمد عبدالله المزعل : شابٌ سوري قيادي الشخصية، أسس مجلة مخيم الأزرق للاجئين. متعب عوض الحمدان؛ استاذ في مدرسة ثانوية سورية، أدت جهوده لإدخال إمتحان الثانوية العامة (التوجيهي) إلى المخيم، لتمهيد الطريق أمام القبول الجامعي. في لقاء نقاشي مع فريق التحرير، أكد محمد ومتعب أهمية نشر الأعمال الإبداعية للاجئين، ودور الخيال في العملية التعليمية في المخيم.

الوصول إلى المخيم

فريق التحرير: لقد أثبتَّ بالفعل أنك أحد القادة المجتمعيين الشباب في مخيم الأزرق يا محمد، من خلال انخراطك في مبادرات تنظيم المجتمع والفئة الشابة فيه، وتأسيسك لمجلة في المخيم، ومساهمتك في توثيق الاختراعات الإبداعية في هذا الكتاب. أخبرنا متى جئت إلى هنا، وكيف كانت أولى انطباعاتك؟

محمد: أتينا إلى المخيم عام 2014، عندما كنت في الثالثة عشر من عمري. كنا قد هربنا وقتها من الحرب في سوريا، وكانت فترة مجيئنا صعبة. سافرتُ مع عائلتي ضمن مجموعة كبيرة من السوريين الآخرين، وأضعنا أختي في أحد أيام رحلتنا. توقفنا، أول وصولنا إلى الأردن، عند أحد نقاط العبور خارج المخيم حتى نحصل على بطاقات هوية، وهناك سألت أحد الموظفين عن الوضع في مخيم الأزرق للاجئين. شعرت بالارتياح عندما علمت بأننا سنمنح ملجأ مريح ومكيف. ولكننا فوجئنا، عندما دخلنا الملجأ، بعدم وجود التكييف أو الكهرباء. أتذكر أنني قلت في نفسي يومها: «لا حول ولا قوة إلا بالله»، وأنّ عليّ أن أتقبل مصيري، وأمضي قدمًا في حياتي.

فريق التحرير: كيف كان شعورك في مخيم الأزرق؟

محمد: شعرت بالأمان، لأننا هربنا من القصف والقنابل. لقد كان المخيم أول ملجأ آوي إليه في حياتي، واستغرقني التأقلم فيه قرابة عام كامل، ثم تقبله كبيئتي الجديدة، كان كل شيء فيه جديد بالنسبة لي، وعندما بدأنا تأثيث المكان وتحسينه، بدأت أشعر بأنه منزلي. اعتمدنا في الفترة الأولى على الطاقة الشمسية للإضاءة وشحن الهواتف لأن الكهرباء لم تكن متوفرة.

إطلاق المبادرات المجتمعية

فريق التحرير: متى بدأت بتولي الأدوار التفاعلية في المجتمع؟ وهلّا أخبرتنا عن تطور دورك في المخيم وتمكّنك من تأسيس مجلة مخيم الأزرق للاجئين؟

محمد: بدأت منذ ثاني يوم بعد وصولي إلى المخيم، بالبحث عن مدرسة لألتحق بها، لأنني أؤمن بأهمية التعليم. بعد أن التحقت أخيرًا بالمدرسة، لاحظ أساتذتي بأنني أمتلك موهبة في كتابة وإلقاء الشعر، وشجعوني على السعي لتطوير قدراتي الكتابية.

عندما كنتُ في سوريا، كان عمي أستاذ لغة عربية، وكان دائمًا ما يعطيني مقالات وكتب لأقرأها، جعلني تشجيعهُ لي أقرأ بشراهة، وطوّر لديَّ عادةُ قراءة أيٍّ مجلة أو صحيفة تقع أمامي. يفتح التعليم والقراءة أبواب العقول والفرص، ويسهمان في تطوير التفكير العقلاني. مررت مع مجتمعي بأهوال ومصاعب لا حصر لها، أهوال لا أعتقد أنّ الصحفيين يقدرون على التقاطها ونشرها بصورتها الكاملة، لهذا، قررت أن تكون هذه المجلة مساحة يشارك فيها اللاجئون قصصهم.

بدأتُ المجلة مع أربعة من أصدقائي، وعندما عرضت فكرة المجلة لأول مرّة، اعترض اثنان منهم خشية عدم الحصول على الدعم، ولكنهما في النهاية وافقا بتردد. لم يكن لدينا شيءٌ لنخسره، لذا عرضنا الفكرة على منظمة كير CARE. أردنا مجلة خاصة بالمخيم، تتضمن معلومات عن المكان، وقصص وحكايا، ومحتوى تعليمي وتراثي.

تحتوي المجلة اليوم، على عمود صحفي يرحب بالقادمين الجدد ويساعدهم على الانخراط بالمجتمع، بالإضافة إلى قسم تحريري يتضمن مقالات وصور، ومحتوى مخصص للأطفال. كما وأننا أضفنا على مضمون المجلة أيضًا، قسمًا يشارك فيه الناس المواضيع التي يرغبون في القراءة عنها، والتي توسع مدارك القراء وفريق المجلة.

فريق التحرير: ما هو أكثر مقال تفتخر به وتحبه؟

محمد: إنها بلا شك مقالة بعنوان «غدير البستان»، وغدير البستان هو اسم القرية التي يقع فيها مسقط

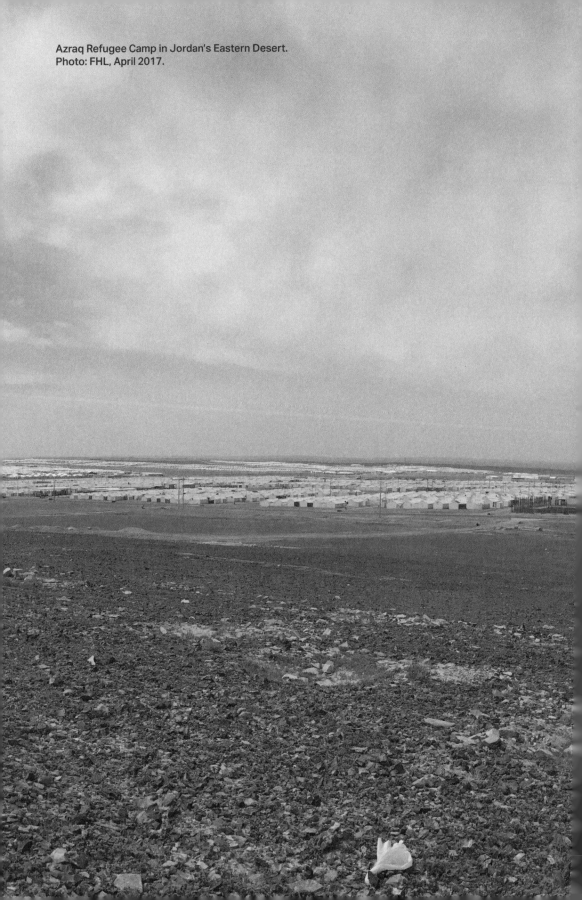

Azraq Refugee Camp in Jordan's Eastern Desert.
Photo: FHL, April 2017.

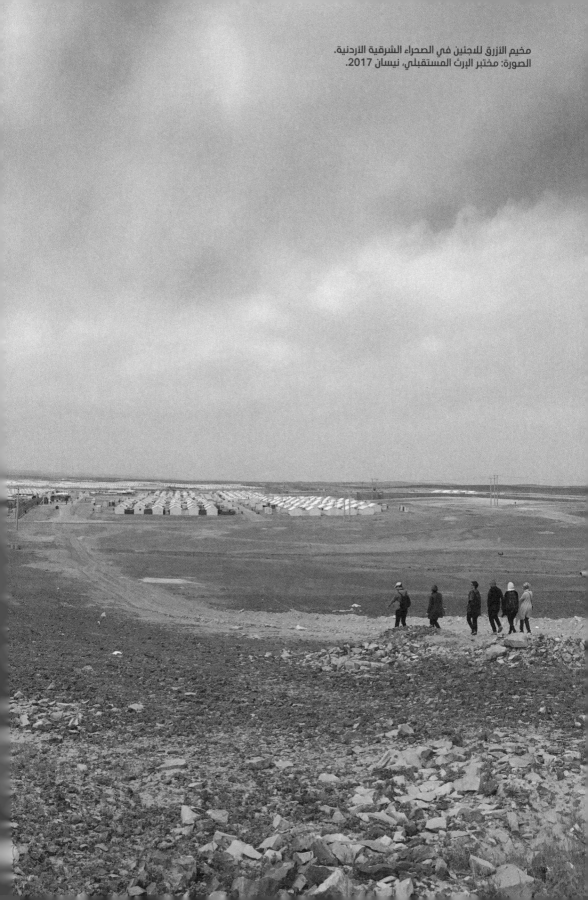

Working in a Field of Traps

Malek Abdin *is the Jordanian team leader of CARE International at the Azraq camp, Jordan. He supported CARE's collaboration on cultural interventions with the MIT Future Heritage Lab (FHL). In conversation with the editors he discusses the significance of creative work in refugee spaces.*

The interview took place online with participants connecting from Amman, Jordan, Nicosia, Cyprus, and Boston, Massachusetts on 30 June 2020.

Care's role and responsibilities at the camp

Editors: CARE Jordan has been present at the Azraq camp since 2013, a year before its official inauguration, when it began receiving Syrian refugees. In collaboration with other NGOs, UN agencies, and governmental authorities, you offer support across the camp. How is your work at Azraq different compared to other camps?

Malek: The Azraq camp plan and activities are based on the lessons learned from other camps in the country. A significant challenge was the overlap of activities: 50 NGOs at the same camp would do similar projects if not properly managed. With the support of the UN agencies and the government, we decided that each sector should be handled by only one NGO. The role of that organization is to facilitate the work, meet refugee needs, find solutions, but also make sure that overlaps are avoided.

CARE in specific is the "one-stop-shop" for all activities taking place in the camp. Any refugee who is interested in participating in cultural activities and/or needing assistance both with CARE and any of the other 25 or so actual NGOs will reach out to us. We will look at their needs and profile to issue referrals. When residents have concerns related to shelter maintenance, quality of assistance, suggestions for improvements, or proposals for new interventions, they also report to our offices. In this case, we would either issue referrals and follow up on them or include the concerns in our advocacy campaigns with the support of different NGOs and authorities. CARE shifted all the intervention implementation modalities into a hybrid online/offline method as of the first day of the lockdown due to the COVID-19 pandemic, in March 2020. The change in modalities had a significant impact in reaching all refugees, especially the most vulnerable ones, and also contributed to enriching the digital literacy skills within the camp environment.

Another facet of our work is community empowerment through skill-building and self-development activities. CARE oversees four community centers, one at each camp village. Additionally, the organization's outreach team engages with the most vulnerable refugees who cannot access the community center for various reasons, such as mobility or cultural issues. We support recreational sports and other psycho-social activities (peer support groups, psychodrama, etc.) for all community members, providing safe spaces for women and girls to expand their protection networks,

34 ∧ ∨ 291

improve skills that are relevant to the local market, and provide daycare facilities for their children to empower women's participation in capacity-building trainings. We are also moving toward livelihood interventions: refugees have access to business development training, vocational training, and small grants to kickstart their own businesses. A recent major development in the income-generating efforts was witnessed in harvesting the first plants in Azraq camp from the established hydroponic systems. These systems were built to encounter the harsh camp environment and untreated soil and to contribute to food security and livelihood opportunities.

One of our main objectives is to support community initiatives and innovation. We support refugees who approach us with ideas and solutions for their own community, be it in the camp at Azraq or beyond. Our help covers human resources, logistics, and partially financials. In cases where we are not able to help effectively, part of CARE's approach in Jordan is to establish relevant partnerships with different entities who can support refugees in need.

Art & design in humanitarian work

Editors: CARE is the head of activities at the camp. Part of that role is to operate as the point of contact between the camp and external contributors. With your support and in collaboration with residents, we facilitated intergenerational art & design workshops, designed a school for learning in crisis, and conducted research related to the cultural production on site. Where do you see the contribution of art & design in your work?

Malek: As a humanitarian aid organization, we believe it is important to give

access to outside-the-box ideas and interventions. Our role in overseeing the needs and processes of the camp can be limiting in terms of creativity, so establishing partnerships with other entities is critical. Our collaboration with the Future Heritage Lab on art & design activities at the camp was the first of its kind. You were the first in Azraq camp to enter such a field of traps.

Editors: Over the last couple of years, we've been asking ourselves the haunting question of what we can ultimately do, and what's the actual impact of our involvement?

Malek: I am sure it's not easy to measure the impact of cultural interventions in quantifiable terms. Still, we've been able to see the difference in residents' everyday lives, social interactions, and creative expression. The success of our collaboration encouraged a series of innovative partnerships. If you see the number of partners involved in different types of activities today, you see the fruits of your interventions, and it makes it all worth it. We found that collaboration yielded better results.

This year, outstanding results were seen in relation to expanding innovative interventions, among which was the washable face mask prototype done in response to the COVID-19 outbreak at the camp. Your design, Co-mask, was approved by the authorities and saw the light recently when CARE started producing face masks intended to be distributed for free for all camp refugees.

We found that collaboration yielded better results. Having one body be responsible for everything is an outdated model of humanitarian work that is no longer viable.

Enabling community initiatives

Editors: One of CARE's main objectives is to support community initiatives. We had the opportunity to meet and collaborate with the young founders of the *Azraq Journal* initiative. They played an essential role in the ideation and research of this book.

Malek: I still recall Mohammad's words when he reached out with the idea for a camp periodical. He pointed out that NGOs think, discuss, and problem solve on behalf of refugees in the camp; they even represent the residents to outside stakeholders. He said: "We have voices and we have ideas, and we're capable of doing a lot of things. So why isn't there a platform speaking the language of young refugees?"

What we did was open the door in making the project possible. At the time, the camp didn't have an electricity network. We made sure there was a safe space with electricity and the technological tools for the group to gather and talk freely. Six teenagers worked together on drafting the first edition of the camp journal. After several reviews from different entities and the government, it was approved and published. We printed it outside the camp to ensure the best quality. It was then distributed both in and outside the camp. The journal team felt really proud of that accomplishment. What was discussed between shelters was now published and could reach people from different cultures around the world. They gradually worked on a second issue, and they are currently working on the third. It wasn't only about creating a journal for the world. It also

It is our responsibility to make visible the shortcomings of the field and share the stories of resilience and success with the rest of the world.

تقع على عاتقنا مسؤولية إظهار أوجه القصور في المجال ,ومشاركة قصص عن الصمود والنجاح مع بقية العالم.

had a significant impact on their personalities; the group grew from six founders to 29 members in different parts of the camp. The project allowed the founders to outline their concerns and express personal and educational frustrations.

Editors: We worked closely with the journal founders to document the creative work of residents. Interventions include alterations to the standardized design of the camp, mechanical inventions, and social spaces. Over time, we observed the impact of refugee-led interventions on both other residents and NGOs. Residents replicated and built upon the design work of their neighbors and NGOs adapted camp regulations to accommodate and support interventions that improve everyday life. Characteristic examples are the "deregulation of gardening" and the shelter improvement program for the addition of partitions. Is humanitarian work informed by the creative production of refugees?

Malek: It is common to look at humanitarian work as rigid. Many entities follow a traditional approach. Anything beyond the established ways is met with resistance for fear of possible harms. The increased bureaucracy of the field results in delays. Tasks that should take a month, take a year. In other cases, regulations challenge the implementation of good ideas.

That said, when organizations and their agents witness the successful implementation of a community initiative, it can loosen up the interpretation of regulations. Going back to the journal, the first edition took forever to be approved. For a group

هذا المجال، ومشاركة قصص الكفاح والنجاح مع بقية العالم. لا تبدو مشكلة اللاجئين قابلةً لأنْ تجد حلولاً في أي مكان أو وقت قريب، مما يزيد الضغط على البرامج، ويدفع لزيادة التركيز على التنمية وإيجاد الحلول عن طريق التعاون وبمشاركة المجتمع، على عكس ما يفرضه النهج التقليدي للمساعدة الإنسانية. تتجه أنشطة منظمة CARE في المخيم استراتيجيًا نحو تمكين اللاجئين من حيازة الملكية الكاملة للخدمات المقدمة، واستبدال البطالة بالإنتاجية، وخلق الفرص من المساعدات لتمكين اللاجئين من استغلالها، لتعزيز قدراتهم، ومشاركتها مع الآخرين.

في حالات النزوح القسري. كيف ترى مستقبل العمل الإنساني؟

مالك: يخضع عملنا للتغيير المستمر، ففي العام 2018، لاحظنا تأثير الإنخفاض الكبير لقيمة التمويل على الفئات الأكثر ضعفًا في مجتمع اللاجئين، مما دفع كلاً من اللاجئين والمنظمات غير الربحية للتفكير بشكل مختلف. انتقلنا من استقطاب المساعدات النقدية والطرود الغذائية، إلى بناء القدرات وتقديم دعم صغير للاجئين ليبدأوا مشاريعهم الخاصة– فالدعم الجاهز يفقد قيمته عندما يُستنفد. أدار أعضاءٌ من منظمة كير CARE النشاطات في المخيم قبل عامين، أما اليوم، فيدير اللاجئون المراكز المجتمعية، مع وجود عدد قليل من موظفينا لتقديم الدعم. تم عقد هذا اللقاء في خضم جائحة كورونا التي أدت إلى غياب أعضاء منظمة كير CARE عن المخيم، وأصبح محمد والأعضاء الآخرين لفريق مجلة مخيم الأزرق، مسؤولين عن إعداد التقارير ومقابلة الناس وعقد النقاشات الجماعية. بقيّ محمد على اتصال مع المنظمات غير الحكومية، مناقشًا معها جودة عملها. قام محمد بعمل رائع رغم قلة الدعم، مما يجعل المسؤولية واقعة على عاتقنا لإظهار أوجه القصور في

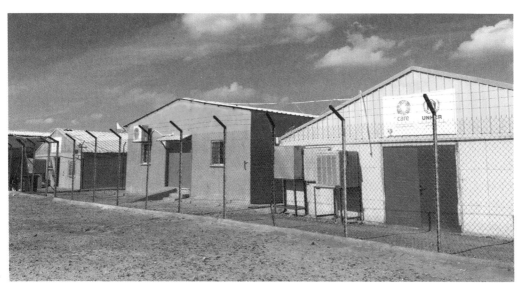

CARE community center.
Photo: FHL, January 2018.

مركز منظمة كير المجتمعي. الصورة: مختبر
الإرث المستقبلي، كانون الثاني 2018.

فريق التحرير: لقد عملنا عن كثب مع مؤسسي المجلة لتوثيق الأعمال الإبداعية للاجئين، والتي تشمل تعديل التصاميم التقليدية لمأوى اللجوء، والاختراعات الميكانيكية، والمساحات الاجتماعية. لاحظنا مع مرور الوقت آثار اختراعات اللاجئين على بقية السكان في المخيم وعلى المنظمات غير الحكومية، حيث استجاب اللاجئون الآخرون مع تلك التصاميم عبر تقليدها، واستفادت المنظمات غير الحكومية من الطبيعة المرنة لأنظمة المخيم من أجل دعمها، ومن الأمثلة المميزة على تلك التصاميم «تحديث البستنة»، وبرنامج تحسين المأوى عبر إضافة الحواجز الفاصلة بينها. هل يصح القول أنّ الإنتاجات الإبداعية للاجئين تنير الطريق أمام العمل الإنساني؟

مالك: من الشائع الاعتقاد بأن العمل الإنساني صارم في طبيعته، نظرًا لوجود الكثير من الجهات التي تتبع طرقًا تقليدية في عملها، ونظرًا لمقاومة ظهور أي طريقة غير تقليدية خوفًا من أضرارها المحتملة. تؤدي البيروقراطية في هذا المجال إلى تأخير تنفيذ المهام، وتستغرق المهام التي يجب أن تُنجز في غضون شهر واحد عامًا كاملًا، كما تعيق القوانين في حالات أخرى، تطبيق الأفكار الجيدة.

تُقلل بعض القيود والعقبات عندما تشهد إحدى المنظمات تطبيقًا ناجحًا لمبادرة مُجتمعية، وأفضل مثال على ذلك، كان الطبعة الأولى من مجلة المخيم، إذ استغرقت الموافقة عليها وقتًا طويلًا جدًا، بسبب اعتبار قيام مجموعة من اللاجئين بنشر مجلة أمرًا مستحيلًا وصعبًا.

برزت النتائج الإيجابية لتعاوننا، في اقدام الجهات الحكومية وإدارات المنظمات غير الحكومية على دعم تصاميمَ نفذها اللاجئون أنفسهم، التي تحمل رسالة مفادُها «لا نريد تلقي المساعدات الجاهزة والموحدة بعد الآن». لا شكَّ أنّ العمل الإنساني مهمٌ جدًا، ولم تعد أدوارنا تقتصر على المساعدة فقط، بل أصبحت تسعى لتمكين المُجتمع أيضًا، وللتأكيد على قدرة اللاجئين على دعم بعضهم البعض.

مستقبل العمل الإنساني

فريق التحرير: تشير النقاط التي ذكرتها في حديثك إلى التحديات التي تواجه العمل الإنساني والجهود المبذولة لتحديث هذا القطاع في ظل الارتفاع غير المسبوق

of refugees to publish a journal sounded outrageous.

A positive outcome of our collaboration is that governmental agencies and NGOs saw experts supporting refugee-led interventions, with designs that say: "we don't want to receive ready assistance anymore." Humanitarian work is definitely invaluable; at the same time, we see our role moving from assistance to community empowerment, showcasing what refugees themselves have to support one another

The future of humanitarian aid

Editors: In light of this effort to update the sector in the face of an unprecedented rise of forced displacement, where do you see the future of humanitarian work?

Malek: Our work is changing. Around 2018, we could really see how the significant reduction of funding affected the most vulnerable members of the community. At the same time, it led refugees and NGOs to think differently. We transitioned from attracting cash-assistance and food parcels to building capacities and providing small support for refugees to start their own businesses. Readymade support is only valuable until its depletion. A couple of years ago, it was members of CARE who would run the activities of the camp. Today, it is refugees that are in charge of community centers with minimal support from our staff. Our discussion takes place in the midst of COVID-19 pandemic. In the absence of CARE members at the camp, Mohamed and other members of the journal initiative took the lead on reporting, meeting with people, and holding focus group discussions. He

ما فعلناهُ هو فتح الباب لجعل هذا المشروع ممكنًا في الوقت الذي لم يكن فيه المخيم مزودًا بشبكة كهرباء، وقد وفرنا للمشاركين الشباب مكانًا آمنًا مزودًا بالكهرباء والوسائل التكنولوجية، حتى يتمكنوا من عقد اجتماعاتهم والحديث بحرية. شارك في تصميم الطبعة الأولى من المجلة ستة شباب في سن المراهقة، وتم الموافقة على المجلة وطباعتها بعد عدد من المراجعات التي قامت بها الحكومة وعدد من الهيئات. قمنا بطباعة المجلة خارج المخيم لضمان جودة أفضل، وتم توزيعها داخل المخيم وخارجه. شعر فريق المجلة بالفخر من هذا الإنجاز، وأصبحت المواضيع التي كان اللاجئون يناقشونها فيما بينهم متاحة للمشاركة مع الثقافات الأخرى حول العالم. بدأ الشبان بعدها بالعمل على الإصدار الثاني من المجلة، وهم يعملون الآن على الإصدار الثالث. لم يهدف هذا المشروع لإصدار مجلة تخاطب العالم فقط؛ فقد كان لهذه المجلة أثرٌ عميق على شخصياتهم، وازداد عدد أفراد فريق التحرير من 6 إلى 29، وجميعهم من أماكن مختلفة في المخيم، كما ساعدت المجلة مؤسسيها في التعبير عن قضاياهم ومشاكلهم الشخصية والتعليمية.

أصبح توكيل كافة مسؤوليات العمل لجهة واحدة فقط، أسلوبًا قديمًا في العمل الإنساني، ولم يعد يُطبق في عالم اليوم.

تمكين المبادرات المُجتمعية

فريق التحرير: يكمن أحد الأهداف الرئيسة لمنظمة كير CARE في دعم المبادرات المُجتمعية، وقد أتيحت لنا فرصة اللقاء والتعاون مع المؤسسين الشباب لمبادرة مجلة مخيم الأزرق، الذين لعبوا دورًا أساسيًا في تطوير المحتوى الفكري والبحثي لهذا الكتاب.

مالك: ما زلتُ أتذكر كلمات محمد عندما جاءنا ليعرض علينا فكرة المجلة في المخيم، قال حينها أن المنظمات غير الحكومية تفكر وتناقش وتحل المشكلات نيابة عن اللاجئين في المخيم، وأنهم يمثلونهم حتى أمام الجهات المختلفة، ثم أضاف «لدينا أصوات..ولدينا أفكار.. ونحن قادرون على فعل الكثير من الأشياء..فلماذا لا توجد منصة يتحدث من خلالها اللاجئون الشباب؟»

was in contact with the NGOs and discussed with them about the quality of their work. He did an amazing job with little support. It is our responsibility to make visible the shortcomings of the field and share the stories of resilience and success with the rest of the world.

The refugee problem is not going anywhere, anytime soon, and this has pushed further the nexus agenda with its focus on finding solutions with community engagement and participation in contrast to the traditional humanitarian approach. CARE activities in the camp are moving strategically toward empowering refugees to have full ownership of the services provided, idleness to be replaced with productivity, and every assistance an opportunity that refugees can use to build and transfer capacities to others.

الفن والتصميم في العمل الإنساني

فريق التحرير: تترأس منظمة كير CARE الأنشطة المقامة في المخيم، وتمثل حلقة وصل بين المخيم والمساهمين الخارجيين. استطعنا من خلال الدعم الذي قدمتموه وتعاونكم مع سكان المخيم، أن نقيم ورشة عمل حول الفن والتصميم بين الأجيال، وصممنا مدرسة للتعلم في أوقات الأزمات، وأجرينا بحثًا حول موضوع الإنتاج الثقافي في المخيم. ما هي مظاهر مساهمة الفن والتصميم في عملكم؟

مالك: نؤمن، بصفتنا منظمة معنية بالمساعدات الإنسانية، بأهمية مبدأ الإبداع والتفكير المبتكر، لكن دورنا المرتكز على الاهتمام باحتياجات اللاجئين والاشراف على الأنشطة التي تُجرى في المخيم، يحدّ أحيانًا من تداخل الإبداع في عملنا، ولذلك نضطر لإقامة شراكات مع جهات الأخرى في هذا المجال. كانت مبادرتنا التعاونية، مع مختبر الإرث المستقبلي في مجال الفن والتصميم في المخيم، الأولى من نوعها، وكنتم أول من دخل هذا المجال المليء بالعقبات والصعاب.

فريق التحرير: خلال العامين الماضيين، استمرينا في التساؤل حول ما نستطيع تحقيقه بالفعل، وحول الأثر الحقيقي لمشاركتنا.

مالك: ليس من السهل قياس تأثير الأنشطة الثقافية بالمؤشرات الكمية، ولكننا نستطيع مع ذلك رؤية الاختلاف في حياة السكان اليومية والنشاطات الاجتماعية والتعبير الإبداعي. يُشجع نجاح تعاوننا إقامة سلسلة من الشراكات المبتكرة، كما أنّ تزايد أعداد شركائنا في مختلف الأنشطة هو مؤشر على أنّ تعاوننا مثمر وذو نتيجة.

شهدت هذه السنة نتائج مميزة فيما يتعلق بتوسيع التدخلات المبتكرة، ومن ضمنها تصميم نموذج أولي للكمامات القابلة للغسل، استجابة لتفشي وباء كورونا في مخيم الأزرق. تمت الموافقة على التصميم الذي قدمه معهد ماساتشوستس للتكنولوجيا من قبل السلطات، وتمّ تنفيذ التصميم مؤخرًا عندما بدأت منظمة كير CARE في إنتاج الكمامات، بهدف توزيعها مجانًا على جميع اللاجئين في المخيم.

العملُ في حقل من العقبات

مالك عابدين؛ قائد أردني لفريق منظمة كير العالمية CARE INTERNATIONAL في مخيم الأزرق في الأردن. دعم عابدين أول تعاون حصل بين المنظمة و «مختبر الإرث المستقبلي» في معهد ماساتشوستس للتكنولوجيا بخصوص المداخلات الثقافية. وفي لقاء أجراه مع فريق التحرير، ناقش عابدين أهمية العمل الإبداعي في مساكن اللاجئين.

دور ومسؤوليات منظمة كير CARE في المخيم

فريق التحرير: بدأت منظمة كير CARE في الأردن عملها في مخيم الأزرق منذ العام 2013، أي قبل عامٍ من الافتتاح الرسمي للمخيم، عندما بدأ باستقبال اللاجئين السوريين. قمتم، بالتعاون مع المنظمات غير الحكومية والجهات الحكومية الأخرى بتقديم الدعم في المخيم، ما الذي يميز عملكم في مخيم الأزرق عن باقي المخيمات؟

مالك: تم بناء خطط ونشاطات مخيم الأزرق للاجئين بناءً على الدروس المستفادة من المخيمات الأخرى في البلاد. وكان تداخل الأنشطة من أبرز التحديات؛ إذ ساعد تنظيم العمل في تجنّب قيام 50 منظمة غير حكومية بتنفيذ مشاريع متشابهة. قررنا، وبدعمٍ من الوكالات التابعة للأمم المتحدة والحكومة، أن تتعامل كل منظمة غير حكومية مع واحد من القطاعات، وأن تقوم المنظمة بتسهيل العمل وتلبية احتياجات اللاجئين وإيجاد الحلول للعقبات، بالإضافة إلى تجنب التشابك في الأنشطة.

تُعتبر منظمة كير CARE المحطة الأولى التي تجمع كل الأنشطة التي تجري في المخيم، ويقصدها أي لاجئٍ يحتاج إلى مساعدة، أو يرغب في المشاركة في النشاطات الثقافية التي تنظمها المنظمة أو المنظمات غير الحكومية الأخرى، البالغ عددها 25 تقريبًا. ننظر كذلك في الملفات الشخصية للاجئين المعنيين، وندرس تقديم المساعدة لهم، لتحديد ما يناسبهم. كما يقدم اللاجئون تقريرًا لمكاتبنا، يبلغون فيها عن أي مشكلة تتعلق بصيانة المأوى، وجودة المساعدة، واقتراحات لتحسين النشاطات أو إقامة نشاطات جديدة. نقوم في هذه الحالة، بإصدار تقرير للمتابعة معهم، أو ندوّن

ملاحظاتهم ليتم حلها في الحملات التي تدعمها المنظمات غير الحكومية وغيرها من الجهات. أدخلت منظمة كير CARE أساليب تنفيذ الأعمال جزئياً عبر الإنترنت، منذ اليوم الأول للإغلاق بسبب جائحة كورونا، أي بتاريخ 20 آذار 2020. تكمن أهمية هذا التحول الوصول لجميع اللاجئين، وخاصة غير المقتدرين منهم، كما في المساهمة في إثراء مهارات المعرفة الرقمية في المخيم.

يسعى عملنا كذلك لتحقيق جوانب الأخرى منها تمكين المجتمع من خلال أنشطة بناء المهارات وتطوير الذات. تشرف منظمة كير CARE على أربعة مراكز مجتمعية في قرى المخيم المختلفة، ويقوم فريق التوعية في المنظمة بمساعدة أكثر فئات اللاجئين ضعفاً، والفئات التي لا تستطيع الوصول إلى المراكز الاجتماعية لأسبابٍ مختلفة مثل صعوبة التنقل أو العوائق الثقافية. ندعم كذلك النشاطات الرياضية الترفيهية والأنشطة النفسية والاجتماعية (مجموعات الدعم، وتدريبات كرة القدم، والمسرحيات النفسية، وغيرها) لجميع أفراد المجتمع، ونسعى لتوفير مساحات آمنة للنساء والفتيات لتوسيع شبكات الحماية الخاصة بهنّ، وتطوير المهارات المتعلقة بالسوق المحلي، وتوفير حضانات للأطفال، من أجل تمكين النساء من المشاركة في تدريبات بناء القدرات. نسعى أيضًا، لإقامة نشاطات تتعلق بسبل العيش، وذلك من خلال تمكين اللاجئين من الوصول إلى دورات تدريب تطوير الأعمال والتدريب المهني والمنح الصغيرة التي تساعدهم على بدء أعمالهم التجارية الخاصة. لوحظ مؤخرًا، تطور كبير في الأعمال المدرة للدخل، في قطاع زراعة النباتات لأول مرة في مخيم الأزرق، من خلال أنظمة الزراعة المائية، التي تم بناؤها لمواجهة بيئة المخيم القاسية والتربة غير المعالجة، من أجل المساهمة في توفير الأمن الغذائي وفرص كسب العيش.

إنّ أحد أهدافنا الرئيسية هو دعم المبادرات المجتمعية والابتكار، ودعم اللاجئين الذين يقدمون لنا أفكارًا وحلولاً تتعلق بمجتمعهم في حدود مخيم الأزرق أو أبعد من ذلك. يغطي ما نقدمه من مساعدات الاحتياجات الإنسانية والدعم اللوجستي والمساعدات المالية الجزئية، وعندما لا نكون قادرين على تقديم المساعدة بالشكل الكافي، فإننا نلجأ إلى شراكاتنا المقامة مع الجهات العديدة التي تُعنى بتقديم الدعم للاجئين.

Communal garden. Photo: Zeid Madi, Nabil Sayfayn, and the *Azraq Journal* team, July 2017.

Land

scape

أحب أن أخضع أتعلم و أجلب العيش
ى العلم كي أعطي هذا العلم إلى
الجيل الآتى و لكل الناس

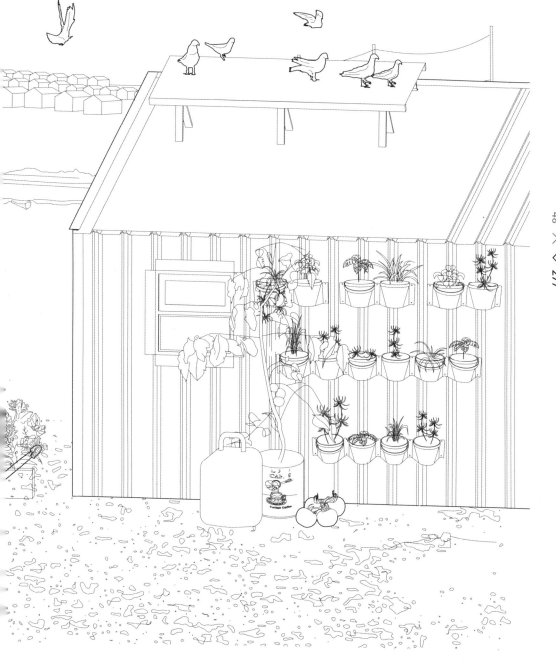

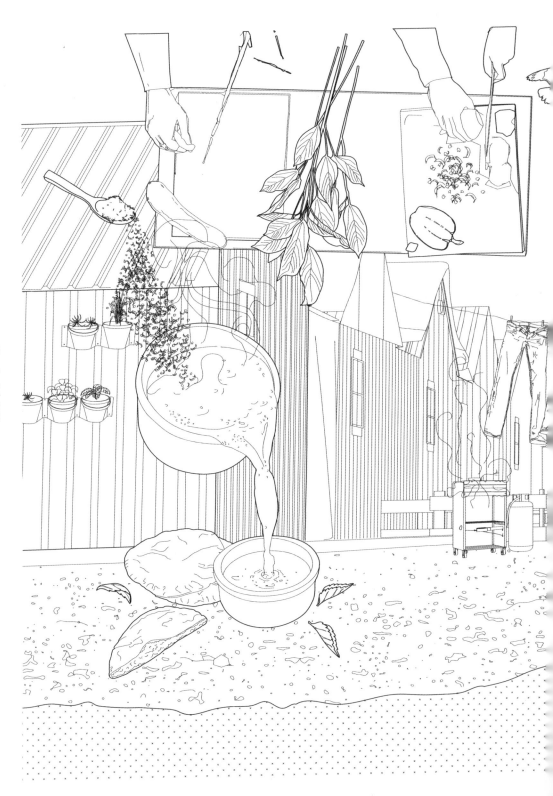

Sirnica (cheese pie)
magluba, (syrian food)
Martini Gans (Austian goose)

المنزل هو الوجود في الحياة

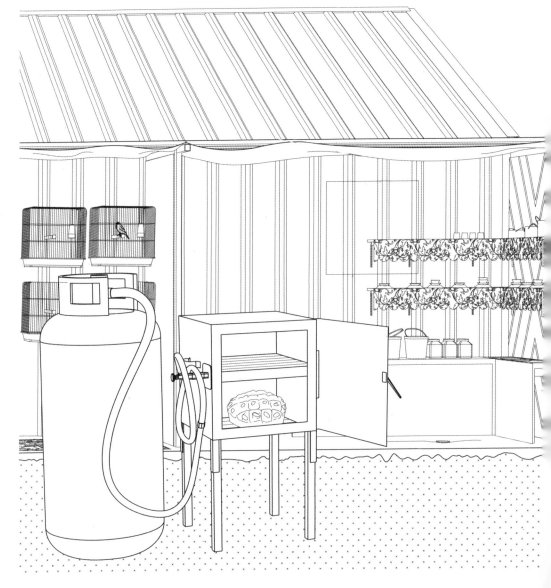

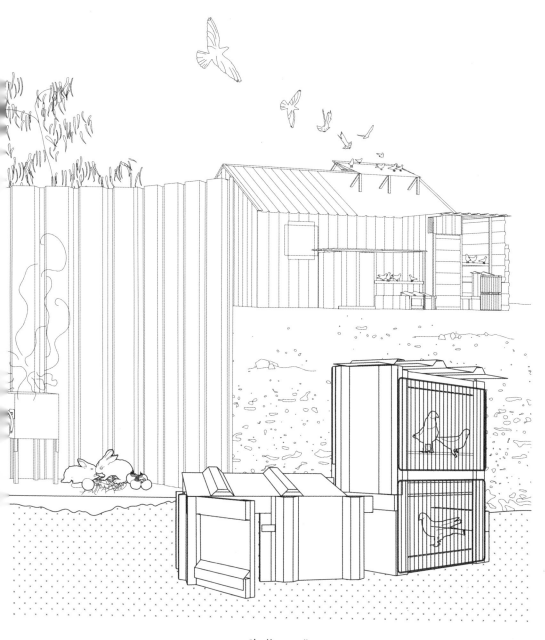

Designs That Connect Residents with the Surrounding Landscape

A stroll at the camp reveals a collage of landscapes, worlds at different scales and levels of completion. Between temporary shelters and along the margins of legality, residents of the Azraq camp transform the harshness of the desert through complex mechanisms of home making. DIY fountains infuse the dry air with the sound of water. Together with the aromas of herbs, shadows of trees, and cooing of pigeons, one can reassess the camp not as a residual space, but rather one intentionally recreated by its inhabitants. The contrasts between these interventions and their construction materials recalls the plurality of authorship at the camp. Every step testifies to a moment of transformation. A garden is not only about the flowers; it is a form of resistance to a life deprived of its meaning. The well is not only a source of water, but a conductor of life and familiarity. It is not unusual to see residents sitting together after a harvest, sharing the process of cleaning the stems and leaves of plants that would eventually be cooked as staples of Syrian cuisine. The cultivation of spices and the collection of Mulukhiyah plants, for example, fortifies the link to flavors and rituals of home. Each of the activities extends the landscapes across time and space, consolidating artisanal skills and new design techniques to ensure the safety and longevity of their authors' identities.

تصاميمٌ تربط سكان المخيم بالطبيعة المحيطة بهم

كشفت لنا جولتنا في المُخيم عن مجموعة من المناظر الطبيعية والعوالم المختلفة. يقوم اللاجئون في مخيم الأزرق بتخفيف وطأة قسوة الصحراء من خلال ابتكارهم لاختراعات وتصاميم منزلية في الملاجئ المؤقتة، ويجري ذلك بطريقة مسموح بها ضمن حدود القوانين المفروضة على المكان. ومن هذه الابتكارات، النوافير اليدوية الصنع، والتي يصدر منها صوت خرير الماء عندما يُفرّغ الهواء الجاف منها. تظهر، إلى جانب النوافير، الروائح الزكية للأعشاب العطرية، وظلال الأشجار المخفية، وهديل الحمام. تواجد مثل هذه الأشياء مع بعضها يجعل الفرد ينظر بشكل مختلف إلى الملاجئ، التي أعاد سكانها إعادة تشكيلها عن قصد لتُذكركم بما فقدوه. تُعد الاختلافات بين هذه التدخلات والمواد المستخدمة في تصميمها تذكيرًا بالتعددية التي يمتاز بها مجتمع المخيم، ويُعتبر كل تغيير في المكان خطوة نحو طريق التحول. تصبح الحديقة أكثر من مجرد أزهار؛ لتشكل وسيلة مقاومةٍ لحياة مجردة من معناها، ويصبح بئر الماء أكثر من مجرد مصدر للمياه، بل هو حلقة وصل بين الحياة والحنين. من المألوف رؤية مشهد سكان المخيم وهم يجلسون مع بعضهم، ويتشاركون في تنظيف سيقان وأوراق النباتات بعد قطفها، تلك النباتات التي سُتطبخ لاحقًا لإعداد وجبة لذيذة من المطبخ السوري. توثق زراعة التوابل، وجمع نبات الملوخية، الروابط بين النكهات والطقوس في المنازل، ويمزج كل نشاط من هذه الأنشطة المتعلقة بالطبيعة المحيطة المهارات البيتية الحرفية مع تقنيات التصميم الجديدة، وذلك لضمان سلامة وديمومة هويات مبتكريها.

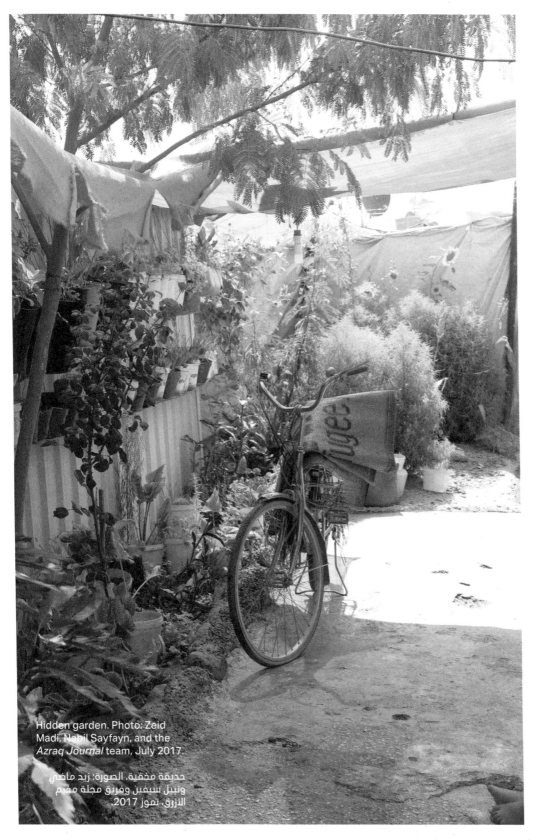

54 ∧
∨ 271

Hidden garden. Photo: Zeid
Madi, Nabil Sayfayn, and the
Azraq Journal team, July 2017.

حديقة مخفية. الصورة: زيد ماضي
ونبيل سيفين وفريق مجلة مخيم
الأزرق، تموز 2017.

Pigeon flock in the sky over Azraq.
Photo: Zeid Madi, April 2019.

أسراب الحمام في سماء مخيم الأزرق للاجئين
الصورة: زيد ماضي، نيسان 2019.

Landscape
الحـــدود

Designs and activities to enrich the flora
and fauna of the camp with sounds,
smells, and flavors reminiscent of Syria.

 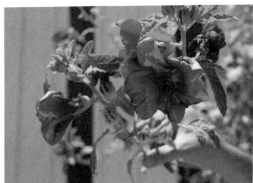

Gardening

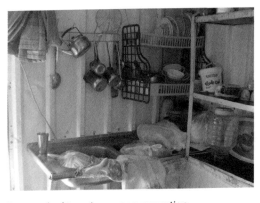

Sun-cooked tomato sauce preparation

Photo: Zeid Madi, Nabil Sayfayn, and the
Azraq Journal team, July 2017 & Melina
Philippou, April 2019.

تصاميمٌ وأنشطة لإثراء الحياة النباتية
والحيوانية في المخيم عبر الأصوات وعبق
الروائح والنكهات التي تُذكر بسوريا.

البستنة

تحضير صلصة الطماطم المجففة تحت الشمس

الصورة: زيد ماضي ونبيل سيفين وفريق مجلة
مخيم الأزرق، تموز 2017، وميلينا فيليبو
نيسان 2019.

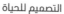

التصميم للحياة

Kitchen equipment for baking

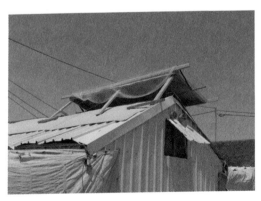

Pigeon breeding

Photo: Zeid Madi, Nabil Sayfayn, and the
Azraq Journal team, July 2017 & Melina
Philippou, April 2019.

الحدود

معدات الخبز في المطبخ

تربية الحمام

الصورة: زيد ماضي ونبيل سيفين وفريق مجلة
مخيم الأزرق، تموز 2017، وميلينا فيليبو
نيسان 2019.

Story قصة

The Jasmine Flower

Yassin Al-Yassin

In this story, written as part of the creative writing workshops for the youth conducted at the camp in collaboration with Mr. Muteeb Awad Al-Hamdan, Yassin tells the story of a little rabbit that had to flee his homeland because of the war. The story starts by Bunny leaving his home and building a Rabbit Camp in the middle of the desert with his friends. In this desert, life goes on, but Bunny is bored. He tells himself, "There is something missing or maybe my home needs something." He gets a job in an educational institution where he remembers his love of flowers and decides to plant a garden similar to the one he had back home. The jasmine flower, his favorite, was hard to find, but he left a space for it in his garden in hopes that one day it would arrive. On his birthday, surprise! His friends had come together to get him his favorite flower, and after overcoming several obstacles, Bunny is finally able to spends most of his time again with the flowers and birds he so dearly loves.

زهرة الياسمين

ياسين الياسين

تمت كتابة هذه القصة ضمن عمل ورش حول الكتابة الإبداعية لفئة الشباب المُقامة في المخيم، بالتعاون مع الأستاذ متعب عوض الحمدان. يروي ياسين في قصته هذه حكاية أرنب صغير اسمهُ باني، هرب من وطنه بسبب الحرب. تبدأ أحداث القصة بمغادرة الأرنب لموطنه، وقيامهِ ببناء مخيم للأرانب في الصحراء مع أصدقائه، ثم يشعر الأرنب بالملل بسبب طبيعة الحياة في الصحراء، ويقول «هناك شيءٌ ما أفتقدهُ، أو ربما بيتي ينقصهُ شيءٌ ما». يحصل الأرنب على عمل في مؤسسة تعليمية، ويتذكر هناك حبّهُ للأزهار، ويُقرر زراعة حديقة تشبه حديقتهُ في موطنه الأم. وجد الأرنب صعوبة في العثور على زهرة الياسمين المفضلة لديه، ولكنه رغم ذلك أبقى لها مكانًا في حديقته علَّهُ يجدها يومًا ما. وفي يوم عيد ميلاده، قام أصدقاء الأرنب باني بمفاجأته، وأحضروا له جميعًا زهرتهُ المفضلة. استطاع باني الأرنب في النهاية تخطي الكثير من العقبات في حياته، وأصبح قادرًا على إمضاء المزيد من الوقت مع الأزهار والطيور في حديقتهِ، التي أحيَت فيه شعور الحب من جديد.

Hi Melina, how are you 19:40

I finished my story yesterday, I wrote it in Arabic and English 19:40

The title is (jasmine flower) I chose this title because Jasmine Flower is the favorite flower of Omran as you know 19:41

Banny is a small rabbit living happily with his family in a beautiful house and was playing with his friends in his garden and picking flowers and listening to a wonderful bird. Banny loved flowers, he had a lot of kinds of flowers, he was interested in the garden and especially the flower of jasmine because it was a favorite flower.
One day his life changed and he decided to emigrate because of the difficult circumstances and problems that were taking place in his country. 00:41

The rabbit woke up one morning and banned the breakfast. Then he sat in front of his house. He was bored since arriving at the camp. May he misses his family or friends. He did not know, but he always said to himself: There is something I lack or maybe my home needs something.
He finished his food and then went as usual to look for work. On his way, he met a rabbit named John and asked him about work. John replied: Yes, I have a job for you in an educational place and you can start tomorrow morning. The next day he got up and banned the breakfast. He was bored and lonely. Then he went to see where he worked. He entered

not lose hope. He decided to go to his place of work to ask the shop manager about the shop Garden Workplace.
The next day, Banny went to the manager and asked him to sell him some flowers. The manager laughed. Then he said, "These flowers are not for sale but I will give you some of them." So he took some flowers and went to complete the garden. He worked hard and was helped by some of his good friends. Late in the night, my builder was eager to finish his garden. 19:49

He planted a flower that the manager had given him but was not enough. He decided to ask his friends to bring flowers from outside the camp. He also asked them to buy his favorite blossom of the jasmine flower, but they told him they did not find the jasmine flower. He built a garden and planted lots of different flowers and some trees, but he left a vacant place in the middle of the garden for the jasmine flower he did not get. Then he began to build the garden fence. Finally finished building the park. The next morning he looked out the window to see the park. He felt excited because he has finished his garden . Then he prepared a cup of coffee and sat in the garden, but he was sad because he could not find the jasmine flower 19:49

After a few minutes, he knocked his door and when the door builder opened he saw his friends. They told him "Happy Birthday". He was surprised. He has forgotten his birthday. His friends entered with a Christmas cake and a gift covered and decorated. One of his friends said to him: Open your gift. He opened his gift and was enthusiastic and when he opened it he felt very happy. Give him the jasmine flower
His friends told him to plant it together. They went to the park and planted it. Then they ate the cake. Suddenly my son heard a beautiful voice. It was a bird singing on the flower of jasmine .. Then began the birds and butterflies come from everywhere and returned to smile to Bunny and returned to play with his friends in the new garden. Wakes up early every day for breakfast in his garden with beautiful birds and flowers. 19:49

Yassin your story discusses beautifully the importance of friendship and community on realizing your dreams 13:03

64 261

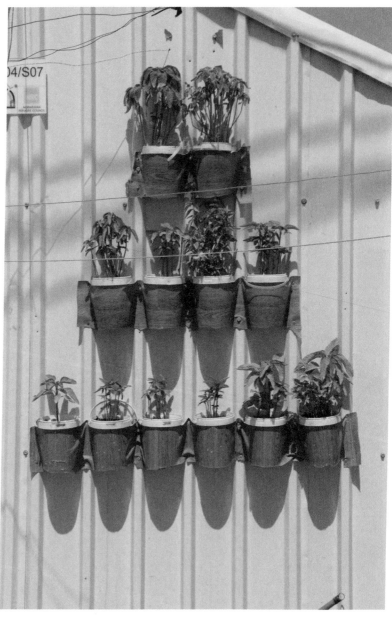

Photo: Zeid Madi, Nabil Sayfayn, and the *Azraq Journal* team, July 2017.
Drawings: Andrea Baena, Stratton Coffman.

الصورة: زيد ماضي ونبيل سيفين وفريق مجلة مخيم الأزرق، تموز 2017.
الرسومات: أندريا بينا وستراتون كوفمان.

Vertical Garden

During the first few years of the camp, the administration challenged the permissibility of gardening based on UNHCR guidelines regarding minimum environmental impact on site.[1] Vertical gardens became a popular way to maintain plants without contesting camp regulations. Residents reused food containers as plant pots and arranged them on the shelter facade with shallow shelves and fabric pockets. In the herb garden featured on the left, yoghurt containers hang from the wall with linoleum bands anchored with nails. Over time, in response to the widespread ad hoc gardening, the camp management adapted the implementation of environmental guidelines to the needs of residents, allowing them to plant directly on the ground.

[1] UNHRC Environmental Guidelines, 6.2.9 Agriculture, Environment, Technical Support Section, UNHCR Geneva and IUCN, August 2005, 30–31.

| 01 | Yogurt container |
| | علبة لبن |

| 02 | Linoleum floor strip |
| | شريط مشمع الأرضيات |

الحديقة العمودية

خلال السنوات القليلة الأولى من افتتاح المخيم، أوقفت إدارته جميع ممارسات البستنة، بناءً على إرشادات المفوضية السامية للأمم المتحدة لشؤون اللاجئين «UNHCR» حول الحد الأدنى من التأثير البيئي في المخيم.[1] أدى ذلك المنع إلى انتشار الحدائق العمودية، كوسيلة شائعة للمحافظة على النباتات من دون معارضة قوانين المخيم. ولبناء الحدائق العمودية، أعاد سكان المخيم استخدام علب الطعام لتصبح قوارير للنباتات، وقاموا بوضعها في واجهة الملاجئ على رفوف خفيفة، أو داخل أكياس قماشية. تمّ تعليق علب اللبن على جدار الملجأ باستخدام أشرطة المشمع المثبتة بالمسامير، في حديقة الأعشاب التي تظهر في الصورة. استجابت إدارة المخيم مع مرور الوقت لاحتياجات اللاجئين، وسمحت بممارسة الزراعة المباشرة في الأرض، ضمن حدود المبادئ التوجيهية البيئية.

[1] المبادئ التوجيهية البيئية، قسم الدعم الفني البيئي، المفوضية السامية للأمم المتحدة لشؤون اللاجئين "UNHCR"جنيف، والاتحاد العالمي للحفاظ على الطبيعة ومواردها "IUCN"، آب، 2005، ص30.

1:10

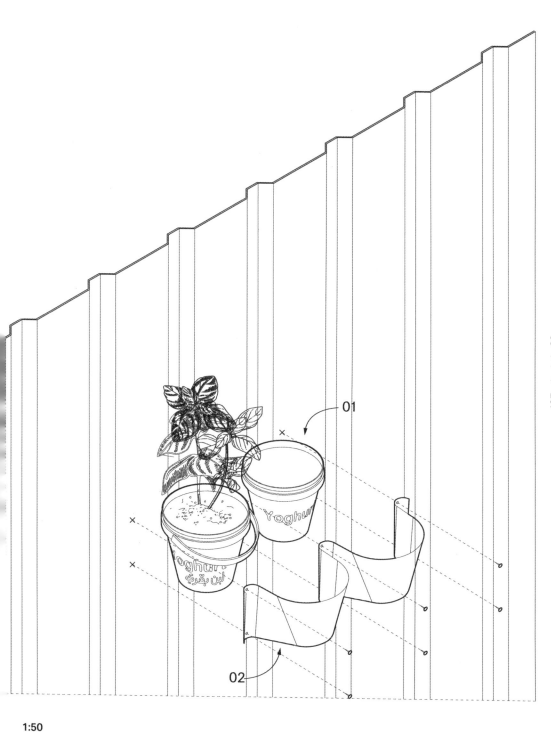

01

02

1:50

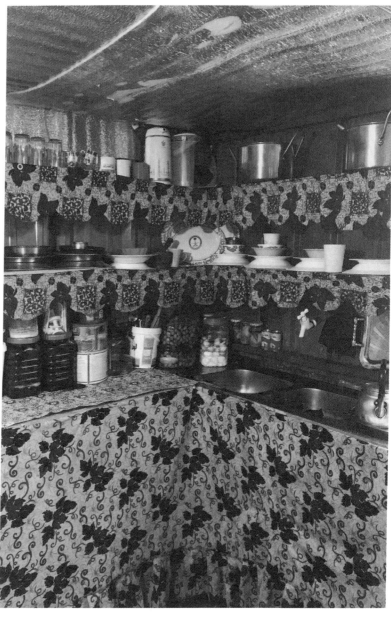

Photo: Melina Philippou, April 2019.
Drawings: Stratton Coffman, Ziyuan Zhu.

الصورة: ميلينا فيليبو، نيسان 2019.
الرسومات: ستراتون كوفمان وزايوان تزو.

Kitchen

The initial shelter design did not consider a space for cooking. Residents soon incorporated kitchen areas either as part of the unified interior or as a separate room attached to the main structure. The kitchen featured on the left is an extension of the house in the space between shelters. Mohammad covered and weatherproofed the roof with IBR metal sheets and insulation. He designed a kitchen with an L-shaped MDF bench and open shelving. The room has access to a hallway leading to the living room and a small yard. The cooking and grilling take place outside since the fumes from traditional fuels and stoves are a potential health hazard in shelters lacking efficient ventilation systems.[1] Eventually, the administration of the camp recognized the importance of the kitchen and upgraded all shelters with similar extensions.[2]

[1] Lara A. Alshawawreh, R. Sean Smith, and John B Wood, *"Assessing the Sheltering Response in the Middle East: Studying Syrian Camps in Jordan,"* International Journal of Social, Behavioral, Educational, Economic, Business and Industrial Engineering, 11, no. 8 (2017): 7.

[2] Factsheets: Jordan, Azraq camp, UNHCR, May 2018.

01 Metal sheet (IBR)
صفيحة IBR المعدنية

02 Plastic sheet
غطاء بلاستيكي

03 Metal column
عمود حديدي

04 Metal bracket
صفيحة معدنية

05 Plastic tablecloth
غطاء طاولة بلاستيكي

المطبخ

لم يحتوي التصميم الأولي للملجئ على مساحة للطهي، مما دفع اللاجئين لإيجاد مطبخ إما في المساحة الداخلية للملجأ، أو عبر بناء غرفة خارجية متصلة بهيكله. المطبخ الذي يظهر في الصورة عبارة عن مساحة منفصلة تم بناؤها بين الملجئين، وقد قام محمد بتغطية السقف لحمايته من تسرب الماء بصفائح IBR المعدنية وبالألواح العازلة، وأضاف لتصميمه طاولة صنعها من خشب ليفي متوسط الكثافة (MDF) يحيط بها إطار بزوايا على شكل حرف ـ، إلى جانب الرفوف المفتوحة. تتصل هذه الغرفة بالرواق المتجه نحو غرفة المعيشة والحديقة الصغيرة، وتتم عملية الطهي والشوي

في الخارج بسبب الأدخنة المضرة بالصحة التي تنبعث من المواقد والأفران التقليدية، في ظل افتقار الملجئ إلى أنظمة التهوية الفعالة.[1] أدركت إدارة المخيم أهمية وجود المطبخ وتأثيره في الحياة اليومية، فقامت بإضافة هذه المساحات المنفصلة لجميع الملجئ.[2]

[1] لارا الشواورة، شون بي سميث، جون بي وود، "تقييم استجابة الإيواء في منطقة الشرق الأوسط: دراسة المخيمات السورية في الأردن," المجلة الدولية للهندسة الاجتماعية والسلوكية والتعليمية والاقتصادية والتجارية والصناعية، 11، عدد 8 (2017):7

[2] ورقة حقائق: الأردن، مخيم الزرق، المفوضية السامية للأمم المتحدة لشؤون اللاجئين، أيار 2018

01

02

1:150

الحدود

1:50

Worldmakers

Ali Fawaz

Ali is one of Azraq's prolific inventors. He's been a welder since he was fourteen years old in Syria, where he learned the trade on the job.

He is responsible for a lot of designs that were replicated heavily throughout the camp, such as the water trolley, the oven, and the rocking crib. "We all need each other here." Ali explains that the sharing economy and transfer of knowledge play a significant role in the camp, perhaps more than in life outside. At Azraq, people know they need to rely on each other to survive. So if there's something someone needs, it's a no-brainer to lend it to them.

Ali's development of an oven appliance helped him and his community regain and connect back to their culinary traditions. "There are dishes that you can't cook on the stove. For desserts like namoura, you absolutely need an oven!" Ali is particularly excited about the grilled chicken he can now make—"World-class chicken!" he calls it.

Year by year, Ali feels that the camp is progressing. He thinks he is also progressing and doing things he never imagined. He recently worked on a big construction project. He is involved in the maintenance of the camp, and is currently learning more about electrical works, something completely new to him. He eagerly plugs himself into every workshop he can find, and shows us pictures of certificates on his phone: shoe-making, life skills, sewing, haircutting and grooming, as well as welding and general maintenance. And while he has a permit to work in all of these sectors outside the camp, he prefers to work in Azraq, where he is close to his wife, children, and extended family.

ضنّاع العالم

علي فوّاز

يمتلك علي فواز حصيلة كبيرة من الاختراعات في مخيم الأزرق، وهو يعمل في تلحيم المعادن منذ أن كان في الرابعة عشر من عمره في سوريا، حيث تعلم هذه الحرفة وامتهنها.

نفذ علي فواز الكثير من التصاميم التي تم تقليدها كثيرًا في جميع أنحاء المخيم، مثل عربة نقل المياه، والفرن والسرير الهزاز، ويعلق على ذلك قائلاً: «جميعنا بحاجة إلى بعضنا البعض هنا». يرى علي أنّ اقتصاد المشاركة ونقل المعرفة يلعبان دورًا مهمًا في المخيم، الذي يحتاج فيه الناس إلى الاعتماد على بعضهم للبقاء على قيد الحياة، لذلك يهب علي لمساعدة أي شخص في المخيم، وإقراضه الأغراض التي يحتاج إليها إن وُجدت.

ساعد تصميم الفرن الذي عمل عليه علي مجتمع المخيم على استرجاع تقاليد المطبخ السوري، ويعلق على ذلك قائلاً: «هناك أطباق لا يمكن إعدادها على الموقد، وخاصة الحلويات مثل النمورة التي تحتاج الفرن لصنعها». بالإضافة إلى الحلويات، يسعد علي جدًا بالدجاج المشوي الذي بات بإمكانه إعداده، ويصفه بأنه «دجاج من الطراز العالمي».

يشعر علي أنّ المخيم في حالة تطور مستمر مع مرور السنين، ويعتقد أنه يطور من نفسه أيضًا، إذ يقوم بأمور لم يتخيل أبدًا أنه كان قادرًا عليها. عمل علي مؤخرًا في مشروع بناء كبير، وشارك كذلك في أعمال صيانة المخيم، ويتعلم حاليًا المزيد عن المهارات الكهربائية التي لم يسبق أن مارسها من قبل. يدفع الفضول علي للانخراط في أي ورشة يستطيع إيجادها، وقد أطلعنا على صور الشهادات التي حصل عليها على هاتفه، مثل صناعة الأحذية، والمهارات الحياتية، والخياطة، وقص الشعر والعناية به، واللحام والصيانة العامة. يحمل علي تصريحًا للعمل في جميع هذه القطاعات خارج المخيم، ولكنه يفضل العمل في مخيم الأزرق بالقرب من عائلته، حتى يبقى مطمئن البال على راحتهم وأمنهم.

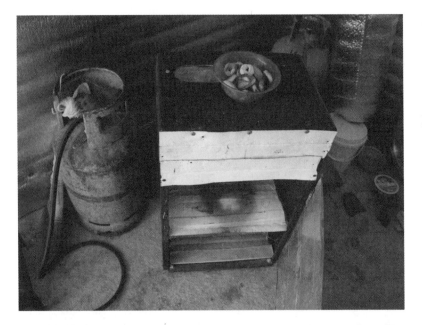

Photo: Zeid Madi, Nabil Sayfayn, and the *Azraq Journal* team, July 2017 & Melina Philippou, April 2019. Drawings: Jaya Eyzaguirre, Michelle Xie.

الصورة: زيد ماضي ونبيل سيفين وفريق مجلة مخيم الأزرق، تموز 2017 وميلينا فيليبو، نيسان 2019. الرسومات: جايا آيزاجوير وميشيل شيه.

Oven

A gas stove and utensils are the cooking equipment residents receive upon arrival at the camp. Often households will add their own oven. Ali Fawaz welded an oven with multiple metal pieces.[1] Another designer built an oven with the metal frame of a broken refrigerator, to which he attached a door from metal scraps and wheels for easy transfer. Both ovens heat with the initial stove burners connected to gas cylinders distributed to residents upon arrival to the camp.

[1] The Norwegian Refugee Council offers welding training at the camp. The training is accredited by the Jordanian Ministry of Labor.

| 01 | Metal scraps صفائح معدنية |
| 02 | Corner flashing زوايا معدنية |

| 03 | Gas-powered stove (CRI) موقد يعمل على الغاز (من مواد الإغاثة الأساسية) |

الفرن

يستلم اللاجئون عند وصولهم إلى المخيم موقد غاز وأدواتٍ للطبخ، وتقوم الأسر في أغلب الأوقات بإضافة فرن إلى تلك المعدات. قام علي فوّاز بتلحيم عدد من القطع المعدنية لصناعة فرن تقليدي[1]، بينما استخدم مصممٌ آخر هيكلاً معدنيًا جلبه من ثلاجة معطلة، وصمم له بابًا من الصفائح المعدنية، وأضاف له عجلات لتسهيل تحريكه، وتتم تحمية كلا الفرنين عبر أسطوانة الغاز المتصلة بهما، والتي تمّ توزيعها على اللاجئين في المخيم فور وصولهم إلى المكان.

[1] يقدم المجلس النرويجي للاجئين دورات تدريبية في تلحيم المعادن في المخيم. وهذا التدريب معتمد من وزارة العمل الأردنية.

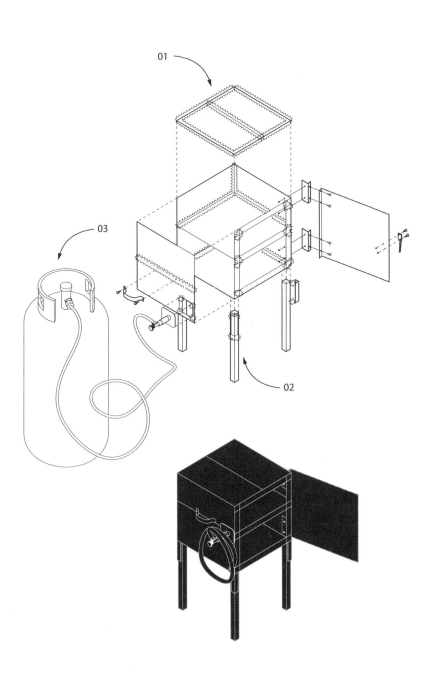

1:20

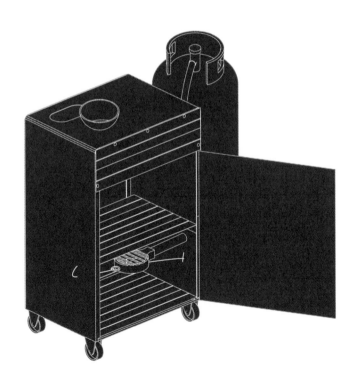

1:20

الحدود

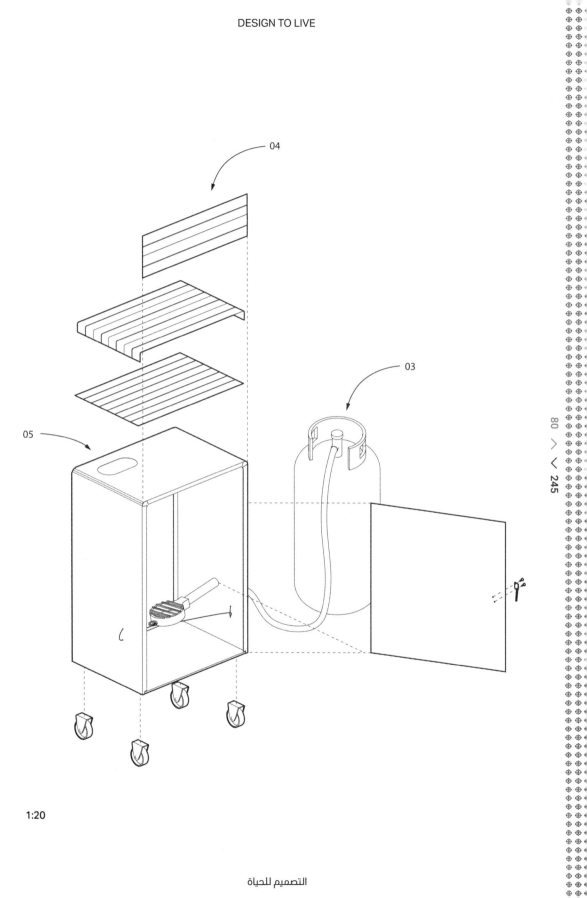

04

03

05

1:20

التصميم للحياة

Worldmakers

Amir Yassin Abo Haitham

The high border walls and deep cooing sounds from the pigeon den on the side of the house build a welcoming world where Abu Haitham spends most of his time. Like many people at the camp, he started raising pigeons at Azraq because he had a lot of time on his hands. Training his pigeons to fly by his gestures is a full-time affair. Pigeon breeding was his hobby in Syria, something he picked up from his father and is passing on to his son, who is now fourteen years old.

There are a lot of pigeon breeders at the camp, and Abo Haitham makes it seem like it's a collaborative network of people that help each other in their hobbies. We try to tease him with the stereotype of pigeon breeding that entails stealing each other's pigeons, but he laughs it off: "I don't think if you're a pigeon breeder it changes your personality into a thief… If a stray pigeon finds her way here, mind you, she can stay."

Abo Haitham insists that "the pigeons know their owner, their voice and gestures," but it's safe to say there is a thin line in the sky about the borders of ownership of pigeons. To that, he makes a point that it's a hobby of continuous exchange. In a place like Azraq, where resources are scarce, it is no longer about ownership but rather about enjoyment and camaraderie. "If one of my friends doesn't have a white pigeon, and I have two, I'll give him one, and I know they would do the same."

صُنّاع العالم

أمير ياسين أبو هيثم

يُمضي أبو هيثم غالبية يومه في عالمه الخاص، حيث أسوار الفناء العالية والأصوات العميقة الصادرة من بيوت الحمام بجانب المنزل. بدأ أبو هيثم تربية الحمام كالكثيرين في مخيم الأزرق، بسبب أوقات الفراغ الكثيرة التي تطغى على أيامه. قام بتدريب حماماته على الطيران، وقد شغلت تربية الحمام أوقاته حتى أصبحت تشكل له عملًا بدوام كامل. كان أبو هيثم يمارس تربية الحمام كهواية في سوريا، وقد تعلمها من والده، وها هو الآن يعلمها لابنهِ البالغ من العمر 14 عامًا.

يضم المخيم الكثير من مربّي الحمام، ويبدو من كلام أبي هيثم، أنهم يشكلون مجموعة تعاونية خاصة بهم، وأنهم يتساعدون فيما بينهم على تلك الهواية. سألنا أبا هيثم عن رأيه بخصوص الصورة النمطية الشائعة عن مربي الحمام، واتهامهم بالغش وسرقة الحمام، فضحك وقال: «لا يعني أن تربي الحمام أن تكون لصًا. أما إذا ضلت إحدى الحمامات طريقها وجاءت إلى هنا، فأهلًا وسهلًا بها».

يؤكد أبو هيثم في كلامه قائلاً: «الحمام يعرف صاحبه عبر صوته وإشاراتهِ»، ويجزم بأنَّ في السماء خيط رفيع يفصل بين حدود ملكية الحمام، ويشير إلى أن تربية الحمام هواية يجري فيها تبادل الطيور بشكل مستمر، وفي مكان مثل مخيم الأزرق، حيث تشح الموارد، لا يتعلق الأمر بملكية الطيور، بل بالمتعة والصداقة والصحة. يضيف أبو هيثم قائلاً: «إذا كان أحد أصدقائي لا يملك حمامة بيضاء، وكنتُ أنا أملك اثنتان، فسأعطيهِ واحدة، فكلتا الحمامتين سواء بالنسبة لي».

قصة Story

Life & Optimism

Hassan Ghazi Al-Abdallah

This is the story of Omar and his love for his two birds, Life and Optimism, through which he expresses a transforming view on life, love, and freedom. When Optimism died, one of Omar's friends urged him to get another bird, Honesty. After a while, Life and Honesty laid two eggs. Omar was excited, "I found two names for the eggs! Love and Hope." Marveling at the fact that the passing of Optimism gave birth to Love and Hope, he could not stand that they were still caged, so he set them free: "Let them spread their love, optimism, truth, and give hope to nature!"

الحياة والتفاؤل

حسن غازي العبد الله

تحكي هذه القصة عن عمر وحبِّه لطائريه اللذين أسماهما الحياة والتفاؤل. يعبر عمر من خلال طائريهِ عن وجهة نظره حول التغير الذي طرأ على الحياة والحب والحرية. عندما مات الطائر الذي يُدعى التفاؤل، شجع أحد الأصدقاء عمر على اقتناء طائرٍ آخر مكانه، وهذا ما حصل بالفعل. أطلق عمر على الطائر الجديد اسم الصدق، وبعد مرور فترة من الزمن، تزاوج طائري الحياة والصدق، ووضعت الحياة بيضتين، وكان عمر سعيدًا جدًا بذلك، وقال: «لقد اخترت اسمين من أجل البيضتين؛ الحب والأمل». لم يتحمل عمر فكرة بقاء طيوره حبيسة الأقفاص بعدما أدرك أنّ فقدانه للتفاؤل تسبب في ولادة الحب والأمل، مما جعله يطلق سراحها جميعًا ... « لنجعلها تُحلق في الطبيعة، وتنتشر فيها الحب والتفاؤل والصدق والأمل.»

يذهب وهو مبسوط كثيرا. ويم من الايام نظرت اليه وكان شاردا فسالته ما بك يا عمر شارد ؟ عمر:لا شيء لكني نسيت أن اطعم التفاؤل قبل أن اذهب إلى المدرسة ،ضحكت كثيرا على ما قال ،وقلت له سوف اسميك باسم جديد ،فقال عمر مستغربا :ماذا تقول ماذا سوف تسميني ،فقلت له سأسميك(عاشق الطيور) ،فضحك كثيرا ثم تركني وذهب .وفي اليوم التالي رأيته يبكي فسألته ما بك يا عمر ؟ فأجابني اتذكر في الامس نسيت ان اتفقد طيوري ولقد مات لقد مات التفاؤل من الجوع ،فقلت له انه طير اصبر فلا تقلق سوف اذهب معك كي نشتري غيره ؟ فقال لي كلا انه طائري المفضل ،فقلت له لا عليك هيا لندفن العصفور ونشتري لك واحدا آخر بنا .فذهبنا ودفنا الطائر ثم ذهبنا الى السوق واشترى طائر يشبه طائره

Hasan Al abdallah

كان في أحد مخيمات اللاجئين السوريين شاب اسمه عمر ،كان هذا الشخص يحب عمل الخير وأيضا يحب الطيور والحيوانات الاليفة ،لقد قال أنه لا يستطيع العيش بدون الحيوانات خاصته ،كان لديه العديد من الحيوانات الاليفة مثل الطيور والأرانب والقطط وقد كان يحبهم كثيرا لدرجة انه لا يستطيع الاستغناء عن أحد منها .
كان ليه زوج من الطيور الاول اسمه (التفاؤل) والثاني (الحياة) .
كان عمر عندما يذهب إلى المدرسة كان

القديم ،وعندما وضعنا الطائر في القفص اقتربت منه (الطائر اللتي اسمها الحياة) ثم ابتعدت عنه وهي تغرد بحزن على فراق زوجها التفاؤل ،فقلت لعمر:يا عمر ماذا سوف نسمي العصفور الجديد ؟فقال لي :اعتقد أني سوف أسميه الصدق ؟وبعد مرور ثلاث شهور قال لي عمر بأن الحياة والصدق قد تزوجا ووضعا بيضتين،لقد كان عمر سعيدا جدا وقال لي لقد وجدت اسمين من أجل البيضتين ،فسألته ما هما ؟ فقال لي (الحب والامل) ،فقلت له انهما اسمين جميلين .
وبعد أن خرج العصفورين الصغيرين من البيضتين جلسات انا وعمر ننظر إلى القفص فقال لي : ماذا ترى في هذا

القفص ؟فقلت اني ارى مكان التفاؤل الذي مات و ارى الحب والحياة والصدق والأمل في اماكنهم ،فقال لي وهو فرح ويتأمل الطيور إن فقدت أحدا منها فقدت جزأ من جسدي وأصبحت شخصا لا نفع له
اذا فقدت الحب افقد قلبي
اذا فقدت الصدق تعقد لساني
واذا فقدت الحياة انتهيت امالي
واذا فقدت التفاؤل أصبح بدون حواس
واذا فقدت الأمل ضاع مستقبلي وكل شيء.
فقلت لعمر لنخرج هذه الحواس وهي طيورك الى خارج هذا القفص كي تنتشر في هذه الطبيعة و تنشر حبها و تفاؤلها وصدقها و تبعث الامل للطبيعة
شكرا لكم لحسن استماعكم
Hasan Al Abdallah
20:51

قصة Story

Sugarland

Hanaa Ahmad

This is a story about the power of imagination in coping with war and life at the camp. Zahra is a little girl whose world revolved around her friends and play, something that changed radically after the war began. Zahra escapes to a world in her imagination where she can play and express herself again. "Look there," she tells her family as they flee their home, "there are giant sugar cubes all over the place! Our new home is Sugarland!" These sugar cubes are in fact the white shelters at the Azraq camp as seen through her eyes. After not being able to connect with new friends in this new place, Zahra uses her imagination to strike an unusual friendship with a rabbit who had cherry-colored eyes and a young girl named Marah. Together they make Sugarland feel like a world built with spectacular colors and imagination.

أرض السّكر

هناء أحمد

تعكس هذه القصة قدرة الخيال على مواكبة ظروف الحرب والحياة في المخيم، وتحكي أحداثها عن الطفلة الصغيرة زهرة، التي كان عالمها محصورًا باللعب مع أصدقائها. بعد اندلاع الحرب، طرأت الكثير من التغيرات على حياة زهرة، مما جعلها تترك عالمها الخيالي حيث تلعب وتستمتع بوقتها، حين هربت مع عائلتها من الوطن. عندما رأت زهرة المكان الجديد الذي ستعيش فيه مع عائلتها، قالت لهم بحماس «يوجد الكثير من مكعبات السكر هناك، سيكون بيتنا الجديد في أرض السكر!». لم تكن مكعبات السكر تلك ولكن في الحقيقة، سوى ملاجئ مخيم الأزرق. لم تستطع زهرة التعرف على أصدقاءٍ جدد في المخيم، واستخدمت مخيلتها بدلاً من ذلك في تكوين صداقة مع الأرنب ذُو العينين الكرزيتين، والفتاة التي تُدعى مرح، وعاشت معهما في عالم أرض السكر الخيالي، الذي امتلئ بالألوان البراقة والخيال.

Hana'a

≡ Untitled

1 page · 17 KB · docx 22:06

القصة كاملة بهذا الملف

22:06

Azra Aksamija
Thank you Hana'a! I look forward to reading it

22:42

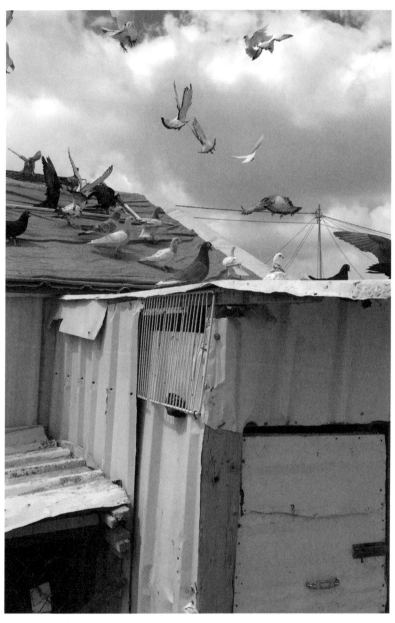

Photo: Melina Philippou, April 2019.
Drawings: Stratton Coffman, Catherine Lie.

الصورة: ميلينا فيليپو نيسان 2019.
الرسومات: ستراتون كوفمان وكاثرين لي.

Pigeon Breeding

Pigeon breeding is a passion that Syrian refugees continue to practice in the confines of the camp. A typical setup for the collection, breeding, and flying of the birds includes the landing board and the pigeon lofts. The landing board is at the highest point of the shelter. Residents place absorbing material under the board to reduce the noise from landing. Usually, the board is covered with a net for better grip. The lofts are large cages with specialized wings for nesting and individual cages for star pigeons. Abo Haitham's lofts are hidden in a fenced yard attached to the house. The wings for nesting and the protection of squabs are further insulated and are closer to the ground. Another pigeon enthusiast modified the space between shelters into one large pigeon loft with smaller jerry can pens.

01	Refrigerator shelf
	رف ثلاجة
02	Metal sheet
	صفيحة معدنية

03	Water jug (CRI)
	قارورة مياه
	(من مواد الإغاثة الأساسية)

04	Metal column
	عمود حديدي
05	Laundry rope (CRI)
	حبل غسيل
	(من مواد الإغاثة الأساسية)

06	Door frame
	إطار باب
07	Carpet
	سجادة

تربية الحمام

استمر اللاجئون السوريون في ممارسة شغفهم بتربية الحمام ضمن حدود المخيم، حيث يقومون بالاعتناء بمجموعات من الحمام وتربيتها وتطييرها، وهذا ما يحتاج استحداث لوح هبوط وبيوت للحمام. يتم تثبيت لوح الهبوط على أعلى نقطة في الملجأ، ويضع السكان أسفل اللوح شيء ليمتص الضوضاء الصادرة عن هبوط الحمام، ويتم تغطية اللوح في العادة بشبكة تتمسك بها الطيور. أما بيوت الحمام، فتُصنع من أقفاص كبيرة، وتضاف إليها

أماكن مخصصة للتعشيش، كما وتُصنع أقفاص خاصة للطيور المميزة. يُخفي أبو هيثم بيوت الحمام الخاصة به في حديقة مسيّجة بجانب الملجأ، ويعزل أماكن التعشيش والحظائر التي تضم الفراخ الصغيرة وتحميها في موقع قريب من الأرض، كما وقام مربي حمام آخر بتعديل المساحة الموجودة بين الملجئين وتحويلها لبيت حمام كبير، يضم حظائر مصنوعة من جراكن صغيرة.

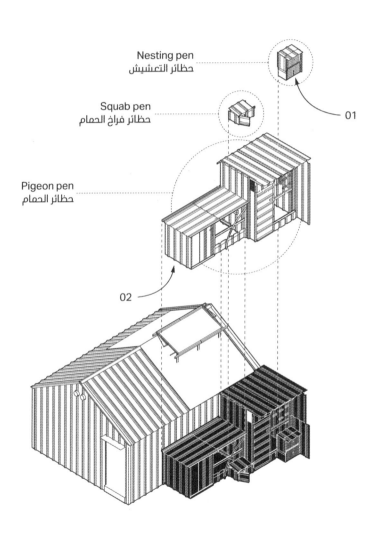

Nesting pen
حظائر التعشيش

Squab pen
حظائر فراخ الحمام

Pigeon pen
حظائر الحمام

01

02

1:150

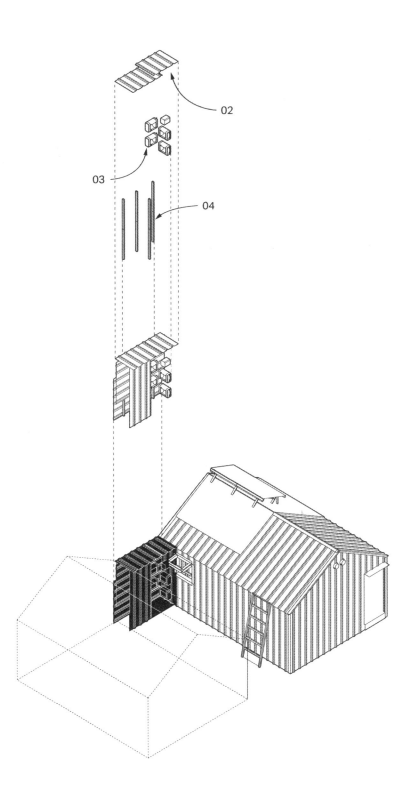

02

03

04

1:150

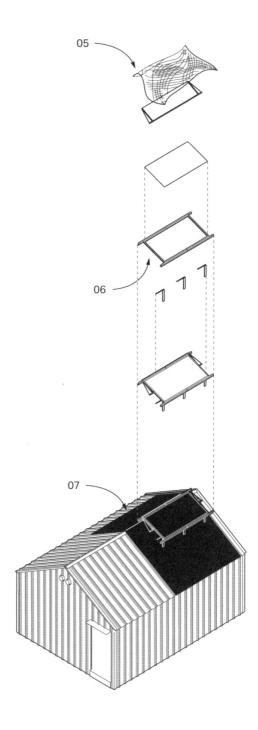

05

06

07

1:150

الحدود

Land

scape

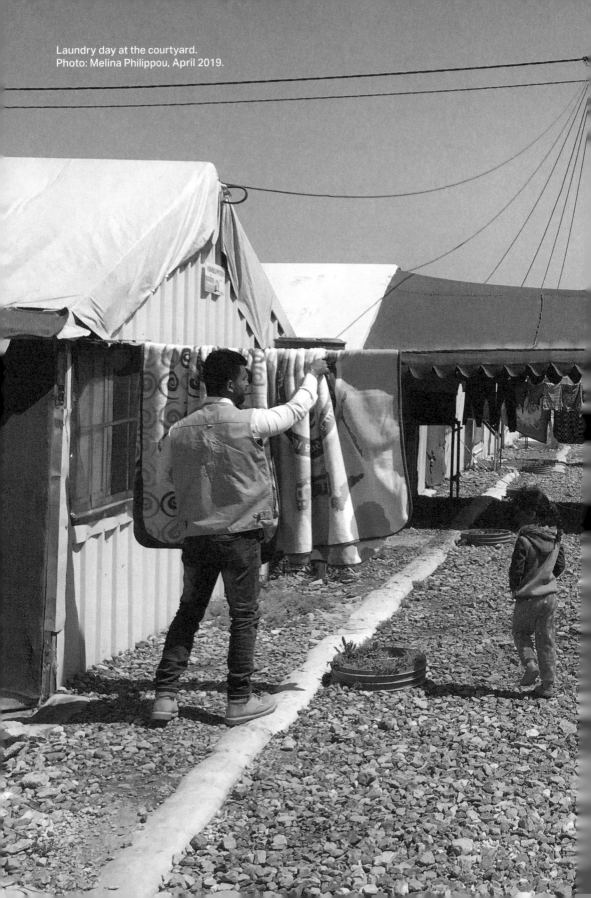

Laundry day at the courtyard.
Photo: Melina Philippou, April 2019.

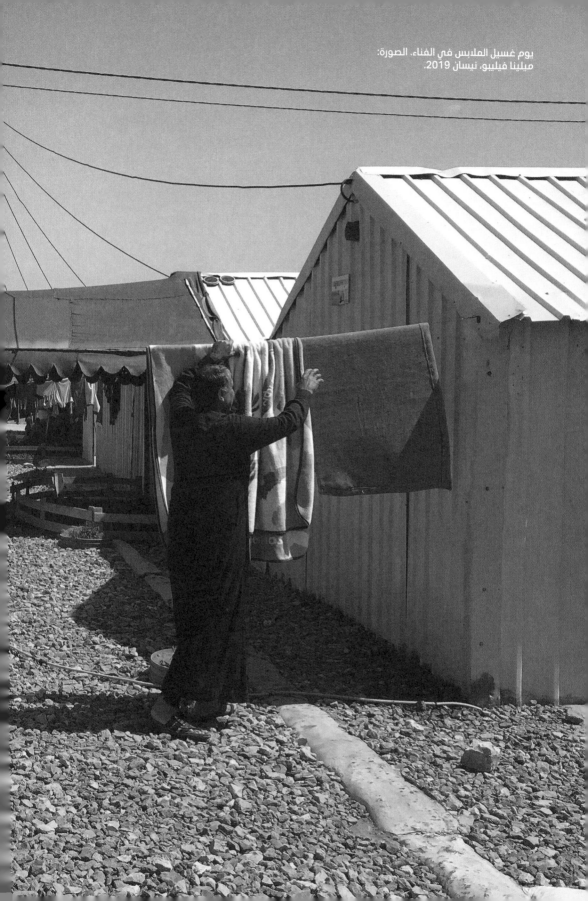

Intin

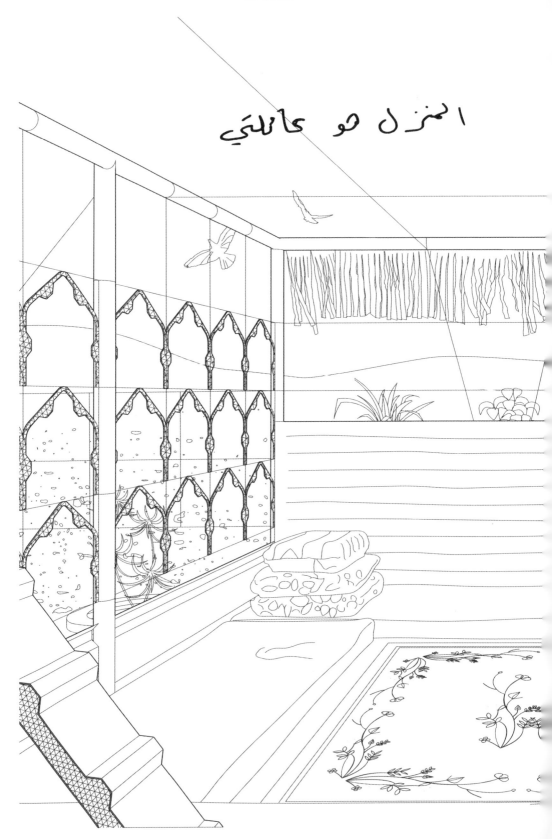

المنزل هو عائلتي

أنا أحلم بتحقيق طموحاتے و أصدقاء
للحباب في المستقبل ، خصوصاً التي أقدر
على تحقيقها بنفسي وبالمقابل أريد
زرعلا الحب .

were you are loved.

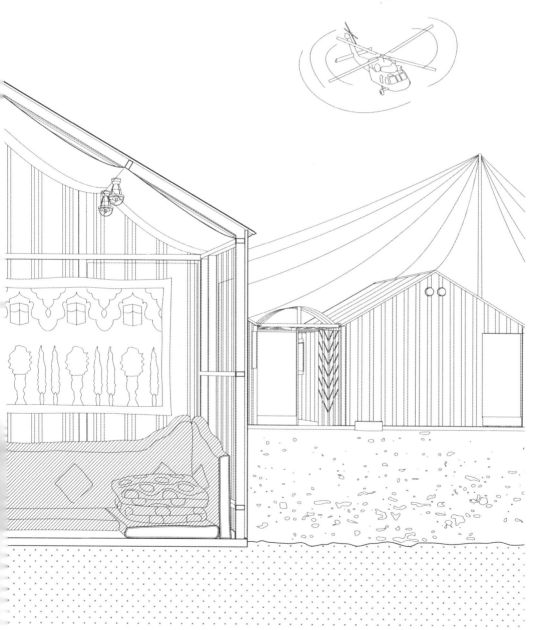

Designs That Mediate Intimacy within the Family and the Community

Contrary to the seemingly rigid borders between outside and inside, the architectures of privacy and intimacy at the Azraq camp are designed to be adapted to different situations. Multiple thresholds mediate between moments of sharing, family gatherings, and solitude. The continuity of the camp is often disrupted with fenced neighborhoods. The carefully designed gate reveals walled courtyards reflecting inward-facing domestic setups inherited from the homeland. The curtains between shelters filter the gaze toward the living space of the family. These filters form an entrance hall that orchestrates the welcoming of guests to the household within the rules and limits of *mahram*. The unified space of the home separates in two, allowing a space for hospitality but also moments of introspection and intimacy. During the month of Ramadan, the limits of enclosures dissolve. Courtyards and family spaces open to the community. People travel across the camp to attend celebrations in customized living spaces with colorful decorations. The complexity of sharing and retreat in the nested worlds of Azraq reflects an ongoing negotiation of the standard regulations of encampment. It shows the power of community-led design practices in defining the versatility and nuance of public life.

تصاميمٌ تولد اليسر بين أفراد العائلة والمُجتمع

على عكس جمود الحدود التي تفصل بين المخيم وخارجه، تمّ مراعاة موضوع الخصوصية واليسر في تصاميم مخيم الأزرق للاجئين، حتى تكون مناسبة على اختلاف وتعدد حالات ساكنيها، إذ أن لحظات المشاركة والتجمعات العائلية في المخيم لا تخلو من الضوابط، وهي ضوابط خفية، على عكس الأسوار التي تفصل أحياء المخيم، قاطعة عمليات التواصل في أرجائه.

يظهر، خلف البوابة المصممة بعناية، فناء مُسوّر يقود إلى داخل المكان الذي يحوي إضافات ذات طابع محلي موروث من الوطن. استُخدمت الستائر لفصل المساحات في الملاجئ، فتظهر فيها غرفة معيشة خاصة للأسرة، يتم استقبال الضيوف فيها، مع مراعاة قواعد وضوابط المَحرَم، إذ ينقسم المنزل إلى قسمين، يخصص أحدهما لاستقبال الضيوف، ومشاركة لحظات الخصوصية والألفة العائلية. أما في شهر رمضان المبارك، فتتلاشى الحدود، وتصبح الأفنية والمساحات العائلية متاحة للمشاركة. يسافر الناس كذلك، من جميع أنحاء المخيم لحضور الاحتفالات التي تجري في الأماكن المخصصة لذلك، والمطلة على القرية، والتي يتم تزيينها بالديكورات الملونة. تطرحُ تعقيدات المشاركة والعزلة في مخيم الأزرق للاجئين تساؤلات حول القوانين المُنظمة للمخيم، بغية أن يُعاد التفكير بها، كما تُظهر هذه التعقيدات قدرات المجتمع، من خلال ممارسات التصميم، ودورها في تحديد الابتكارات المتعددة الاستخدامات التي تفيد الحياة العامة وتُحدث فوارق دقيقة.

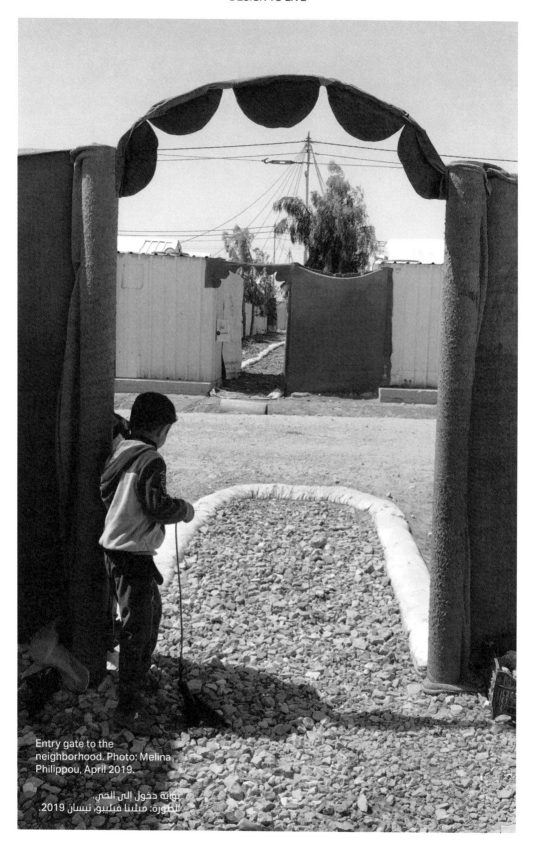

Entry gate to the
neighborhood. Photo: Melina
Philippou, April 2019.

بوابة دخول الى الحي.
الصورة: ميلينا فيليبو، نيسان 2019.

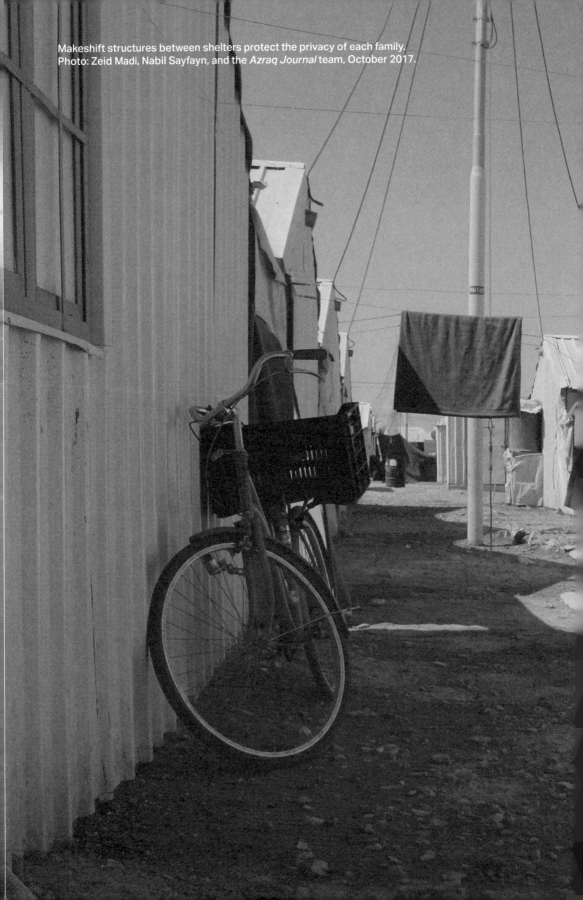
Makeshift structures between shelters protect the privacy of each family.
Photo: Zeid Madi, Nabil Sayfayn, and the *Azraq Journal* team, October 2017.

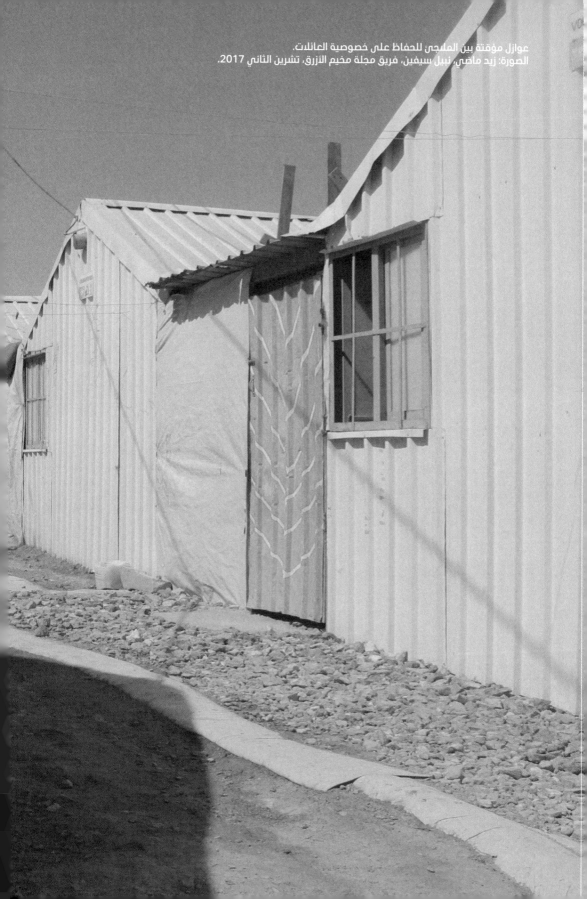

عوازل مؤقتة بين الملاجئ للحفاظ على خصوصية العائلات.
الصورة: زيد ماضي، نبيل سيفين، فريق مجلة مخيم الازرق، تشرين الثاني 2017.

Intimacy

الْيُسر

Designs for social spaces to negotiate
distinct levels of intimacy in the
community, neighborhood, and family.

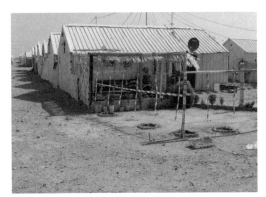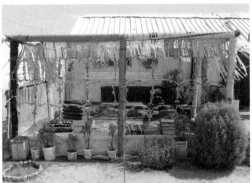

Outdoor *Majlis*

Front porches

Photo: Zeid Madi, Nabil Sayfayn, and
the *Azraq Journal* team, July 2017.

تصميماتٌ للمساحات الاجتماعية حيث
تجري أجواء من الألفة في المجتمع
والحي والأسرة.

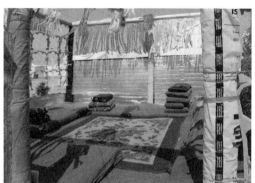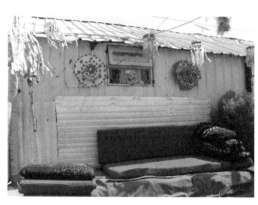

المجالس الخارجية

شرفات أمامية

الصورة: زيد ماضي نبيل سيفين، وفريق مجلة
مخيم الأزرق، في تموز 2017.

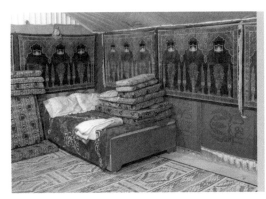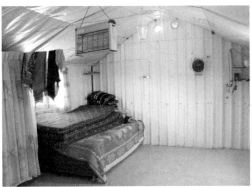

Bedroom

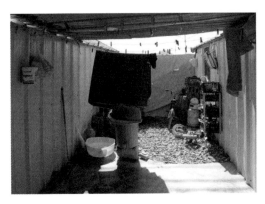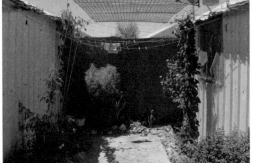

Open air and covered entrance hall extensions

Photo: Zeid Madi, Nabil Sayfayn, and the
Azraq Journal team, July 2017 & Melina
Philippou, April 2019.

غرفة النوم

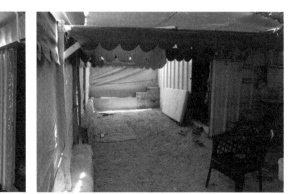

قاعات المداخل المفتوحة والمغلقة

الصورة: زيد ماضي ونبيل سيفين وفريق مجلة مخيم
الأزرق، تموز 2017 وميلينا فيليبو، نيسان 2019

Worldmakers

Mohammad Khalid Al-Marzouqi

"When we built this," Marzouqi tells us, "I was seventy kilos heavier and couldn't move a lot. I designed this *Majlis* while sitting on a chair in the middle telling my children what to do. They were my hands." The *Majlis* was mainly a place where he could meet people when moving was difficult for him. Now, after losing so much weight, his friends make him walk around more often, and his world extends beyond the previous confines of the house.

Marzouqi is very proud of the *Majlis*, speaking less about the design and more about how happy the neighbors were to see it being built near their houses. "In Syria, this is the life we had," he says. "These are traditions passed on from our ancestors." Whether the owner of the house is present or not, guests are welcome to enter for rest and refreshments. All members of the family are expected to make them feel at home.

The *Majlis* is a place to meet and celebrate. Marzouqi's son got married a few days before we visited, and people were still coming in to congratulate him. "When the weather is nice, everything happens here. We play cards, we eat lunch and dinner, we invite people over." He also updates the design quite regularly. As we have a chat, some of his friends come in and comment on new decorations, layouts, and landscaping. Marzouqi nods his head with pride and does not allow anyone to leave before being served coffee and sweets.

ضنّاع العالم

محمد خالد المرزوقي

يخبرنا محمد المرزوقي: «عندما بنينا هذا المجلس، كان وزني أثقل مما أنا عليه الآن بسبعين كيلو، ولم أستطع التحرك كثيرًا. صممت هذا المجلس وأنا جالس على كرسي في المنتصف، ورحت آخذ أطفالي بما يجب عليهم فعله. لقد كان أطفالي كذراعيّ ويديّ». كان المجلس عنصرًا أساسيًا بالنسبة لمحمد، فهو المكان الذي يستطيع فيه لقاء الناس عندما كان لا يستطيع التحرك، إلا أنه الآن خسر الكثير من الوزن، وأصبح أصدقاؤه يصطحبونه معهم إلى الخارج، مما جعل عالمه يمتد إلى ما وراء الحياة المنزلية السابقة.

يفتخر محمد المرزوقي بالمجلس كثيرًا، ويتحدث عن مدى سعادة الجيران بتشييده بالقرب من منازلهم أكثر من حديثه عن التصميم، ويقول عن ذلك: «هذه هي الحياة التي عشناها عندما كنا في سوريا، وقد ورثنا هذه التقاليد من أسلافنا». سواءً كان صاحب المنزل حاضرًا أو غائبًا. يتم الترحيب بالضيوف من خلال دعوتهم للجلوس وتقديم المشروبات لهم، ويُتوقع من جميع أفراد العائلة الترحيب بهم واستضافتهم كما لو أن البيت بيتهم.

يعتبر المجلس مكانًا لإقامة التجمعات والاحتفالات، وقد تزوج نجل محمد المرزوقي قبل زيارتنا بأيام قليلة، وكان الناس ما يزالون يأتون لتهنئته. أخبرنا محمد: «عندما يكون الطقس لطيفًا، يمكن أن نقوم بأي شيء هنا، مثل لعب الشدة وتناول الغداء والعشاء، إضافة إلى دعوة الناس للمكان». يقوم محمد بتحديث تصميم المجلس باستمرار، وقد جاءَه أحد أصدقائه أثناء حديثنا، وأثنى على الزخارف والإضافات الجديدة للمكان. هز محمد رأسه بفخر، ولم يسمح لأي شخص بالمغادرة قبل تناول القهوة والحلوى.

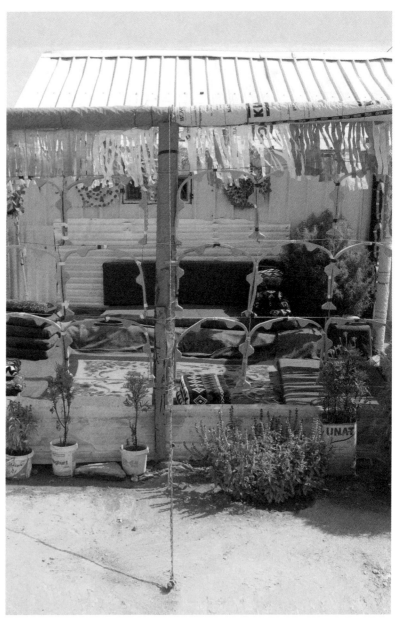

Photo: Zeid Madi, Nabil Sayfayn, and the *Azraq Journal* team, July 2017.
Drawings: Melina Philippou, Stratton Coffman.

الصورة: زيد ماضي ونبيل سيفين وفريق مجلة مخيم الأزرق، تموز 2017.
الرسومات: ميلينا فيليبو وستراتون كوفمان.

Outdoor Majlis

The Marzouqis built an outdoor living area for the extended family around the neighborhood. The celebratory space faces the street in front of their household. The design is influenced by the *Majlis* tradition of the Arab world, referring to the typical low-seating area for the welcoming of guests. The compartment facing the street is raised to allow for a view of the surrounding landscape. The light columns and fencing of the porch are decorated with geometric patterns, shapes, and colorful garlands. The patio is surrounded by herbs and flowers. During important celebrations like Ramadan, it opens up as a reception hall to the community.

المجلس الخارجي

قام المرزوقي ببناء مجالس خارجية للعائلات الممتدة في أحياء المخيم. تستضيف هذه المساحة الأحداث والفعاليات الإجتماعية، وتقع مقابل الشارع أمام منازلهم. اشتوحي هذا التصميم من المجالس الموجودة في التراث العربي، فحوى مقاعد منخفضة تُستخدم لاستقبال الضيوف، وواجهات مرتفعة تُطل على الشوارع من حوله. تمّ تزيين أعمدة الإنارة القريبة من المجلس والسياج بأنماط وأشكال هندسية وزينة ملونة، وزُرع الفناء بالأعشاب والنباتات. يصبح هذا المجلس قاعة استقبال لجميع أفراد المجتمع في الأوقات المميزة مثل شهر رمضان المبارك.

01	Laundry rope (CRI)
	حبل غسيل
	(من مواد الإغاثة الأساسية)

02	Paper tube
	لفافة ورقية

03	Yogurt container
	علبة لبن

04	Metal sheet insulation (IBR)
	ألواح معدنية

05	Metal sheet (IBR)
	صفيحة IBR المعدنية

06	Sleep mattress (CRI)
	فرشة نوم
	(من مواد الإغاثة الأساسية)

07	Vegetable crate
	صندوق خضار

08	Tarpaulin (CRI)
	قماش مشمع
	(من مواد الإغاثة الأساسية)

09	Foil-faced foam insulation sheet (CRI)
	لوح قصديري عازل
	(من مواد الإغاثة الأساسية)

01

Structure
هيكل الشد

02

03 04

Fencing
التسييج

05 06

Seating
المقاعد 08

09 07

Water insulation
عزل المياه

1:150

اليسر

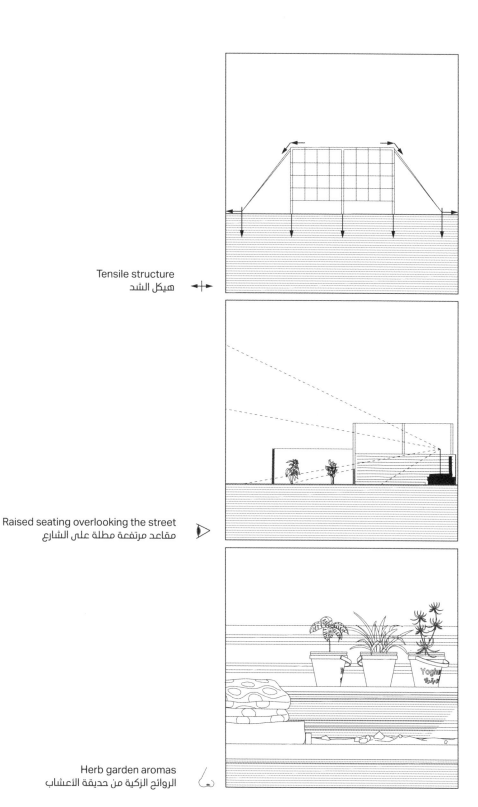

Tensile structure
هيكل الشد

Raised seating overlooking the street
مقاعد مرتفعة مطلة على الشارع

Herb garden aromas
الروائح الزكية من حديقة الأعشاب

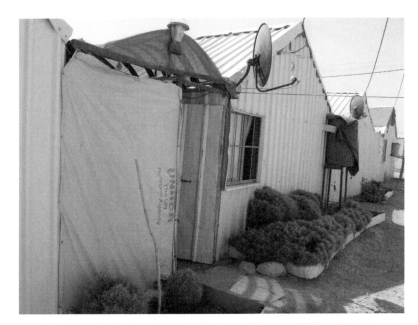

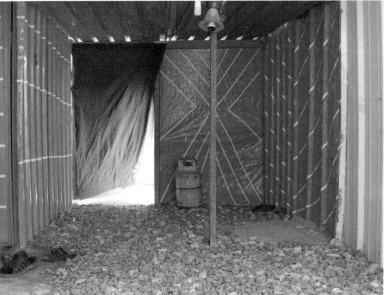

Photo: Zeid Madi, Nabil Sayfayn, and the *Azraq Journal* team, July 2017.
Drawings: Melina Philippou, Stratton Coffman.

الصورة: زيد ماضي ونبيل سيفين وفريق مجلة مخيم الأزرق، تموز 2017.
الرسومات: ميلينا فيليبو وستراتون كوفمان.

Entrance Hall

A widespread modification of the T-shelter at the camp is the addition of an entrance hall. The hall allows the shifting of the house entrance from the street facade to a transitional space on the side of the shelter. The design is influenced by the climatic conditions of the desert and the principles of veiling concerning *mahram*.[1] The hall limits a direct view into the house interior. It functions as an in-between space to welcome guests while the unveiled members of the family continue their activities in the main living area. A typical design includes reconfiguring the openings and fencing the space between shelters. Mohammad decorated the interior and openings of the entrance hall with bright graphic patterns drawn directly to the wall surface. Another designer built a hall with a domed roof. The dome consists of arches made out of linoleum floor strips, and it is covered with mosquito netting to allow sunlight into the room.

[1] In Islam, *mahram* describes the people with a level of kinship where marriage would be considered illegal and concealment of the body with hijab is not obligatory.

01	Twine net شبكة مصنوعة من الحبال
02	Linoleum floor strips شرائط من مشمع الأرضيات
03	Metal sheet (IBR) صفيحة IBR المعدنية

| 04 | Bottle cap غطاء قنينة |
| 05 | Plastic sheet غطاء بلاستيكي |

ردهة المدخل

تعتبر ردهة المدخل واحدة من التعديلات الواسعة النطاق في الملاجئ الانتقالية في المخيم، وتسمح هذه القاعة بتحويل المدخل من واجهة الشارع ليصبح في مساحة بديلة بجانب الملجأ. تستمد الحاجة لهذا التصميم أهميتها من الظروف المناخية في الصحراء، إلى جانب قواعد الحجاب والمحرم.[1] يمكن رؤية داخل المنزل مباشرةً من القاعة، التي تمثل أيضًا مكانًا لاستقبال الضيوف، مما يتيح لبقية أفراد العائلة أخذ حريتهم وممارسة أعمالهم في غرفة المعيشة.

يتضمن أحد التصاميم النموذجية إعادة تشكيل المداخل وتسييج المساحة بين الملاجئ، وقد قام محمد بتزيين جدران قاعة المدخل من الداخل ومداخلها برسومات جميلة، وبنى مصمم آخر قاعة ذات سقف مُقبب، باستخدام أقواس مصنوعة من شرائط مشمع الأرضيات، وغطّاها بشبكة ناموسية للسماح لأشعة الشمس بالدخول إلى الغرفة.

[1] في الإسلام، يُعبر مصطلح المحرم عن الرجل القريب الذي لا يمكن الزواج به، ولا يستوجب ارتداء الحجاب في حضوره.

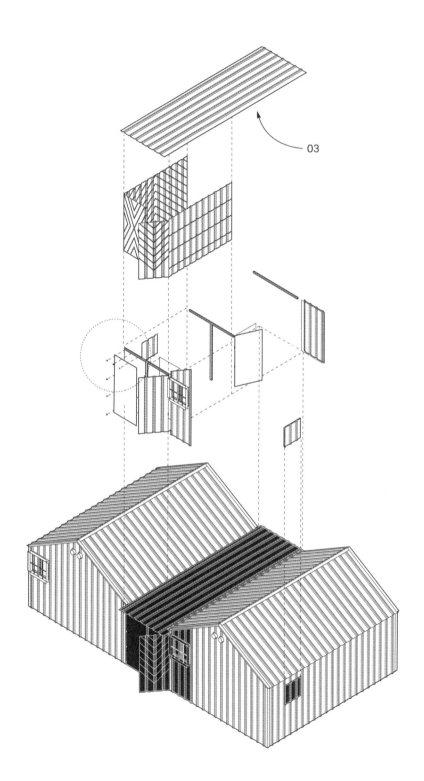

03

1:150

النَّيسر

Assembly detail: Bottle cap nut تفاصيل التركيب: غطاء زجاجة

Reconfiguration of openings إعادة تشكيل المداخل

01

02

03

1:150

اليُسر

Worldmakers

Aziza

Aziza is a busy woman. She is a teacher at the camp and a single mother of two. She gives us five minutes of her time with a gentle reminder that she's running late to her next meeting. There was word around the camp that the minister of education was visiting!

We meet at the living area she built with her neighbors to make this place feel more like home. "In Syria, we used to live in Arab houses where the outdoor spaces play an important role. Usually, the house has a courtyard. Our house had an indoor room and a large covered patio in front of the house with a concrete slab above it and two columns supporting the cantilever." The open living area under the shade is a reflection and a reminder of life in Syria. She says it makes her and her community feel safer, allowing them to adapt and maintain a sense of normalcy day to day.

Aziza's *Majlis* is a space for women made by women. A place to catch up, smoke shisha, and cook together. A lot of Syrian staples have a long preparation time before it becomes a kitchen affair, so all of this preparation happens in groups at the *Majlis*. "When we harvest the Mulukhiyah plants, the seven of us meet at this *Majlis* to help each other clean the leaves. It took us seven days to finish, one day for each lady's harvest." Especially during Ramadan, the holy month of fasting in Islamic practice, people spend more time eating and cooking with each other. "Dishes like Shish Barak (yoghurt dumplings), Sambusik (fried dumplings), and Kibbeh (meat and bulgur balls) are impossible not to share with the neighbors!"

ضُنّاع العالم

عزيزة

تعمل عزيزة كمعلمة في المخيم، وهي امرأة عاملة وأم وحيدة لطفلين. منحتنا عند لقائنا بها، خمس دقائق من وقتها، ثم أخبرتنا بلطف أنها ستتأخر عن اجتماعها التالي، الذي سمعنا أنّ له علاقة بزيارة وزير التربية والتعليم للمخيم.

اجتمعنا مع عزيزة في مساحة معيشية قامت ببنائها مع جيرانها لجعل المكان يبدو شبيهًا بالوطن، وأخبرتنا: «في سوريا، كنا نعيش في منازل ذات طابع عربي، حيث تلعب المساحات الخارجية دورًا مهمًا في حياتنا، وكانت المنازل تحتوي فناءً في العادة. كان منزلنا يضم غرفة داخلية وفناء كبير أمام المنزل يعلوه لوح خرساني، وعمودين يدعمان الكابول (العتبة الناتئة)». يستذكر سكان المخيم الحياة في سوريا من خلال مساحة المعيشة المفتوحة المظللة، وتقول عزيزة أنّ هذه المساحة تشعرها هي ومجتمعها بمزيد من الأمان، وتسمح لهم بالتكيف والحفاظ على شكل من أشكال الحياة الطبيعية في حياتهم اليومية.

يعتبر مجلس عزيزة مكانًا بنتهُ النساء لأجل النساء، إذ يقمن فيه التجمعات، ويدخنّ النرجيلة ويطبخن معًا. تحتاج الكثير من المواد الغذائية الأساسية في المطبخ السوري لمدة تحضير طويلة قبل أن تصبح جاهزة للاستهلاك، فتقوم النساء بإعدادها بمساعدة بعضهن البعض في المجلس. تضيف عزيزة: «عندما نجمع نبات الملوخية، تأتي مجموعتنا المكونة من سبع نساء إلى المجلس لتنظيف الأوراق، ويستغرقنا إنهائها سبعة أيام كاملة، كوننا نخصص يوم واحد لمحصول كل سيدة منا». يحرص الناس في شهر رمضان المبارك، على قضاء وقت أطول في تناول الطعام مع بعضهم البعض، والطبخ بشكل جماعي، وعن ذلك تضيف عزيزة قائلة: «هناك أطباق يستحيل أن لا نشاركها مع الجيران، مثل الشيشبرك والسمبوسة والكبة».

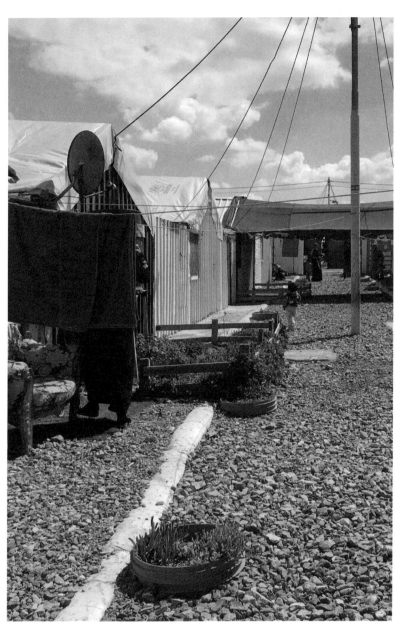

Photo: Melina Philippou, April 2019.
Drawings: Jaya Eyzaguirre, Melina Philippou.

الصورة: ميلينا فيليبو، نيسان 2019.
الرسومات: جايا آيزاجوير وميلينا فيلبو.

Courtyard

The residents of the plot in this photo designed an insular communal space for the neighborhood. The transition from the village to the courtyard is marked by the contrast between the austere environment of the desert and the beautifully landscaped, paved interior with a central canopy. Due to the initial regulation of gardening connected to the UNHCR guidelines on the environmental sustainability of the site, residents avoided planting directly into the ground.[1] Instead, they planted on areas they first enveloped with a plastic surface and repurposed sewage lids into planters. They paved the courtyard with stones picked from the desert and built barriers that protect shelters from flooding.[2] The central canopy serves as an open living area. Made out of thermal blankets and plastic sheets, it allows gatherings, rain or shine. The courtyard filters the visual and physical access to the plot, allowing the neighborhood to move on with everyday life in an environment of controlled privacy.

[1] UNHRC Environmental Guidelines, 30.

[2] Part of the camp is situated on a dry riverbed of the Azraq basin resulting in the flooding of villages during the rainy season.

01	Thermal blanket (CRI) بطانية حرارية (من مواد الإغاثة الأساسية)
02	Plastic sheet (CRI) غطاء بلاستيكي (من مواد الإغاثة الأساسية)
03	Tension tie مثبت معدني
04	Laundry rope (CRI) حبل غسيل (من مواد الإغاثة الأساسية)
05	Desert sand رمل صحراوي
06	Tree شجر
07	Sewer cover plate غطاء صرف صحي
08	Desert rocks صخور صحراوية

الفناء

صمّم السكان الأرض التي تظهر في الصورة لتصبح ساحة منفصلة مشتركة للحي، وقد شكّل هذا التصميم نقلة نوعية في طبيعة المخيم الصحراوية القاسية. يحوي الفناء مساحة داخلية مرصوفة ومناظر داخلية جميلة مع مظلة مركزية. لم يقم سكان المخيم بزراعة أي نباتات بشكل مباشر في الأرض، وذلك بسبب التعليمات الأولية الصادرة عن المفوضية السامية للأمم المتحدة لشؤون اللاجئين «UNHCR» بخصوص الزراعة والاستدامة البيئية للموقع، بل قاموا بدلاً من ذلك باستخدام الأغطية البلاستيكية، وأعادوا استخدام أغطية الصرف الصحي للزراعة.[1] قام السكان كذلك برصف الفناء بالحجارة التي جمعوها من الصحراء، وبنوا حواجز تحمي من الفيضانات.[2] أما مكان المظلة المركزية، فيمثل منطقة معيشة مفتوحة، وقد تمّ تصميم المظلة والمكان من البطانيات الحرارية والأغطية البلاستيكية، ليصبح من الممكن إقامة التجمعات تحتها في الأيام المشمسة والماطرة. يتيح موقع الفناء للسكان رؤيته بشكل مباشر والوصول إليه بدون عوائق، والقيام بأعمالهم اليومية، في بيئةٍ تسود فيها الخصوصية.

[1] المبادئ التوجيهية البيئية، قسم الدعم الفني البيئي، المفوضية السامية للأمم المتحدة لشؤون اللاجئين "UNHRC" جنيف، والاتحاد العالمي للحفاظ على الطبيعة ومواردها "IUCN"، آب، 2005، ص30.

[2] يقع جزء من المخيم على مجرى نهر جاف في حوض الأزرق، مما يؤدي إلى حدوث الفيضانات في القرى خلال موسم الأمطار.

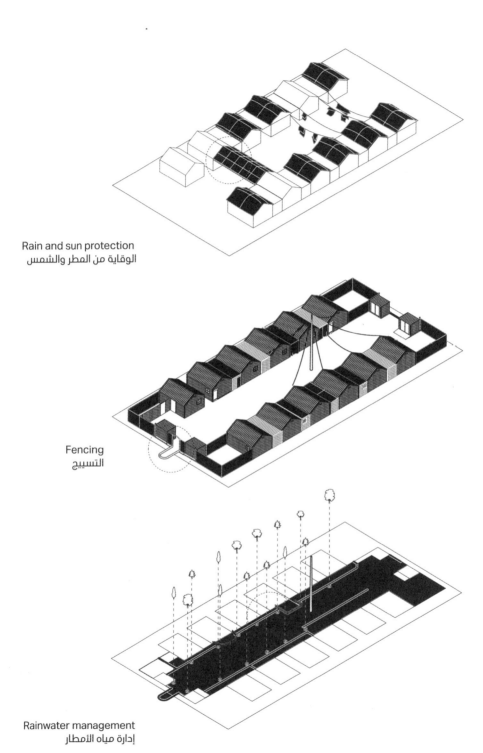

Rain and sun protection
الوقاية من المطر والشمس

Fencing
التسييج

Rainwater management
إدارة مياه الأمطار

1:750

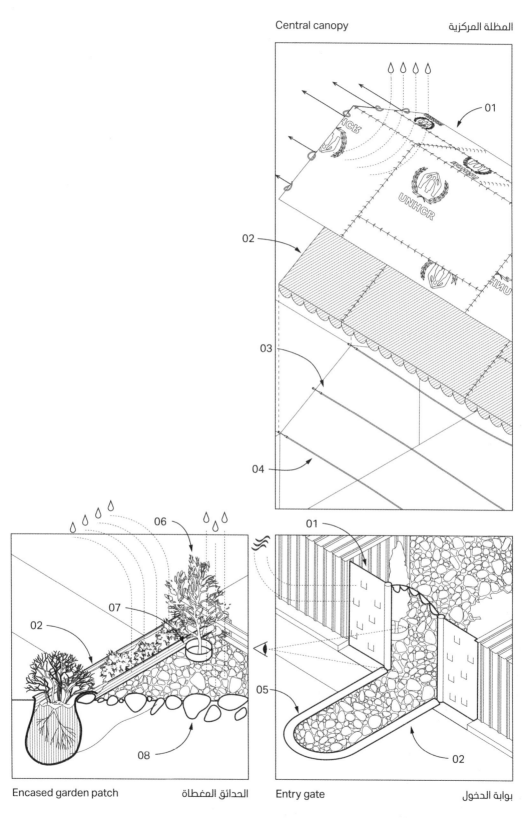

DESIGN TO LIVE

Central canopy المظلة المركزية

06

07

02

08

Encased garden patch الحدائق المغطاة

01

05

02

Entry gate بوابة الدخول

التصميم للحياة

Intir

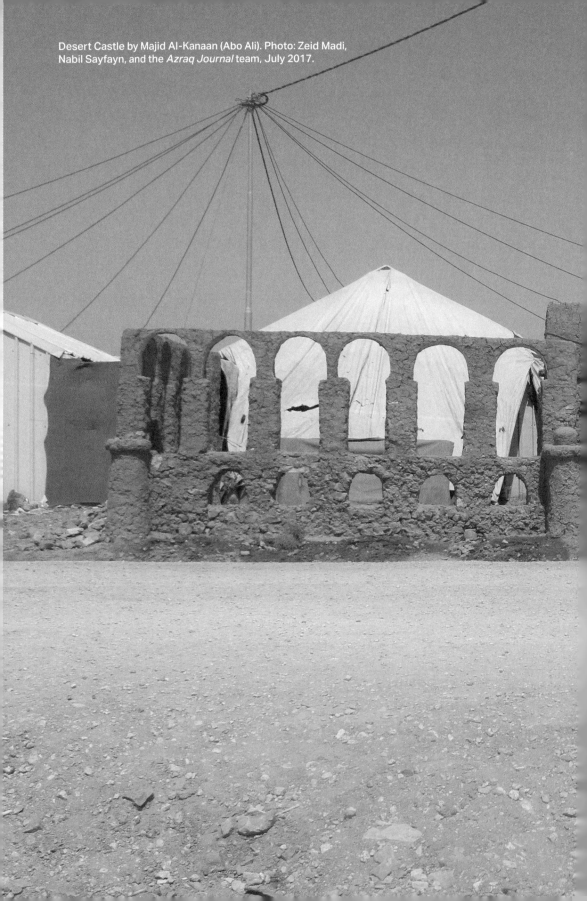

Desert Castle by Majid Al-Kanaan (Abo Ali). Photo: Zeid Madi, Nabil Sayfayn, and the *Azraq Journal* team, July 2017.

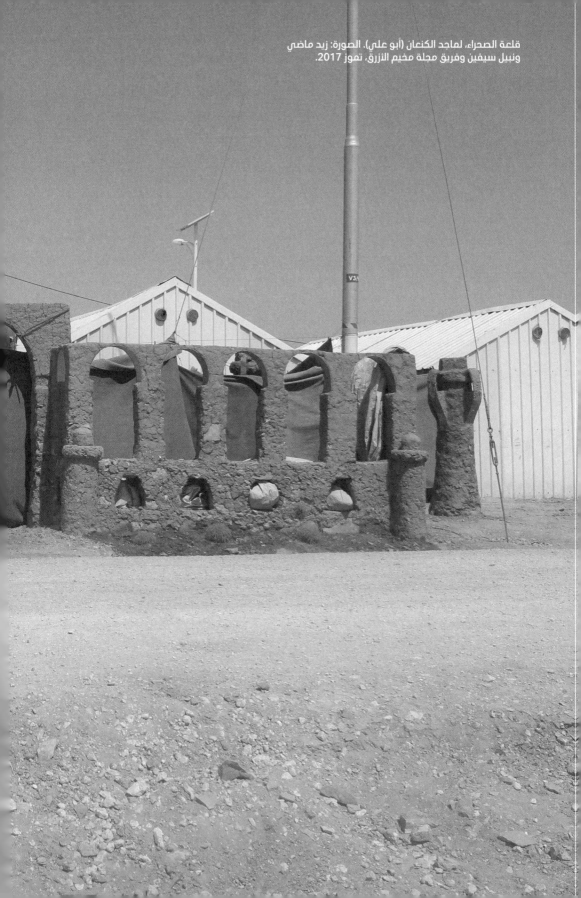

قلعة الصحراء، لماجد الكنعان (أبو علي). الصورة: زيد ماضي ونبيل سيفين وفريق مجلة مخيم الأزرق، تموز 2017.

Fello

vship

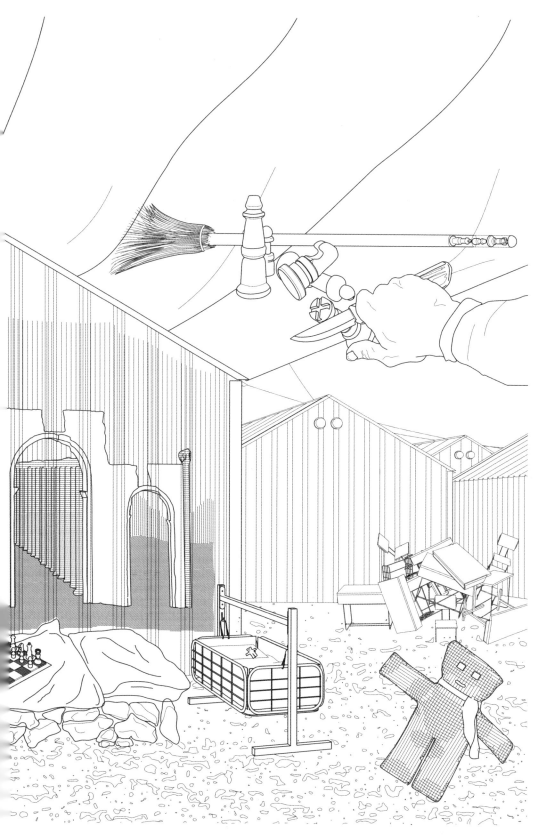

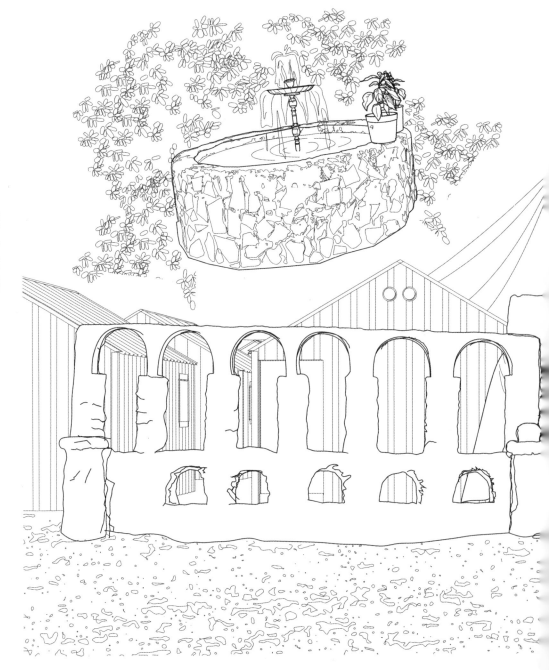

البيت هو الذي يعون أسرة متفاهمة
ومتعاونة ومثقفة

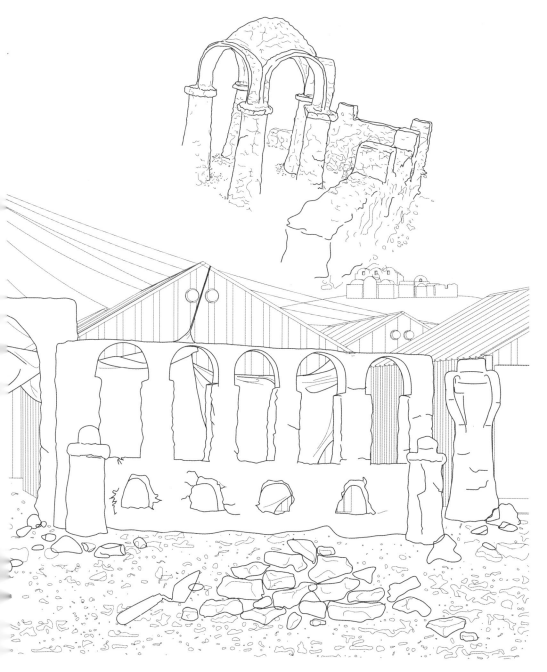

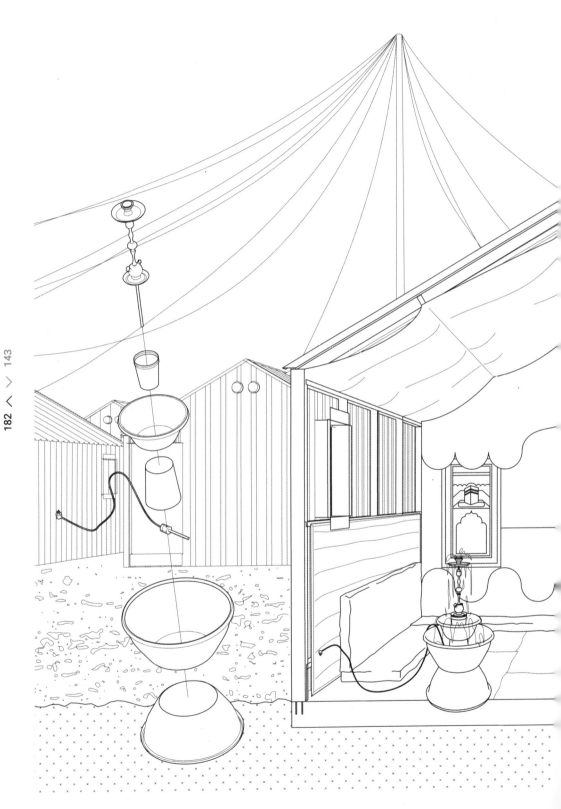

... a world without
war

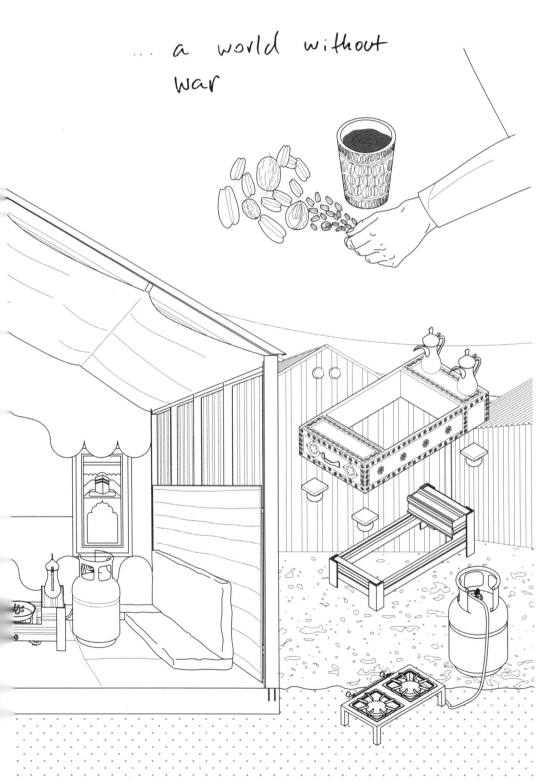

Designs That Question Life under Cultural Austerity

Refugees at Azraq build imaginative collages of the homeland. They design familiar moments with objects of standardized humanitarian aid. It takes weeks to gather the necessary materials for a simple fountain, and when refugee construction is forbidden, it takes delicate knowledge of loopholes in the system to build the life-sized sandcastles resembling the Arch of Triumph in Palmyra. However tricky the process, to bring people together is a worthy cause. The *Majlis*, traditional living spaces, are at the core of the residents' social lives and are the places where celebrations, casual visits, and gatherings happen around traditional coffee and tea rituals. Raised without a lived experience of Syria, the children of the camp form their identities from these symbols and social practices. Fellowship is an important aspect of Syrian heritage, and older generations at the camp try to keep that tight-knit social structure alive. Through acknowledging solidarity as a native characteristic for design at the camp, we are able to better highlight the making process as a conduit for heritage and cultural reproduction at Azraq.

تصاميمٌ تناقش الحياة في ظل التقشف الثقافي

يبني اللاجئون في مخيم الأزرق تصاميم خلاقة تعكس صور الوطن في أذهانهم، ويستخدمون في ذلك أدوات من المساعدات الإنسانية الموحدة. يتطلب جمع المواد الضرورية التي يحتاجها تصميم نافورة بسيطة عدة أسابيع، كما يتطلب صنعها معرفة دقيقة بالثغرات الموجودة في النظام في المخيم، لأجل تحقيق بناء لمجسم رملي بالحجم الطبيعي، يشبه قوس النصر الموجود في مدينة تدمر السورية. تقرب هذه العملية ومثيلاتها، سكان المخيم من بعضهم البعض، على الرغم من صعوبتها. تُعبّر المجالس عن مساحات المعيشة التقليدية، وتمثل الأماكن التي تستضيف الاحتفالات والزيارات والتجمعات غير الرسمية، وغيرها من الفعاليات التي تتخذ في العادة مكانًا حول الطقوس التقليدية للقهوة والشاي. نشأ أطفال المخيم بعيدًا عن سوريا، ولم يحظوا بتجربة العيش فيها، ولهذا فإنهم يشكلون هوياتهم الأصلية من خلال تلك الرموز والممارسات الاجتماعية. تُعتبر الألفة جانبًا مهمًا في التراث السوري، لذلك يحاول الجيل الأكبر سنًا في المخيم الحفاظ عليها، وعلى تماسك مثل هذه العادات واستمراريتها. يساعد الاعتراف بالتضامن كميزة أصيلة في تصميم المخيم الأزرق، على تمكيننا من تسليط الضوء بشكل أفضل على عملية المحافظة على التواصل مع التراث والثقافة فيه.

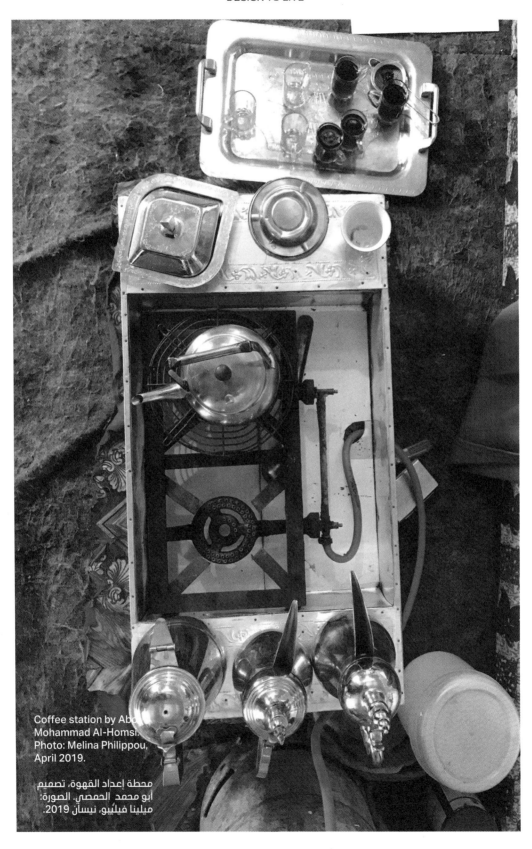

Coffee station by Abo
Mohammad Al-Homsi.
Photo: Melina Philippou,
April 2019.

محطة إعداد القهوة، تصميم
أبو محمد الحمصي. الصورة:
ميلينا فيليبو، نيسان 2019.

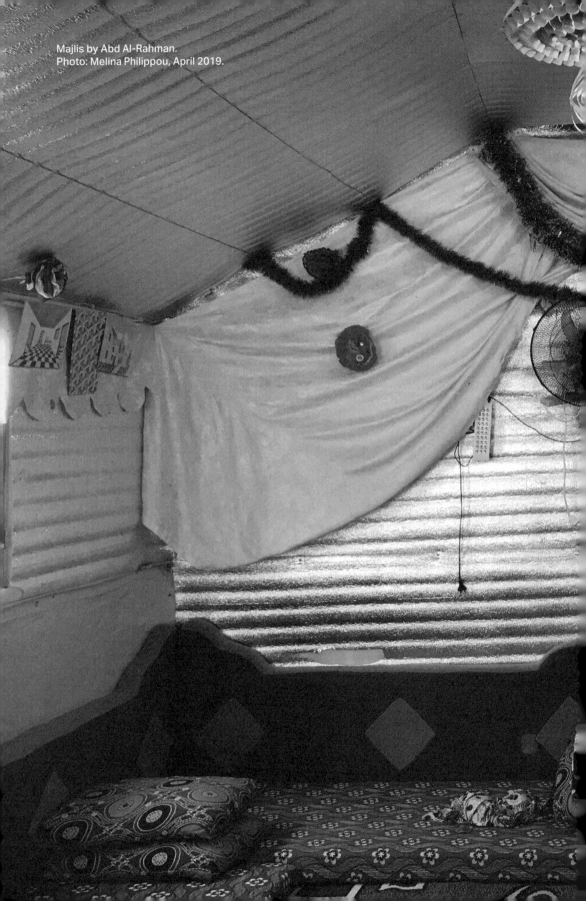

Majlis by Abd Al-Rahman.
Photo: Melina Philippou, April 2019.

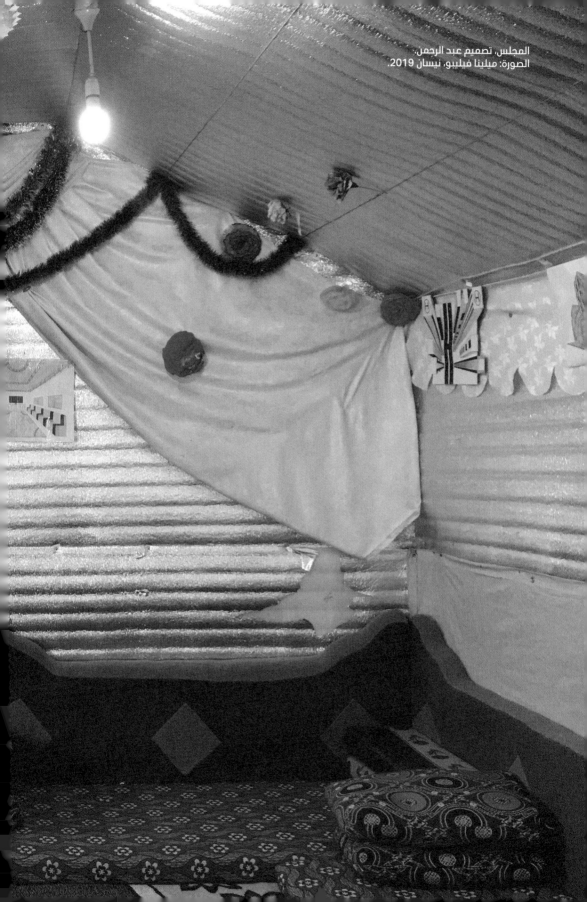

المجلس، تصميم عبد الرحمن.
الصورة: ميلينا فيليبو، نيسان، 2019.

Fellowship
الألـــفة

Designs to transfer rituals and images
of Syria to the children of Azraq who
have little memory of the homeland.

Toys

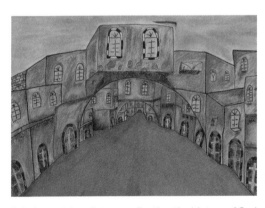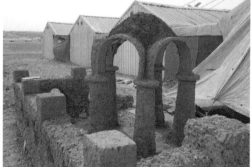

Paintings and sculptures reflecting the history of Syria

Photo: Zeid Madi, Nabil Sayfayn, and the
Azraq Journal team, July 2017 & Malek
Abulatif, April 2019.

تصاميمُ تنقل طقوس وصور سوريا لأبناء
اللاجئين في مخيم الأزرق، الذين لا يملكون
الكثير من الذكريات من وطنهم

ألعاب

لوحات ومنحوتات تعكس تراث سوريا

الصورة: زيد ماضي ونبيل سيفين وفريق مجلة
مخيم الأزرق (تموز 2017)، ومالك أبو لطيف
(نيسان 2019).

 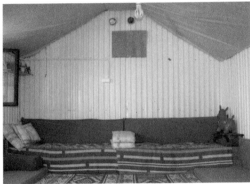

Majlis building blocks

 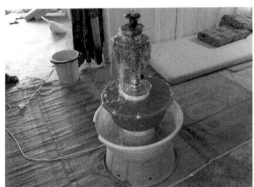

Fountains

Photo: Zeid Madi, Nabil Sayfayn, and the
Azraq Journal team, July 2017.

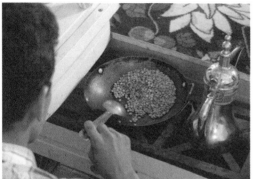

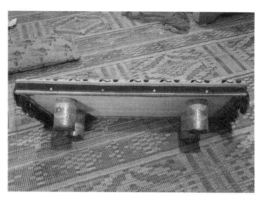

لبنات بناء المجلس

النوافير

الصورة: زيد ماضي ونبيل سيفين وفريق مجلة
مخيم الأزرق، تموز 2017.

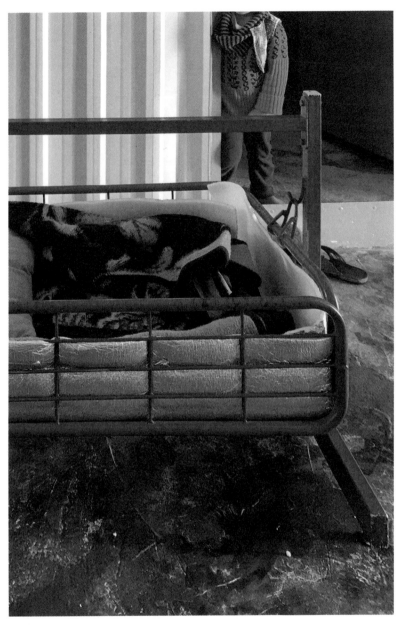

Photo: Melina Philippou, April 2019.
Drawings: Jaya Eyzaguirre, Stella Zhujing Zhang.

الصورة: ميلينا فيليبو، نيسان 2019.
الرسومات: جايا آيزاجوير وستيلا زوجنغ تشانغ.

Rocking Crib

Ali Fawaz reappropriated old student desks into a rocking crib for his newborn. He reused the desk under-frame as a bearing structure and the stationary racks for the basket. He quilted the basket interior with layers of foil-faced insulation foam (CRI).

سرير هزاز

قام علي فؤاز باستخدام أجزاء من مقعد مدرسي لتصميم سرير هزاز لطفله حديث الولادة؛ حيث استخدم هيكل المقعد السفلي لصناعة جسم السرير، وصنع سلة من رفوف المقعد، ثم قام بتبطين الجزء الداخلي للسلة بطبقاتٍ من الفوم العازل الذي حصل عليه من ضمن مواد الإغاثة الأساسية.

01	Table legs أرجل الطاولة	
02	Foil-faced foam insulation sheet (CRI) لوح قصديري عازل (من مواد الإغاثة الأساسية)	
03	Desk legs أرجل مقعد دراسي	
04	Chair back ظهر الكرسي	

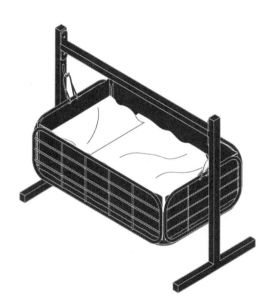

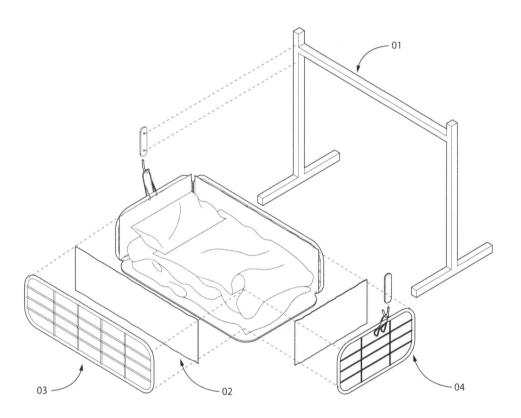

01

03

02

04

1:10

التصميم للحياة

Photo: Zeid Madi, Nabil Sayfayn, and the *Azraq Journal* team, July 2017.
Drawings: Noora Aljabi, Stratton Coffman.

الصورة: زيد ماضي ونبيل سيفين وفريق مجلة مخيم الأزرق، تموز 2017.
الرسومات: نورا الجابي وستراتون كوفمان.

Plush Toy

The thermal blanket is one of the few available fabrics at the camp. They are distributed to residents upon arrival and periodically throughout the year. Residents upcycle the blankets in numerous ways including as clothing, tapestries, and shades. The picture on the left is of a plush toy filled with seeds.

01	Beans حبوب البقوليات
02	Rice الأرز
03	Rags قطع قماش
04	Thermal blanket (CRI) بطانية حرارية (من مواد الإغاثة الأساسية)

دمية محشوة

تُعد البطانيات الحرارية من ضمن الأقمشة القليلة المتوافرة في المخيم، إذ يتم توزيعها على السكان عند وصولهم للمكان، وبشكل دوري خلال العام أيضًا. يعيد سكان المخيم استخدام البطانيات بعدة طرق، مثل الملابس والمفروشات والمظلات، وتظهر في الصورة على اليسار دمية محشوة مصنوعة من البطانيات الحرارية، وقد تم حشوها بالبذور.

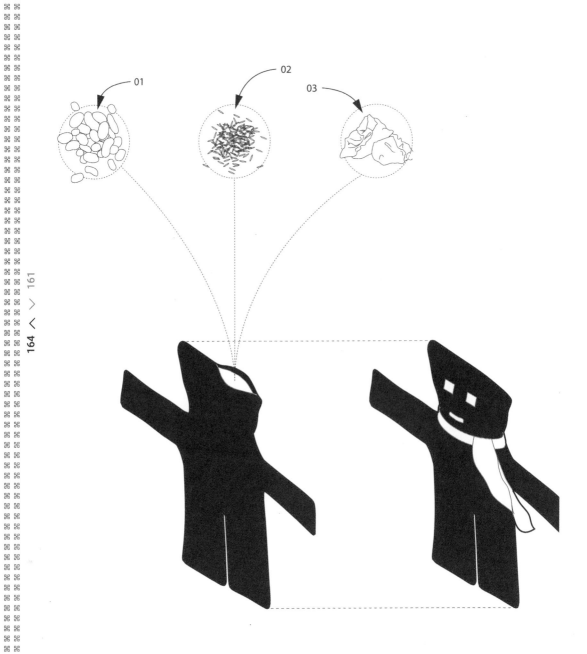

1:20

66 x

04

2 m

1.5 m

1:20

التصميم للحياة

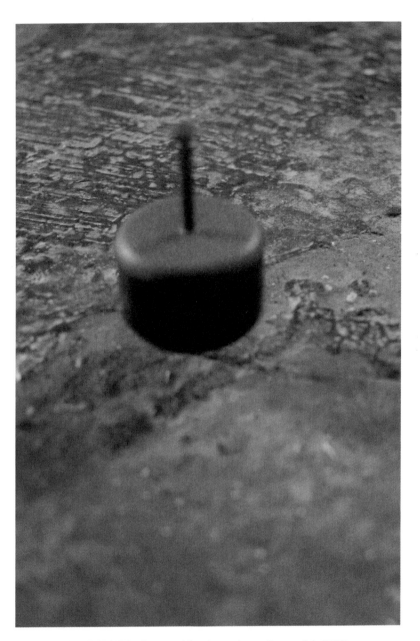

Photo: Zeid Madi, Nabil Sayfayn, and the *Azraq Journal* team, July 2017.
Drawings: Jaya Eyzaguirre, Catherine Lie.

الصورة: زيد ماضي ونبيل سيفين وفريق مجلة مخيم الأزرق، تموز 2017.
الرسومات: جايا أيزاجوير وكاثرين لي.

Spinning Top

This spinning top is representative of the toy making at Azraq based on the ingenious use of household waste. The handle of the pull-off spinner is a short pencil that connects to the top with a rubber band through an empty marker. The top itself is a water cap.

لعبة البُلبل

لعبة البُلبل التي تظهر في الصورة هي واحدة من الألعاب المُبتكرة في مخيم الأزرق، وتُستخدم في صناعتها الأدوات المنزلية المهملة. يُصنع مقبض اللعبة من قلم كتابة فارغ، ويُلف شريط مطاطي على قلم رصاص صغير على المقبض لتثبيته على البلبل، بينما يُصنع هيكل لعبة البلبل بمجمله من غطاء زجاجة ماء.

01	Pencil	قلم رصاص
02	Rubber band	شريط مطاطي
03	Marker	قلم كتابة
04	Nail	مسمار
05	Bottlecap	غطاء قنينة

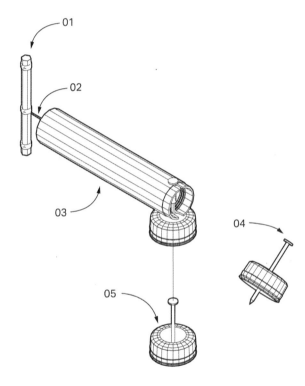

Spinning top pull

سحب اللعبة من الأعلى

1:20

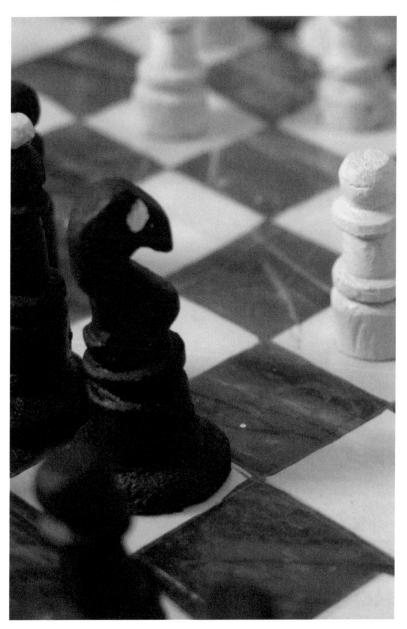

Photo: Zeid Madi, Nabil Sayfayn, and the *Azraq Journal* team, July 2017.
Drawings: Stratton Coffman, Calvin Zhong.

الصورة: زيد ماضي ونبيل سيفين وفريق مجلة مخيم الأزرق، تموز 2017.
الرسومات: ستراتون كوفمان وكالفين تشونغ.

Chess Set

The wooden chess set is the result of laborious craftsmanship. The designer carved pieces from the length of a broomstick. The board is hand drawn on food packaging.

01 Cardboard
 لوح كرتون

02 Broom
 مكنسة

لعبة الشطرنج

صُنعت لعبة الشطرنج نتيجة عمل حرفي جاد، حيث قام المصمم بنحت قطع الشطرنج من عصا مكنسة خشبية، وقام برسم لوح الشطرنج على كرتونة مواد غذائية.

01

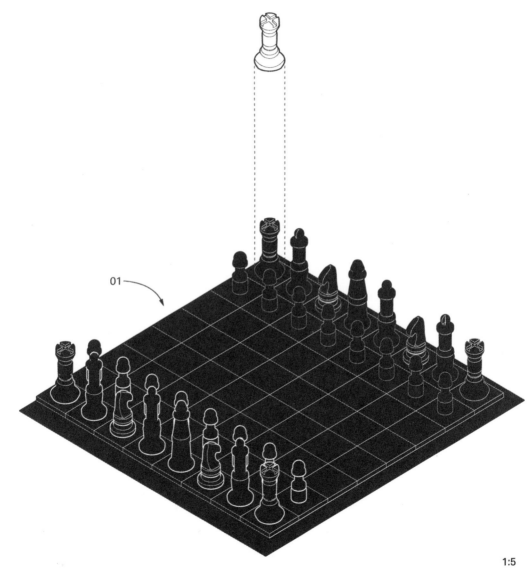

1:5

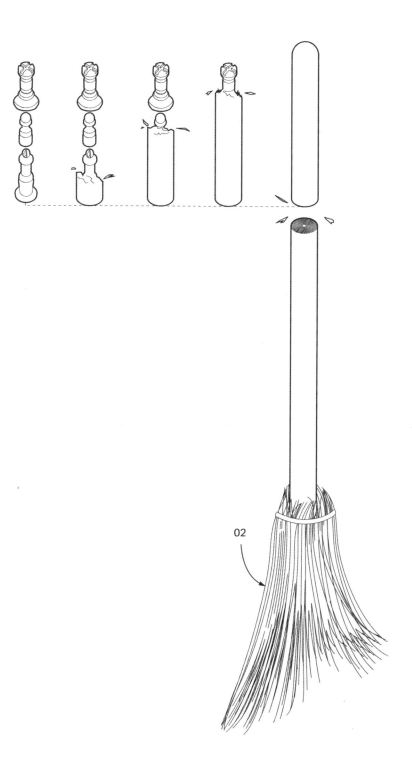

02

1:5

Worldmakers

Majid Al-Kanaan (Abo Ali)

Abo Ali is the architect behind one of the most photographed structures at the camp, the clay arches in front of his house. The arches are now gone due to the lack of long-lasting building materials and the rough weather, but he recalls a time when his work was destroyed on purpose. "When I first made the structure, I was exploring what could be done with the sand and stone of this area," he said, "but then one night I heard a huge bang and the entire household woke up to a man destroying my work." The man had mistaken Abo Ali's work for a religious shrine. "His brains were tired," he says of the man, "so we let him go."

Abo Ali was labelled a pagan for a while after the incident by several people, but he laughs it off: "I rebuilt the structure, but made it look like the Aleppo Citadel, and everyone flocked from every part of the camp to take pictures with it." Abo Ali has an interesting nonchalance toward group dynamics, and interprets everything poetically. "Human beings are made of clay too. Allah took some clay and made us out of it, so we have an eternal empathy with the ground. Now there's concrete. The world changed. Sobhan Allah."

Ironically for his analogy, concrete is not allowed at the camp. "Brother, they don't want us to stay here forever," Abo Ali says. "And they know that if they give me concrete, I'll build a three-story house for myself. I swear." After all, most people living in Azraq are builders by trade and would do the same thing. But Abo Ali doesn't want to stay here. He dreams of an "amazing" piece of land he owns back home in Syria, where he will recreate his designs the way he wants, without restrictions. "And I'll make it last 100 years if I want to!"

صُنّاع العالم

ماجد الكنعان (أبو علي)

أبو علي، هو الفنان الذي أبدع في تصميم واحدة من أشهر الابتكارات التي جرى تصويرها وتوثيقها في المخيم، وهي الأقواس الطينية المشيدة أمام منزله. لم تعد هذه الأقواس موجودة، إذ تعرضت للدمار بسبب قسوة ظروف الطقس، ولأن بنائها لم يتضمن مواد بناء أصلية طويلة الأمد في الأساس. لا يزال أبو علي يتذكر اليوم الذي جرى فيه هدم ما بناه عن قصد، ويقول في ذلك: «خطرت لي فكرة بناء هذه الأقواس عندما كنت أستكشف ما يمكن فعله بالرمال والحجارة التي تملأ المكان. وفي إحدى الليالي، سمعتُ صوت جلبة وضجة استيقظ على إثرها جميع من في المنزل، ثم خرجنا لنجد رجلاً يحطم كل ما بنيته». عرف أبو علي لاحقًا أن الرجل هدم الأقواس لأنه ظنّ أنها مزار ديني، وقد تركه يذهب في حال سبيله لأنه، وحسب ما يقول أبو علي «لم يكن رجلاً ذا عقل سليم».

اتهم عددُ من الأشخاص أبا علي بالوثنية بعد تلك الحادثة، واستمرت هذه الاتهامات لمدة من الزمن، إلا أن أبا علي لم يعلق عليها سوى بالضحك والسخرية. يتحدث أبو علي عما فعله بعد تلك الحادثة قائلاً: «أعدت بناء المجسم، ولكنني جعلتُ هذه المرة شبيهًا بقلعة حلب، وقد توافد إليه أشخاصٌ كثيرون من جميع أنحاء المخيم لالتقاط الصور قربه». يمتاز أبو علي برباطة جأشه، وميله إلى تفسير كل شيء بشكل شاعري ومجازي، ومن أقواله: «خلق الله تعالى البشر من الطين أيضًا، ولهذا نرتبط بالأرض، لأن أصلنا من تراب. الآن لا نرى إلا الأسمنت.. لقد تغير العالم حقا.. سبحان الله»

يُمنع استخدام الأسمنت في المخيم، وتلك مفارقة يقول عنها أبو علي: «يا أخي، هم لا يريدوننا أن نبقى هنا إلى الأبد. أقسم لك أنهم إذا وزعوا علينا الأسمنت فسوف أبني منزلاً من ثلاثة طوابق بنفسي». يحترف أغلب السكان في مخيم الأزرق مهنة البناء، ومنهم من يرغب في البناء لو أتيحت الفرصة، إلا أن أبا علي لا يرغب في البقاء في المخيم، ويحلم بالعودة إلى وطنه سوريا، حيث يملك قطعة أرض، ويرغب أن يبني عليها تصاميمه دون أية قيود. يضيف أبو علي على كلامه قائلًا: «لو أردتُ، لجعلتُ تصاميمي تدوم لأكثر من مئة عام».

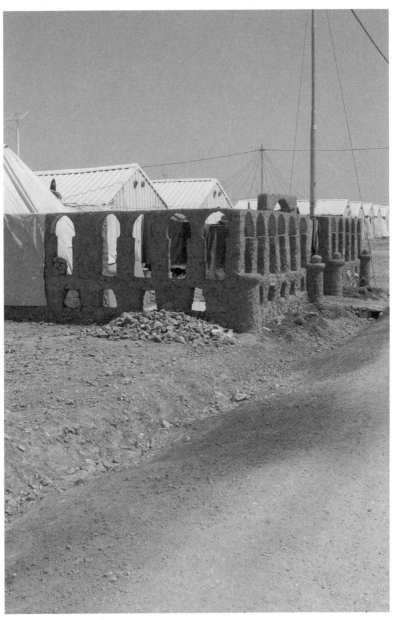

Photo: Zeid Madi, Nabil Sayfayn, and the *Azraq Journal* team, July 2017.
Drawings: Jaya Eyzaguirre, Melina Philippou.

الصورة: زيد ماضي ونبيل سيفين وفريق مجلة مخيّم الأزرق، تموز 2017.
الرسومات: جايا آيزاجوير وميلينا فيلبو.

Desert Castle

This life-sized sculpture references the history of the region: the Arch of Triumph in Palmyra, the Citadel of Aleppo, and the Umayyad desert palaces of Jordan's Eastern Desert. It contrasts with the standardized architectures that surround it. Abo Ali conceived the idea in the idleness of the camp. He built multiple iterations using clay and stones from the desert. His structures overcome regulations that forbid residents from introducing buildings at the camp. Technically, Abo Ali's sandcastles resemble sculptures more than buildings. They do not have foundations, are not made out of construction materials, and are not enclosed. A landmark and social space for residents and humanitarian workers alike, the castle eventually got destroyed by the elements. The Desert Castle of the Azraq camp momentarily transformed the desert from a symbol of isolation to a place for the community and a medium for cultural expression.

01	Sand رمل
02	Clay طين
03	Rocks صخور
04	Metal sheet صفيحة معدنية

174 › ‹ 151

قلعة الصحراء

يمثل المُجسم المنحوت الذي يظهر في الصورة بالحجم الطبيعي عددًا من الآثار التي تعكس تاريخ المنطقة، بما في ذلك قوس النصر في مدينة تدمر، وقلعة حلب، والقصور الأموية الصحراوية في الصحراء الشرقية الأردنية. تُناقض هذه المنحوتة التصميمات المعمارية المُوحدة التي تحيط بها، وقد دفع الفراغ الذي يطغى على الحياة في المخيم أبو علي لتبني هذه الفكرة، إذ قام ببنائها باستخدام الطين والحجارة التي جمعها من الصحراء. يتجاوز تصميم أبو علي تعليمات المخيم التي تمنع السكان

من تشييد المباني، وقد كان المُجسم الطيني الذي بناه شبيهًا بالقلاع الرملية، ولا يتضمن بناؤه أيّ أساسات ثابتة، كما أنه لا يحتوي على نوافير، ولا يُستخدم فيه أي مواد بناء، وليس مساحة مغلقة. وقد كان المجسم بمثابة معلم يزوره السكان والعاملين في المجال الإنساني، ولكنه تعرض للدمار بسبب عوامل الطبيعة. أسهمت قلعة الصحراء التي شُيدت في مخيم الأزرق في إعادة تشكيل صورة الصحراء النمطية، من رمز للعزلة، إلى مكان مجتمعي ووسيلة للتعبير الثقافي.

1:150

01

Azraq basin soil survey
مسح تربة حوض الأزرق

Limestone
حجر الكلس

Chalk Marl
الحجر الطباشيري

↑ 1: 50,000

02

03

Al Husayniyya Al Janubiyya
(Jurf Ad Darawish), map
sheet No. 3151 II, National
Geological Mapping Project,
Nat. Res. Auth., Geol. Dir.,
Geol. map. Div., Amman

الحسينية الجنوبية (جرف الدراويش)،
خارطة رقم 3151 II، مشروع
رسم الخرائط الجيولوجية الوطنية،
سلطة المصادر الطبيعية في
مديرية الجيولوجيا/قسم المسح
الجيولوجي، عقان

04

Arch mold
مجسم قوس

The Arch of Triumph in Palmyra
قوس النصر في تدمر

Worldmakers

Abo Mohammad
Al-Homsi

Strong coffee. No Sugar. As the host of the *Majlis*, Abo Mohammad transfers the habits of Syrian life to the future generations currently living at the camp. He, himself, learned the rituals of coffee from his late father, who in turn learned the traditional ways of the *Majlis* from his own father. "The tools I used to prepare coffee in Syria were passed on for three generations. The copper pot is around 130 years old, and I took care of it to pass it on," he says. Abo Mohammad had to leave his precious tools behind when he fled from war, but what he is still able to articulate is the essence of his heritage: hospitality and generosity.

As the eldest in the neighborhood, the gatherings take place at this house and the setup needs to always be ready for hosting. "It's a symbol of Arab hospitality. Whenever anyone passes by, everything needs to be ready to entertain the company. And when my guests tell me they like my coffee pots and tools, I offer them as gifts."

The *Majlis* is usually an informal affair, where people just walk in. It is a way to check on people. Who's doing what, everyone's health, families, and so on. In cases where invitations are sent for special occasions, Abo Mohammad insists that the first to be invited are the neighbors. Even before family members. "The close neighbor is better than the far blood relative," he says. Even if, at the time of the invitation, he was not on good terms with his neighbors, he would find ways to resolve the dispute and host them.

Besides being spontaneous forms of social conflict resolution, Abo Mohammad says something beautiful to describe the role of the *Majlis*: "Al Majalis Madaris," or "The *Majlis* [gatherings] are schools." These gatherings break the isolation of people in general—and specifically when they live in a place such as the camp—by engaging them in open and informal conversations. Abo Mohammad explains that when people from different age groups and backgrounds meet, they learn from each other's life experiences, and stop being alone. The topics of his *Majlis* range from nostalgias to current social issues, but he explains that it is a flexible format that changes drastically depending on the people attending. Even with the lack of official educational channels around, the young listen to the old, and have the chance to absorb their life experiences and stories. It is an open forum where one can learn from a conversation, a poem, a story.

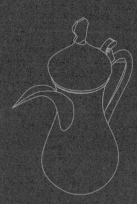

صنّاع العالم

أبو محمد الحمصي

تمتاز قهوة أبي محمد بنكهتها الغنية والقوية، وعدم احتوائها السكر. نقل أبو محمد من خلال ممارسته لعادات حسن الضيافة في المجلس، التقاليد السورية إلى الأجيال الجديدة التي تعيش في المخيم، وكان قد تعلم عادات المجلس وإعداد القهوة بالطريقة التقليدية من والده الراحل، ويقول عن ذلك: «ورثت الأدوات التي كنت أستخدمها لإعداد القهوة في سوريا عن ثلاثة أجيال، ويبلغ عمر القدر النحاسي المستخدم في تحضيرها حوالي 130 سنة، وقد احتفظت به حتى يرثه الجيل الذي يأتي بعدي». اضطر أبو محمد لترك أدواته الثمينة عندما غادر وطنه بسبب ظروف الحرب، ولكنه ما زال قادرًا على التعبير عن جوهر تراثه الأصيل وكرم الضيافة والعطاء.

يُعتبر أبو محمد الأكبر سنًا في الحي، وتُقام التجمعات في منزله، مما يتطلب أن يكون كل شيء معدًا مسبقًا وجاهزًا على الدوام لاستقبال الضيوف. ويقول أبو محمد عن ذلك: «هذا رمزٌ للضيافة العربية، ويجب أن يكون كل شيء جاهزًا، استعدادًا لاستضافة أي شخص. عندما يُعبر ضيوفي عن إعجابهم بركاوي القهوة وأقداحها، أعرضها عليهم كهدايا».

لا تُعقد الاجتماعات الرسمية في المجلس، فهو مكان غير رسمي بطبيعته، ويرتادهُ الناس للاطمئنان على بعضهم وعلى صحتهم، وتداول آخر الأخبار والمجريات. وعندما تُقام المناسبات الخاصة في المكان، يصر أبو محمد على توجيه الدعوة للجيران قبل الأقارب، ويقول: «الجار القريب أفضل من القريب البعيد»، أما إذا تخلف أحد الجيران عن الحضور بسبب خلاف ما، فإن أبو محمد يجد طريقة لحل الخلاف ويصر على استضافتهم.

للمجالس دور عفوي في حل الخلافات الاجتماعية، لذلك يصفها أبو محمد بشكل جميل قائلا: «المجالس مدارس». تكسر التجمعات التي تجري في المجالس العزلة التي يعيشها الناس، وخاصة في ظل ظروف الحياة في المخيم، كما تساعدهم المجالس على الانخراط في الأحاديث والحوارات المفتوحة وغير الرسمية. ويفسر أبو محمد تلك المقولة عن المجالس بأنه عندما يلتقي أشخاصٌ من مختلف الفئات العمرية والخلفيات الاجتماعية، فإنهم يتعلمون من تجارب بعضهم البعض في الحياة، ويكسرون حواجز الوحدة والعزلة. يجري تداول العديد من المواضيع في مجلس أبي محمد، ومنها الحنين إلى الماضي، وغيرها من القضايا الاجتماعية الراهنة. يضيف أبو محمد كذلك، آراءه حول طبيعة المجالس المرنة، وتغيرها بشكل كبير بحسب طبيعة الأشخاص الحاضرين، يفتقر المكان إلى وجود قنوات تعليمية رسمية، ولكن الشباب يستمعون فيه إلى كبار السن، مما يتيح لهم الفرصة للتعلم والاستفادة من تجاربهم وقصصهم في الحياة. المجالس دعوة مفتوحة، يمكن للفرد فيها التعلم من الأحاديث التي تجري، أو من قصيدة تُلقى، أو قصة تُحكى.

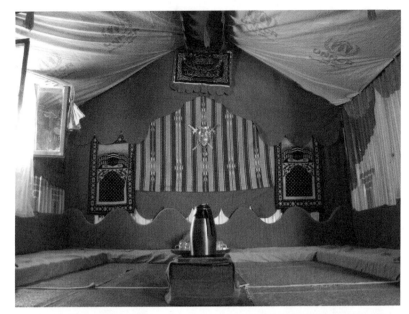

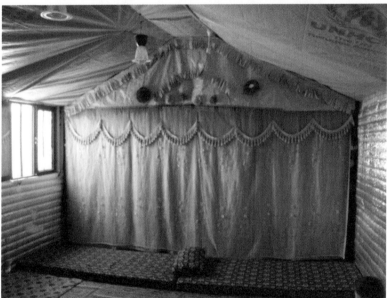

Photo: Zeid Madi, Nabil Sayfayn, and the *Azraq Journal* team, July 2017.
Drawings: Noora Aljabi, Andrea Baena, Jaya Eyzaguirre.

الصورة: زيد ماضي ونبيل سيفين وفريق مجلة مخيم الأزرق، تموز 2017.
الرسومات: نورا الجابي وأندريا بينا وجايا آيزاجوير.

Majlis

Formal public spaces for the community outside the boundaries of NGO structures are prohibited.[1] In these circumstances, the *Majlis* tradition contributes as an informal means for community gatherings led by refugees themselves. One can find a *Majlis* both as the living area of a household and as shared spaces for the community in specialized shelters. The carefully ornamented interior highlights their significance in the social life of the camp. A typical composition includes U-shaped low seating, an upholstered ceiling, symmetrical wall tapestries, and a central area for the preparation and serving of coffee. The featured *Majlis* designs add an aesthetic and cultural value to the function of Core Relief Items (CRI), especially humanitarian fabrics like plastic sheets, tarpaulins, and the thermal blanket.

[1] Malek Abdin, CARE Program Manager at the Azraq camp, conversation with editors, January 2018.

01 Plastic sheet (CRI)
غطاء بلاستيكي
(من مواد الإغاثة الأساسية)

02 Thermal blanket (CRI)
بطانية حرارية
(من مواد الإغاثة الأساسية)

03 Foam mattress (CRI)
فراش اسفنجي
(من مواد الإغاثة الأساسية)

04 Prayer rug
سجادة صلاة

182 ❯ ❮ 143

المجلس

يتم تنظيم الأماكن العامة خارج الحدود التي تفرضها المنظمات غير الحكومية[1]، فتصبح المجالس التقليدية مكانًا يعقد فيها اللاجئون الاجتماعات غير الرسمية. تتخذ هذه المجالس شكلين، إما كمناطق معيشة خاصة داخل المنزل، أو كمساحات مشتركة للمجتمع في الملاجئ المخصصة لهذه الغاية. يعكس التصميم الداخلي المزخرف للمكان أهميته في الحياة الاجتماعية في المخيم، كما ويحتوي على فرشات أرضية مصفوفة على شكل حرف U،

وسقف مُنجد، ومساند للظهر، ومنطقة خاصة لإعداد وتقديم القهوة. يضيف تصميم المجلس الذي يظهر في الصورة قيمة جمالية وثقافية لمواد الإغاثة الأساسية، وخاصة الأقمشة، مثل الأغطية البلاستيكية والقماش المشمّع والبطانيات الحرارية.

[1] مدير برنامج كير للإغاثة CARE، مخيم الأزرق للاجئين، مالك عابدين، حوار مع مؤلف الكتاب، كانون الثاني 2018.

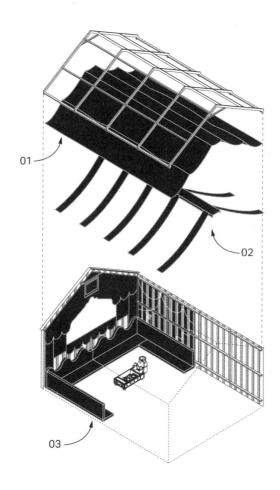

01

02

03

1:150

Symmetrical textile arrangement تنسيق المنسوجات المتماثلة

Painted mural, ancient ruins جدارية مرسومة، آثار قديمة

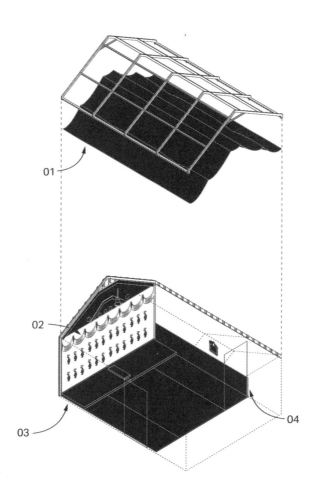

01

02

03

04

1:150

Living room to bedroom configuration
شكل غرفة المعيشة إلى غرفة النوم

Story قصة

Students Are Not From Another Planet

Samer Al-Naser

In this text, Samer, a displaced Syrian teacher at the camp writes about outdated models of teaching, and the need for a participatory and conversational approach to education by using an example of a *Majlis* where one person dominates the conversation: "Our students are the same," he insists. "They are not from another planet." Samer adds that the lecturing way of teaching is one of the past. Today's students need to express themselves, and feel heard. He then offers some musings on life. He explains that tolerance is key to coherent communities: "If you judge people right away, you will lose all your friends"; and that intelligence magnifies the senses, so life's smallest details become magnified. "Be careful what you wish for," he adds. Finally, on our relationship with power, he notes that "we think using force is a positive form of expression, while neglecting knowledge and conversation as more valid means of making better change."

الطلاب ليسوا من كوكب آخر

سمير الناصر

هذا النص من تأليف معلم سوري نازح يعيش في المخيم ويُدعى سمير، يحكي فيه عن أساليب التدريس التي عفا عليها الزمن، وعن الحاجة لوجود نهج تشاركي في التعليم يعتمد على الحوار. يذكر سمير المجلس الذي يهيمن فيه شخص واحد على الحديث كمثال، ويقول «الأمر سيّان للتلاميذ، فهم مثلنا، من كوكب الأرض ومن جنس البشر، وليسوا من كوكبٍ آخر.» يؤكد سمير على أنّ التلقين طريقة قديمة في التدريس، فطلاب اليوم يحتاجون للتعبير عن أنفسهم. كما يُضمّن سمير نصهُ المكتوب ببعض التأملات الحياتية، فيوضح، أنّ التسامح هو أساس تماسك المجتمعات... ويضيف «إذا حكمت على صديقٍ لك من ردة فعله السلبية الأولى، فإنك حتمًا ستخسر معظم الناس الذين تعرفهم.»، ويكتب أيضًا «أنّ الذكاء يُنمي الحواس، ويضخم أصغر تفاصيل الحياة». وأخيرًا، يُعلق سمير على موضوع علاقتنا بالقوة، ويقول «نؤمن بالقوة واستخدامها كوسيلة للتعبير الإيجابي، بدل ايماننا بالمعرفة والتنوير كوسائل أكثر صحة لإحداث التغيير نحو الأفضل».

A blessed morning to you all!
12:15

These are three short new pieces of writings
12:18

Muteeb
Forwarded

Muteeb
Written by my colleague

Samer Al-Naser
12:19

Azra Aksamija
Wow, amazing!
12:19

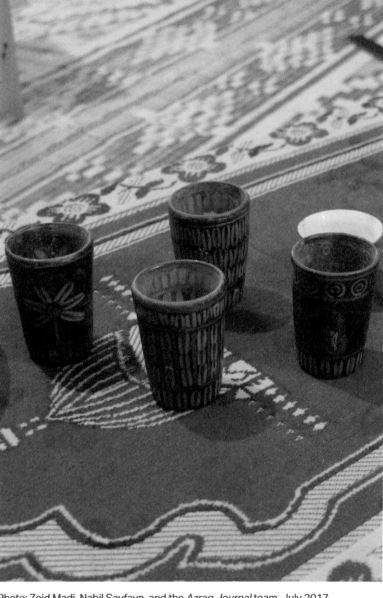

Photo: Zeid Madi, Nabil Sayfayn, and the *Azraq Journal* team, July 2017.
Drawings: Stratton Coffman, Calvin Zhong.

الصورة: زيد ماضي ونبيل سيفين وفريق مجلة مخيم الأزرق، تموز 2017.
الرسومات: ستراتون كوفمان وكالفين تشونغ.

Tea Set

Dates are a staple in Syrian cuisine. Date products, like date molasses, result in an abundance of disposed seeds. Abo Jar upcycles the seeds into graphic mosaics. His geometric patterns and shapes transform Core Relief Items and food packaging into personalized homeware.

طقم الشاي

تعتبر التمور إحدى المكونات الأساسية في المطبخ السوري، وتستخدم في تصنيع عدة منتجات ومنها دبس التمر. غالبًا ما تُخلّف هذه الأطباق والمنتجات كمّيات كبيرة من نواة التمر، التي يُعيد أبو جار استخدامها في الفسيفساء. يحول أبو جار مواد الإغاثة الأساسية وتغليفات المواد الغذائية من خلال الأنماط والأشكال الهندسية التي يضيفها إلى تصاميم منزلية متميزة.

01 Teacup
كوب شاي

Date seed pit
نواة التمر

02

03 Black adhesive
(glue and ground coffee)
مادة سوداء لاصقة
(مصنوعة من الغراء والقهوة
المطحونة)

04 White adhesive
(glue and condensed milk)
مادة بيضاء لاصقة
(مصنوعة من الغراء والحليب
المكثف)

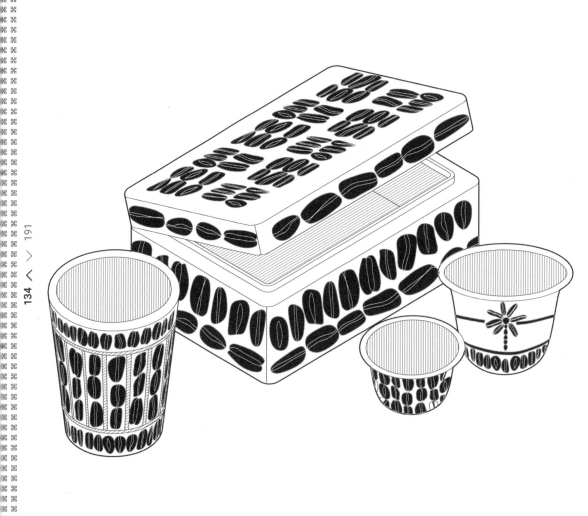

1:2

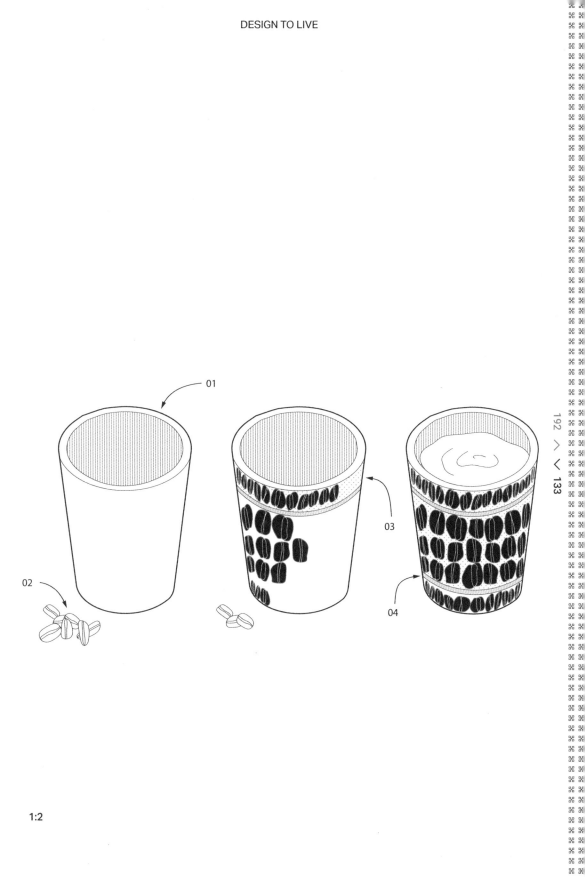

1:2

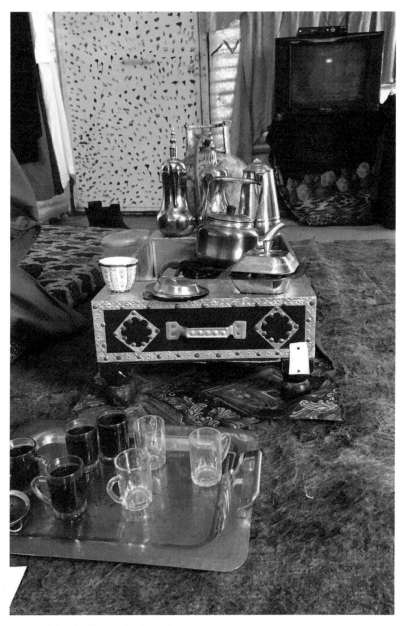

Photo: Melina Philippou, April 2019.
Drawings: Stratton Coffman, Calvin Zhong.

الصورة: ميلينا فيليبو، نيسان 2019.
الرسومات: ستراتون كوفمان وكالفين تشونغ.

Coffee Station

Coffee and Tea are rituals of everyday life and a big part of the *Majlis* hospitality at the camp. The small appliance in this image is representative of a widespread design for the preparation of warm beverages. The device has two stoves, a raised platform for serving, hooks for the storage of the relevant utensils, and handles for portability. Abo Mohammad made the initial design with metal scraps and corner flashings from the T-Shelter. The second iteration is larger, wooden, and embellished with metal decorations he handcrafted himself.

01	Prefabricated wooden legs
	أرجل خشبية مسبقة الصنع

02	Corner flashing
	زوايا معدنية

03	Gas-powered stove (CRI)
	موقد يعمل على الغاز
	(من مواد الإغاثة الأساسية)

محطة إعداد القهوة

يُعتبر تقديم القهوة من العادات اليومية التي تحتل مكانة كبيرة في الضيافة في المجالس، وتُظهر الأداة في الصورة تصميمًا منتشرًا في المخيم، يُستخدم لتحضير المشروبات الساخنة، ويتكون من موقدي نار، ومنصة مرتفعة للتقديم، وخطافات لتعليق الأدوات، ومقابض لحمل الأدوات بسهولة. استخدم أبو محمد في صناعة التصميم الأولي صفائح معدنية وزوايا معدنية من قطع الملاجئ الانتقالية. أما التصميم الثاني، فقد كان حجمه أكبر، وصُنع من الخشب، وزُيّن بالزخارف المعدنية اليدوية.

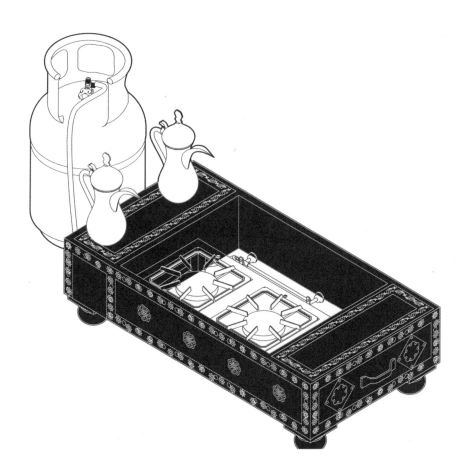

1:10

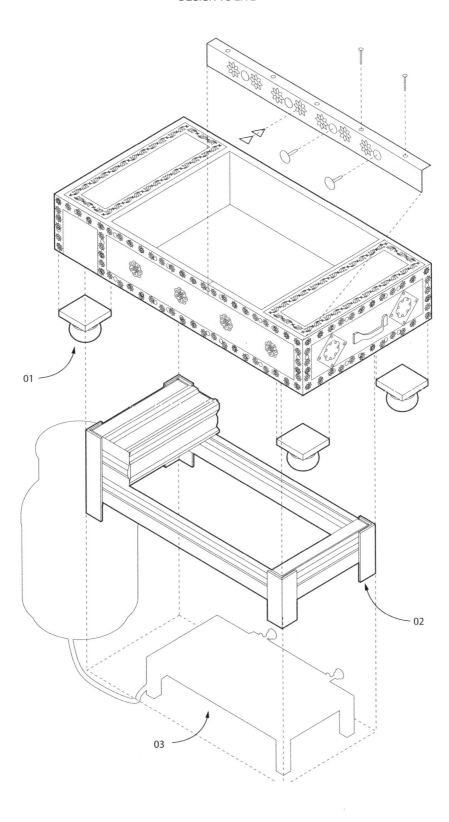

01

02

03

1:10

التصميم للحياة

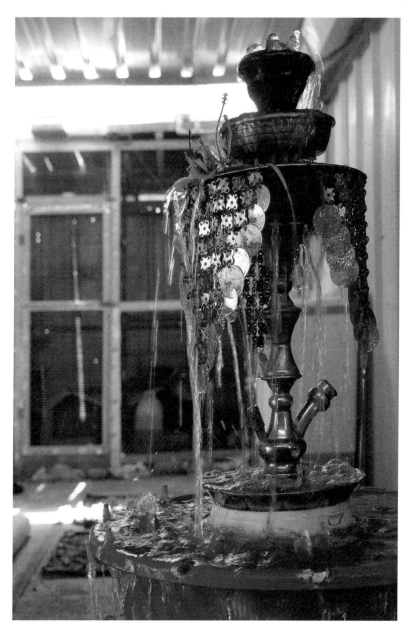

Photo: Zeid Madi, Nabil Sayfayn, and the *Azraq Journal* team, July 2017.
Drawings: Jaya Eyzaguirre, Melina Philippou.

الصورة: زيد ماضي ونبيل سيفين وفريق مجلة مخيم الأزرق، تموز 2017.
الرسومات: جايا آيزاجوير وميلينا فيلبو.

Fountain

The fountain is a traditional feature of the Arab house and the Syrian courtyard. One observes multiple types across the camp, from large concrete fountains in open spaces to makeshift indoor iterations. The portable fountain featured here improves the temperature and humidity of the shelter during the summer and turns back into a shisha and a set of buckets during winter. The reversibility of the device is an intelligent concession to resource scarcity at the camp.

النافورة

تُعتبر النافورة واحدة من السمات التقليدية الأساسية في البيت العربي والفناء السوري، ويوجد العديد من تصاميم النوافير ذات الأشكال المختلفة في المخيم، ومنها النوافير الاسمنتية في المساحات المفتوحة، والنماذج التي صممت من أدوات معاد تكرارها في المساحات الداخلية. تساعد النافورة المحمولة التي تظهر في الصورة على تحسين درجة الحرارة والرطوبة في الملجأ خلال فصل الصيف، ويتكون تركيبها من أجزاء شيشة ومجموعة من الدلاء، ويمكن فك الأجزاء وإعادة تركيبها واستخدامها، كما وتعد فكرة هذا التصميم استجابة لندرة الموارد في المخيم.

| 01 | Shisha body
هيكل الشيشة |
| 02 | Yogurt container
علب اللبن |

03	Motor محرك
04	Hose خرطوم
05	Bucket set طقم دلاء

198 > < 127

1:10

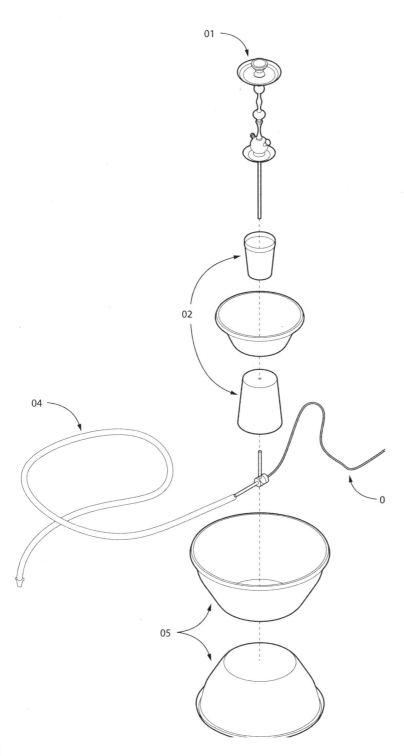

01

02

04

0

05

1:10

التصميم للحياة

Fello

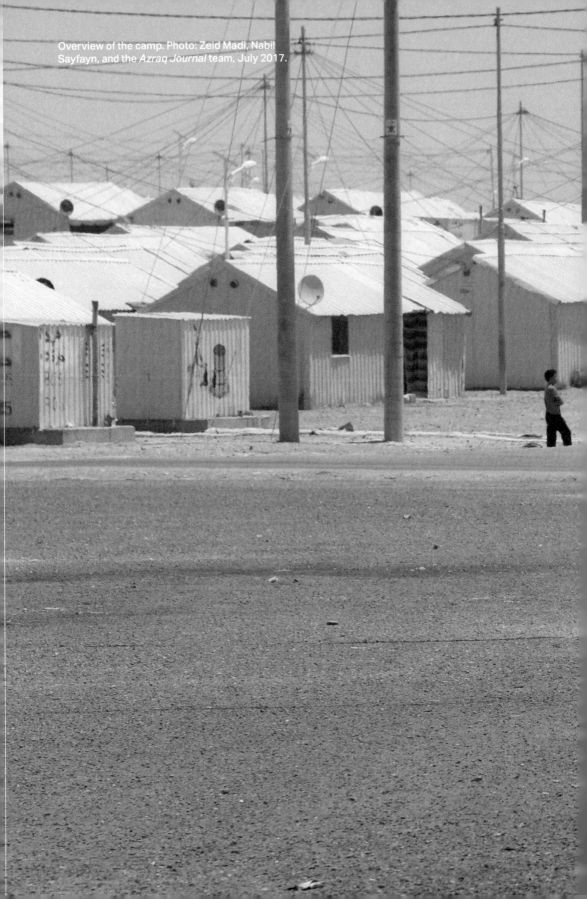

Overview of the camp. Photo: Zeid Madi, Nabil Sayfayn, and the *Azraq Journal* team, July 2017.

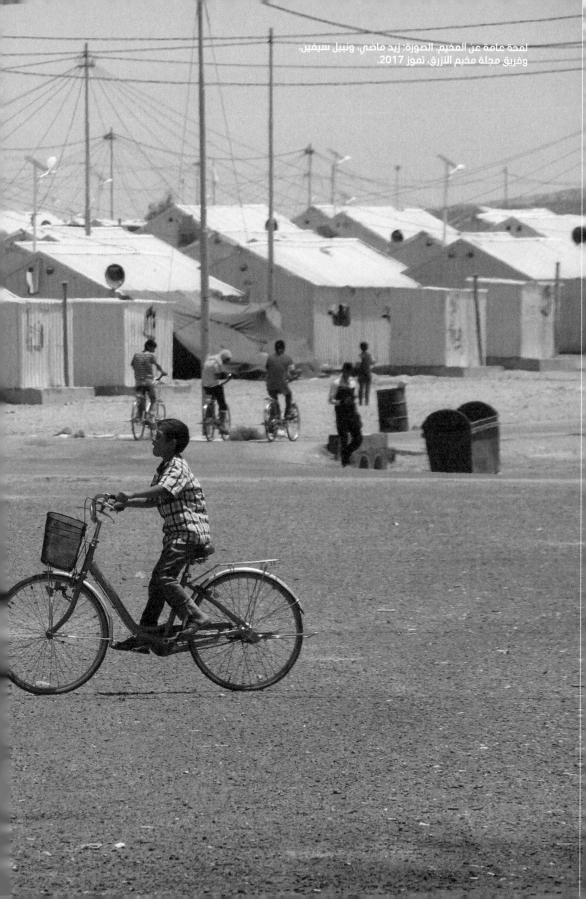

لمحة عامة عن المخيم. الصورة: زيد ماضي، ونبيل سيفين،
وفريق مجلة مخيم الأزرق، تموز 2017.

TIBRIAS LAKE

Irbid

Salt Zarqa
 Amman Azraq Basin

DEAD SEA

DEAD SEA Karak

Ma'an

Aqaba

0 25 50 100 150 Kilometers

التمديدات

أحلم بأن أنهي دراستي وأصبح
مهندساً لكي حينها أعود إلى بلدي
وأقوم بنشر ثقافات بلدي
ورسم أثنا الجميل لكي أقوم بإحياء
بلدي من جديد.

dream of

حلم ان اذهب البلاد لا انضف والا
دمار ولا الكره وان اصبح مهندس

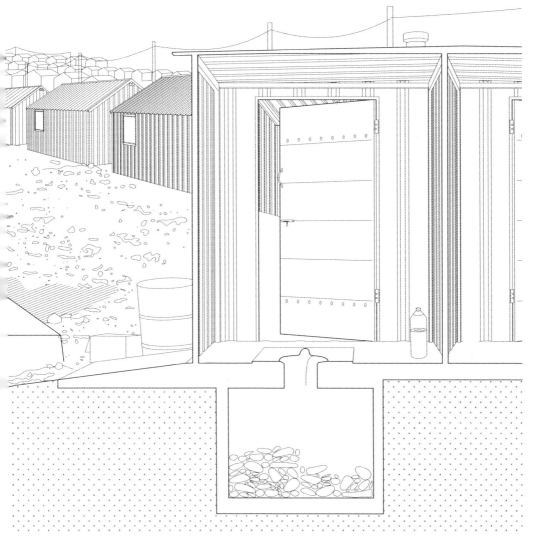

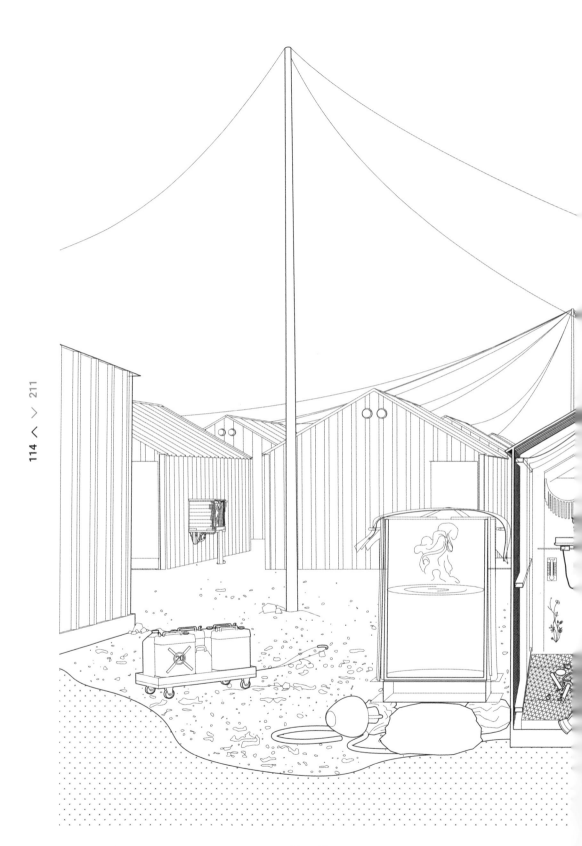

Home is....
always changing,
it is wherever I take my
heart
and find the ones I love

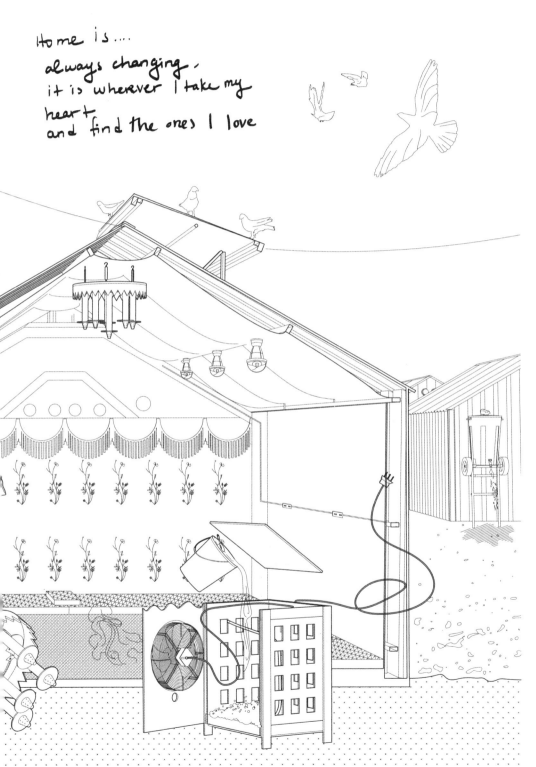

Designs That Enable Access to Resources

Rarely when one walks in a city do they consider the invisible forces that make it work. The Azraq camp, built at the stony plains of Jordan's Eastern Desert, stands disconnected from the rest of the world. The barren landscape around the camp extends to the horizon, stripped of any signs of human infrastructure. Two years into the operation of the camp, the only source of electricity for residents were solar lanterns. Eventually, a small part of the camp was connected to the local grid, and then to a solar farm—a first for a refugee camp. As Azraq transitioned to a domestic grid, residents celebrated with complex designs for home appliances, cooling devices, and light fixtures. In regard to water, the camp relies on the underlying aquifer. Residents collect their limited share of water from the closest public tap stand. They have to carry the water back home on foot through the heat, occasional floods, and sandstorms. This would not be possible without a handcart, one of the earliest and most popular designs of residents at the camp. As a matter of fact, the Norwegian Refugee Council incorporated handcarts as the final project of its welding vocational program on site. This is evidence that refugee designs at Azraq not only fill the gap within infrastructure planning schemes, but also feed back into evolving camp services on a systemic level.

<div dir="rtl">

تصاميمٌ تمكّن الوصول إلى مصادر الطاقة

من النادر أن يفكر المرء في القوى غير الملموسة التي تَمد المدنَ بالطاقة وتجعلها أماكن حيوية. تم بناء مخيم الأزرق للاجئَين في منطقة السهول الحجرية في الصحراء الأردنية الشرقية، في معزلٍ عن بقية العالم. تمتد المناظر الطبيعية القاحلة حول المُخيم حتى الأفق، ولا يظهر سوى آفاق مجردة من المناطق المأهولة بالسكان. بعد عامين على افتتاح المخيم، كانت المصابيح الشمسية المصدر الوحيد للإنارة في الملاجئ، وبعد أن تمّ ربط المخيم بشبكة كهربائية محلية، قام سكانُه بتنفيذ تصاميم مركبة لتغطي احتياجاتهم من الأجهزة المنزلية وأجهزة التبريد وتركيبات الإضاءة. أما فيما يتعلق بالمياه، فيعتمد المخيم على المياه الجوفية، ويحصل اللاجئون على حصصهم المحدودة من المياه من أقرب صنبور عام، ليحملوها إلى منازلهم سيرًا على الأقدام، وتحت أشعة الشمس الحارقة، وأثناء الفيضانات والعواصف الرملية. لم يكن لنقل المياه بهذه الطريقة أن يكون ممكنًا من دون العربة اليدوية، التي تم تصميمها في المخيم، وهي واحدة من أشهر الأدوات المُستخدمة فيه. أدرج المجلس النرويجي للاجئَين (NRC) لهذا السبب تصميم العربات كمشروع نهائي في برنامج المعادن المُعتمد الذي يتبناه المجلس، وهذا ما يدل على أنّ تصميمات اللاجئَين في مخيم الأزرق لا تغطي الثغرات الموجودة في مخططات البُنى التحتية فحسب؛ بل أنها تخلق أيضًا وسائل لتطوير خدمات المخيم على المستوى التنظيمي.

</div>

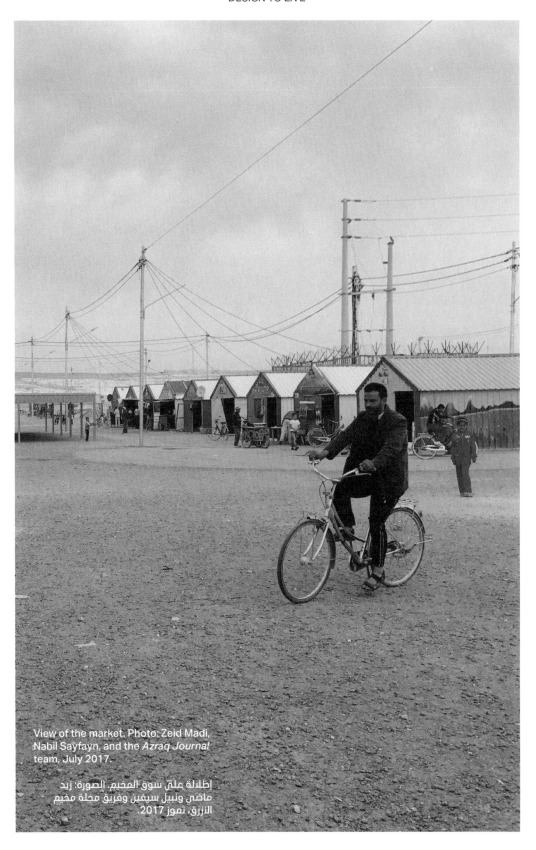

View of the market. Photo: Zeid Madi,
Nabil Sayfayn, and the *Azraq Journal*
team, July 2017.

إطلالة على سوق المخيم. الصورة: زيد
ماضي ونبيل سيفين وفريق مجلة مخيم
الازرق، تموز 2017

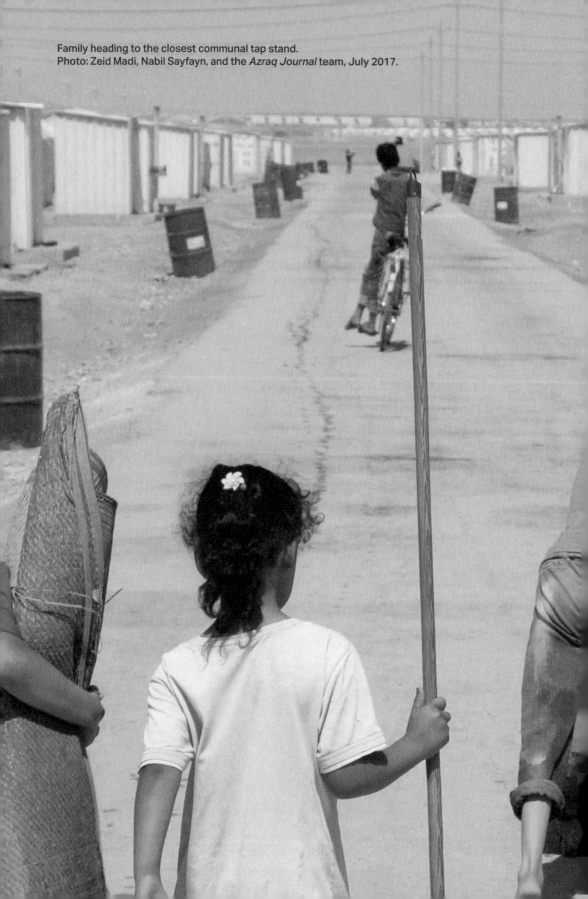

Family heading to the closest communal tap stand.
Photo: Zeid Madi, Nabil Sayfayn, and the *Azraq Journal* team, July 2017.

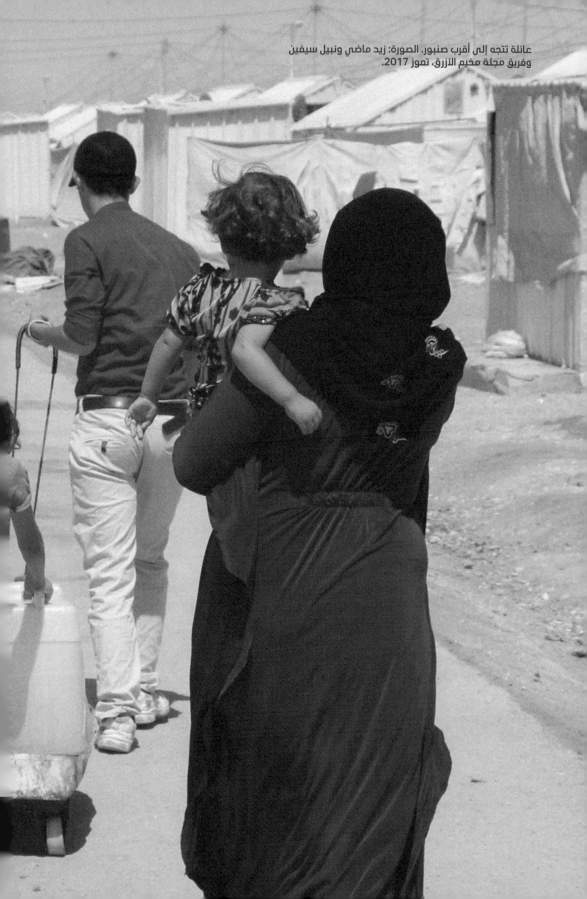

عائلة تتجه إلى أقرب صنبور. الصورة: زيد ماضي ونبيل سيفين
وفريق مجلة مخيم الأزرق، تموز 2017.

Energy
التمديدات

Designs adapting to the infrastructural
deficiencies of the camp.

 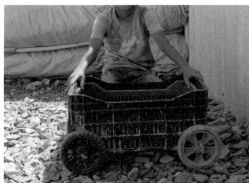

Handcarts to carry water and distribution items

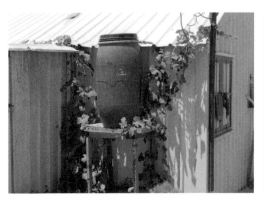 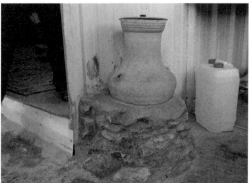

Water storage tanks

تصاميمٌ لمواجهة القصور في
البنية التحتية للمخيم.

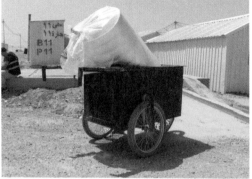

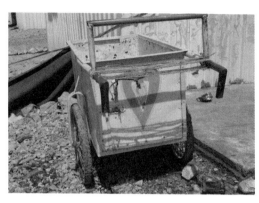

عربات يدوية لحمل المياه والمواد الموزعة على اللاجئين

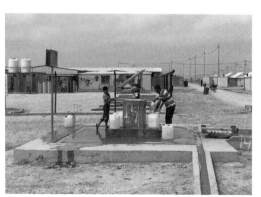

خزانات لحفظ المياه

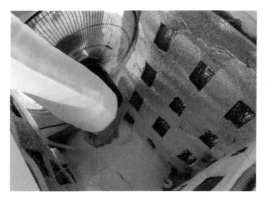 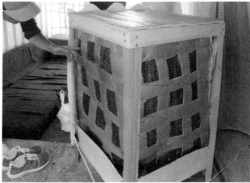

Desert cooler

Photo: Zeid Madi, Nabil Sayfayn, and the
Azraq Journal team, July 2017.

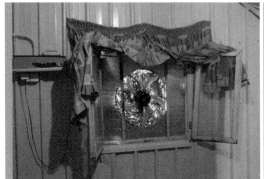

فبرد صحراوي متكامل

الصورة: زيد ماضي ونبيل سيفين وفريق مجلة
مخيم الأزرق، تموز 2017.

التصميم للحياة

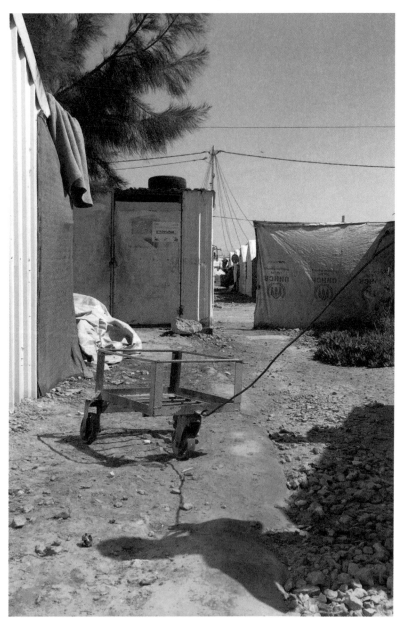

Photo: Zeid Madi, Nabil Sayfayn, and the *Azraq Journal* team, July 2017.
Drawings: Jaya Eyzaguirre, Stella Zhujing Zhang.

الصورة: زيد ماضي ونبيل سيفين وفريق مجلة مخيم الأزرق، تموز 2017.
الرسومات: جايا آيزاجوير وستيلا زوجنغ تشانغ.

Water Cart

Water carts were one of the earliest and most popular designs at the camp. They became indispensable to everyday life to such an extent that they were incorporated as an exercise into the camp's welding curriculum.[1] Ali Fawaz welded an L-section metal frame supported with metal rods. The handle is hooked on the structure and reinforced with a piece of rubber hose for a comfortable grip. Other designers top the metal frame with a basket welded with metal scraps.

[1] The final project of the NRC welding program is a water cart. Dina Ala'eddin, NRC Youth Project Coordinator – Zaatari Refugee Camp, conversation with the editors, April 2019.

عربة الماء

تعتبر عربات نقل المياه من أولى وأشهر التصاميم في المخيم، إذ كان من الصعب الإستغناء عنها، وقد تمت لذلك إضافة فكرة تصميمها إلى برنامج لحام المعادن المقام في المخيم.[1] صمم علي فواز عربة يدوية لنقل المياه، عن طريق لحام إطار معدني بزوايا على شكل حرف ـ L مدعّم بقضبان معدنية، ووصل المقبض بالإطار وأحاطه بقطعة من خرطوم مطاطي من أجل تسهيل الإمساك به. يضيف بعض المصممين كذلك سلة على الإطار المعدني، ويلحمونها بصفائح معدنية في العديد من العربات.

[1] المشروع النهائي لبرنامج اللحام الذي عقدة المجلس النرويجي للاجئين (NRC)، هو صناعة بعربة عربة مياه. دينا علاء الدين، منسق مشروع الشباب في المجلس النرويجي للاجئين - مخيم الزعتري للاجئين، في حوار مع فريق التحرير في نيسان 2019.

01	Water jug (CRI)	قارورة مياه (من مواد الإغاثة الأساسية)

02	Corner flashing	زوايا معدنية

03	Metal scrap	صفائح معدنية
04	Chord	حبل
05	Hose	خرطوم
06	Rebar	حديد التسليح

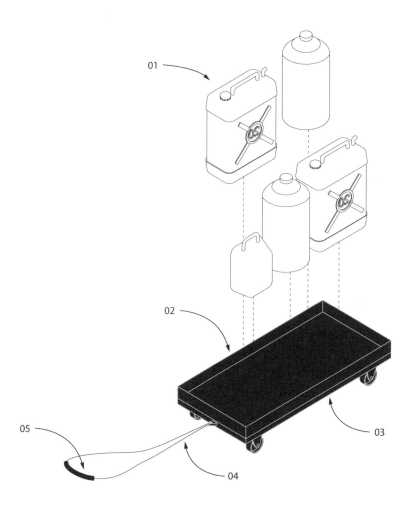

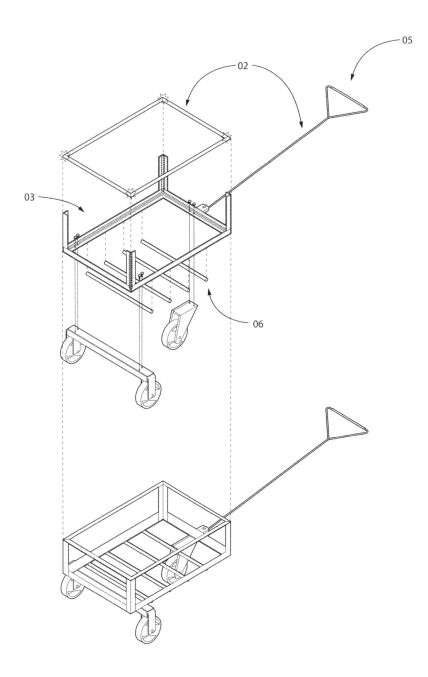

1:20

Photo: Zeid Madi, Nabil Sayfayn, and the *Azraq Journal* team, July 2017.
Drawings: Jaya Eyzaguirre, Stella Zhujing Zhang.

الصورة: زيد ماضي ونبيل سيفين وفريق مجلة مخيم الأزرق، تموز 2017.
الرسومات: جايا آيزاجوير وستيلا زوجنغ تشانغ.

Water Storage

In the absence of a domestic water net-work, residents store their share locally. Water storage tanks serve as the house-hold's primary source of water. Residents place the tanks on platforms to create water pressure similar to a pump. The water container pictured here stands on a window frame over large rocks. The tank is covered with thermal blankets and tarpaulins that residents periodically wet. The elevation from the ground and cooling effect of evaporation keeps the water cool during the summer months.

خزان المياه

يفتقر المخيم لوجود شبكة مياه محلية، وهذا ما يدفع السكان لتخزين حصصهم من الماء. تمثل خزانات المياه المصدر الرئيسي للمياه في المنازل، ويضع سكان المخيم الخزانات على منصات مرتفعة لتوليد ضغط مياه شبيه بالمضخة. تمّ وضع خزان الماء الظاهر في الصورة على إطار نافذة فوق صخور كبيرة، وقد غطاه السكان بالبطانيات والأغطية الحرارية التي يرطبونها بالماء بشكل دوري. يحافظ الماء داخل الخزان على برودته خلال فصل الصيف بسبب ارتفاعه عن الأرض، وبفضل عوامل تبخر الماء.

01	Laundry rope (CRI) حبل غسيل (من مواد الإغاثة الأساسية)

02	Tarpaulin (CRI) قماش مشمع (من مواد الإغاثة الأساسية)

03	Plastic water tank خزان مياه بلاستيكي
04	Hose خرطوم
05	Thermal blanket (CRI) بطانية حرارية (من مواد الإغاثة الأساسية)

06	Windowpane لوح نافذة زجاجي
07	Water jug قارورة مياه

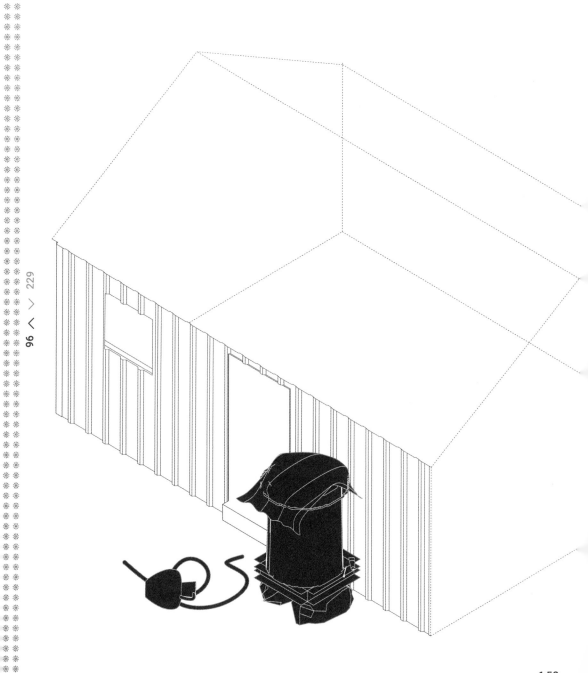

1:50

التمديدات

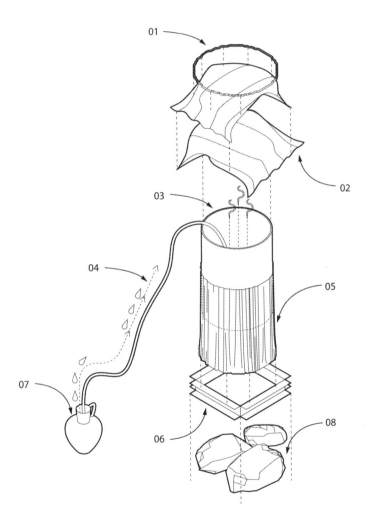

01
02
03
04
05
06
07
08

1:20

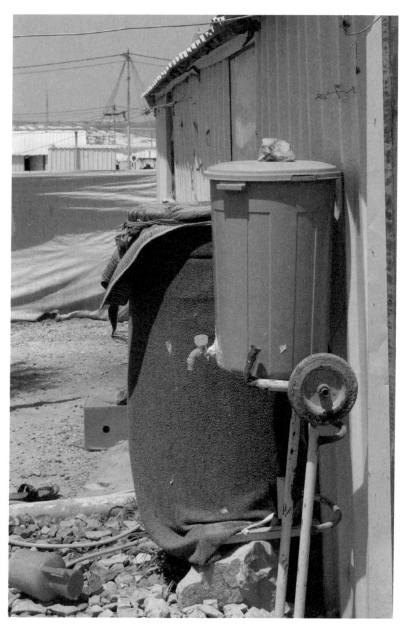

Photo: Zeid Madi, Nabil Sayfayn, and the *Azraq Journal* team, July 2017.
Drawings: Jaya Eyzaguirre, Stella Zhujing Zhang.

الصورة: زيد ماضي ونبيل سيفين وفريق مجلة مخيم الأزرق، تموز 2017.
الرسومات: جايا آيزاجوير وستيلا زوجنغ تشانغ.

Water Faucet

This water faucet responds to the lack of running water on the household level. The container was initially a garbage bin and is raised on a trolley base. The faucet outside the shelter serves the daily ablutions of the household members.

01	Rock
	صخرة

02	Garbage bin
	حاوية (صندوق قمامة)

03	Water valve
	صنبور ماء

04	Handcart base
	قاعدة عربة يدوية

صنبور المياه

يعوض الصنبور نقص مصادر المياه داخل المنازل، ويتصل بحاوية موضوعة على قاعدة متنقلة. وتخدم الصنابير الموجودة خارج الملجئ احتياجات الأسر من سكان المخيم، وتُستخدم يوميًا للوضوء.

1:50

التمديدات

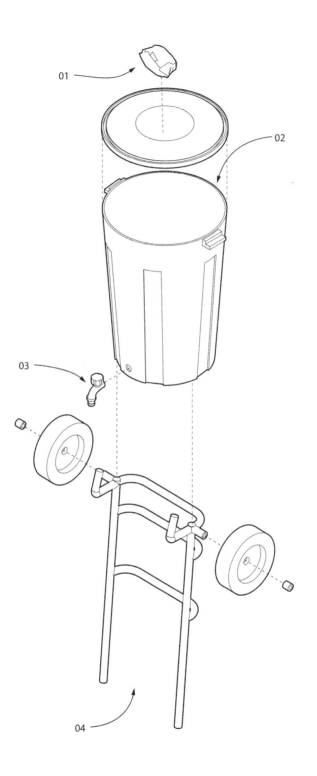

01

02

03

04

1:20

Worldmakers

Majed Shaman Al-Khalifa

Majed breaks his toys to make new, fascinating inventions.
He's a shy, very respectful young man of few words. It takes
a big joke for him to break a small smile, or confess that he
in fact doesn't like school. Sitting together with his father and
younger brothers, he's careful not to say anything wrong: "It's
just boring," he says, "I prefer experimenting and discovering
on my own."

Majed's father interrupts him to highlight that his inven-
tor son made an air conditioner for his mother, who wasn't
feeling well because of the weather, and that he did so from
scratch on his own. But Majed wants to speak about robots
and helicopters. His past inventions aren't of much value to
him, at least not as much as ones he still dreams to create. He
dreams of making robots. It's his ambition. Majed's robots
would be designed to help people do things they don't want to
do, "like dishwashing," he says, to the amusement and laughter
of everyone in the room.

صُنّاع العالم

ماجد شامان الخليفة

قام ماجد بتكسير ألعابه من أجل أن يصنع منها اختراعات جديدة ورائعة. ماجد شاب خجول ومحترم وقليل الكلام، يصعب الحصول على ابتسامة صغيرة منه من دون إلقاء نكتة معتبرة. اعترف ماجد بأنه لا يحب المدرسة، وقد صرح بذلك وهو يجلس مع والده وإخوانه الصغار، وكان حريصًا أن لا يتفوه بشيء خاطئ، فقال: «المدرسة مملة، وأنا أفضل استكشاف الحياة وتجربتها بطريقتي الخاصة».

قاطع أبو ماجد حديث ابنه ليذكر لنا أنّ ماجد المخترع، صنع مكيف هواء لوالدته التي لم تكن حالتها الصحية جيدة بسبب الطقس، وأنه بنى المكيف من الصفر بنفسه. لا تحظى اختراعات ماجد الصغيرة تلك بمكانة كبيرة بالنسبة له، إذ يحلم باختراع أشياء أخرى كالروبوتات والمروحيات. يطمح ماجد لاختراع إنسان آلي، ويأمل أن يساعد تصميمه الناس بالقيام بأمور مضنية مثل غسيل الأطباق. أثار اقتراح ماجد هذا الضحك والدهشة في أنفس جميع من كانوا في الغرفة.

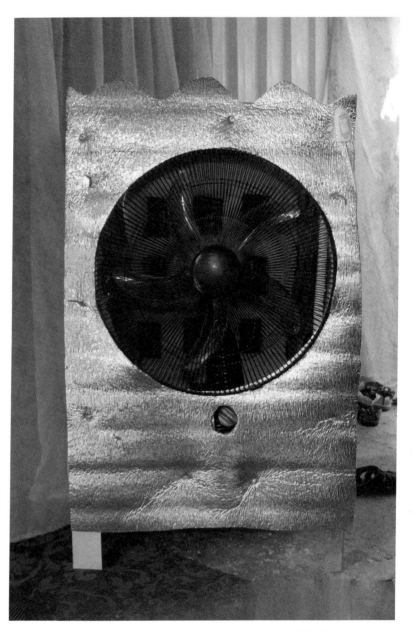

Photo: Zeid Madi, Nabil Sayfayn, and the *Azraq Journal* team, July 2017.
Drawings: Jaya Eyzaguirre, Khan Nguyen.

الصورة: زيد ماضي ونبيل سيفين وفريق مجلة مخيم الأزرق، تموز 2017.
الرسومات: جايا آيزاجوير وخان نوين.

Desert Cooler

Azraq is subject to an arid climate with high temperatures during the summer. With max indoor temperatures at T-shelters reaching 45 degrees C, the desert cooler is a popular makeshift alternative to an air conditioner.[1] It functions based on the cooling effect of evaporation. A typical design consists of a water reservoir, absorbing pads, a pump to infuse the pads with water, and a fan to circulate the fresh air from the device to the shelter. The stand-alone design featured in this image includes a box-like reservoir with a frame of corner flashings from a T-Shelter and pads from the layering of insulation sheets with burlap. Taking into consideration the water scarcity on site, residents often use gray water for the cooling process. There are multiple iterations of the cooler at the camp, including a mechanical version devised before Azraq connected to the grid, coolers attached to shelter openings, and integrated designs.

[1] Daniel Fosas, Dima Albadra, Sukumar Natarajan, and David Coley, "Overheating and Health Risks in Refugee Shelters: Assessment and Relative Importance of Design Parameters," 2017, 1, https://www.researchgate.net/publication/318325101 Overheating_and_health_risks_in_refugee_shelters_assessment_and_relative_importance_of_design_parameters.

| 01 | Metal sheet (IBR) صفيحة IBR المعدنية |

| 02 | Hose خرطوم |

| 03 | Corner flashing زوايا معدنية |

| 04 | Fan مروحة |

| 05 | Foil-faced foam insulation sheet (CRI) لوح قصديري عازل (من مواد الإغاثة الأساسية) |

| 06 | Burlap الخيش |

238 〉 〈 87

المكيف الصحراوي

يطغى المناخ الجاف ودرجات الحرارة المرتفعة على مخيم الأزرق في فصل الصيف، ويُستخدم المبرد التبخيري في الملاجئ، التي قد تصل درجات الحرارة فيها إلى ٤٥ درجة مئوية. ينتشر وجود هذا المبرد في المخيم، ويعد بديلاً عن المكيفات الهوائية . يولد هذا النوع من المكيفات البرودة من خلال عملية تبخر الماء، ويتكون أحد تصاميم المبردات النموذجية من خزان مياه، وقطع من الخيش لامتصاص الماء، ومضخة لنقل المياه إلى الخيش، ومروحة لتوزيع الهواء البارد من الجهاز إلى أرجاء الملجأ. يتكون التصميم الذي يظهر في

الصورة من خزان يشبه الصندوق يحيطه إطار مأخوذ من قطع بناء الملاجئ، وقد أحيط بألواح عازلة وقطع من الخيش. يلجأ السكان، بسبب ندرة المياه في المكان، لاستخدام المياه الرمادية الخارجة من المغاسل والغسالات وأحواض الاستحمام لأغراض التبريد. تنوعت تصاميم المبردات في مخيم الأزرق قبل وصله بالشبكة الكهربائية، فكان منها تصاميم آلية، وتصاميم متصلة بالفتحات في الملاجئ.

[1] دانيال فوساس، ديما البادرا، سوكومار ناتاراجان، وديفيد كولي، "مخاطر ارتفاع درجة الحرارة والمخاطر الصحية في ملجئ اللاجئين: تقييم وبيان الأهمية النسبية لمعايير التصميم"، 2017، 1، /https://www.researchgate.net publication/318325101

التمديدات

Evaporative cooling mechanism آلية التبريد التبخيري

1:10

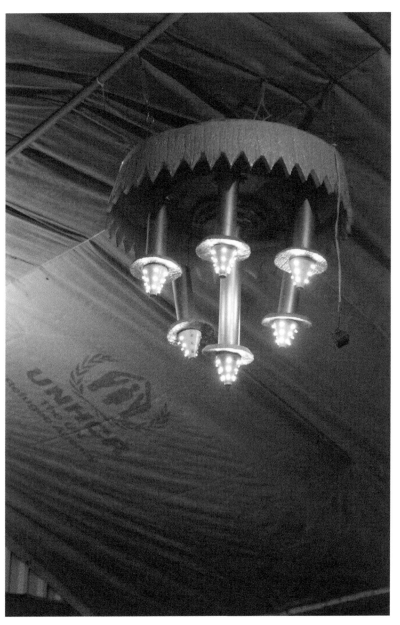

Photo: Zeid Madi, Nabil Sayfayn, and the *Azraq Journal* team, July 2017.
Drawings: Jaya Eyzaguirre, Khan Nguyen.

الصورة: زيد ماضي ونبيل سيفين وفريق مجلة مخيم الأزرق، تموز 2017.
الرسومات: جايا آيزاجوير وخان نوين.

Chandelier

In preparation for winter, camp NGOs distribute materials for the weatherproofing of shelters. Although Jordan is known for a warm climate, the winter season can be harsh, with temperatures reaching below zero. Abo Jar upcycled the remnants and packaging of the materials into an impressive lighting fixture that resembles a chandelier. The foil-faced insulation attached to a food tray serves as a shade. The empty silicone sealant tubes turn into multiple light branches. The body and bulbs of the lamp result from the modification of the solar lantern into an electric ceiling fixture. Every single item of the chandelier is a carefully upcycled Core Relief Item.

الثريا

<div dir="rtl">

تقوم المنظمات غير الحكومية في المخيم، ضمن الاستعدادات لفصل الشتاء، بتوزيع مواد مقاومة للظروف المناخية في الملاجئ، وعلى الرغم من المناخ الدافئ في الأردن، إلا أنّ فصل الشتاء قد يكون قاسيًا، إذ تنخفض درجات الحرارة فيه إلى الصفر المئوي. قام أبو جار بإعادة تدوير بقايا هذه المواد الإغاثية، واستخدمها لصناعة مصباح سقف يشبه الثريا. استخدم أبو جار الألواح العازلة لصنع الغطاء الذي يُوضع فوق المصباح المتدلي من السقف، ووصله بصينية طعام، وصنع فروع الإنارة من أنابيب مانعات التسرب الفارغة المصنوعة من السيليكون. أما هيكل المصباح واللمبات، فقد تم تشكيلها عبر تعديل فانوس يعمل بواسطة الطاقة الشمسية، ومن اللافت أن كل القطع المستخدمة في صناعة هذه الثريا، هي قطع تمت إعادة تدويرها من مواد الإغاثة الأساسية.

</div>

01 Foil-faced foam insulation sheet (CRI)
<div dir="rtl">ألواح عازلة معدنية (من مواد الإغاثة الأساسية)</div>

02 Metal plate (CRI)
<div dir="rtl">صفيحة معدنية (من مواد الإغاثة الأساسية)</div>

03 Silicone sealant tube (CRI)
<div dir="rtl">أنبوب سيليكون مانع للتسرب (من مواد الإغاثة الأساسية)</div>

04 IKEA solar lantern
<div dir="rtl">فانوس الطاقة الشمسية من IKEA</div>

1:2

التمديدات

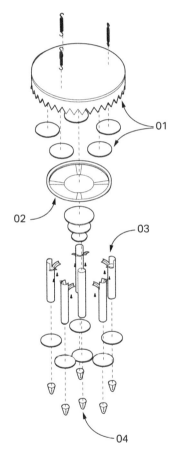

01

02

03

04

1:5

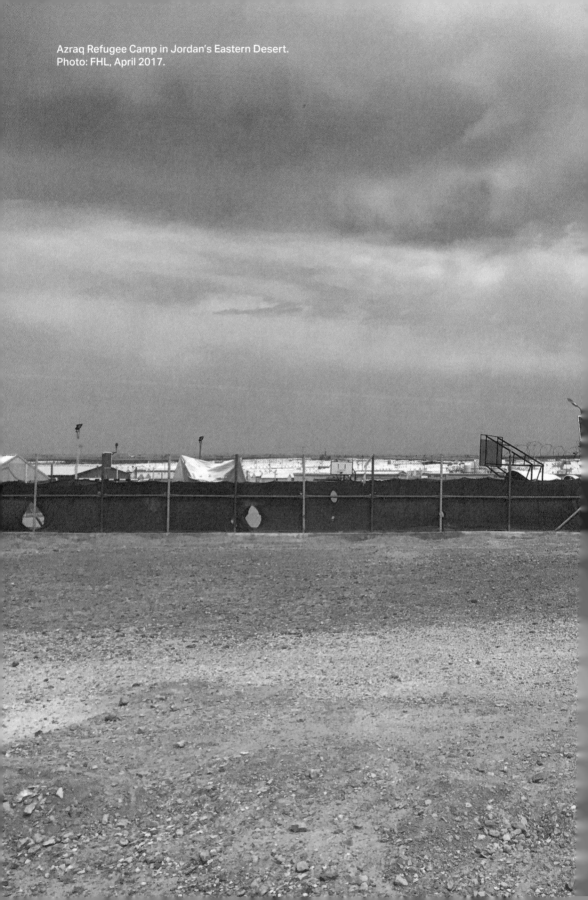

Azraq Refugee Camp in Jordan's Eastern Desert.
Photo: FHL, April 2017.

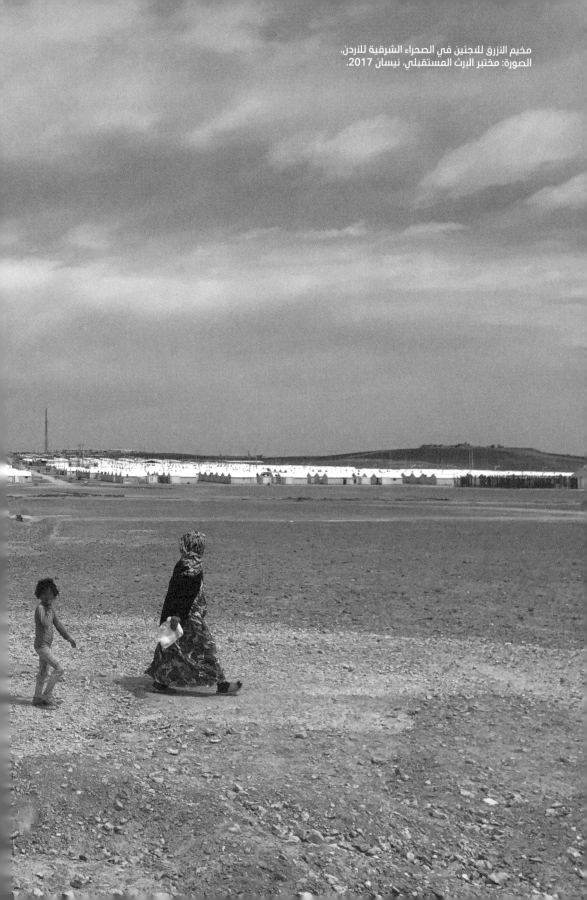

مخيم الازرق للاجئين فى الصحراء الشرقية للأردن.
الصورة: مختبر الإرث المستقبلي، نيسان 2017.

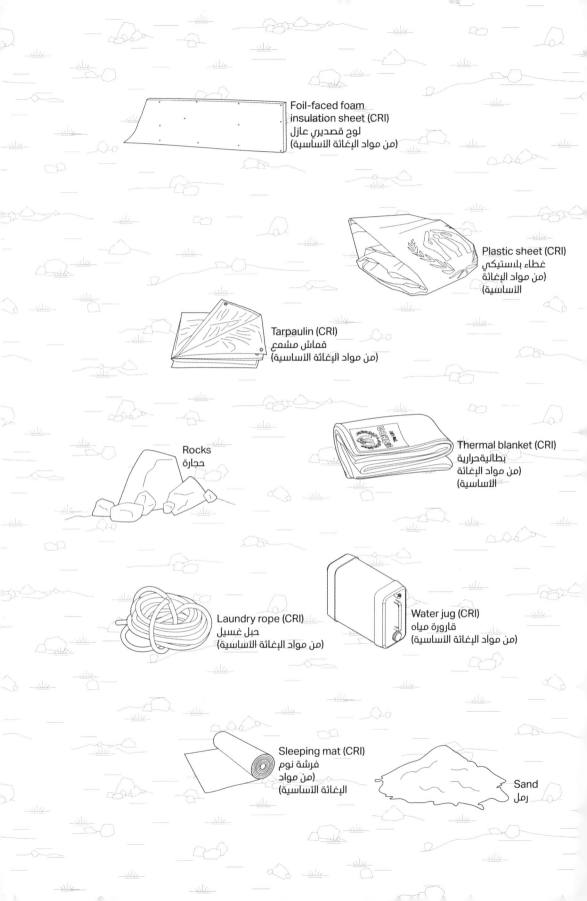

Foil-faced foam
insulation sheet (CRI)
لوح قصديري عازل
(من مواد الإغاثة الأساسية)

Plastic sheet (CRI)
غطاء بلاستيكي
(من مواد الإغاثة
الأساسية)

Tarpaulin (CRI)
قماش مشمع
(من مواد الإغاثة الأساسية)

Rocks
حجارة

Thermal blanket (CRI)
بطانية حرارية
(من مواد الإغاثة
الأساسية)

Laundry rope (CRI)
حبل غسيل
(من مواد الإغاثة الأساسية)

Water jug (CRI)
قارورة مياه
(من مواد الإغاثة الأساسية)

Sleeping mat (CRI)
فرشة نوم
(من مواد
الإغاثة الأساسية)

Sand
رمل

Available Materials

The residents of the Azraq camp identify resources to better their lives and edit their surroundings by maximizing the use of Core Relief Items (CRI) and multiplying their possible functions, recovering materials from the camp's built environment and mining limited resources from the surrounding Eastern Desert.

المواد المتاحة

يستخدم سكان مخيم الأزرق الموارد المتاحة لتحسين حياتهم وتعديل محيطهم، من خلال استخدام عناصر الإغاثة الأساسية بأكثر من طريقة، واستخدام المواد من البيئة التي بني عليها المخيم، والتنقيب عن الموارد المحدودة في الصحراء الأردنية الشرقية.

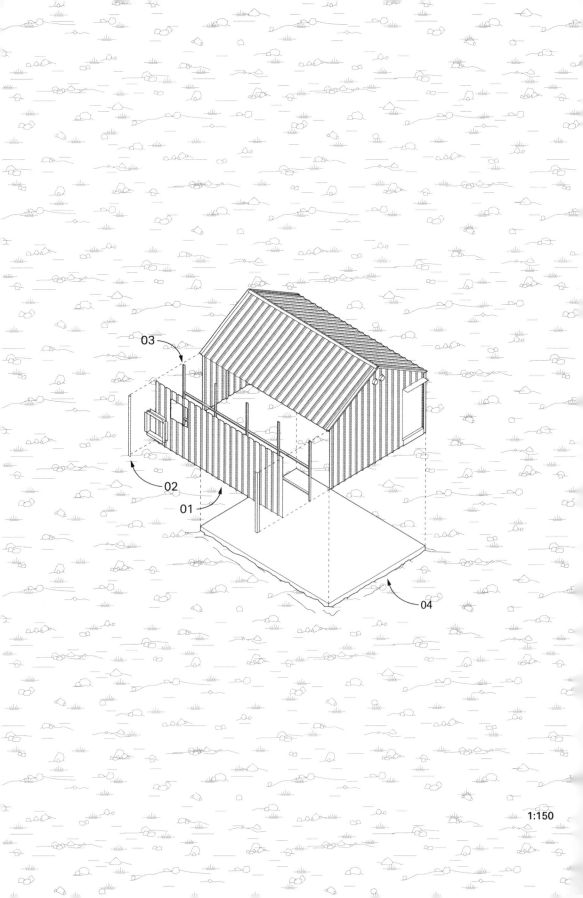

03

02

01

04

1:150

T-shelter

The T-shelter was designed explicitly as the housing unit for the Azraq camp, providing protection against the strong winds, dust, and extreme changes in climate. Each shelter is 24 square meters and usually accommodates a family of four or five people. Approximately 9,000 shelters are currently in use.[1]

[1] Jordan: Azraq Camp Factsheet (July 2020), UNHCR Operational Data Portal (ODP), https://data2.unhcr.org/en/documents/details/78179.

الملاجئ الانتقالية

تم تصميم الملاجئ الانتقالية كوحدات سكنية في مخيم الأزرق للاجئين، وهي توفر الحماية من الرياح القوية والغبار والتقلبات المناخية. تبلغ مساحة المأوى 24 مترًا مربعًا، ويتسع عادةً لعائلة مكونة من 4-5 أشخاص. وهناك حوالي 9000 ملجأ قيد الاستخدام حاليًا.[1]

[1] الأردن: ورقة حقائق حول مخيم الأزرق (تموز 2020)، بوابة البيانات التشغيلية الخاصة بالمفوضية السامية للأمم المتحدة لشؤون اللاجئين (ODP).

01 Metal sheet
صفيحة معدنية

02 Corner flashing
زوايا معدنية

03 Metal column
عمود معدن

04 Reinforced concrete flooring
أرضيات من الخرسانة المسلحة

Life Worth Living

Amani Alshaaban *is a participatory urban development practitioner and the former Secretary-General of Architecture Sans Frontières International.* **Muhsen Albawab** *is the lead architect and CIVIC Project Lead, working on urban interventions in Azraq, both the camp and the town. In 2016, Amani and Muhsen supported participatory action research at the Azraq camp as part of the collaboration between the MIT Future Heritage Lab and the School of Architecture and Built Environment (SABE), German Jordanian University. In conversation with the editors they discuss the significance of the Azraq camp inventions as means of dignity under trying circumstances.*

The interview took place online with participants connecting from Salt and Amman, Jordan, Nicosia, Cyprus, and Boston, Massachusetts on 14 July 2020.

The co-production of space and visual representation of the Azraq camp

Editors: The designs we document in this book tell the story of what is not provided at the camp. This documentation of everyday objects made by the residents of the camp is thus a visual critique. We, as artists and designers, had no stake in these interventions. We simply wanted to be useful through documenting this issue and making it visible to a larger audience as one of the many possible formats of support. As spatial practitioners in Jordan what, in your opinion, is the value of sharing this work?

Amani: A book like this can powerfully convey the value of the co-(re)production of space, storytelling, and collective memory in community mobilization, peacebuilding, and strengthening the social fabric within the camp. The documentation of spaces designed by refugees, such as the *Majlis*, shifts the spotlight from standardized humanitarian design and the rigid structural element of the shelter to spaces that have meaning, tell a story of heritage, and give character to everyday life in the camp. I also find the process of co-producing this book with residents and other stakeholders, as a means of telling stories of the past and present, to be a valuable and important approach.

In the Azraq camp, standardization prevails. This book is a reminder that shelters are homes with people and stories. It represents the human infrastructure of the camp. In my opinion, these small interventions at the camp are examples of the reproduction of spaces within controlled environments. The local customization of rigid infrastructure is where co-production, storytelling, and collective memory merge with the practice of everyday life. The creative work at Azraq brings back bits and pieces of life in Syria to these rigid spaces through art, painting, fabrics, or any other medium. This will never truly bring home to this emergency settlement, but it does preserve traces of the past.

This brings us to the question of what is a home? And what gives us the warm feeling of being at home? The answers are many: sometimes it's the smell of a certain soup;

it's a fabric or a shade on your kitchen window—each individual and collective has different and intimate senses of the definition. However, storytelling, poems, and small tangible interventions present simple and humane attempts at bringing back the intangible senses of home. This is a major aspect of the role of art as a conciliation tool that would makes people's everyday living slightly better, more bearable. As a practitioner and as a person who has been involved with recovery processes and community development, I find significant value in these interventions with respect to shaping everyday life inside the camp.

Lastly, I think it's important to discuss collective memory. Collective, or social, memory brings people together. It creates a sense of solidarity and supports the strengthening of social fabric within the camp. Camps are spaces of exception. A person is reduced to a number on an ID card. In a way, working on reflecting collective memory through spatial transformations and interventions could be foundational for promoting a real sense of cohabitation and thus a better living experience inside the camp.

Muhsen: The visual representation, or depiction, of these interventions in this book humanizes the numerical experience of encampment. In other words, it shows that these numbers you read about in a report or in a paper have faces and living experiences; it shows the reality of refugees as humans rather than numbers. The illustrations transparently reveal the chaotic nature of the camp: it's a multilayered and multifeatured reality composed of memory, present, and future, all colliding. The representations of the camp at the LIFE drawings are not photographic images, but illustrations that one could identify with according to his or her

collective or social memory; yet, at the same time, these illustrations are collages that don't exist in real life. The images find a way to appreciate the chaos that is born out of the camp as a response to the needs of everyday life.

Cultural preservation at the camp

Muhsen: The topic of memory is very sensitive, especially in the camp environment. There, the understanding of what amounts to "heritage" becomes more or less warped, and the relationship between reproducing physical spaces and cultural practices is contentious. My view is that heritage preservation is not about recreating, for example, the exact park where people used to play in Aleppo, but in understanding and facilitating new experiences and games that are based on the qualities of the original.

Editors: The continuation of cultural practices in the camp can be challenging.

Muhsen: Absolutely, I argue that, within the camp, existing is an act of resistance and being yourself is an act of resilience because you're living in an environment where you're constantly being reminded: "this is not yours." When you exist in an environment where your home is a temporary structure that shakes with a strong gust of wind, and you're not allowed to plant anything permanent in the ground to create what might feel like a home, holding onto your home in subtle, even mundane ways is an act of resistance.

Amani: So, in a way, continuing life in the camp, holding onto one's cultural heritage and cultural values, it's a form of resistance. Maybe it's resistance to the format of the camp, resistance to

the dehumanization of the camp and in a bigger sense resistance to forced displacement. I believe that documentation of these forms of resistance is imperative at the level of ethical and humanitarian action.

The ethics of cultural interventions at the camp

Editors: We observe a growing interest among creative practitioners and scholars in the issue of forced displacement. What is your take on the role of art & design in particular in the refugee context?

Amani: The growing interest of the creative community in refugee camps is to be coupled with a discussion around the ethics of engagement, research, and practice in fragile contexts. As designers,

we have a professional responsibility to tell the truth, to enable people, to share their stories, to support their contributions, to foster co-creation. Perhaps our second role as part of the international humanitarian system is to be mediators and find space for maneuvering. To discuss, negotiate, ensure fairness, push for participatory approaches and for the right of people to make decisions for themselves. I think this should be at the core of our practice, to be fighters that enable local communities to be an integral part of the decision-making processes around their living conditions and surroundings.

Muhsen: On the topic of ethics, we must make clear that good intentions are not enough. A major responsibility we have is to assure and ensure the seriousness and proper understanding of the context that

256 〉〈 69

للنقاش والتفاوض والعمل نحو أطر تشاركية عادلة، وحق الناس في تقرير مصيرهم.

To discuss, negotiate, ensure fairness, push for participatory approaches and for the right of people to make decisions for themselves.

we're working within. Working in a refugee camp has many challenges including bureaucracy, uncertainty, and standardization. It is not uncommon for projects to be implemented far from their initial goals and good intentions. But I think if we're discussing the role of art and artists and the ethics that ought to guide actions, we should underline a serious need for them to dedicate themselves to a long journey. At the end of the day, if you do open Pandora's box, you'll have to expect that it's going to pour everything out at you.

Editors: What about reimagining the system? I wonder if a disciplinary contribution of the creative community is to insert a seed of reenvisioning humanitarian design. How do we start thinking about that?

Amani: I really like this point, and I think it goes back to the idea of building an enabling, participatory environment of exchange that works as a fertilizing ground for new ideas.

Creative barriers and accountability

Editors: What would an accountability structure for art & design interventions in the humanitarian sector look like? The process of our disciplinary contribution is not linear; interventions overflow the silos of humanitarian activity categories and our "outputs" are not easily quantifiable, which goes against the existing structures of the humanitarian sector. That said, when trying to align with the existing humanitarian structures, one can deviate from the initial scope of the intervention and

مؤقت، لأن هناك أعدادًا هائلة من الأشخاص الذين ولدوا وماتوا في المخيمات، كما وأنّ الحفاظ على الشكل التقليدي للتفكير في المخيمات يعني وضع اللاجئين في حلقة دائمة من فكرة الآنيّة الزمنية. يكمن جوهر مسؤوليتنا في هنتنا في هذا الأمر تحديدًا في رأيي، وفي تحويل هذه المساحات لتصبح أكثر حيوية، وأكثر استحقاقًا للعيش، بدلاً من أن تكون مجرد أماكن لحياة يغزوها الانتظار المؤقت.

تتمثل العديد من قيم والأسباب في بنية وشكل المخيم بالطبع، وتؤخذ العودة الشرعية والكريمة إلى الوطن في عين الإعتبار كحل مثالي ونموذجي دائم، وتنعكس بشكلٍ واسع في تصميم وبنية وإدارة المخيمات. ومع ذلك، فإن لدورنا كفنانين ومصممين، يتبنون ويدعمون التغيير الجماعي والمحلي للمساحات، تأثير كبير على الحياة داخل المخيم، لجعله مكانًا أفضل وأكثر احتمالاً للعيش.

diminish the power of creative expression. We found that arriving at the camp as outsiders was partly beneficial because it allowed the team to engage with agencies and residents outside the prescribed norms and encouraged a reorientation and adaptation to different ways of doing things.

Muhsen: Art, design, and ethics, are vague and broad concepts and it's tough to bring them together in clear conversation. When you define them in a particular way, you become stuck with the definition, and in a constantly changing and evolving cultural environment like the camp, or Jordan in general, it's all about acknowledging that these concepts are vague in their very essence. Accountability is relative to context. Again, context and setting are vague terms, but it's all about informing and understanding terms that remain vague

without insisting on them being quantifiable. Personally, I'm wary of the modern way of making sentences and the common way of describing experiences. We use these linguistic structures to define what's going on, when what's going on can be understood with the same sentence in a different place completely differently.

Amani: When discussing the issue of accountability in humanitarian interventions, one concern that comes to my mind, as you mentioned, is that the monitoring and evaluation measures are always connected to quantifiable indicators. So when an agency measures social cohesion through the co-production or minor transformations of space, if this cannot be quantified and therefore justified as the project's main indicator, the project will struggle to attract or retain resources. For

بيوتًا دائمةً لهم. تمنح التدخلات الأمل للناس، وتؤجل من خيبات الأمل، ولكنها لا تغير من الواقع في المخيم.

فريق التحرير: تُعَدُّ التصاميم المبتكرة في مخيم الأزرق، مثل النوافير والمجالس التي صَنَعها اللاجئون باستخدام المواد التي عثروا عليها ومواد الإغاثة المقدمة من قبل المفوضية السامية للأمم المتحدة لشؤون اللاجئين «UNHCR» والتي قاموا بتدويرها، وسائل يقاوم عبرها اللاجئون فرضية أنّ الملجأ ليس بيتًا.

أماني: تظهر فكرة وجود المخيم كمكان مؤقت للحياة غير المستقرة، وحياة النزوح والطوارئ، جلية في تصميم المخيم نفسه، إلا أن الحياة فيه ترتبط بجوانب أبعد من وجوده وتصميمه. يصعب التحكم في تصميم المخيم بسبب ارتباطه بالسياسة والحالات الطارئة، وخضوعه لعدد لا محدود من القيود الإنسانية والسياسية. لكنني أعتقد بأنّ ما نستطيع العمل عليه، هو تمكين الحياة في المخيم، وتحسينها لكي تصبح حياة كريمة، حتى وإن كانت لفترة مؤقتة. يُعد تحسين حياة المقيمين في ملاجئ المخيم، وتحقيق رؤيتهم وراحتهم اليومية أمرًا ضروريًا وممكنًا، وفي رأيي، لا ينبغي النظر إلى المخيم كمكان

محسن: ربما، لكن فيما يتعلق بالملجأ القائم على التصميم الإنساني الموحد، فإن فكرة وجوده في الأصل تكمن في عدم منح اللاجئين مسكنًا دائمًا.

أماني: حتى مصطلح «الملجأ» يشير إلى شيء مؤقت، إلى مسكن يُبنى بسرعة بمعايير محددة ومن دون أي شكل من أشكال التخصيص، التي تعتبر مهمة لتلبية المتطلبات والحاجات المختلفة للسكان، خصوصًا في الحالات الطارئة. أؤمن مع ذلك، بدور الفنانين والمصممين في تمكين ودعم التحول الذي يحركه المجتمع المحلي للملاجئ، الأمر الذي يسمح للناس بتلبية احتياجاتهم ورغباتهم ضمن حدود المخيمات، وهذه جزئية قيّمة عند تخصيص المساحات داخل المخيم.

محسن: ترتبط فكرة المخيم بالآنيّة، ويعتمد مفهومه بالنسبة لنا على حرمان سكانه من حياة مريحة، لكي يصبح المكان تذكيرًا دائمًا لهم أنّ هذه الأرض ليست ملكًا لهم. أرى أنّ هذا يمثل جوهر المشكلة في المخيم، ولهذا يتم اعتبار أي تداخل يجري فيه – حتى لو كان مجرد جدارية – أمرًا يتعارض مع ما يفترض أن يكون عليه المخيم، الذي يُمنح فيه الناس ملاجئ للسكن وليست

example, an indicator could be that "10 murals were painted in the camp by 15 children" and upon fulfillment of these numbers the project will close successfully. There is no concern for the artistic methods, engagement process, or content of the mural, let alone the intangible impact of the projects on everyday life. Our main problem in the humanitarian sector while dealing with such interventions is that accountability structures are connected to indicators and numbers that to a certain extent dehumanize the entire sector.

Humanitarian design

Editors: The securitization of refugee protection in refugee camps and blurry accountability systems reproduce the dependency of refugees on the humanitarian system. They make people feel

powerless. We would like this book to make that visible. That said, where do we go from here? On the one hand, there is this heavy frustration connected to the shortcomings of the humanitarian sector, but on the other, there is so much space for artists and designers to contribute to this field.

Muhsen: Perhaps, but starting with the idea of the "shelter," humanitarian design is already foregrounding that it is not giving people a stable ground.

Amani: Even the term "shelter" implies that it is something temporary that requires fast production and fast construction, all made through standardization, without the customization required to accommodate the different needs of diverse residents. Which is, of course,

على النظام الإنساني. تحتل هذه القضايا جوهر السياسة المتبعة في مخيم اللجوء، فهم يُشعرون سكان المخيم بالعجز، أود أن يوضح الكتاب هذه النقطة. إلى أين يقودنا هذا؟ وما الشيء الذي يجب أن نحققه من منظور خبرتنا والتزامنا؟

محسن: أتاحت لنا تجربة عملنا في المجال الإنساني فرصة رؤية الأمور من منظورٍ شبه شامل، جعلنا نرى كمَّ النعم التي نحظى به، ولكننا عاجزون جدًا فيما يتعلق بكيفية التدخل وتغيير الوضع. لذلك، يشكل هذا الكتاب تعبيرًا عن شعور الإحباط الذي يصيب الأشخاص المدركين للتحديات الأخلاقية التي تواجه العمل في بيئة المخيم.

التصميم الإنساني

فريق التحرير: ثمة إحباط شديد مرتبط بالنواقص التي يحتاجها العمل الإنساني، ولكن هذا لا ينفي وجود مساحة كبيرة يستطيع الفنانون والمصممون الاستفادة منها للمساهمة في هذا المجال.

أماني: يطرأ في ذهني، عند مناقشة موضوع المسؤولية في التدخلات الإنسانية، قضية تثير الاهتمام كنتِ قد ذكرتِها، وهي إجراءات المراقبة والتقييم المرتبطة دائمًا بمؤشرات القياس الكمي. لذلك، عندما تقيس جهة معنية مستوى التماسك الاجتماعي من خلال إعادة بناء المساحة أو التغيير البسيط عليها، فإنها لا تعتبر مؤشرًا رئيسيًا للمشروع، إذا أنها لم تُحدد كميًا، مما يقلل الموارد المخصصة للتمويل. مثال ذلك ما قد يحصل في أحد المشاريع، عندما تشير مؤشرات المشروع إلى أنّه «تم رسم ١٠ جداريات في المخيم من قبل ١٥ طفل»، وأنّ المشروع سُيغلق بنجاح عند اكتماله، من دون الأخذ بعين الاعتبار الأساليب الفنية وآليات المشاركة، ومضمون الجداريات، والتأثير المعنوي للمشروع على الحياة اليومية، إلا إذا انعكس كل ذلك صراحة في منهجية العمل وتم تنفيذه فعليًا بناءً على تلك المنهجية. مشكلتنا الرئيسية في القطاع الإنساني أثناء التعامل مع التدخلات، هي أنّ أشكال المسؤولية مرتبطة بالمؤشرات والأرقام التي قد تجرد كامل القطاع من إنسانيتهِ.

فريق التحرير: تعيد الحماية الأمنية للاجئين في مخيمات اللجوء وأنظمة المساءلة غير الواضحة اعتماد اللاجئين

عندما تعيش في المخيم، يتطلب الحفاظ على شخصيتك الحقيقية منك بذل جهد جبار

In the camp, existing is an act of resistance and being yourself is an act of resilience.

فريق التحرير: ماذا عن إعادة تصور النظام المعمول به في المكان؟ نتساءل إن كانت المساهمات التنظيمية في المجتمع الإبداعي تتم عبر إعادة تصور التصميم الإنساني. كيف نبدأ التفكير في ذلك؟

أماني: تعجبني هذه النقطة فعلًا، وأعتقد أنها تعود إلى فكرة بناء بيئة تمكينية تشاركية، تمثل بيئة خصبة للأفكار الجديدة.

الحواجز الإبداعية والمسؤولية في تدخلات الفن والتصميم في مخيمات اللاجئين

فريق التحرير: ما هو الشكل الذي تتخذه المسؤولية في تدخلات الفن والتصميم في قطاع العمل الإنساني؟ لا تتخذ مساهماتنا التنظيمية شكلًا محددًا، كما لا يمكن قياس التدخلات في فئات ونواتج النشاط الإنساني بالمؤشرات الكمية، وهذا ما يعارض الأشكال القائمة في القطاع الإنساني. تؤدي محاولة التماشي مع الأشكال الإنسانية القائمة، رغم ذلك، إلى الانحراف عن الهدف الأساسي للتدخلات، وإضعاف قوة التعبير الإبداعي.

وجدنا فائدة من زيارة المخيم، لأنها سمحت لفريقنا بالتفاعل من الجهات المعنية والسكان المقيمين خارج إطار القواعد المنصوص عليها، وشجعت التكيف، وحثّت على القيام بالأمور بأشكال مختلفة.

محسن: الفن، والتصميم، والأخلاقيات؛ تُعتبر جميعها مفاهيم غامضة وواسعة، يصعب التعبير عنها في جملة ذات سياق سهل. وعندما نُعرف هذه المفاهيم بطريقة معينة، نصبح عالقين في التعريف نفسه. يتطلب الأمر أن نعترف بغموض هذه المفاهيم في جوهرها، وخاصة في بيئة ثقافية تخضع للتغير والتطور المستمرين، مثل بيئة المخيم، أو الأردن ككل. أما المسؤولية، فترتبط بالسياق، والسياق أو المحيط في جوهرها مصطلحات غامضة. يتعلق الأمر إذًا، بتداول وفهم المصطلحات التي تظل غامضة والتي يصعب إحصاؤها. أحاول، على الصعيد الشخصي، توخي الحذر قدر المستطاع في تراكيب الجمل الحديثة، والطرق الشائعة في وصف التجارب، فنحن نستخدم هذه التراكيب اللغوية للتعبير عمّا يحدث، في الوقت الذي يمكن فهم ما يحدث بطريقة مختلفة تمامًا، من خلال نفس الجملة، إذا استُخدمت في سياق مختلف.

justifiable and is indeed required in cases of emergency. However, I believe the role of artists and designers in enabling and supporting community-driven transformation of space that allows people to apply their needs and desires within the limitations of camps is a crucial and valuable part of enabling customization of space within the camp.

Muhsen: The idea of a camp is rooted in impermanence. The very concept of the camp is based on us not giving its residents a comfortable life. Again, there's a constant reminder, "this land isn't yours." To me, this is more or less the core of the problem in the camp; any intervention, even a mural, is something that goes against what a camp is supposed to be. You're giving people a shelter that isn't a home, yet you tell people to live in it. Interventions give people hope but do not shift the basis of what the camp is, and so then "hope" turns into postponed disappointment.

Editors: And yet designs of Azraq residents like fountains and *Majalis* made out of found objects and recycled UNHCR materials counter the premise of a shelter that is not a home.

Amani: There is the core existence of the camp as a temporary space of unstable living in cases of displacement and emergencies which predominates in the design of the camp. Then, there is the life within the camp. The first is out of our control; they're political and related to emergencies and subjected to endless humanitarian and political restrictions. But I think the life at the camp is what we can improve, and enabling life in the camp is what matters.

أخلاقيات التدخلات الثقافية في مخيمات اللاجئين

فريق التحرير: نلحظ وجود اهتمام متزايد من قبل المبدعين والباحثين بقضية التهجير القسري. ما هي المساهمة التي يحتمل أن يحققها الفن والتصميم في قضية اللاجئين؟

أماني: يجب أن يقترن الاهتمام المتزايد الذي يوليه المجتمع الإبداعي لمخيمات اللاجئين مع النقاش حول أخلاقيات المشاركة والبحث والممارسة في الحالات المهمشة. تفرض علينا مسؤوليتنا المهنية كمصممين، أن نقول الحقيقة، وأن نُمكِّن الناس، وأن نشارك قصصهم وندعم إنجازاتهم، وأن نشارك في عملية إعادة البناء. وقد يفرض علينا دورنا الثانوي، كأعضاء في النظام الإنساني الدولي، أن نكون وسطاء لإيجاد مساحة للإنجاز الفعلي، وأن نناقش ونفاوض ونضمن تحقيق العدالة، وأن ندعم المشاركة وحق الناس في تقرير مصيرهم بأنفسهم. أعتقد بأنّ هذا ما يجب أن يكون جوهر دورنا، أي أن نكون مقاتلين في سبيل تمكين المجتمعات المحلية لتكون جزءًا لا يتجزأ من عمليات صنع القرار المتعلقة بظروف

معيشتهم وبيئتهم. تكتسب هذه المسؤوليات الأخلاقية أهمية متزايدة في عملنا، حيث تلعب المساعدات الإنسانية وتمويل التعاون الدولي دورًا كبيرًا في خطة التنمية. لذلك، فإن الجهات المانحة والوكالات المنفذة والعاملين في المجال الإنساني والإنمائي، مسؤولون على قدم المساواة عن تمكين الناس من أجل تحسين ظروفهم المعيشية.

محسن: يجب التأكيد بدايةً، عند تناول موضوع الأخلاقيات، على أنّ النوايا الحسنة وحدها لا تكفي. يتمثل الجزء الأكبر من فهم الأخلاقيات في ضمان الجدية والفهم السليم لسياق ومحيط العمل، فالعمل في مخيم للاجئين يتضمن الكثير من التحديات، ومنها البيروقراطية والغموض ووحدة المعايير. قد يتم تنفيذ بعض المشاريع أحيانًا بعيدًا عن أهدافها الأساسية، وبفعالية، من قبل أشخاص بنية حسنة، فتراهم يبذلون قصارى جهدهم وفقًا لقدراتهم. أعتقد بأننا إذا ما ناقشنا دور الفن والفنانين والأخلاق التي تحكم أفعالهم، فإنها ستكون رحلة طويلة يمكن فهمها من خلال الجدية والتفاني. ينبغي توخي الحذر في جميع الأحوال عند الانخراط في هذا العمل، لكي لا يصبح الوضع شبيهًا بصندوق باندورا، الذي يخرج منه الأمل نهاية، لكن بعد العديد من الفظائع.

Just enabling life that is worth living, even if it is a temporary life, it is still part of the human life. And for people living in these spaces, life could be improved to achieve their definition of comfortable and convenient everyday life. In my opinion, the camp should no longer be looked at as a temporary space. We are witnessing massive numbers of people who are born and die in a camp. Keeping the traditional form of thinking about camps is putting refugees in the loop of permanent liminality. That, in my opinion, is where our responsibility aligns with our profession: to find room to maneuver in an otherwise compromised space; to enable the trans-forming of these spaces as spaces for a life of living rather than a life of waiting.

الحفاظ على الإرث الثقافي في المخيم

محسن: لا شكَّ في ذلك، أعتقد بأنّك عندما تعيش في المخيم، يتطلب الحفاظ على شخصيتك الحقيقية منك بذل جهد جبار، لأنك تعيش في بيئة تذكرك دائمًا أنّك لا تنتمي إليها، وهذا ما يولد فيك شعورًا خفيًا يدفعك لمقاومتها، خاصة عندما تعيش في مساكن مؤقتة تهتز مع هبوب الرياح القوية، وعندما لا يُسمح لك بزراعة أي شيء في الأرض، أو القيام بأي عمل يشعرك بأنّك في منزلك الخاص، وعند امكانية اعتبار فعل التمسك بالوطن، حتى بأبسط وسائله وأضعفها، نوعًا من المقاومة.

أماني: يعتبر الاستمرار في العيش في المخيم إذًا، والتمسك بالإرث والقيم الثقافية شكلًا من أشكال المقاومة، ومن الممكن أن تكون أيضًا مقاومةً لتصميم المخيم، ومحاولة تجريده من الإنسانية، ومقاومة للنزوح القسري بمفهوم أكبر. أعتقد أنّ توثيق أشكال المقاومة هذه يحتل مكانة عالية على المستوى الأخلاقي والإنساني.

محسن: يضفي التمثيل أو الإظهار البصري لهذه التصاميم طابعًا إنسانيًا على التجارب العديدة للنزوح، إذ أنّه يظهر أنّ لتلك التجارب – التي نقرأ عنها في التقارير والصحف– جوانب أخرى، أكثر واقعية وإنسانية، كما أنه يظهر حقيقة اللاجئين كبشر، وليس كأرقام. تكشف الرسوم التوضيحية عن الحقيقة الفوضوية للمخيم بشفافية، وتجمع بين الذاكرة والحاضر والمستقبل لتُرسي بذلك حقيقة متعددة الطبقات والمعالم، لكنها طبقاتٌ تتصادم في بيئة المخيم. تتميز تمثيلات المخيم هذه بأنها ليست صورًا فوتوغرافية؛ بل هي رسوم توضيحية يمكن للفرد تمييزها وفقًا لذاكرته الجماعية والمشتركة، إذ أنها لا تحل في الحياة الواقعية بهذه الهيئة، كما وأنها تعبر عن الفوضى التي ولّدتها المتطلبات اليومية للاجئين.

فريق التحرير: يمكن القول أيضًا بأنها تعالج قضايا وحدة المعايير والاقتصاد في المخيمات.

حياةٌ تستحقُّ العيش

أماني الشعبان؛ مخططة تنمية حضرية، شغلت منصب الأمين العام لشبكة Architecture Sans Frontieres International (العمارة بلا حدود الدولية). محسن البواب؛ مهندس معماري ومدير مشروع في منظمة Civic Jordan، حيث يعمل على التدخلات الحضرية في مدينة الأزرق ومخيم الأزرق للاجئين. في العام 2016، دعم كل من أماني ومحسن إجراء بحث مشترك في مخيم الأزرق للاجئين، ضمن إطار تعاون بين مختبر الإرث المستقبلي في معهد ماساتشوستس للتكنولوجيا، وقسم الهندسة المعمارية في الجامعة الألمانية الأردنية. ناقشا في حوار أجرياه مع فريق التحرير، أهمية ودور الاختراعات في مخيم الأزرق في خلق حياةٍ كريمة.

تمّ إجراء المقابلة عبر الإنترنت بحضور المشاركين في مواقعهم في مدينتي السلط وعمّان في الأردن، ونيقوسيا في قبرص، وبوسطن في ماساتشوستس، في تاريخ 14 تموز 2020.

الإنتاج المشترك للمساحة والتمثيل البصري لمخيم الأزرق للاجئين

فريق التحرير: تخبرنا التصاميم التي قُمنا بتوثيقها في هذا الكتاب، قصصًا عن احتياجات اللاجئين، إذ يعتبر هذا التوثيق لاختراعات سكان المخيم نوعًا من النقد البصري . ليس لدينا، كفنانين ومصممين، أي ريع من تلك التصاميم، ولكننا نرغب من خلال عملنا أن نحقق فائدة، وأن نساهم عبر طرح القضايا بشكل مرئي لجمهور أوسع. من وجهة نظرك الخاصة، كمساهمة مقيمة في الأردن، ما القيمة التي سيضيفها نشر هذا الكتاب؟

أماني: يناقش هذا الكتاب مواضيع إعادة إنتاج المساحة، ورواية القصص، وذاكرة النزوح، وتحقيق السلام، وتقوية النسيج الاجتماعي في المخيم. لا يكتفي توثيق ما صممه اللاجئون، كالمجالس مثلًا، بتسليط الضوء على التصاميم الإنسانية التقليدية التي قد تتسم بالجمود، بل يتوجه بدلًا من ذلك نحو مساحات العيش المريحة التي تعكس التراث، وتعزز تخصيص سمات الحياة اليومية في المخيم. أجدُ كذلك أنّ منح الفرصة لسكان المخيم والمصممين بالمشاركة في تطوير محتوى

هذا الكتاب هو وسيلة لتوثيق قصصهم التي تروي الماضي والحاضر، ولهذا الأمر أهمية كبيرة.

تتسم التصاميم المنفذة حاليًا في المخيم بالمعايير الموحدة. يذكر هذا الكتاب بأنّ الملاجئ التي تحوي اللاجئين هي بيوتٌ لهم، تضمهم وتمتلئ بقصصهم، وهي تمثل البنية البشرية الأساسية في المكان. أرى من وجهة نظري الخاصة، أنّ هذه التصاميم الصغيرة في مخيم الأزرق هي أمثلة على إعادة إنتاج المساحة في بيئة مُقيدة. يؤدي تخصيص الملاجئ الموحدة إلى تمازج إعادة إنتاج المساحة، ورواية القصص والذاكرة الجماعية وممارسات الحياة اليومية مع بعضها البعض في مكان واحد. يستعيد اللاجئون من خلال الأعمال الإبداعية في مخيم الأزرق أجزاءً من وطنهم سوريا، ويضيفونها إلى مساكنهم من خلال الفن والرسم والنسج والعديد من الوسائل الأخرى. وعلى الرغم من أنّ هذه الإضافات واللمسات في الملاجئ لن تعوض شعورِ تجربة الحياة الحقيقية في الوطن، إلا أنها تحمل بعضًا من الحنين لها.

يقودنا كل ذلك إلى السؤال عن ماهية الوطن، وعن العناصر التي تبث فينا الدفء عندما نكون في بيوتنا وأوطاننا … قد تتمثل هذه العناصر أحيانًا في رائحة الصابون، أو في قماشة تظلل نافذة مطبخ، وهي تختلف بالطبع، من شخصٍ لآخر أو من جماعة لأخرى. ثمة أشياء بسيطة أخرى، أشياءَ غير ملموسةٍ تعبر عن المحاولات البسيطة لاستذكار الوطن وما يثيره من مشاعر، مثل القصص والقصائد والتذكارات الصغيرة. تعبر هذه الأشياء البسيطة عن قدرة الفن على جعل حياة الناس اليومية أفضل قليلًا. أجدُ من خلال عملي كمخططة حضرية، وبصفتي شخص على اتصال بعمليات إعادة الإعمار وتطوير المجتمع، قيمة كبيرة في تلك التصاميم الصغيرة التي تمثل الحياة اليومية في المخيم.

أظنُّ نهايةً، بأنه من المهم مناقشة موضوع الذاكرة الجماعية أو المشتركة، لأنها تجمع الناس وتخلق حسًا من التكافل بينهم، وتدعم النسيج الاجتماعي في المخيم الذي يُعد مكانًا استثنائيًا، يصبح فيه الإنسان مجرد رقم على بطاقة الهوية. يمكن لعكس الذاكرة الجماعية المشتركة في مثل تلك المساحات، أن يؤدي، بطريقة ما، إلى توطيد أسسِ تعايشٍ تحسن أوضاع الحياة في المخيم.

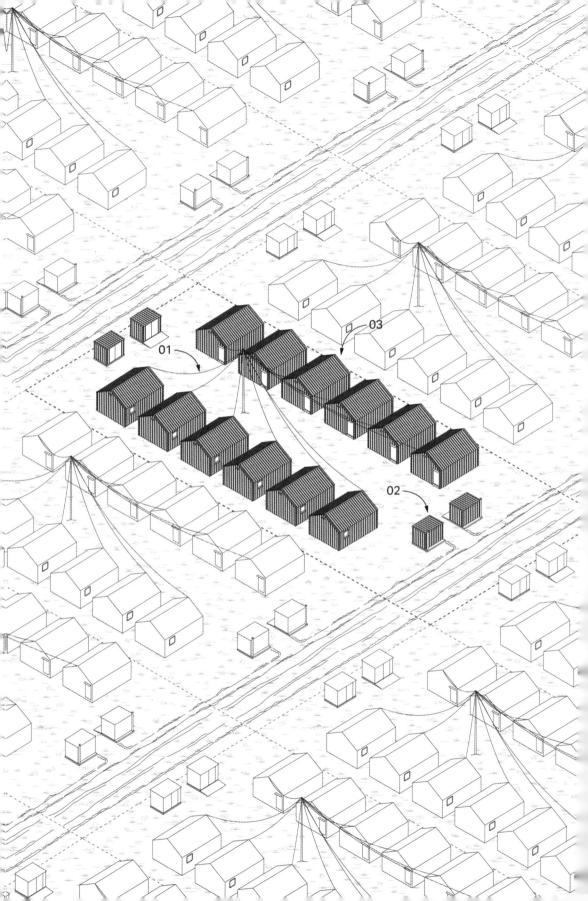

Village Plot

The camp's smaller collective unit is the Village Plot: twelve neighboring shelters that share four external spaces for hygiene and one central open space.

01	Electricity supply إمدادات الكهرباء
02	Latrines دورات المياه
03	T-shelter الملجئ الانتقالية

قطعة الأرض

قطعة الأرض التي تمثل القرية في المخيم هي أصغر وحدة جماعية في المكان، وتضم اثنا عشر ملجًنا متجاورًا، تتشارك أربع مساحات خارجية للمستلزمات الصحية ومساحة مركزية مفتوحة في المنتصف.

Reverse Urbanization

Zeid Madi *is an architect and an urban researcher with extensive experience working on cultural interventions in refugee contexts. He is the director of Cluster Labs, an urban research and development module based in Amman, Jordan. In collaboration with the Future Heritage Lab he led the outreach and documentation of designs at the Azraq camp. In conversation with the editors he discusses the history of refugee camps in Jordan and design processes that contest standardization at Azraq and Za'atari.*

The interview took place online with participants connecting from Amman, Jordan, Nicosia, Cyprus, Boston, Massachusetts on 2 June 2020.

A brief history of displacement in Jordan

Editors: Refugee camps are the predominant Jordanian policy in addressing the inflow and accommodation of displaced Syrian people. Could you guide us through the history of displacement and refugee camps in the country?

Zeid: The topic of refugees in Jordan is a juggled political and economic subject related to the development of Jordan since the 1950s. The first wave of refugees arrived in Amman in the late 19th century after an internal conflict in the Tsardom of Russia. Chechens and Circassians did not settle in refugee camps. They arrived as independent individuals and groups and inhabited a city that was not yet the capital of a sovereign state. This group played an essential role in the development of the social, political, and economic layers that founded the country.

The second wave of refugees was in 1948, in the wake of the Palestinian-Israeli conflict. That was during British rule over the region of Palestine. With the arrival of hundreds of thousands of refugees to the land that was soon to be the sovereign state of Jordan, the question of whether or not the arriving population was part of this state arose. For refugees with an established financial standing, it was easy to integrate not only within the community but also in the political and the governing channels of Jordan in the years to follow. Refugees lacking financial means lived within clusters that would soon transform into refugee camps. At the time, what is now called the UNRWA (United Nations Relief and Works Agency for Palestine Refugees in the Near East) was part of the League of Nations. These urban concentrations of arriving populations settled in areas close to the border, sometimes in areas close to urban hubs and sometimes within the city. In refugee camps, provision of housing was basic: standardized housing, standardized food, standardized education. Even in the case of clothing, you often see refugees wearing UNRWA jackets with a stamp of their donor country. The evolution of these camps is very similar to how Syrian refugee camps are evolving right now in Jordan.

After the 1967 War, more Palestinian refugees fled to Jordan. The vast majority were settled in refugee camps. In the case of the Gulf War in the 1990s, there were no Iraqi

refugee camps, since most of the Iraqis that arrived had financial means. In the second Gulf War (2003), most of the displaced population settled in the capital of Amman.

The situation of the Syrian refugees is comparable to the case of the Palestinians in 1948. Most Syrian refugees that were financially able settled in the capital and its suburbs. Migrants and refugees who were not so well off settled near the border between Syria and Jordan, primarily at the Za'atari camp. The common denominator of the integration of the arriving population in Jordan, regardless of where they came from, is their socioeconomic situation. Financial support will be the primary determining factor over whether you live in a city with dignity and freedom or you are forced, not against your will but by the circumstances, to live in refugee concentrations where you and your children are provided with means of the bare minimum.

At Za'atari, we observe a dynamic development of the camp. The typology of housing shifted from tents to caravans, to some basic semi-permanent urban structures with concrete and block-work. The Azraq camp is a completely different case, tied to the principles of standardization. The question of funding and financing becomes a major factor in the spatial composition of the camp. In most cases, Jordan will depend on international and foreign donations from the UNHCR (United Nations High Commissioner for Refugees), the UNRWA, the UNDP (United Nations Development Programme), and any other affiliated organizations.

The journey of Syrian refugees to self-subsistence

Editors: Considering that displaced Syrians' engagement in the economy is mostly reduced to cash assistance and limited employment opportunities, how does this population achieve self-sufficiency, and how is that expressed in space?

Zeid: Arriving refugees lack means for financial autonomy. That said, my thesis research at the German Jordanian University, "Rethinking Za'atari as a Potential Urban Incubator for Cross Integration Development," made visible the emergence of economies that operate in gray areas and contribute to the sustenance of Syrian refugees. Residents utilize their extensive background in trade and agriculture to found their own market and livelihood zones. The camp market has loose ties to the local urban economy, services in agriculture, construction, craftsmanship, and other knowledge refugees arrive with. This informal market gained a big reputation, reflected in its name, the "Champs-Élysées." It is the elite area of the camp, despite a lack of official documentation from the Jordanian government.

As I discovered in one of my visits, the documentation of the incoming and outgoing supplies of the market is handled by refugees themselves. I entered one of these shops to discover it was actually an informal distribution area. I saw a Syrian bookkeeper meticulously recording the goods he received from a Jordanian merchant. He explained that he was receiving goods that would then be distributed to

تُظهر ابتكارات اللاجئين المتطلبات الضرورية التي يحتاجونها، وتعمل إنسانيتنا على توسيع حدود الحاجات الأساسية، وتجعلنا نرى أشخاصًا مُنحوا فرصة التجمع حول نسخة مطابقة من قوس النصر في تدمر، وبنَوا النوافير وزرعوا الحدائق. لا ترتبط الحدائق بتوفير الطعام فقط، لأن للاجئين القدرة على تأمينه من المحال التجارية في المخيم؛ بل هي بمثابة مرساة تربطهم بالأرض التي يعيشون عليها.

فريق التحرير: كيف يمكن توعية القطاع الإنساني بمخاوف الحفاظ على الإرث الثقافي؟

زيد: أعترض شخصيًا على توحيد المعايير في التصاميم الإنسانية. يمكن دمج السياسات التي تشجع التنمية العضوية المرنة مع المبادئ التوجيهية للمخيم، حتى من دون تمويل إضافي، بالإضافة إلى أخذ أهمية تقرير المصير والعوامل الثقافية بعين الاعتبار.

أريد أن أضيف بأنني لا أتفقُ مع الضوابط التنظيمية الخاصة بالأنشطة الاجتماعية والثقافية. تجري في الوقت الحالي، أنشطةٌ مثل الرقص والشعر والتجمعات الاجتماعية وحفلات الزفاف بإشراف المنظمات، وفي تواريخ وفترات زمنية يحددها شخص آخر نيابة عن اللاجئين أنفسهم. أعتقد أنّ مثل هذه الأنشطة يجب أن تكون ممكنة في أي مكان وأي وقت من دون أية قيود. تثير هذه النقطة أيضًا موضوع توفر الأماكن العامة والمجتمعية، التي تكاد تكون معدومة في مخيمات اللاجئين. يؤثر تقييد تنظيم الأنشطة الثقافية في المراكز المجتمعية التابعة للمنظمات غير الحكومية على حياة العامة، ويمنح هذه المنظمات الأحقية الحصرية في تنظيم المناسبات الثقافية والتأثير على الثقافة السائدة وطريقة التعبير عنها وأشكالها. لماذا يقوم كيان خارجي بتعريف وتحديد الثقافة للاجئين السوريين؟ أريد كذلك أن أدافع عن أهمية توفير بيئة تحتية تسمح للسكان باستكشاف الثقافة وتطويرها والتعبير عنها بطرقهم الخاصة. وتحديد الثقافة للاجئين السوريين؟ كما أنني أدافع عن أهمية توفير بيئة تحتية تسمح للسكان باستكشاف الثقافة وتطويرها والتعبير عنها بطرقهم الخاصة.

Syrian shop owners around the camp to develop their own small businesses.

The encounter with the accountant gave me a different outlook on the market. According to my calculations, the daily exchange of capital for a population of 80,000 people in the market is approximately 100,000 JOD (or approximately 141,000 USD) per day! What at first glance seemed to be informal was actually the most formal part of the camp.

Editors: You supported the research and implementation of various projects at the camps of Jordan. What's your takeaway regarding the design and operations of these spaces?

Zeid: I had the opportunity to work for various NGOs in the humanitarian realm.

A lot of NGOs operating at the camp seem to have the same standardized model of providing humanitarian services. People of particular expertise work on specific areas including education, health, capacity building, or general social services. These services are identical, and their organizations siloed, which results in paradoxes related to the bureaucracy of standardization. An example would be an NGO building a playground and then right next to it another NGO building a similar playground through a different funding pathway. Why aren't the services diverse and/or distributed? Why is there a football field on my left and then another on my right? Why is one football field occupied most of the time and the other almost vacant throughout the day? The situation is symptomatic of standardized living, the IKEA model applied to the deployment of the camp.

الكبرى. لماذا يختلف تطبيق التحضر العكسي بين المخيمين؟

زيد: يختلف وضع مخيم الأزرق عن مخيم الزعتري كثيرًا، ففي مخيم الأزرق، لا يمكن لك تحريك منزلك أو تغير أي شيءٍ فيه، على عكس المنازل في الزعتري. أضف إلى ذلك، أن مخيم الأزرق يقع على بعد نصف ساعة على الأقل من أقرب مدينة يسكنها 20000 نسمة، وهذا يمنع تطور الأسواق غير الرسمية فيه. أما مخيم الزعتري، فيقع على بعد أقل من 15 دقيقةً من المدينة، كما لا ننسى وجود قرية بجواره مباشرة. تجدر الإشارة إلى أن مخيم الأزرق يقع في وسط الصحراء، ولهذا فهو لا يشهد عملية التحضر العكسي بالسرعة التي يشهدها مخيم الزعتري، ولكن عملية التحضر العكسي ستكون عند حصولها، أكثر شمولاً وتنوعًا في مخيم الأزرق.

أذكرُ عندما شبّهت إحدى المراهقات التي عملنا معها في مخيم الأزرق الكرفانات في وسط الصحراء بأنها مكعبات سكر. إذا نظرت إلى المخيم من مسافة بعيدة، سترى أنها تبدو كذلك بالضبط، وأنّ المكان يبدو قاحلاً

للغاية. ولكن عندما تقترب من التجمعات السكنية التي تُسمى بالقرية والأحياء المعروفة بأراضي القرية، فإنك سترى الكرفانات مصفوفة بجانب بعضها البعض، وتتحول مكعبات السكر تلك، إلى مساحات يبذل الناس قصارى جهدهِم –على الرغم من ظروفهم اليائسة– لجعلها شبيهة بالوطن. سترى، كلما اقتربت من تلك الملاجئ وأمعنت النظر فيها، حياة سكانها على حقيقتها.

فريق التحرير: ماذا نتعلم من عملية التحضر العكسي ومن الإنتاج الإبداعي للاجئين السوريين؟

زيد: تشير ابتكارات وتصاميم اللاجئين إلى الفجوات الموجودة في التصميم الإنساني، وتوضح أنّ تلبية الاحتياجات الأساسية لا تكفي وحدها، فالنظام الإنساني لا يتطرق إلى موضوع تحقيق الذات. تدل البدائل والتعديلات والإختراعات التي يقدمها اللاجئون على الثغرات في جوانب كالخصوصية، والظروف الجوية القاسية، والبُنية التحتية للمياه، وعلى القوة المؤثرة للبيئة التي يعيشون فيها وتأثيرها على احتياجاتهم الشخصية والثقافية والعقائدية، وعلى غياب كل هذه الخيارات في ظل النموذج موحد في المخيمات.

The process of reverse urbanization

Editors: How do residents respond to the principle of standardization?

Zeid: There is a gap between the standardized humanitarian services and the real needs of camp residents. Let's refer to it as the humanitarian gap. This gap is compensated for by the inhabitants themselves.

When people arrive at the Za'atari camp, they receive identical shelters regardless of family size, cultural habits, or perception of privacy. Privacy in Syria is not a black-and-white constant but expands in a spectrum of spaces and times in between. People utilize the range differently. One might find it more suitable to change the direction of neighboring shelters and create a buffer

space in between. In this case, there is one space for the parents, a semi-private space, and then another space for the children. As the children grow older, a divider separates the older male of the family, supporting the increased need for privacy for female members of the household.

This process of breaking the grid from the standardized built environment of the camp from the bottom up to fit the real needs of residents I call "reverse urbanization."

Under conventional circumstances, urbanization is characterized as a continuous overlaying process of spatial and ethnographic systems. An evolving, complex interplay between the collective mindset of humans and their built environments. In a specific geographic context, language, culture, economics, and politics are of the few

مسبقًا، إلى عملية تحضر عكسي، اعتمادًا على درجة الحرية التي تسمح بها الإدارة في المخيمين، وأدت مرونة الإدارة في مخيم الزعتري والطبيعة المتنقلة للوحدات السكنية فيه إلى التنوع في شكل التدخلات المكانية. من ناحية أخرى، تسببت صرامة الإدارة في مخيم الأزرق، وطبيعة الوحدات السكنية الثابتة إلى الحد من القدرة على التعبير عن مثل هذه التدخلات التي تعبر عن احتياجات السكان.

تتمثل هذه العملية في مخيم الزعتري، بتقسيم أماكن السكن وبناء وحدات جديدة. أما في مخيم الأزرق، فتجري إعادة تخصيص عناصر البيئة المحيطة واستخدامها بطرق جديدة غير متوقعة، تُعبر عمّا يدور في أذهان السكان واحتياجاتهم بتطبيقات فعلية في البيئة المحيطة. تؤدي إعادة الابتكار، وإعادة التخصيص في السياقين إلى التحضر العكسي، في ظل محدودية المعايير الإدارية.

فريق التحرير: نستطيع الآن أن نرى كيف ينطبق تعريف التحضر العكسي على المفارقات التاريخية لمخيمات اللاجئين، بالمقارنة مع النموذج المعاصر للمدن

تتكون من مساحة واحدة للأهالي، ومساحة أخرى شبه معزولة، ومساحة أخرى للأطفال، ومع تقدم الأطفال بالسن، يتم وضع حاجز يفصل الذكور عن الإناث في الأسرة، من أجل تعزيز خصوصيتهنّ.

تُغير هذه العملية من البيئة المبنية على المعايير المحددة لجعلها أكثر مُلائمة لاحتياجات السكان الحقيقية، أسمي ذلك بـ«التحضر العكسي».

يتميز التحضر، في الظروف العادية، بكونه عملية تراكب مستمرة، للأنظمة المكانية والإثنوغرافية (وصف الأعراق البشرية)، ويعتبر تفاعلًا معقدًا ومتطورًا بين عقلية البشر الجماعية وبيئاتهم المبنية، وفي سياق جغرافي محدد، تعتبر كل من اللغة والثقافة والاقتصاد والسياسة معايير إدارية تحدد شروط «كيفية تطور النظام الحضري» بمرور الزمن. يُعبر البشر عن التصورات والرؤى التي تدور في عقولهم في الطبيعة التي تحيط بهم، والعكس صحيح، وقد تكونت أغلب المدن عبر التاريخ بهذا الشكل.

أما في حالة مخيمي الزعتري والأزرق للاجئين، فخضعت «الشبكات الإنسانية الحضرية» المحددة

but main governing systems which parameterize the conditions of how an urban system develops over time. Mentalscapes of humans are expressed and translated into their landscapes and vice-versa. Across history, the majority of settlements were yielded in such a fashion.

However, in the cases of Za'atari and Azraq Refugee Camps, the predesignated "Humanitarian Urban Grids" underwent reverse urbanization according to the degrees of freedom afforded to the refugees by the camp managements. The more flexible management of Za'atari and its mobile housing units allowed a more diverse form of spatial intervention. On the other hand, the more rigid management of Azraq and the ground-mounted housing units limited the expression of such needs-based interventions.

In Za'atari, it materialized with fragmenting the households and creating new clusters; at Azraq through reappropriating elements of the built environment in new, unexpected ways. A translation of mentalscapes into landscapes, so to say. Reinvented and reappropriated, limited only by the governing parameters of the two contexts—hence, reverse urbanized.

Editors: Why is the expression of reverse urbanization so different in the two camps?

Zeid: The case of Azraq is very different from Za'atari. The ability to move your house and cluster in neighborhoods witnessed in Za'atari was not possible at Azraq. Additionally, the location of Azraq, at least half an hour away from the closest settlement, a town of 20,000 people, prevented the development of informal

الأوقات؟ ينطبق هذا المثال على العيش ضمن معايير محددة، ويجعل المخيم شبيهًا بتصاميم الأثاث الموحدة التي تنتجها شركة «إيكيا».

عملية التحضر العكسي

فريق التحرير: كيف يتجاوب سكان المخيمات مع موضوع المعايير المحددة؟

زيد: يوجد فرق بين الخدمات الإنسانية الموحدة والاحتياجات الحقيقية لسكان المخيم، أحب أن أعطي هذا الفرق اسم الفجوة الإنسانية، وغالبًا ما يتم تعويض هذه الفجوة من قبل سكان المخيم أنفسهم.

يحصل القادمون إلى مخيم الزعتري على ملاجئ متطابقة فور وصولهم، بغض النظر عن عدد أفراد الأسرة أو العادات الثقافية أو احتياجات الخصوصية. تتعلق الخصوصية في سوريا بوجود مساحة بين المساكن، وقد استخدم اللاجئون تلك المساحات قدر استطاعتهم. قد نجد بأنه من الأنسب تغيير اتجاه الملاجئ القريبة من بعضها، وخلق مساحات فاصلة بينها، ولكنها في الواقع،

فريق التحرير: لقد دعمتَ القيام بالأبحاث وتنفيذ المشاريع المختلفة في المخيمات في الأردن، ما هو أهمُّ ما تمّ تنفيذه فيما يتعلق بتصميم وإدارة هذه الأماكن؟

زيد: أُتيحت لي فرصة العمل مع العديد من المنظمات غير الحكومية في المجال الإنساني، وبدا لي أنّ الكثير من هذه المنظمات العاملة في المخيم تمتلك نموذجًا موحدًا لتقديم الخدمات الإنسانية. يعمل أعضاء هذه المنظمات من ذوي الخبرة الخاصة في المجالات المختلفة كالتعليم والصحة وبناء القدرات والخدمات الاجتماعية العامة، وتكون الخدمات المقدمة متشابهة على الرغم من اختلاف المنظمات التي تقدمها، وهذا ما يُنتج مفارقات تعزز بيروقراطية المعايير الموحدة.

نرى مثالًا على ذلك عندما تتولى منظمة غير حكومية معينة بناء ملعب في أحد الأماكن مثلًا، ونجد أن منظمة غير حكومية تبني ملعبًا مشابهًا، بمسار تمويل مختلف، بجانب الملعب الأول. لماذا لا تتنوع الخدمات المقدمة أو يتم توزيعها؟ لماذا أجد ملعب كرة قدم على يساري، وملعبًا آخر على يميني؟ لماذا يُستعمل أحد الملعبين معظم الوقت، ويبقى الآخر شبه فارغ في الكثير من

markets. On the contrary, in Za'atari, the closest city is no more than 15 minutes away, and the nearest village is just next to the camp. Lastly, it is worth noting that Azraq is in the middle of the desert. Accordingly, in Azraq, the process of reverse urbanization was not as rapid as in Za'atari, but when it manifested, it was more extensive and diverse.

I quote one of the teenagers at the Azraq camp we have worked with. She described the caravans in the middle of the desert as "a hilly land of sugar cubes." If you look at the camp from a distance, that's exactly what you seem to see. It's a very sterile environment, but as you come closer and start approaching the clusters known as villages and the neighborhoods known as village plots, you see the caravans arranged one next to the other. The sugar cubes

Refugee interventions point out that humanitarian design must go beyond covering basic needs.

تدل اختراعات اللاجئين على أنّ التصميم الإنساني لا يجب أن يكون مقتصرًا على تغطية الاحتياجات الأساسية.

اكتشفتُ في إحدى الزيارات للمخيم أنّ توثيق الإمدادات الواردة والصادرة من السوق يتم من قبل اللاجئين السوريين أنفسهم. دخلتُ واحدًا من المحلات، لأكتشف أنه يشكل في الواقع منطقة توزيع غير رسمية، وشاهدتُ محاسبًا سوريًا يسجل بدقة البضائع التي استلمها من تاجرٍ أردني، وأوضح لي أنه يستلم البضائع التي توزع لاحقًا على أصحاب المحلات من السوريين في أنحاء المخيم، لمساعدتهم في تطوير مصالحهم التجارية الصغيرة.

منحني اللقاء مع المحاسب نظرةً مختلفة للسوق، فقد كنت أسميه سوقًا غير رسمي، في حين أنه سوق رسمي يقوم على اقتصاده الخاص في الواقع. يبلغ حجم التبادل اليومي لرأس المال لعدد سكان يبلغ 8000 نسمة، اعتمادًا على حساباتي، حوالي 100,000 دينار أردني في اليوم الواحد.

تبين لي، أنّ المكان الذي بدا للوهلة الأولى كمكان غير رسمي، هو أكثرُ أجزاء المخيم رسمية.

turn into spaces people are trying their best in this most desperate of circumstances to make like home. The closer you approach the more life you observe.

Editors: What do we learn from the process of reverse urbanization and the creative production of Syrian refugees?

Zeid: Refugee interventions point out the gaps of humanitarian design, making visible the fact that addressing basic needs is not enough. The humanitarian system does not quite touch the subject of self-actualization. The alterations, modifications, and inventions of refugees point to gaps regarding privacy, extreme weather conditions, water infrastructure, but most of all, agency—the agency to influence the environment you live in according to your personal, cultural, and theological needs.

These choices are not possible in the standardized camp model.

The refugee interventions make visible what is an essential need, according to refugees themselves. Our humanity extends beyond the borders of basic needs. We see people gathering around the replica of the Palmyra Arch, building fountains, and planting gardens. Gardens are not connected only to the cultivation of food. People can already get food from the camp supermarket. They are looking for an anchor to the ground they find themselves living on.

Editors: How can the humanitarian sector be informed by concerns of cultural preservation?

Zeid: I argue against standardization in

Lightweaver design workshop facilitators Omar Darwish, Zeid Madi, Manisha Mohan, Azra Akšamija, and Nabil Sayfayn handing a certificate to Yassin Al-Yassin during the closing ceremony at the Azraq Refugee Camp. Photo: FHL, October 2017

القائمون على ورشة العمل حول التصميم بعنوان "Lightweaver" عمر درويش، زيد ماضي، مانيشا موهان، أزرا أكشامية، ونبيل سيفين، يسلمون شهادة لياسين الياسين خلال فعالية الحفل الختامي الذي أقيم في مخيم الأزرق للاجئين. الصورة: زيد ماضي ونبيل سيفين وفريق مجلة مخيم الأزرق، تشرين الأول 2017.

humanitarian design. Policies that encourage organic development through levels of flexibility could be incorporated into the guidelines of the camp, even without additional funding, taking into account the significance of self-determination and cultural expression.

Additionally, I argue for the deregulation of social and cultural activities. Currently, activities such as dancing, poetry, community gatherings, or weddings take place under the umbrella of organizations, in specific dates and time slots that someone else chose on behalf of refugees. I believe that these activities should be possible anywhere and at any time without constraints. This matter also raises the topic of public and communal spaces which are almost non-existent in refugee camps. Constraining cultural activities in NGO

community centers regulates what really is part of the vernacular of everyday life. This approach assigns to NGOs not only the provision of cultural events but also the power of facilitating and therefore determining what culture is, how culture is expressed, what it looks like. Why would an external entity define culture to Syrian refugees? Instead, I argue for infrastructure that allows residents to explore, develop, and express culture in and on their own terms.

إلى مساعدات نقدية وفرص عمل محدودة؟ وكيف يتم التعبير عن هذا الأمر؟

زيد: يفتقر اللاجئون إلى وسائل الاستقلال المالي، وهذا ما توضحه الأطروحة التي أجريتها في الجامعة الألمانية الأردنية بعنوان «مخيم الزعتري للاجئين – بين فرص التحضر العمراني في ظل تعزيز التكامل الاجتماعي»، بخصوص ظهور اقتصادات عاملة في المناطق الرمادية، وهي الأماكن التي تشهدُ حالة حرب وسلم في آن معًا، والتي من الممكن أن تتحول في أي لحظة إلى مناطق حروبٍ مفتوحة. تُسهم مثل هذه الاقتصادات العاملة في إعالة اللاجئين السوريين، ويستخدم سكان المخيمات معرفتهم الواسعة في التجارة والزراعة لتأسيس أسواقهم الخاصة، حيث يرتبط سوق المخيم الرئيسي بعلاقاتٍ هشة مع الاقتصادات الحضرية المحلية، وخدمات الزراعة والبناء، والصناعات اليدوية وغيرها من المهارات والمعارف التي يمتلكها اللاجئون. اكتسب هذا السوق غير الرسمي سمعةً كبيرة، وأُطلق عليه اسم الشانزليزيه، وأصبح يمثل منطقة نخبوية في المخيم، ويعمل بموافقةٍ غير مُوثقة من الحكومة الأردنية.

إكراهًا– إلى العيش في تجمعات اللاجئين، التي تؤمن لهم ولعوائلهم أدنى المتطلبات المعيشية.

يُمكن ملاحظة التطور الفعال الذي يطرأ على مخيم الزعتري، والذي يظهر من خلال تحول المساكن من الخيام إلى الكرفانات، وإلى بعض المباني الحضرية شبه الدائمة، المبنية من الأسمنت والطوب. يختلف حال مخيم الأزرق كليًا بسبب ارتباطه بمعايير موحدة، إذ تؤثر عوامل التمويل والموارد بشكل رئيسي في تحديد الطابع المكاني للمخيم. يعتمد الأردن في معظم الحالات على التبرعات الدولية والأجنبية من المفوضية السامية للأمم المتحدة لشؤون اللاجئين (UNHCR) ووكالة الأمم المتحدة لإغاثة وتشغيل اللاجئين الفلسطينيين (-UNR WA) وبرنامج الأمم المتحدة الإنمائي (UNDP)، وبعض المنظمات المعنية الأخرى.

رحلة اللاجئين السوريين نحو الاكتفاء الذاتي

فريق التحرير: كيف يُحقق اللاجئون السوريون الاكتفاء الذاتي في الوقت الذي تُقلص فيه مشاركتهم الإقتصادية

عملية التحضر العكسي

زيد ماضي؛ مهندس معماري وباحث حضري، يتمتع بخبرة واسعة في مجال التدخلات الثقافية في بيئات اللاجئين. يعمل ماضي مديرًا لمشروع Cluster Labs، الذي يمثل وحدة للبحث والتطوير الحضري في العاصمة الأردنية عمّان، كما وساهم بالتعاون مع «مختبر الإرث المستقبلي» في معهد ماساتشوستس للتكنولوجيا، في الكشف عن التصاميم في مخيم الأزرق للاجئين وتوثيقها. ناقش ماضي، في حوار أجراه مع فريق التحرير، تاريخ مخيمات اللاجئين في الأردن، والتصاميم التي تعارض الأشكال الموحدة في مخيمي الأزرق والزعتري.

تمّ عقد هذا اللقاء عن بعد، بمشاركة المحاورين من العاصمة الأردنية عمان، ومدينة بوسطن في الولايات المتحدة الأمريكية، ونيقوسيا في قبرص، في تاريخ 2020/06/02.

نبذة عن تاريخ النزوح في الأردن

فريق التحرير: تُعتبر مخيمات اللاجئين جزءًا من سياسة الأردن السائدة لمعالجة تدفق وإيواء النازحين السوريين. هل يُمكنك إخبارنا عن تاريخ النزوح ومخيمات اللاجئين في هذا البلد؟

زيد: إنّ موضوع اللاجئين في الأردن هو شأن سياسي واقتصادي متشابك، يتعلق بتطور الأردن منذ خمسينيات القرن العشرين. وصلت أول موجة لجوء تكونت من الشيشان والشركس إلى العاصمة الأردنية عمّان في أواخر القرن التاسع عشر بعد نشوب صراع داخلي في روسيا القيصرية. لم يستقر الشيشان والشركس في مخيمات اللاجئين، بل وصلوا إلى عمّان حينها على شكل أفراد وجماعات مستقلة، وسكنوا في المدينة التي لم تكن جزءًا من الدولة ذات السيادة آنذاك. لعبت هذه الجماعات دورًا أساسيًا في تطور الطبقات الاجتماعية والسياسية والاقتصادية التي أسست الدولة.

أما الموجة الثانية من اللجوء، فكانت عام 1948، عندما اندلع الصراع الفلسطيني–الإسرائيلي، وكان ذلك خلال فترة انتداب الحكومة البريطانية على فلسطين. قدم مئات الآلاف من اللاجئين عندها إلى المنطقة التي

أصبحت تُعرف بالمملكة الأردنية الهاشمية، وأُثير التساؤل حول اعتبار السكان القادمين جزءًا من الدولة أم لا. لم يكن من الصعب على اللاجئين من ذوي الخلفيات الاقتصادية القوية، الاندماج في المجتمع والمجال السياسي والتقرب من نظام الحكم الأردني خلال السنوات التي تلت لجوئهم. أما اللاجئون غير المتمكنين ماديًا، فاستقروا في تجمعات سكنية تحولت في وقت لاحق إلى مخيمات لجوء. كانت المفوضية السامية للأمم المتحدة لشؤون اللاجئين (UNHCR) جزءًا من عصبة الأمم في ذلك الوقت، حين استقرت هذه التجمعات الحضرية للسكان اللاجئين في المناطق القريبة من الحدود، أو في المناطق القريبة من المراكز الحضرية، أو حتى في داخل المدينة. كانت مستلزمات الحياة والسكن في مخيمات اللاجئين أساسية، تشتمل على شكل موحد من السكن والطعام والتعليم، وحتى الملابس؛ إذ كان اللاجئون غالبًا ما يرتدون سترات من المفوضية السامية للأمم المتحدة لشؤون اللاجئين (UNHCR) وعليها شعار الدول المتبرعة. أصبح تطور هذه المخيمات يشبه إلى حد بعيد التطور الحالي لمخيمات اللاجئين السوريين في الأردن.

بعد حرب الأيام الستة في العام 1967، وصل المزيد من اللاجئين الفلسطينيين إلى الأردن، واستقرت الغالبية العظمى منهم في مخيمات اللجوء، وأثناء حرب الخليج في تسعينيات القرن العشرين، لم تُبنى مخيمات مخصصة للاجئين العراقيين، إذ كان أغلب العراقيين الذين قدموا إلى الأردن حينها من المقتدرين ماليًا، واستقر معظم النازحين منهم في حرب الخليج الثانية في العام 2003، في العاصمة عمّان.

يعد وضع اللاجئين السوريين شبيهًا بوضع الفلسطينيين عام 1948، إذ استطاع معظم اللاجئين السوريين المقتدرين ماليًا الاستقرار في العاصمة وضواحيها، وبقيّ المهاجرين واللاجئين من غير المقتدرين على الحدود بين سوريا والأردن، وخصوصًا في مخيم الزعتري. يُعد الوضع الاجتماعي والاقتصادي قاسمًا مشتركًا لاندماج السكان القادمين إلى الأردن بغض النظر عن المكان الذي أتوا منه، حيث تعد القدرة المادية المحور الذي يحدد إن كانوا سيعيشون في إحدى المدن حياة كريمة وحرة، أو إن كانوا سيضطرون بسبب الظروف –وليس

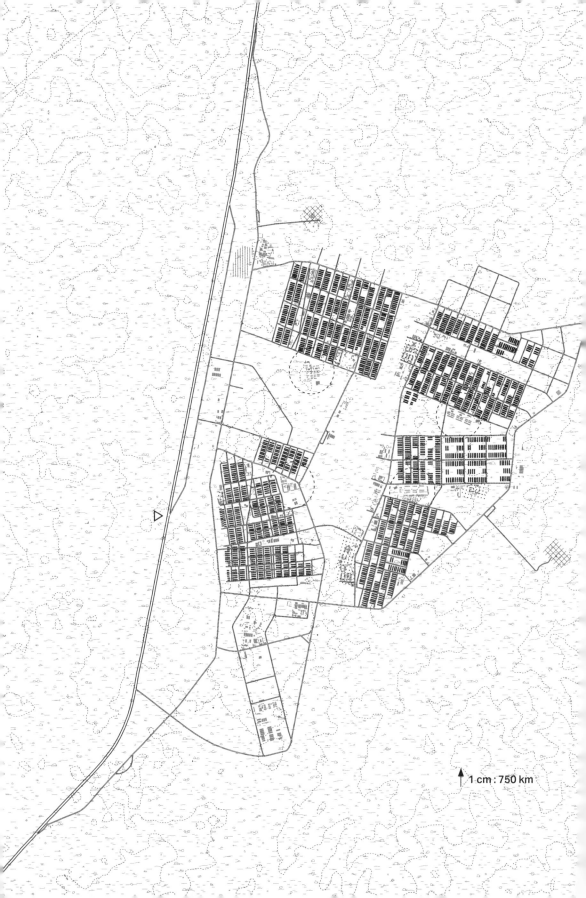

1 cm : 750 km

The Azraq Refugee Camp

The Azraq Refugee Camp in Jordan is a centrally planned, closed civilian camp for displaced Syrians founded in 2014 in response to the overflow of the Za'atari camp. It is situated 90 kilometers from the Jordan-Syria border and 20 kilometers west of the town of Azraq in Jordan's Eastern Desert. The camp is managed by the Jordanian government through the Syrian Refugee Affairs Directorate (SRAD) with the support of the United Nations High Commissioner for Refugees (UNHCR). It expands over 14.7 square kilometers.It is divided into four villages, subdivided into blocks, and then plots with most services available at the village level. The plan aimed to prioritize security and improve living conditions. The camp can host up to 130,000 people and currently accommodates approximately 36,000 residents.[1]

[1] Jordan: Azraq Camp Factsheet (July 2020), UNHCR Operational Data Portal (ODP), https://data2.unhcr.org/en/documents/details/78179.

- ■ Households
 المساكن

- ■ Camp facilities
 مرافق المخيم

- — Main roads
 طرق رئيسية

- — Secondary roads
 طرق فرعية

- ▽ Public entry
 المدخل الرئيسي العام

- Markets
 الأسواق

- School
 مدرسة

- Water infrastructure
 مصدر تزويد المياه

- Solar infrastructure
 مصدر تزويد الطاقة الشمسية

280 ⟩ ⟨ 45

مخيم الأزرق للاجئين

مخيم الأزرق للاجئين في الأردن هو مخيم مدني مغلق ومخطط مركزيًا للنازحين السوريين، تأسس عام 2014 استجابة لزيادة أعداد اللاجئين في مخيم الزعتري. يقع مخيم الأزرق على بعد 90 كم من الحدود الأردنية السورية، وعلى بعد 20 كم غرب منطقة الأزرق الواقعة في الصحراء الأردنية الشرقية. تدير الحكومة الأردنية المخيم من خلال مديرية شؤون اللاجئين السوريين (SRAD) وبدعم من المفوضية السامية للأمم المتحدة لشؤون اللاجئين (UNHCR). تمتد مساحة المخيم إلى 14.7

كيلومتر مربع، وهو مقسم إلى 4 قرى، تُقسّم بدورها إلى أحياء، ومن ثم إلى قطع أراضي تتوافر فيها معظم الخدمات على مستوى القرية. يهدف تخطيط المخيم إلى إعطاء الأولوية للأمن، وتحسين ظروف المعيشة. كما يمكن أن يستوعب المخيم ما يصل إلى 130 ألف شخص، وهو يستوعب حاليًا قرابة 36000 لاجئ.[1]

[1] الأردن: ورقة حقائق حول مخيم الأزرق (تموز 2020)، بوابة البيانات التشغيلية الخاصة بالمفوضية السامية للأمم المتحدة لشؤون اللاجئين (ODP)،

Humanitarian Design Gaps

Mohammad Yaghan *is a Professor in Design and Visual Communication at the German Jordanian University.* **Rejan Ashour** *is an Industrial Professor in Architecture and Interior Design, also at GJU. Together with Azra Akšamija they led participatory action research and transcultural workshops at the Azraq Refugee Camp from 2016 to 2018. Mohammad and Rejan discuss with the editors the value of refugee-led interventions and the ethics of cultural production with external entities at the camp.*

The interview took place online with participants connecting from Amman, Jordan, Nicosia, Cyprus, and Boston, Massachusetts on 17 June 2020.

The agency of art & design in encampment

Editors: Our collaboration with you and displaced Syrians at the Azraq camp started in 2016. After initial discussions over Skype we finally accessed the camp and met the team on a visit with you the fall of the same year.

Rejan: Our shared visit with MIT and GJU students was my first at a refugee camp. I was astonished by the complexity and effectiveness of modifications and new designs by Syrian refugees, given the newness of the camp, which had only just been inaugurated the year before. Interventions like the communal tent where people socialized every evening were helping residents acclimate to the new environment. Then I was impressed with the resilience of the Syrian youth. We met teenagers that

founded a newspaper at the camp, built their own toys, and channeled their emotions into poetry. I had never witnessed such sights before.

Mohammad: We visited the camp with high hopes and the daunting question: "What can we really achieve?" Our first meeting with residents and other stakeholders showed that a single visit could lift spirits. It made clear that residents wanted to break the idleness of life at the camp. Reaching out we met a community eager to collaborate and take the lead. It gave me hope that a contribution was indeed possible.

Rejan: One would assume that in conditions of conflict and crisis, art is secondary. What we witnessed at the camp is that creative expression is as necessary as any other primary commodity. Art & design at the camp are the means for the development of cultural bonds, the building of social ties, a way for residents across classes and regions of Syria to find cultural unity. Early on, displaced Syrians at Azraq recognized the need to surround themselves with objects reflective of their identity, to preserve their memories. The numerous fountains of the camp, a feature of the Syrian courtyard, is a representative example of this need.

Editors: The fountains are a very good example, as their role is not utilitarian. Beyond the cultural value of these projects I appreciate their design approach. We recorded the fountain of Abo Jar, who used buckets and shisha parts to assemble

282 > < 43

a portable fountain that could be easily reversed back to its parts when the use of the shisha or the bucket set would prevail as more important. The designer takes into account reversibility and the potential reuse of parts in the future!

Mohammad: The highlighting and crediting of these designs is a valuable tribute to displaced refugees. It makes visible the necessity of individuality and self-expression in a community over the anonymity of standardized designs.

Editors: The inventions articulate the shortcomings of the existing design scheme that appears to disregard the cultural and emotional dimension of the built environment.

Mohammad: Indeed, an example would be the lack of using the shared WCs because of their unsuitable design for women. Turning the spotlight to the exigency of cultural resilience and artistic expression is so important in large refugee infrastructures such as the Azraq camp. I believe the involvement of a creative community with the experience of refugeehood and encampment in the planning of spaces and everyday items for the displaced population would be valuable in providing better solutions.

A code of ethics for cultural practice in fragile environments

Editors: Our work in Jordan followed a big learning curve; our visits to the camp provoked questions on the ethics of our practice in fragile environments. One

of the issues of concern is the ethics of engagement and collaboration among groups of different capacities and privilege: an international group from MIT, your students representing the host community, humanitarian workers, and displaced Syrians at the camp. How do all of these groups work together? It was very important to work as a collective, build on each group's strengths and learn from each other. Eventually all these dilemmas came together as a crowdsourced code of ethics which was exhibited during the Amman Design Week that you hosted at the German Jordanian University; we learned from this that it is important to share these questions with others who will be entering the same context and dealing with the same issues.

Mohammad: There are so many lenses through which ethics can be considered, be they cultural, economic, psychological. There is no definitively correct judgement, and for that reason there should be an ethical committee assembled among many necessary groups when a country is hosting displaced people or when a camp is being built, to preserve the rights and dignity of the vulnerable.

The issue of income generation in refugee camps is particularly contentious. What does an ethical approach to livelihood under conditions of displacement look like?

Editors: From a western perspective of social entrepreneurship, the offering of employment in encampment enables self-reliance. From another point of view, the displaced populations in refugee camps

التي نواجهها في هذا الشأن، إضافةً إلى اضطرارنا تقبل هذا الواقع، حتى نتمكن من دخول المخيم وتقديم المساعدة.

فريق التحرير: هناك صراع داخلي حول الكثير من الجوانب المتعلقة بالعمل مع اللاجئين في المخيم، مثل حقيقة أننا جميعًا قادرون على الخروج من المخيم بينما لا يستطيع اللاجئون ذلك، الأمر الذي يعكس حالة من عدم المساواة، كما وأنّ اضطرارنا لقبول هذا الواقع والتعامل معه، يزيد من العبء على كاهلنا، ويؤدي إلى الإخلال بالتوازن بين الحرية والرفاهية.

محمد: يمكن النظر للأخلاقيات من عدة منظورات؛ سواءً كانت ثقافية أو اقتصادية أو نفسية. يتطلب هذا التنوع وجود لجنة أخلاقية ضمن المجموعات التي تتشكل عندما يستضيف بلدٌ ما لاجئين أو عندما يتم بناء مخيم، بهدف الحفاظ على حقوق وكرامة الفئات الضعيفة.

أما مسألة الحصول على الدخل في المخيم، فهي مسألة ضميرية. هل يمكن اعتبار العمل في المخيم مقابل الحد الأدنى للأجور أمر أخلاقي؟ وما الشكل الذي يتخذهُ النهج الأخلاقي لكسب العيش في حالات النزوح؟

فريق التحرير: من وجهة نظر اجتماعية غربية، يحفز توفير فرص العمل في المخيمات مبدأ الاعتماد على الذات. ومن وجهة نظر أخرى، لا يملك اللاجئون في المخيمات الخيار، إذ يعتمدون على الجهات التي تعمل على تمكينهم، والتي بدورها تجني الأموال من خلال اللاجئين أنفسهم.

محمد: يشكل التعامل مع المنظومة التي تتحكم بالأمور، والتي لا تخلو من الظلم، واحدًا من المعضلات الأخرى

don't necessarily have a choice: they are dependent on enablers, and enablers are making money off of them.

Mohammad: Another dilemma is having to deal with a system that isn't fully resolved and might contain moments of injustice, and simply having to accept that fact in order to be able to reach the camp and provide help, imperfect as the situation may clearly be.

Editors: There is an ongoing battle within oneself over many aspects concerning working with refugees at the camp. The fact is that we are all able to exit the camp while refugees are not. Right there is an unequal relationship, and you have to deal with that and accept that the benefit of a contribution outweighs this imbalance of freedom and privilege.

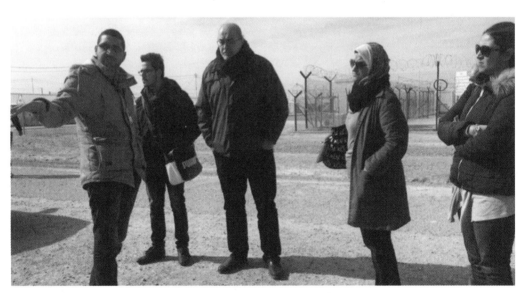

Malek Abdin, prof. Mohammad Yaghan, prof. Omayma al-Arja and prof. Rejan Ashour during the first visit of the team at the camp. Photo: FHL, January 2017.

مالك عابدين، والدكتور محمد ياغان، والدكتورة أميمة العرجا، والدكتورة ريجان عاشور خلال الزيارة الأولى لمخيم الأزرق للاجئين. الصورة: مختبر الإرث المستقبلي، كانون الثاني2017.

At the Azraq Refugee Camp we witnessed that creative expression is as necessary as any other primary commodity.

شهدنا في مخيم الأزرق للاجئين أن التعبير الإبداعي توازي ضرورته الاحتياجات الأساسية الأخرى.

مدونة أخلاقيات حول الممارسات الثقافية في البيئات المهمشة

فريق التحرير: أعطانا عملنا في الأردن الكثير من الدروس، وولدت زياراتنا للمخيم أسئلة كثيرة حول أخلاقيات ممارساتنا في البيئات المهمشة. كانت أكثر القضايا إثارة للجدل، هي الأسئلة حول أخلاقيات المشاركة والتعاون بين المجموعات المختلفة القدرات والامتيازات، والممثلة بالمجموعة الدولية من معهد ماساتشوستس للتكنولوجيا، وطلابكم في الجامعة الألمانية الأردنية الذين يمثلون المجتمع المضيف من جهة، والعاملين في المجال الإنساني، واللاجئين السوريين في المخيم من جهة أخرى. أسئلة مثل: كيف تعمل جميع هذه المجموعات معًا؟ هل كان العمل بشكل جماعي مهمًا في هذه الحالة؟ وكيف نرتكز على نقاط قوة كل مجموعة، ونتعلم من بعضنا البعض؟ في نهاية المطاف، تم جمع كل التحديات التي واجهتنا في مدونة أخلاقية، عُرضت في «أسبوع عمّان للتصميم» في الجامعة الألمانية الأردنية. لقد تعلمنا أهمية مشاركة هذه الأسئلة، من أجل الآخرين الذين سيدخلون نفس المجال، وسيواجهون نفس التحديات.

أبو جار على أن يبقى قادرًا على فك أي جزء منها دون أن يتضرر، في حال أراد استعماله لمنافع أخرى لاحقًا.

محمد: يعتبر تسليط الضوء على هذه التصاميم وتقدير قيمتها تكريمًا للاجئين المهجرين، كما ويوضح ضرورة الاستقلال الفردي والتعبير عن الذات في المجتمع، بدلاً من طمس الهوية الفردية تحت التصاميم الموحدة.

فريق التحرير: توضح التدخلات أوجه القصور في مخطط التصميم الحالي، الذي من الواضح أنه تجاهل البعد الثقافي والعاطفي في البيئة المصممة.

محمد: بالفعل، ومثال ذلك هو قلة استخدام دورات المياه المشتركة بسبب تصاميمها غير المناسبة للنساء. يصبح تسليط الضوء على الضرورة الملحة للمرونة الثقافية والتعبير الفني، أمرًا شديد الأهمية في البنى التحتية الكبيرة التي تضم اللاجئين، مثل مخيم الأزرق. أعتقد أنّ مشاركة مجتمع مبدع -ذي خبرة بموضوع اللجوء والتهجير القسري- في تخطيط المساحات وعناصر الحياة اليومية للاجئين، سينعكس إيجابًا على توفير حلول تصميمية ومعيشية أفضل.

الثغرات في التصميم الإنساني

محمد ياغان: أستاذ في التصميم والتواصل المرئي في الجامعة الألمانية الأردنية. **ريجان عاشور:** أستاذ ممارس في الهندسة المعمارية والتصميم الصناعي في الجامعة الألمانية الأردنية. أجرى الدكتور ياغان والدكتورة عاشور مع الدكتورة أزرا أكشامية بحثًا علميًا مُشتركًا وورش عمل متعددة الثقافات في مخيم الأزرق للاجئين بين الأعوام 2016–2018. في حوارٍ لهما مع فريق التحرير، ناقشا قيمة التدخلات المصممة من قبل اللاجئين، وأخلاقيات الإنتاج الثقافي في المخيم وعلاقتها بالجهات الخارجية.

تمَّ عقد هذا اللقاء عن بعد، بمشاركة المحاورين من العاصمة الأردنية عمان، ومدينة بوسطن في الولايات المتحدة الأمريكية، ونيقوسيا في قبرص، في تاريخ 2020/06/17.

قوة الفن والتصميم في مخيمات اللجوء

فريق التحرير: بدأ تعاوننا معكم ومع اللاجئين السوريين في مخيم الأزرق في العام 2016، وبعد عدد من النقاشات الأولية التي أجريناها عبر برنامج سكايب، قمنا بزيارة المخيم للقاء هذه المجموعة برفقتكم في خريف ذلك العام.

ريجان: كانت الزيارة التي قمنا بها برفقة الوفد من معهد ماساتشوستس للتكنولوجيا وطلاب الجامعة الألمانية الأردنية أولى زياراتي للمخيم. أدهشتني التراكيب والتعديلات والتصاميم الجديدة التي قام بها اللاجئون السوريون، خاصةً بالنظر إلى القصر النسبي لفترة تواجدهم في المخيم، إذ تمَّ افتتاح المخيم قبل زيارتنا بعام واحد فقط. ساعدت تدخلاتٌ - مثل الخيمة الجماعية التي يجتمع فيها الناس كل مساءً - سكان المخيم على التأقلم مع البيئة الجديدة. تأثرت بقدرة الشباب السوري على التكيف، عندما التقينا المراهقين الذين أسسوا مجلة في المخيم، وصنعوا ألعابهم الخاصة، وعبروا عن مشاعرهم من خلال كتابة الشعر. لم يسبق لي أن شهدت مثل هذا الوضع من قبل.

محمد: في زيارتنا للمخيم، رافقتنا آمالٌ كبيرة وسؤالٌ مهم بقيَّ يجوب في أذهاننا، وهو «ما الذي يمكننا تحقيقُه بالفعل؟». أظهر لقاؤنا الأول مع سكان المخيم وأصحاب التصاميم ما تستطيعُ زيارة واحدة تحقيقه من رفع للروح المعنوية. بيَّن هذا اللقاء أيضًا، رغبة اللاجئين في كسر الجمود الذي يحيط بالحياة في المخيم. أتاحت لنا زيارتنا الفرصة للقاء مجتمع حريص على التعاون وتولي زمام المبادرة، وقد منحتني كل هذه العوامل الأمل في إمكانية المساهمة في تحقيق شيء ما.

يجد اللاجئون في التصميم أدوات ثقافية للتعبير عن البيئة القاسية التي تحوي الملاجئ في الصحراء. تملك جميع التصاميم مراجع ثقافية، سواء كانت أعمالًا فنية، أو أغراضًا بأهداف عملية.

ريجان: قد يفترض المرء أنّ الفن يعتبر موضوعًا ثانويًا في ظروف الصراع والأزمات. ولكننا شهدنا في مخيم الأزرق للاجئين أنّ التعبير الإبداعي ضروري مثل أي أولوية أخرى. يعتبر الفن والتصميم في المخيم، وسيلة لتنمية الروابط الثقافية، وبناء العلاقات الاجتماعية، وطريقة يستطيع عبرها سكان المخيم إيجاد الوحدة الثقافية التي تجمعهم رغم انتمائهم لطبقات مجتمعية ومناطق مختلفة من سوريا. أدرك اللاجئون السوريون في مخيم الأزرق في وقت مبكر، الحاجة لإحاطة أنفسهم بأشياء تعكس هويتهم وتحافظ على ذكرياتهم، وتُعد النوافير المنتشرة في أرجاء المخيم، وهي واحدة من سمات ساحات البيوت في سوريا، أمثلة على هذه الحاجة.

محمد: تُعتبر إضافة النوافير في المشاريع السكنية وتربية الحمام في المخيم بمثابة سبل لحفظ ذاكرة المجتمع، وتطعيم تصميمه بالرموز الثقافية.

فريق التحرير: تعتبر النوافير مثالاً جيدًا، حيث أنّ دورها ليس نفعيًا. نُقدّر مناهج وطرق تصميم هذه المشاريع، وكذلك إلى القيمة الثقافية التي تضفيها. قمنا بتوثيق إحدى النوافير في مسكن أبو جار، وقد استخدم في بنائها عددًا من الدلاء، وقطعًا من الشيشة، لتصبح نافورة يمكن فكها وإعادة تركيبها بسهولة عند الحاجة لاستخدام أجزائها. عند تصميمه لهذه النافورة، حرص

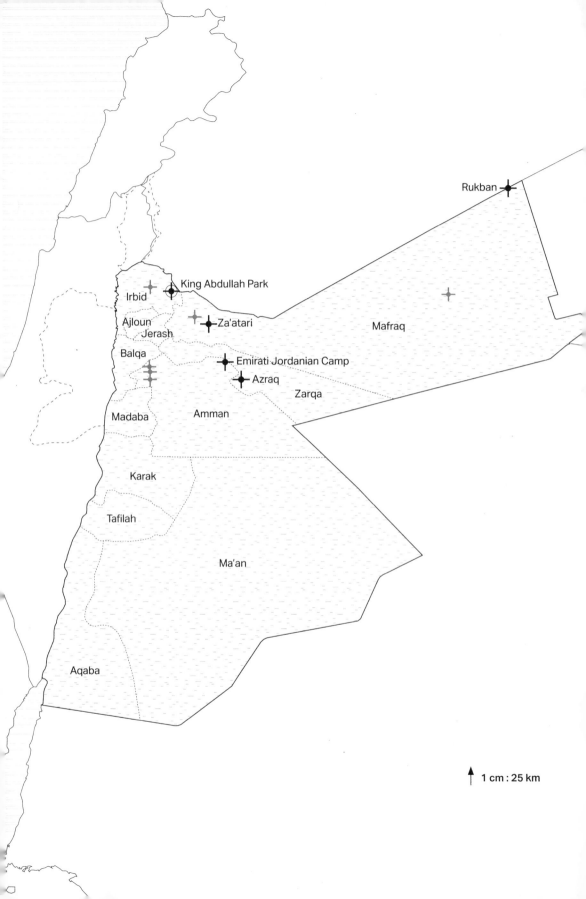

Rukban

King Abdullah Park

Irbid

Ajloun

Jerash Za'atari

Balqa

Mafraq

Emirati Jordanian Camp

Azraq

Madaba

Zarqa

Amman

Karak

Tafilah

Ma'an

Aqaba

1 cm : 25 km

Jordan

Jordan accommodates approximately 2.9 million Palestinian, Syrian, Iraqi, Yemeni, and Somali refugees. It is the second-largest refugee-hosting country in the world after Turkey.[1] About 85 percent of the 654,700 Syrian refugees in Jordan are urban-based, with the remaining population living in camps.[2] The Za'atari refugee camp is the largest in the country, accommodating almost 80,000 Syrian refugees.[3]

[1] The number includes 2.3 million Palestine refugees under UNRWA's mandate. UNHCR, Global Trends: Forced Displacement in 2019, 3, https://www.unhcr.org/globaltrends2019.

[2] Ibid., 20.

[3] Jordan: Zaatari Camp Factsheet (January 2020), UNHCR Operational Data Portal (ODP), https://data2.unhcr.org/en/documents/details/73845.

الأردن

يضم الأردن قرابة 2.9 مليون لاجئ، من فلسطين وسوريا والعراق واليمن والصومال، ويُعتبر ثاني أكبر دولة مستضيفة للاجئين في العالم بعد تركيا.[1] يعيش حوالي 85% من اللاجئين السوريين، أي ما يعادل 654700 لاجئ، في المناطق الحضرية، ويقطن بقية اللاجئين في المخيمات.[2] يُعد مخيم الزعتري للاجئين الأكبر في البلاد، ويضم قرابة 80 ألف لاجئ سوري.[3]

[1] (UNRWA) يشتمل العدد 2.3 مليون لاجئ فلسطيني لاجئ فلسطيني تحت وصاية وكالة الأمم المتحدة لإغاثة وتشغيل اللاجئين الفلسطينيين النزوح القسري 2019، صفحة رقم 3، (UNHCR) تقرير الاتجاهات العالمية للمفوضية السامية للأمم المتحدة لشؤون اللاجئين

[2] المرجع نفسه

[3] الأردن: ورقة حقائق مخيم الزعتري للاجئين، أيار 2020، (UNHCR) المفوضية السامية للأمم المتحدة لشؤون اللاجئين

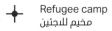
Refugee camp
مخيم للاجئين

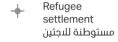
Refugee settlement
مستوطنة للاجئين

UNHRC office
مكتب المفوضية السامية للأمم المتحدة لشؤون اللاجئين

⋯⋯⋯ Governorates
محافظات

وجهات نظر حول التصميم الإنساني

Perspectives on Humanitarian Design

Collaborations Across Borders

Over the course of four years, *Design to Live* evolved as a collaboration between researchers and students of the MIT School of Architecture and Planning (SA+P) and the Future Heritage Lab (FHL) with Syrian refugees at the Azraq Refugee Camp, humanitarian aid workers from CARE International, Jordan, and faculty, students, and alumni from the German-Jordanian University (GJU), School of Architecture and Built Environment. In 2016, with the generous support of SA+P and the MISTI Arab World Program, we initiated a series of encounters and creative collaborations between the above-mentioned collaborators, which unfolded in the form of courses, interdisciplinary seminars, exhibitions, and public events. These encounters informed our shared belief that refugee camps need to be approached as civic spaces where crucial social healing, innovation, creativity, and cross-cultural exchanges take place. From this belief, we explore the potential roles of art, design, and imagination in conditions of forced displacement from the bottom up in order to foreground the urgent need to interrogate the ethics of design practices within the broader context of the many agencies and industries that build and run humanitarian missions and infrastructure.

The various collaborations contributing to this book took different forms. In conversation with artists, engineers, and designers at Azraq, we documented the creative production in the camp to understand how residents themselves deploy design to address the shortcomings of humanitarian aid. Through a process of co-creation, we introduced new designs to address the social, cultural, and aesthetic needs of refugees. In collaboration with InZone, the University of Geneva's initiative for learning in sites of crisis, we designed a space for the creative expression and education of displaced Syrians.[1] With a series of transdisciplinary workshops and exhibitions across the United States, Europe, and the MENA region, we cultivated a conversation on the ethics of design in fragile environments, especially in relation to community engagement, cultural preservation, and equitable development. The series led to the creation of our Code of Ethics platform, a shared repository for the dissemination of best practices, critical questions, and lessons that can be useful for practitioners in the humanitarian context (discussed in more detail below).[2]

Our encounters produced research-based, horizontal collaboration formats prioritizing process over product. We took care to generate multidirectional exchanges across political, disciplinary, and generational borders. Through the methods of participatory art, socially engaged design, and experimental heritage preservation, we have tried to support cultural resilience of displaced communities. Through the dissemination of this work, we aim to

294 > < 31

[1] InZone is an academic center at the University of Geneva that uses connected learning to pioneer innovative approaches to multilingual communication and higher education for refugees and their host communities. The MIT Future Heritage Lab designed the InZone Higher Education Learning Hub at the Azraq Refugee Camp. The hub was inaugurated in the fall of 2018.

[2] See: https://www.codeofethics.online/.

contribute to the valorization and prioritization of social and cultural objectives in crisis zones, moving beyond the established paradigm of "basic needs."

Unfolding our process

The first year of collaborations began in 2016 with the involvement of the faculty and students from the German-Jordanian University, guests from Architecture Sans Frontières, International Art Academy Palestine, Amman Design Week, and Cluster Labs—all within the framework of Azra Akšamija's course Design for a Nomadic World at MIT. We focused on understanding the refugee context in Jordanian cities and camps, and within that broader purview, the specificities of the Azraq Refugee Camp. Through a series of in-person and remote video meetings

with camp residents, and workshops in Boston, Amman, and Azraq, we identified and unpacked the challenges of living within the confines of the camp.

The initial drive for our work was to understand how we could leverage the capacities of our educational institutions, as well as make use of our skills as artists and designers, to support Syrian refugees. Our Participatory Action Research process led to a shared realization: instead of designing for refugees, we ought to learn from them. This meant documenting, understanding, and making visible the many ways in which Azraq residents were tackling the challenges of encampment through design. Their inventions reveal, in a profound way, the effects of geopolitical decisions, conflict, and crisis at the human scale, on the level of the everyday. In

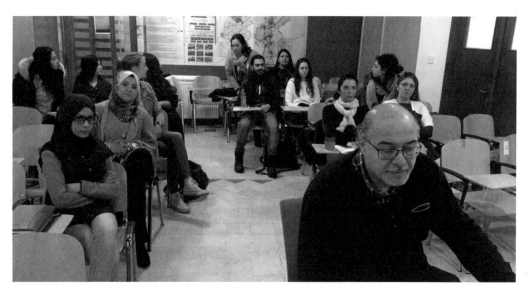

First design workshop at the Azraq Refugee Camp with MIT, GJU, and Syrian students as part of the *Design for a Nomadic World* course. Photo: FHL, April 2017.

أول ورشة عمل حول التصميم في مخيم الأزرق للاجئين، بمشاركة طلاب من معهد ماساتشوستس للتكنولوجيا والجامعة الألمانية الأردنية والطلاب السوريين، ضمن إطار المادة التي تُدرسها الدكتورة أزرا أكشامية في معهد ماساتشوستس للتكنولوجيا بعنوان "التصميم في عالم الترحال". الصورة: مختبر الإرث المستقبلي، نيسان 2017.

relation to the approach and principles of humanitarian relief, refugee-driven creative production unmasks the discrepancy between available aid infrastructure and the real needs of refugees.

During the summer of 2017, we moved forward with the comprehensive documentation of camp inventions in close collaboration with members of the *Azraq Journal*, a refugee-led publication by young community leaders. The journal team reached out to the creative community of the camp and facilitated an introduction with MIT/GJU researchers. In this unprecedented photographic survey, members of the camp journal and MIT/GJU team jointly recorded artifacts, mechanical inventions, shelter alterations, and large-scale design interventions that defy material scarcity, harsh climatic conditions,

camp regulations, and the cultural austerity of the camp to create a life worth living. Pictures of the survey featured in this book, offer an overview of the designs in situ and an intimate view of Syrian inventors' lives.

In conversation with the *Azraq Journal* team, we explored the possibility of showcasing these designs to a wider audience within and outside the confines of the camp. As part of the Kinetic Heritage and Culturally Sensitive Design courses led by Azra Akšamija at MIT, students formed three-way collaborations between MIT, GJU, and the camp. With a focus on selected designs from Azraq, the groups explored the relevance of art and design in conditions of encampment. The photographic survey and the students' collaborative work was exhibited at the Design for a Nomadic World exhibition,

296 〉 〈 29

Collective mapping of issues of concern at the Azraq Refugee Camp with MIT, GJU, and Syrian students. Photo: FHL, April 2017.

خريطة مفصلة تتضمن أبرز القضايا المهمة في مخيم الأزرق للاجئين، وتم تنفيذها من قبل معهد ماساتشوستس للتكنولوجيا، والجامعة الألمانية الأردنية، والطلاب السوريين. الصورة: مختبر الإرث المستقبلي، نيسان 2017.

as part of the Amman Design Week 2017. The show was hosted by the GJU and our Jordanian faculty and student collaborators. Thanks to the tireless efforts of the CARE-Jordan team in navigating complex security bureaucracies, the *Azraq Journal* team and workshop participants were given a special permit to attend the exhibition opening in Amman.

The exhibition success was seminal in moving our collaborative work at Azraq in the direction of a publication. In 2018, the support of the Graham Foundation for Advanced Studies in the Fine Arts allowed for the further development of this research into the book you are currently reading.

Starting in 2018, it became increasingly more difficult to reach the displaced Syrian designers at the camp and continue our collaboration on novel design practices at Azraq. Barriers included shifts in the process for camp permits and increased security measures for visiting refugees in their own settings rather than in NGO facilities. Still, we did manage to engage with the youth of the camp as part of the psychosocial activities program of CARE. In this case, our focus was creative writing, unleashing imagination about new inventions and what's possible with the limited resources in hand. To conduct the writing workshops, we collaborated closely with the displaced Syrian teacher, Muteeb Awad Al-Hamdan. These sessions explored processes for self-expression and provided a medium of self-representation for several of the youth featured in this book. The stories offer a rare insight into camp life through the eyes of teenagers coming to age.

The Lightweaver: Light sculptures for the customization of shelter interiors with the projection of patterns inspired by the textile tradition of the region. The Lightweaver was co-created at MIT, GJU, and the Azraq Refugee Camp as part of the Kinetic Heritage course. Photo: Zeid Madi, February 2018.

تصاميم إنارة تم تنفيذها ضمن مشروع Lightweaver، وهي مخصصة لتزيين المساحات الداخلية في الملجئ، استوحيت من أنماط النسيج التقليدي في المنطقة. مشروع Lightweaver هو مشروع تعاوني مشترك بين معهد ماساتشوستس للتكنولوجيا والجامعة الألمانية الأردنية ومخيم الأزرق للجئين، ضمن إطار دورة "التراث الحركي". الصورة: زيد ماضي، شباط 2018.

Prototypes of the Lightweaver at the *Design for a Nomadic World* exhibition, part of the Amman Design Week parallel program, Amman, Jordan. Photo: Zeid Madi, October 2017.

نماذج أولية من مشروع Lightweaver ضمن إطار معرض "التصميم في عالم الترحال" الذي أقيم ضمن فعاليات أسبوع عمّان للتصميم في الأردن. الصورة: زيد ماضي، تشرين الأول 2017.

مثل السؤال عن قدرة من يمارسون الفن والتصميم على القيام بما هو أبعد من مهمة الإنقاذ فقط، وتطوير الأدوات والنماذج التي تعالج/تعكس اختلالات القوة في البيئات المتضررة، وكيفية دعم ائتلافات المؤسسات للفن والتصميم المجتمعيين لتحقيق مساهمة إيجابية أو تحفيز التغيير في العالم الذي تزداد فيه مظاهر عدم المساواة، وكيفية الاستفادة من المؤسسات التعليمية ذات الامتيازات مثل معهد ماساتشوستس للتكنولوجيا والجامعة الألمانية الأردنية للمساعدة في تسهيل تغيير الانظمة في مجال الإغاثة الإنسانية. قمنا بتطوير «منصة أدبيات الأخلاق Code of Ethics Platform» المذكورة أعلاه، لمساعدتنا في فهم هذه الأسئلة والإجابة عليها، وهي تمثل مصدرًا مفتوحًا على شبكة الإنترنت لتقديم معلومات متعددة التخصصات ووجهات نظر متعددة الثقافات حول الأخلاقيات والتصميم وندرة الموارد. تدعو المنصة الجهات الفاعلة الدولية والمحلية في الولايات المتحدة وكندا والنمسا والأردن والإمارات للمساهمة في طرح الأسئلة والأفكار والمبادئ التوجيهية المتعلقة بدور الفن والتصميم في سياق الصراع والأزمات، والتي يتم تناولها وعرضها بدورها في المعارض والورش الفنية والمحاضرات والندوات.[3] حفز

هذا المشروع النقد الذاتي للعمل بشكلٍ عام، ، ومثّل هيكل مساءلة مهم لكتاب «التصميم للحياة».

نعترف، بصفتنا فنانين ومصممين ومدرسين، بتواطؤنا مع النظام العالمي الذي يسوده عدم المساواة، ونعترف بإمكانيات وحدود قوتنا في تغيير العالم للأفضل. نأمل مواصلة توظيف مهاراتنا وقدراتنا لدعم أحقية المهجرين قسرًا في تقرير مصيرهم. وعليه، يُصر كتاب «التصميم للحياة» على أنّ النزوح القسري في عالمنا اليوم ليس مجرد قضية مهمشة يمكن ببساطة إحالتها إلى الحوكمة الإنسانية والاقتصاد الإغاثي، بل هي حقيقة واسعة النطاق تؤثر على الجميع أكثر فأكثر، ولا يمكن مناقشتها بجدية إلا من خلال نهج تشاركي متعدد الجوانب، وتتصدرُه بشكلٍ أساسي أصوات اللاجئين.

3 على سبيل المثال: ورشة عمل الدكتورة أزرا أكتشامية في قمة Design for Humanity لعام 2019 في مدينة نيويورك، والتي يديرها المعهد الدولي للشؤون الإنسانية في جامعة فوردهام والمنظمة الدولية للهجرة.

Back at MIT, a diverse group of students and researchers in the School of Architecture and Planning reflected on these same refugee designs in the language of their formal training: drawings. Through the analytical framework of "reverse engineering," the MIT students analyzed the design methods deployed in representative refugee inventions and explored the material manipulations involved in their making. The resulting drawings make visible how refugee designs are intentional, transformative, and powerful. These drawings represent a form of documenting, archiving, and sharing lessons about design practices in fragile environments to a wide audience outside the confines of the camp, including humanitarian organizations, policymakers, and academia.

Eventually, in 2019, we were able to reconnect with some of the displaced Syrian designers, who remained living in the camp (in the meantime, some designers also moved away). In contrast to our previous visits, we were accompanied by representatives of the camp police and the Syrian Refugee Affairs Directorate of the Jordanian Ministry of Interior. Recording was not allowed, so the documentation of the designers' work and processes was carried out with notes.

The year 2020 found our group in quarantine in the midst of the COVID-19 pandemic, spread across our working locations in Cyprus, Lebanon, USA, and Jordan. The development of the book in this stage involved working sessions online, interviews with key actors to the project via Zoom and WhatsApp, and

Designers, humanitarian workers, and researchers from MIT, GJU, and the Azraq camp at the *Design for a Nomadic World* exhibition launch, part of the Amman Design Week parallel program, Amman, Jordan. Photo: GJU, October 2017.

مصممون وعاملون في المجال الإنساني وباحثون من معهد ماساتشوستس للتكنولوجيا والجامعة الألمانية الأردنية ومخيم الأزرق للاجئين، في افتتاح معرض "التصميم في عالم الترحال" ضمن فعاليات أسبوع عمّان للتصميم في الأردن. الصورة: الجامعة الألمانية الأردنية، تشرين الأول 2017.

Code of Ethics? exhibition, Keller Gallery, MIT.
Photo: FHL, February 2018.

معرض مدونة الأخلاقيات، معرض كيلر، معهد ماساتشوستس
للتكنولوجيا. الصورة: مختبر الإرث المستقبلي، شباط 2018.

الإنسانية بالتفاعل بين الجهات الإدارية في المخيم، مما يوفر إمكانية لتغيير الوضع الراهن. تحدى تعاوننا مع منظمة كيرعلى سبيل المثال، المفاهيم الراسخة للأنشطة النفسية والاجتماعية، وقدم طرقًا جديدة للتعامل مع سكان المخيم، ومهد الطريق أمام المزيد من المبادرات التعاونية متعددة التخصصات في المستقبل.

من الشائع جدًا في سياق العمل الإنساني، أن يتولى الناس التفكير والكتابة والتخيل وحل المشكلات نيابة عن اللاجئين، ويكون اللاجئون غالبًا مجرد «موضوع بحث» ضمن إطار البحث الأكاديمي في مخيمات اللجوء، لكننا عارضنا هذه الفكرة، وقمنا بدلاً منها بلعب أدوارٍ تعاونية ضمن مشروع مشترك، من دون أن ننوب عن أصوات شركائنا السوريين أو الأردنيين أو الدوليين. يعترف الكتاب بالملكية الفردية لجميع من ساهم في تأليفه من الأفراد الذين يعيشون ويعملون داخل المخيم، والأفراد الذين زاروا المخيم قادمين من الخارج.

كان علينا، في خضم تطوير كتاب «التصميم للحياة»، أن نتجاوز عددًا من المشكلات المتعلقة بالمشاركة في العمل الإنساني، والتي تُثير العديد من التساؤلات،

بعد، والتي على الرغم من فعاليتها، إلا أننا لم تخلُ من عوائق بسبب صعوبة الوصول إلى التكنولوجيا واستخدامها في المخيم، وفي ظل ظروف انقطاع الكهرباء وشبكة الانترنت في أول عامين، اعتمدنا على تبادل الرسائل النصية، واستخدمنا برامج الترجمة لتجاوز حاجز الاختلاف اللغوي، كما تعاون معنا أفرادٌ سوريين وأردنيين في المخيم. أما الصعوبة الأخرى فكان سببها يتعلق بضوابط الفصل بين الجنسين، مثل حالة الزيارات الاستطلاعية للعديد من الأسر، والتي كان يرافقنا فيها ممثلين من فريق مجلة مخيم الأزرق ومنظمة كير والجهات الحكومية، مما شكل مجموعات مختلطة ومنع المبدعات الإناث من المشاركة في الاستطلاع، في حين أدى عقد ورش الكتابة الإبداعية في جلساتٍ منفصلة بين الفتيات والفتيان لزيادة مشاركة الإناث بشكل ملحوظ.

يمتد عدم الإستقرار هذا إلى اللوائح والمبادئ التوجيهية في مخيم اللاجئين. فبينما تعتمد إدارة المخيم على سياسات المؤسسات الدولية والجهات الحكومية، فإن تفسير هذه القوانين في الموقع يعتمد على ردود أفعال الضغوطات المحلية. تسمح الطبيعة المرنة للأنظمة

exploring visual storytelling as a vehicle for the dissemination of the knowledge gained in our four-year engagement with displaced Syrians at Azraq. With the support of the Transmedia Storytelling Initiative at MIT, we developed four drawings representing four conceptual "strolls" through the camp. Inventions from various camp locations were thus woven together to highlight four perspectives on LIFE in the camp—an acronym defining the four sections of this book: 1. Landscape, 2. Intimacy, 3. Fellowship, and 4. Energy.

Navigating access, representation, and privilege

The uncertainty inherent in conditions of displacement was constantly reshaping the team structure and terms of our collaboration. Reductions in funding for the

humanitarian sector saw us lose several collaborators from CARE. Reforms of humanitarian regulations in Jordan meant that we were no longer granted permission to meet Syrian refugees in their private spaces. Access to the camp was contingent on different levels of permits granted by a consortium of governmental agencies with regulations under continuous transformation. To address the challenges of physical access, as mentioned, we relied on remote access to the camp. Although valuable, this also surfaced issues of technological illiteracy and unequal access to technology within the camp. In the absence of stable electricity and internet connections, for the first two years we carried out our exchanges on messaging platforms. To bridge the language barriers, we relied on online translation tools and multilingual Syrian and Jordanian collaborators at

The mid-term review of the Culturally Sensitive Design course at MIT, FHL Digital *Majlis* installation part of the *Housing +* exhibition, Center for Advanced Urbanism biennial, Boston, US. Photo: FHL, September 2018.

استعراض جزء من تصاميم المجالس في المخيم خلال مادة "التصميم الثقافي" في معهد ماساتشوستس للتكنولوجيا في مركز العمران المتقدم، في مدينة بوسطن في الولايات المتحدة الأمريكية. الصورة: مختبر الإرث المستقبلي، شهر أيلول من العام 2018.

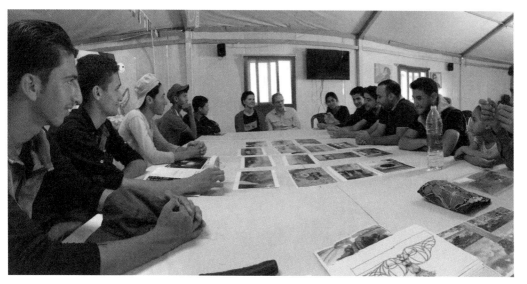

Creative writing workshop, Azraq Refugee Camp,
Jordan. Photo: Akemi Sato, July 2018.

ورشة الكتابة الإبداعية في مخيم الأزرق للاجئين في الأردن.
الصورة: أكيمي ساتو، تموز 2018.

المتضررة لجمهور واسع خارج حدود المخيم، بما في
ذلك المنظمات الإنسانية وصانعي السياسات والأوساط
الأكاديمية.

كنا في العام 2019 من التواصل مجددًا مع بعض
المصممين الذين ما زالوا يعيشون في مخيم الأزرق
للاجئين، إذ انتقل بعض المصممين منهُ في غضون
ذلك. وعلى عكس زياراتنا السابقة، رافقنا في تلك المرة
ممثلون من القوى الأمنية في المخيم ومديرية شؤون
اللاجئين السوريين التابعة لوزارة الداخلية الأردنية،
ولم يُسمح لنا بالالصورة، مما دعانا لتوثيق مجريات
الاختراعات من خلال تدوين الملاحظات.

فرض العام 2020 على مجموعتنا العمل تحت ظروف
الحجر الصحي بسبب جائحة وباء كورونا في مواقع
عملنا في قبرص ولبنان والولايات المتحدة الأمريكية
والأردن. تمّ تطوير الكتاب في هذه المرحلة من خلال
جلسات العمل عبر الانترنت، وعقدنا اللقاءات مع
الأطراف الرئيسية للمشروع عبر تطبيقي Zoom و
WhatsApp، لتعزيز السرد البصري كأداة لنشر
المعارف التي تكونت طوال أربع سنوات من التعاون

مع اللاجئين السوريين في مخيم الأزرق. وبدعم من
مبادرة «رواية القصص عبر الوسائط المتعددة» في معهد
ماساتشوستس للتكنولوجيا، طورنا أربع رسومات تمثل
الجولات المفاهيمية في المخيم، التي تضم اختراعات
من مواقع المخيم المختلفة، من أجل تسليط الضوء على
عناصر الحياة في المخيم، والتي تحدد بدورها أقسام
هذا الكتاب، وهي: 1. الحدود، 2. اليسر، 3. الألفة،
4. التمديدات.

التنقل المتاح، والتمثيل، والامتياز

أثرت ظروف النزوح الغير المستقرة على عملنا وتعاوننا
كفريق، حيث فقدنا العديد من شركاء العمل من هيئة
الإغاثة كير (CARE) بسبب خفض تمويل القطاع
الإنساني، ولم نُمنح الإذن مجددًا لمقابلة اللاجئين
السوريين في ملاجئهم الخاصة بسبب التغيرات على
قوانين العمل الإنساني في الأردن، وأصبح دخول
المخيم مشروطا بتصاريح مختلفة المستويات تُمنح من
قبل الجهات الحكومية ضمن تعليمات خاضعة للتغيرات
المستمرة. ومن أجل التغلب على التحديات التي تواجه
إجراء اللقاءات الشخصية، اعتمدنا عقد اللقاءات عن

the camp. The difficulty of access further intensifies in relation to gender norms. In the case of the survey, we visited several households with representatives from the *Azraq Journal*, CARE, and governmental agencies. It is possible that the presence of a mixed group discouraged female creatives from participating in the survey, whereas the creative writing workshops were held in separate gatherings for girls and boys, significantly increasing female participation.

The uncertainty in the refugee camp extends to regulations and guidelines. While the administration of the camp is contingent on policies of international institutions and governmental agencies, the interpretation of these regulations on site is set according to reactions to local pressures. The elastic nature of humanitarian

regulations allows for an interplay among the administrative agencies of the camp, offering the potential to transform the status quo. Our collaboration with CARE, for instance, challenged established categories of psychosocial activities and introduced new ways of engaging with residents, creating a precedent for more interdisciplinary collaborative initiatives in the future.

In the humanitarian context, it is very common for people to think, write, visualize, and problem solve on behalf of refugees. In the framework of academic research in refugee camps, residents are often the "research subject." We contested this approach and instead assumed the role of collaborators on a shared project. We did not assume the voices of our Syrian, Jordanian, or international collaborators.

Remote meetings with MIT researchers about the visual storytelling of the book. Photo: FHL, April 2020.

لقاء عن بعد مع باحثين في معهد ماساتشوستس للتكنولوجيا حول موضوع رواية القصص عبر الوسائط المتعددة، وأهميتها في نشر هذا الكتاب. الصورة: مختبر الإرث المستقبلي، نيسان 2020.

Remote meetings with MIT students and researchers working on the reverse engineering of the Azraq designs. Photo: FHL, May 2019.

لقاء عن بعد مع طلاب وباحثين في معهد ماساتشوستس للتكنولوجيا، حول الهندسة العكسية في تصاميم مخيم الأزرق. الصورة: مختبر الإرث المستقبلي، شهر أيار من العام 2019.

التدريس والطلاب، وبفضل الجهود الدؤوبة التي بذلها فريق منظمة كير CARE في الأردن في التعامل مع الإجراءات الأمنية المعقدة، تمّ منح فريق مجلة مخيم الأزرق للاجئين والمشاركين في ورشة العمل تصريحًا خاصًا لحضور افتتاح المعرض في عمّان.

كان نجاح المعرض عاملاً أساسيًا في توجيه عملنا التعاوني في الأزرق باتجاه النشر، وفي العام 2018، سمح دعم مؤسسة جراهام للدراسات المتقدمة في الفنون الجميلة بتطوير هذا البحث ليصبح كتابًا تقرأه بين يديك الآن.

ازدادت في العام 2018، صعوبة الوصول إلى المصممين من اللاجئين السوريين في المخيم لمواصلة التعاون بخصوص ممارسات التصميم في مخيم الأزرق. كان سبب العوائق تحولات في عملية منح التصاريح وزيادة التدابير الأمنية لزيارة اللاجئين في مساكنهم بدلاً من مرافق المنظمات غير الحكومية، وبالرغم من ذلك، استطعنا لقاء الشباب في المخيم من خلال برنامج الأنشطة النفسية والاجتماعية الذي تنظمه منظمة كير CARE. كان تركيزنا في تلك المرحلة على

الكتابة الإبداعية وإطلاق العنان للخيال حول الاختراعات الجديدة وما يمكن ابتكاره بوجود موارد متاحة محدودة ومن أجل إقامة ورش العمل، تعاونا بشكل وثيق مع الأستاذ السوري متعب عوض الحمدان، وقد تطرقت جلسات الورش إلى مواضيع التعبير عن الذات، وقدمت وسيلة لتمثيل الذات للعديد من الشباب الوارد ذكرهم في هذا الكتاب. تتيح قصص هؤلاء المراهقين، الذين يكبرون في المخيم يومًا بعد يوم، إلقاء نظرة على الحياة من منظورهم الخاص.

قامت مجموعة متنوعة تضم طلاباً وباحثين في كلية الهندسة المعمارية والتخطيط في معهد ماساتشوستس للتكنولوجيا، بالتعبير عن تصاميم اللاجئين من خلال الرسومات المعمارية التي يستعملونها في عملهم. قام طلاب المعهد من خلال الإطار التحليلي «للهندسة العكسية»، بتحليل الطرق المستخدمة في اختراعات اللاجئين، واستكشاف التلاعبات المادية المتضمنة في صنعها. تُظهر الرسومات الناتجة ما تمتاز به تصاميم اللاجئين من ناحية الإصرار والتحول والقوة. كما تمثل هذه الرسومات شكلاً من أشكال التوثيق والأرشفة ومشاركة العبر حول ممارسات التصميم في البيئات

The book structure acknowledges and retains the individual authorship of its many contributors with two distinct entry points: that of people living and working at the camp and that of people reaching out to the camp.

Throughout the development of *Design to Live* we had to navigate a number of dilemmas inherent in humanitarian engagement: How can art and design practitioners push beyond savior mentalities and develop tools and models that address/reverse the power imbalances in fragile environments? How can coalitions representing powerful institutions support socially engaged art and community-driven design to make a positive contribution or incite change in a world of increased inequalities? How can we leverage privileged educational institutions like MIT and GJU to help facilitate a systems change in humanitarian relief? To help us articulate and respond to these questions, we developed the aforementioned Code of Ethics platform, an open online resource, offering crowdsourced multidisciplinary and cross-cultural perspectives on ethics, design, and scarcity. Code of Ethics invites international and local actors in the United States, Canada, Austria, Jordan, and the United Arab Emirates to contribute with questions, insights, and guidelines concerning the role of art and design in a context of conflict and crisis, which are then conveyed and relayed through art installations, workshops, lectures, and symposia.[3] The project informs critical self-reflection and served as a valuable accountability structure for *Design to Live*.

Code of Ethics? discussion tables at the Design for the Real World across Scales event organized by FHL in collaboration with the Amman Design Week Platform, Amman, Jordan. Photo: ADW Platform, July 2018.

طاولات نقاشية في ندوة حول محور «مدونة الأخلاقيات» بعنوان «التصميم لأجل عالم حقيقي على جميع المقاييس»، بمشاركة أعضاء من معهد ماساتشوستس للتكنولوجيا، ومختبر الإرث المستقبلي، وأسبوع عمّان للتصميم في الأردن. الصورة: أسبوع عمّان للتصميم، تموز 2018.

As artists, designers, and educators, we acknowledge our inevitable complicity in the global system of inequality, and also the possibilities and limits of our agency in changing that world for the better. We hope to continue to employ our disciplinary skills and access to support the self-determination of the forcibly displaced. This said, *Design to Live* ultimately insists that population displacement today is not a marginal issue that can simply be relegated to humanitarian governance and the aid economy. It is a wider reality that affects everyone, more and more, and can only be seriously discussed through an intersectional, participatory approach where refugee voices take center stage.

[3] For example: Azra Akšamija's workshop at the 2019 Design for Humanity Summit in New York, facilitated by the International Institute of Humanitarian Affairs of Fordham University and the International Organization for Migration.

البحثية التشاركية إلى إدراك مشترك، وهو أنه بدلاً من القيام بالتصميم للاجئين، يجب أن نتعلم منهم، وقد تُرجم ذلك عبر توثيق وفهم وإبراز الطرق العديدة التي يتعامل من خلالها سكان مخيم الأزرق مع تحديات النزوح من خلال التصميم. تكشف اختراعات اللاجئين بعمق عن تأثير القرارات الجيوسياسية والصراعات والأزمات الإنسانية على الحياة اليومية. ويكشف الإنتاج الإبداعي الخاص باللاجئين، فيما يتعلق بنهج ومبادئ الإغاثة الإنسانية، التناقض بين البنية التحتية المتاحة عن طريق المعونة والاحتياجات الحقيقية للاجئين.

بدأنا في صيف العام 2017، عملية التوثيق الشامل لاختراعات المخيم عبر تعاون وثيق مع أعضاء فريق مجلة مخيم الأزرق الذين يمثلون فئة قيادية شابة من اللاجئين في المجتمع. تواصل فريق المجلة مع المجتمع الإبداعي في المخيم وقام بتسهيل مقابلتهم من قبل الباحثين من معهد ماساتشوستس للتكنولوجيا والجامعة الألمانية الأردنية، وضمن هذا الاستطلاع الفوتوغرافي غير المسبوق، قام كل من أعضاء فريق المجلة والمشاركين من معهد ماساتشوستس للتكنولوجيا والجامعة الألمانية الأردنية بتوثيق الصناعات اليدوية والاختراعات

الميكانيكية وتعديلات الملاجئ وتدخلات التصميم واسعة النطاق التي تتحدى ندرة الموارد والظروف المناخية القاسية وقوانين المخيم والتقشف الثقافي فيه لخلق حياة تستحق العيش. تقدّم صور هذا الاستطلاع المدرجة في الكتاب نظرة عامة حول التصاميم في الموقع، ونظرة مقربة على حياة المخترعين السوريين.

بحثنا خلال حوار أجريناه مع فريق مجلة مخيم الأزرق إمكانية عرض هذه التصاميم على جمهور أوسع داخل وخارج حدود المخيم، وضمن إطار مادة «التراث الحركي والتصميم الحسي الثقافي» التي تُدرسها الدكتورة أزرا أكشامية في معهد ماساتشوستس للتكنولوجيا، قامت مجموعة من الطلاب بتشكيل تعاونات ثلاثية الأطراف بين المعهد والجامعة الألمانية الأردنية ومخيم الأزرق للاجئين. ركزت المجموعات على تصاميم مختارة من مخيم الأزرق، وناقشت أهمية الفن والتصميم في ظروف النزوح. تمّ عرض الاستطلاع الفوتوغرافي والعمل التعاوني الذي أجراه الطلاب في معرض «التصميم في عالم الترحال» ضمن فعاليات أسبوع عمّان للتصميم في العام 2017، الذي استضافته الجامعة الألمانية الأردنية وشركائنا في الأردن من أعضاء هيئة

تعاون عابر للحدود

تطور كتاب «التصميم للحياة» على مدار أربع سنوات، بجهود تعاونية بين الباحثين والطلاب في كلية الهندسة المعمارية والتخطيط في معهد ماساتشوستس للتكنولوجيا، ومختبر الإرث المستقبلي، واللاجئين السوريين في مخيم الأزرق للاجئين، والعاملين في هيئة الإغاثة كير (CARE)، وطلاب وخريجي وأعضاء هيئة التدريس وكلية هندسة العمارة والبيئة في الجامعة الألمانية الأردنية. بدأنا في العام 2016، وبدعم سخي من قبل كل من كلية الهندسة المعمارية والتخطيط وبرنامج العالم العربي ضمن مبادرات MISTI في معهد ماساتشوستس للتكنولوجيا، سلسلة من اللقاءات والتعاونات الإبداعية على شكل دورات وندوات ومعارض وفعاليات عامة. عززت هذه التبادلات إيماننا المشترك بضرورة أن تصبح مخيمات اللاجئين أماكن مدنية، تتوفر فيها بيئة اجتماعية سليمة، وتحفز الابتكار والإبداع والتبادلات الثقافية، ومن هذا المنطلق، نقوم باستكشاف الأدوار المحتملة للفن والتصميم والخيال في ظروف النزوح القسري بشكل مقرب، بهدف إبراز الحاجة الملحة لدمج أخلاقيات ممارسات التصميم ضمن السياق الأوسع للجهات والمنظمات التي تُعنى ببناء وإدارة المهام والبنى التحتية الإنسانية.

اتخذ تعاوننا في سبيل إنجاز هذا العمل أشكالاً مختلفة، كالمقابلات مع الفنانين والمهندسين والمصممين في مخيم الأزرق، حيث وثقنا وجود اختراعات وتعديلات في الملاجئ لفهم الطريقة التي وظف فيها سكان المخيم التصميم للتغلب على أوجه القصور في المساعدات الإنسانية المقدمة لهم، وعرضنا من خلال عملية الابتكار المشترك، تصميمات جديدة لتلبية الاحتياجات الاجتماعية والثقافية والجمالية للاجئين، كما تعاوننا مع مبادرة InZone التي أطلقتها جامعة جنيف في مخيمات اللاجئين، وصممنا مركز للتعبير والتعليم الإبداعي الخاص باللاجئين السوريين.[1] أجرينا من خلال إقامة سلسلة ورش عمل ومعارض متنوعة المواضيع في الولايات المتحدة وأوروبا ومنطقة الشرق الأوسط وشمال إفريقيا، حوارات حول أخلاقيات التصميم في البيئات المتضررة، ولا سيما ما يتعلق بالمشاركة المجتمعية والحفاظ على الثقافة والتنمية العادلة. أدت هذه السلسلة إلى إنشاء منصة «مدونة الأخلاقيات» التي تُمثّل سجلاً مشتركا لنشر الممارسات الفضلى والأسئلة

المهمة والدروس التي يمكن أن تفيد العاملين في السياق الإنساني (يتم مناقشة مزيد من التفاصيل أدناه).[2]

نجم عن لقاءاتنا أشكالٌ من التعاون الأفقي المبني على الأبحاث، والذي يعطي الأولوية للعملية بحد ذاتها بدلاً من ناتجها. لقد حرصنا على خلق تبادلات متعددة الاتجاهات عبر الحدود السياسية والإلزامية والحدود التي بين الأجيال، وحاولنا من خلال كل من أساليب الفن التشاركي والتصميم الاجتماعي والحفاظ على التراث، دعم المرونة الثقافية للمجتمعات النازحة. إنّ هدفنا الذي نسعى إليه من نشر هذا الكتاب هو تقدير وتحديد أولويات الأهداف الاجتماعية والثقافية في مناطق الأزمات، وتجاوز النموذج الراسخ بخصوص «الاحتياجات الأساسية».

مجريات بدء العمل

بدأت السنة الأولى من التعاون في العام 2016 بمشاركة أعضاء هيئة التدريس وطلبة الجامعة الألمانية الأردنية، وعدد من الضيوف من شبكة Architecture Sans Frontières، وأسبوع عمّان للتصميم، والأكاديمية الدولية للفنون في فلسطين ومشروع Cluster Labs، ضمن إطار المادة التي تُدرسها الدكتورة أزرا أكشامية في معهد ماساتشوستس للتكنولوجيا بعنوان «التصميم في عالم الترحال». ركزنا على تعميق فهم سياق اللجوء في المدن والمخيمات في الأردن، وخاصة ما يتعلق بمخيم الأزرق للاجئين وخصوصياته، وقد قمنا بالكشف عن وتوثيق تحديات المعيشة في المخيم من خلال سلسلة من الاجتماعات الشخصية، وعبر الفيديو مع سكان المخيم، وورشات عمل بين بوسطن وعمّان ومخيم الأزرق للاجئين.

كان الدافع الأولي لعملنا هو فهم استطاعتنا الاستفادة من قدرات مؤسساتنا التعليمية ومن مهاراتنا كفنانين ومصممين لدعم اللاجئين السوريين. توصلت عمليتنا

[1] InZone هو مركز أكاديمي يقع في جامعة جنيف، ويوفر التعليم التواصلي لتطوير الطرق المبتكرة الرائدة والتعليم العالي للاجئين والمجتمعات المستضيفة لهم. صمم مختبر الإرث المستقبلي مركزاً تابعاً لمشروع InZone للتعليم العالي في مخيم الأزرق للاجئين، وتم افتتاحه في خريف العام 2018.

[2] https://www.codeofethics.online

Refugee-led Designs as a Worldmaking Practice

Design to Live showcases refugee-led design as a worldmaking practice in order to rethink refugee camps as civic spaces where much-needed social healing, innovation, creativity, and cultural interactions find expression. Worldmaking is a process of realization that is neither singular nor fixed, but rather composite and continuously in flux.[1] This inclusive notion of the construction of reality is reflected in the ways in which the camp residents interfere with the systemization forced upon their lives by reappropriating their environment through creative authorship.

The book's title alludes to Victor Papanek's seminal publication *Design for the Real World* (1971), which revealed the discrepancy between design and the "real needs" of people, especially the unprivileged and marginalized.[2] The spatial agency of refugees at the Azraq Refugee Camp unveils nuanced realities. It materializes the narratives and imagined realities of displaced Syrians in conditions of encampment.[3] These moments of creation and appropriation become a worldmaking practice that subvert the confines of standardized humanitarian design and point out the real needs of refugees.

The residents of the camp innovate in order to fill the gaps in data-driven centralized design that overlooks culturally appropriate solutions in favor of systemization. Refugee designs, therefore, become tools to map these gaps and propose fair alternatives. Taken together, they offer a comprehensive critique of the homogeneity of architectures for the displaced, as well as evidence that refugees defy what is decided on their behalf by hosting bodies, producing their own worlds in the confines of the camp.

The refugee-design lens enables an accessible, bottom-up, and participatory discussion of camp politics today. A focus on intimate aspects of the everyday life of refugees lends itself to revealing the on-the-ground impacts of dominant governance systems that generate conflict and displacement. Beyond cataloging and archiving designs by refugees in confinement, *Design to Live* deploys the design perspective to foreground conversations on cultural policy, aesthetics, dignity, and identity shaping camp life.

Cultural continuity through dynamic social networks

The everyday activities that constitute worldmaking take place within yet in spite of the blanket terrain of "aid," allowing refugees to express themselves as individuals with complex identities participating in a process of cultural production that is necessary for the community's well-being.[4]

[1] Nelson Goodman, *Ways of Worldmaking* (Hassocks: The Harvester Press, 1978).

[2] Victor Papanek, *Design for the Real World: Human Ecology and Social Change* (New York: Pantheon Books, 1971).

[3] Remei Capdevila-Werning, "Buildings as Ways of Worldmaking," in Goodman for Architects (London: *Routledge*, 2014).

[4] Ashika L. Singh, "Arendt in the Refugee Camp: The Political Agency of World-Building," Political Geography 77 (2020): 102149 https://doi.org/10.1016/j.polgeo.2020.102149.

It is crucial to acknowledge that refugee camps are sites of knowledge production and civic innovation, not simply hubs for aid consumption. Camp residents not only produce artifacts and recreate traditions, but they also evolve and adapt culturally in conditions of encampment and scarcity.

With a systemic lack of spaces for the expression and creation of identity and heritage, residents take the lead in making such spaces for themselves. These spaces of congregation and ritual practice link the past to the future, providing places to co-imagine a better world for generations to come. We can witness this worldmaking practice through social networks that carry cultural production outside singular authorship into an organic ecosystem where ideas radiate throughout the camp as design objects and inventions that get copied, adapted, and reused on the scales of neighborhoods and households, individuals and collectives.

Spatial agency and the production of reality

The interventions of displaced Syrians at the camp maneuver the imposed set of rules and operate in the fringes of permissibility without clearly breaking any official laws at the camp. They are witty bottom-up creations that employ limited resources available to achieve elaborate results. These resident designers mobilize the community through their work as they leverage loopholes within camp legislation and reappropriate donated humanitarian items and materials in unexpected ways.

Within the context of the camp, design transcends mere functional immediacy; it can be seen as a means for producing a new reality through the individual and collective expression of the residents' emotional needs, personal tastes, and forms of play. The designs documented in this book generate a new set of relations, events, and rituals at the camp and carve out space for new worlds in the making.

Acknowledging that the agency of refugees remains burdened, ever bound to the camp and excluded from the civic power, *Design to Live* assumes the responsibility of developing a conversation around the role of art and design in the refugee context while amplifying the methods, tools, and designs refugees themselves employ to build a life of dignity.

Pluralist representation through creative authorship

Everyday situations in refugee camps are often represented with institutional statistics and reports, leaving out the nuances of humanity in humanitarian contexts. In other cases, where more in-depth representation is at play, the image that predominantly comes across is one of victimization. In defiance of both of these representations, *Design to Live* offers an image of camp reality as the result of a cross-disciplinary process that enabled multiple stakeholders to collaborate on an urgent bottom-up depiction of everyday life, human needs, and innovation. The book deploys architectural illustrations, technical drawings, photography, and creative writing to weave narratives of life at the camp through the lens of residents' creative production.

The chapters assemble the residents' designs around the subjects of Landscape, Intimacy, Fellowship, and Energy (LIFE) in speculative scenes that highlight their value in a process of everyday worldmaking and reveal a rarely discussed, refugee-led tactility behind the opaque facade of humanitarian architectures. The

14 〈 〉 311

LIFE method is an alternative to the grid value engineering of centralized planning.

Landscape showcases the structurally troubled connection of residents to the camp's surrounding landscape, a place where they live that is not their own. The transformation of the desert into an oasis with plants and animals reminiscent of Syria defies the suspension of familiar senses in exile.

Intimacy explores the negotiations at play in translating traditional concepts of sharing and privacy to the camp's built environment. The chapter dives into the specificities of social thresholds connected to Syrian cultural habits, such as the communal courtyard and the significance of gendered spaces.

Fellowship highlights contestations of cultural austerity. It focuses on the spatial extensions of rituals and pedagogy to preserve and continue living culture in displacement. It relays the innate drive to create spaces where strangers can meet and share, loosening their tight grip on their culture and traditions, supporting each other to keep their sanity, identity, and dignity intact.

Energy makes visible the infrastructural challenges of inhabiting Jordan's Eastern Desert. The chapter unmasks the insufficient water, sewage, and power infrastructure at the camp and reveals how refugees claim access to resources in an environment of scarcity.

Design to Live follows a tête-bêche structure offering two interconnected, but significantly distinct entry points to the book narrative. From right to left, the

للحياة»، عبر إتاحتِه الفرصة للتفكير خارج نطاق التبعيات المعممة والمفروضة، ويُعتبر الكتاب في حد ذاتِه تمرينًا على صناعة العالم على توقع قريب للمستقبل، حيث لا يعتبر تحديد الناس لحياتهم عملاً تخريبياً، بل أكثر الأعمال بديهية.

باعتبارها عملية إعادة إنتاج مشتركة للمساحة، وأداة للنهوض بالمجتمع وتعزيز تماسكه.

جولة خارج حدود المخيم

يهدف كتاب «التصميم للحياة» إلى إعادة توجيه الخطاب حول مخيمات اللاجئين وتوليد استجابات تصميمية بديلة حول موضوع اللجوء. يشير التغيير الإنتاجي للتصاميم الموحدة إلى الفجوة الكبيرة بين جوانب العمارة الإنسانية والاحتياجات الاجتماعية والثقافية والوظيفية الفعلية تصاعديًا. كما يهدف توثيق ونشر التصاميم في هذا الكتاب أيضًا إلى بناء جسر بين الابتكار الحاصل في المخيم والمهتمين المحتملين في مجالات التصميم والأعمال الإنسانية على المستوى العالمي، من أجل ترسيخ المخيم كموقع حيوي للعيش والتعلم بدلاً من اعتبارِه فقط وجهة للعمل الخيري والبحثي.

في الوقت الذي توفر فيه مخيمات اللاجئين بيئات آمنة نسبيًا للمجتمعات النازحة على إثر أعمال العنف، فإنها تخلق أيضًا مجتمعات تعتمد على الإغاثة الإنسانية باعتبارها عملاً خيرياً. هنا يكمن جوهر كتاب «التصميم

book introduces the reader to the art and design community of the Azraq Refugee Camp through conversations with collaborators who live and work there. Displaced Syrian teacher Muteeb Awad Al-Hamdan and youth leader Mohammad Abdullah Al-Mezael discuss the value of publishing refugee voices and imagination in camp education. CARE deputy manager Malek Abdin expands on the significance of cultural interventions in refugee spaces. From left to right, the book introduces the camp through the point of view of cultural practitioners who reach out to the camp. Professor in Design & Visual communication (GJU), Mohammad Yaghan, and professor in Architecture & Interior Design (GJU), Rejan Ashour, discuss the value of refugee-led interventions in pointing out the gaps of humanitarian design. Cluster Labs founder Zeid Madi examines the

creative production of refugees as a process of reverse urbanization. Participatory urban development practitioner Amani Yousef Alshaaban and CIVIC project lead Muhsen Albawab reflect on the recording and visualization of everyday life at the camp as co-reproduction of space, a valuable tool for community mobilization and social cohesion.

A stroll beyond the camp

Design to Live aims to reorient the discourse around refugee camps and generate alternative design responses on the subject of refugeehood. The productive subversion of standardized designs for life points out the huge gap between humanitarian architecture touchpoints and actual social, cultural, and functional needs from the bottom up. The recording and

في المخيم، ويناقش في خضم ذلك كلُ من المعلم السوري النازح متعب عوض الحمدان والشخصية القيادية الشابةمحمد عبد الله المزعل نشر أصوات اللاجئين وتحفيز الخيال لديهم في العملية التعليمية في المخيم. في حين يتحدث مالك عابدين (قائد فريق منظمة كير العالمية CARE INTERNATIONAL في مخيم الأزرق في الأردن) عن أهمية التدخلات الثقافية في مساكن اللاجئين. أمّا في النقطة الثانية، وهي من اليسار إلى اليمين، فيستعرض الكتاب المخيم من خلال وجهة نظر الخبراء الثقافيين الذين زاروه. من هنا، يناقش كلّ من محمد ياغان (أستاذ في التصميم والتواصل المرئي في الجامعة الألمانية الأردنية) وريجان عاشور (أستاذ ممارس في الهندسة المعمارية والتصميم الصناعي في الجامعة الألمانية الأردنية) قيمة ابتكارات اللاجئين في الكشف عن الثغرات الموجودة في التصميم الإنساني الموحد، بينما يبحث زيد ماضي (مؤسس مشروع Cluster Labs) بالإنتاج الإبداعي للاجئين باعتباره عملية تحضّر عكسي. بالمقابل، يتحدث كل من أماني يوسف الشعبان (مخطط تنمية حضرية) ومحسن البواب (مدير مشروع في منظمة Civic Jordan) عن توثيق وتصور الحياة اليومية في المخيم

الألفة: تُسلط الضوء على الخلافات التي سببها التقشف الثقافي، بتركيز على دور الامتدادات المكانية للعادات والتربية في الحفاظ على الثقافة الحية واستمراريتها في حالات النزوح، وتُوجه الدافع الفطري لخلق مساحات حيث يمكن للغرباء الاجتماع والمشاركة والتعبير عن ثقافتهم وتراثهم، ودعم بعضهم البعض من أجل الحفاظ على صحتهم العقلية وهويتهم وكرامتهم.

التمديدات: تُظهر تحديات البنية التحتية لسكان الصحراء الشرقية الأردنية. يكشف هذا الفصل الستار عن النقص في البنى التحتية الخاصة بالمياه والصرف الصحي والطاقة في المخيم، ويعرض الطرق التي يحصل من خلالها اللاجئون على الموارد في البيئة التي تتميز بشحها.

يقدم «التصميم للحياة» نقطتي عبور إلى محتوى الكتاب، حسب اتجاه تصفحه. وتمتاز كلتا النقطتين بترابطها رغم اختلاف الاتجاه، ففي النقطة الأولى، وهي من اليمين لليسار، يقدم الكتاب للقارئ مجتمع الفن والتصميم في مخيم الأزرق للاجئين من خلال مقابلات أجريت مع المساهمين الذين يعيشون ويعملون

dissemination of the designs in this book is intended as a bridge between the innovation already happening inside the camp and potential stakeholders in the design and humanitarian fields on a global level to help solidify the camp as a dynamic site of living and learning rather than a destination for research and good will.

While refugee camps offer relatively safe environments to communities fleeing from violence, they also create dependent communities sustained by the logic of humanitarian relief as philanthropy. *Design to Live* acts as a segue to think outside of these generalized and enforced dependencies. It is in itself a worldmaking exercise speculating a near future where people determining how they live is not considered a subversive act, but rather the most natural one.

تجمع فصول الكتاب تصاميم المقيمين في المخيم حول مواضيع الحدود، و اليسر، والأُلفة، والتهديدات (الحياة) وتعرضها في مشاهد تخمينية تسلط الضوء على قيمتها في عملية بناء العالم اليومية، وتكشف عن تأثيرات يقودها اللاجئون، ونادرًا ما تُناقش خلف الواجهة القاتمة للهندسات الإنسانية. تعتبر منهجية الحياة التي تتمحور حولها تصاميم اللاجئين بديلاً لشبكة هندسة القيمة الخاصة بالتخطيط المركزي.

الحدود: تُظهر الارتباط الهيكلي المضطرب بين اللاجئين والبيئة المحيطة بالمخيم، باعتباره مكانًا يعيشون فيه ولا يملكونه. يُعتبر تحول الصحراء إلى واحة تشبه سوريا، وتضم نباتات وحيوانات تحديًا لفقدان الأحاسيس الذي سببه العيش في المنفى.

اليسر: تبحث في دور ترجمة المفاهيم التقليدية للمشاركة والخصوصية في بناء بيئة المخيم. يتعمق الجزء الذي يناقش هذا الموضوع في الخصوصيات المرتبطة بالعادات الثقافية السورية، مثل الفناء الجماعي وأهمية المساحات التي تفصل بين الجنسين.

التدخلات المكانية وإنتاج الواقع

تتحدى ابتكارات اللاجئين السوريين في المخيم القواعد المفروضة، وتعمل ضمن الحدود المسموح بها دون خرق واضح لأي من القوانين الرسمية في المخيم. تمتاز الابتكارات بأنها إبداعات بارعة وتصاعدية تستخدم الموارد المحدودة المتاحة من أجل تحقيق نتائج ذات طبيعة منتظمة. تكمن الفائدة التي يحققها هؤلاء المصممين للمجتمع في استفادتهم من الثغرات الموجودة في تشريعات المخيم، وإعادة استخدام القطع اليدوية والمواد الإنسانية المتبرع بها بطريقة غير متوقعة.

يتجاوز التصميم في سياق المخيم، مجرد كونهِ شيئ عملي تفرضهُ الحاجة المُلحة، ويُعتبر وسيلة لإنتاج واقع جديد من خلال التعبير الفردي والجماعي عن احتياجات السكان العاطفية، وأذواقهم الشخصية، وأشكال المتعة والترفيه. تولد التصميمات الموثقة في هذا الكتاب مجموعة جديدة من العلاقات والأحداث والطقوس في المخيم، وتوفر مساحة لعوالم جديدة قيد الإنشاء.

لا تزال ابتكارات اللاجئين مثقلة بالأعباء، بسبب ارتباطها بالمخيم واستبعادها عن نطاق السلطة المدنية خارجه. يتحمل كتاب «التصميم للحياة» من أجل ذلك مسؤولية التأسيس لأرضية حوار حول دور الفن والتصميم في سياق اللجوء، وتسليط الاهتمام على الأساليب والأدوات والتصاميم التي يوظفها اللاجئون أنفسهم لبناء حياة كريمة.

التمثيل الجماعي من خلال التأليف الإبداعي

يتم تمثيل الأوضاع اليومية في مخيمات اللاجئين عادةً بإحصاءات وتقارير مؤسسية، مع استبعاد الفروقات والسياقات الإنسانية الدقيقة، أما في بعض الحالاتِ الأخرى، والتي يكون التمثيل فيها أكثر عمقًا، فإن صورة الضحية هي التي تظهر غالبًا. يتحدى كتاب «التصميم للحياة» هذين التمثيلين، ويُقدم صورة لواقع المخيم باعتباره نتيجة لعملية متعددة العوامل، مكنت العديد من المعنيين من التعاون لخلق تصور يشمل الحياة اليومية والاحتياجات الإنسانية والابتكار. إضافة إلى ذلك، يوظف هذا الكتاب الرسوم التوضيحية المعمارية والرسومات الفنية والصورة الفوتوغرافي والكتابة الإبداعية لنسج روايات الحياة في المخيم من خلال عدسة الإنتاج الإبداعي الخاص باللاجئين.

تصاميم اللاجئين كممارسة لصناعة للعالم

يتبنى كتاب «التصميم للحياة» استعراض ممارسات التصميم التي يقودها اللاجئون كمنهج لصناعة العالم يهدف لتحفيز إعادة التفكير بمخيمات اللاجئين باعتبارها مناطق مدنية ذات بيئة تساعد على التعافي الاجتماعي والابتكار والإبداع والتفاعلات الثقافية في ظل شدّة الحاجة إليها. ليست ما يسمى بـ(ممارسة صناعة العالم) عملية فردية أو ثابتة، بل هي عملية تحقيقية ذات طبيعة مركبة دائمة التغير.[1] ينعكس هذا المفهوم الشامل لبناء الواقع في الطرق التي يسلكها سكان المخيم من أجل التدخل في المنهجية المفروضة على حياتهم، من خلال إعادة تخصيص بيئتهم عبر الممارسة الإبداعية.

يلمح عنوان «التصميم للحياة» إلى كتاب Design for the Real World الذي كتبه فيكتور بابانيك في العام 2017، والذي كشف بدوره عن التناقضِ بين التصميم و «الاحتياجات الحقيقية» للناس، وخاصة الفئات المحرومة والمهمشة.[2] تكشف الوكالات المكانية الخاصة باللاجئين في مخيم الأزرق عن حقائق مختلفة الدلالات، وتجسد السرديات والوقائع التخيلية للنازحين السوريين في المخيمات،[3] وقد أصبحت اللحظات التي يمارسون بها عمليات البناء وإعادة التخصيص ممارسة لصناعة العالم تهدم حدود التصميم الإنساني الموحد، ومؤشر يسلط الضوء على الاحتياجات الحقيقية للاجئين.

تهدف ابتكارات سكان المخيم إلى سد الثغرات الموجودة في التصميم الموحد القائم على البيانات، والذي يتجاهل الجوانب الثقافية ويُركز على الجوانب التنظيمية. تصبح تصاميم اللاجئين بالتالي، بمثابة أدواتٍ لرسم خريطة هذه الثغراتِ واقتراح بدائل متاحة لها، كما تقدم نقدًا شاملاً لتماثل مساكن النازحين، وتقدم دليلاً على تحدي اللاجئين لما يتم تقريرهُ نيابة عنهم من قبل المجتمعات المضيفة، وعلى قدرتهم على إنتاج عوالمهم الخاصة ضمن حدود المخيم.

يعطي النظر عبر عدسة تصاميم اللاجئين إمكانيةً للوصول والمشاركة التصاعدية في النقاش حول سياسات المخيمات اليوم، إذ يؤدي التركيز على الجوانب العاطفية للحياة اليومية للاجئين إلى الكشف عن التأثيرات الميدانية للأنظمة السائدة التي تولد الصراع

والنزوح. يوثق كتاب «التصميم للحياة» تصاميم اللاجئين في المخيمات، ويرسخ للنظر إلى التصميم كأرضية تجري عليها الحوارات حول السياسة الثقافية والجماليات والكرامة وتشكيل الهوية في حياة المخيم.

الاستمرارية الثقافية من خلال الشبكات الاجتماعية الفعّالة

تتم الأنشطة اليومية التي تجري من خلالها صناعة العالم في نطاق «المساعدات» ورغمًا عنها، وهي ما يسمح للاجئين بتجربة العيش كأفراد بهويات معقدة، حيث يشاركون في عملية إنتاج ثقافي ضرورية لتحقيق رفاه المجتمع.[4] من المهم جدًا الاعتراف بأن مخيمات اللاجئين هي أماكن يجري فيها إنتاج المعرفة والابتكار المدني، وليست مجرد بيئات مستهلكة للمساعدات. لا يقتصر دور سكان المخيم على إنتاج الصناعات اليدوية وإعادة إحياء التراث؛ بل يشمل كذلك التطور والتأقلم الثقافي في ظروف العيش في المخيمات وندرة الموارد المتاحة.

رغم الافتقار إلى مساحات التعبير عن الهوية والإرث وتمثيلهما، يتولى سكان المخيمات زمام المبادرة في إنشاء مثل هذه المساحات لأنفسهم. تربط المساحات التي تجري فيها التجمعات والفعاليات المتنوعة بين الماضي والمستقبل، وتوفر أماكنًا للتخيل المشترك لعالم أفضل للأجيال القادمة. يمكننا أن نشهد عملية صناعة العالم من خلال الشبكات الاجتماعية، التي تُخرج الإنتاج الثقافي من نطاق الملكية الفردية إلى بيئة اجتماعية عضوية، تنتشر فيه الأفكار في جميع أنحاء المخيم باعتبارها ابتكارات ومواضيع تصميم يجري نسخها وتعديلها وإعادة استخدامها على مستوى الأحياء والعائلات والأفراد والجماعات.

[1] نيلسون جودمان، طرق صناعة العالم (Ways of Worldmaking) (هاسوكس: مطبعة هارفستر، 1978)

[2] فيكتور بابانيك، تصميم للعالم الحقيقي: البيئة البشرية والتغيير الاجتماعي (Design for the Real World: Human Ecology and Social Change) (نيويورك: كتب البانثيون للنشر، 1971)

[3] ريمي كابديفيلا ورنزو، المباني كطرق لصنع العالم (Buildings as Ways of Worldmaking)، في كتاب جودمان للمهندسين المعماريين (Goodman for Architects) (لندن: مطبعة روتليدج، 2014) (London: Routledge, 2014)

[4] أشيكا سينغ، "آرنت في مخيم اللاجئين: القوة السياسية الكامنة في بناء العالم - Arendt in the Refugee Camp: The Political Agency of World-Building"، مجلة الجغرافيا السياسية 77 (2020): 102149

نبذة عن سيرة المساهمين في الكتاب

Biographies

The MIT Future Heritage Lab (FHL) is a research and art lab led by Azra Akšamija at the MIT School of Architecture and Planning. Operating at the intersection of art and design, heritage preservation, and humanitarian relief, FHL invents creative responses to conflict and crisis. We design frameworks, tools, and infrastructure to improve the lives of communities under threat. We investigate the potency of design and architecture in transforming conflict. We invent new approaches for bottom-up heritage preservation, build models for collaborative knowledge exchange in fragile environments, and develop methods for revitalizing traditional arts and crafts. Our goal is to counter the rapid erasure of cultural memory across the world and to advance transcultural understanding.

Azra Akšamija, PhD, is an artist and architectural historian, director of the MIT FHL, and an associate professor in the MIT Department of Architecture, Program in Art, Culture and Technology. With a background in the history and theory of art and architecture, Akšamija's work explores how social life is affected by cultural bias and by the deterioration and destruction of cultural infrastructure within the context of conflict, migration, and forced displacement. Akšamija has authored two books, *Mosque Manifesto* (Revolver, 2015) and *Museum Solidarity Lobby* (Revolver, 2019), and edited the anthology *Architecture of Coexistence*: *Building Pluralism* (ArchiTangle, 2020). Her artistic work has been exhibited in leading international venues, including

the Biennials in Venice, Valencia, and Liverpool, the Generali Foundation in Vienna, the Gallery for Contemporary Art in Leipzig, the Museums of Contemporary Art in Zagreb, Belgrade, and Ljubljana, SculptureCenter in New York, Secession in Vienna, Manifesta 7, the Royal Academy of Arts in London, Jewish Museum Berlin, the Queens Museum of Art in New York, Design Week festivals in Milan, Istanbul, Eindhoven, and Amman, and Qalandiya International. Most recently, her work has been shown at the Kunsthaus Graz, the Aga Khan Museum in Toronto, and Kestner Gesellschaft in Hanover and the Venice Architecture Biennale 2020/21. She received the Aga Khan Award for Architecture in 2013 for her design of the prayer space in the Islamic Cemetery Altach, Austria, the Art Award of the City of Graz in 2018, and an honorary doctorate from Montserrat College of Art in 2020.

Raafat Majzoub is an architect, artist, writer, director of The Khan: The Arab Association for Prototyping Cultural Practices, editor-in-chief of the Dongola Architecture Series and lecturer in the Architecture, and Design Department at the American University of Beirut. Majzoub's work explores worldmaking through experiments in new pedagogy focused on the abandonment of the notion of one truth and the development of inclusive, collaborative teaching and learning methods. He is the co-founder of the Beirut-based *The Outpost* magazine, where he also published two literary supplements: *The Perfumed Garden* (novella)

and *L'Origine(s) du Monde* (illustrated children's book with artist Joan Baz). His writing has been published in *recto:verso, Perpetual Postponement, antiAtlas Journal, Contemporary Theatre Review,* and *Al-Akhbar* newspaper. He has presented papers and artist lectures focused on worldmaking and speculative fiction in the Beirut Art Center, École nationale supérieure des Arts Décoratifs in Paris, Centre de Cultura Contemporània de Barcelona, and Kaaitheater in Brussels. His public art installations have been exhibited in Beirut, Cairo, Jerusalem, Amman, Brussels, and Cambridge, and he participated in the NSK Pavilion in the 57th Venice Biennale, Drodesera XXXVII Supercontinent, and the Nature public program in Brussels.

Melina Philippou, an architect and urbanist, is the Program Director and Lead Researcher of the Future Heritage Lab (FHL) at the MIT School of Architecture and Planning. Philippou's research explores the agency of spatial practices in building equal opportunity ecosystems in fragile environments. In collaboration with grassroots organizations, municipalities, and academic institutions, she has worked on the ground for the sustainable development of communities at Azraq in Jordan, in the Bronx, New York, and in Lisbon, Portugal. Her work has been exhibited in renowned venues, including the Architecture Venice Biennale, Amman Design Week, the Lisbon Triennial, and the National Museum of Contemporary Art Athens (EMST). Her research on the relationship among forced displacement, ethics, and design has been presented at leading educational institutions such as TU Delft, Bartlett – University College London (UCL), and the National Technical University of Athens (NTUA). Azra and Melina received the acknowledgment prize of the LafargeHolcim Awards

for Sustainable Design, Middle East Africa, 2020. Melina is also the recipient of the Lawrence B. Anderson Award for analytical research and the Harold Horowitz (1951) Student Research Fund for her Master's thesis. Philippou was born in Greece and raised in Cyprus. She holds a professional degree in Architecture from the National Technical University of Athens, Greece, as an IKY Cyprus State Scholar, and a Master of Science in Urbanism from MIT as a Fulbright Scholar.

Malek Abdin is the Azraq camp Team Leader with over twelve years of experience in the humanitarian field working with local and international organizations in the Middle East. With an academic background in psychology, Malek has worked in several organizations, including International Medical Corps, Action Against Hunger, and Médecins Sans Frontières. Since 2013 he has led the CARE international team at the camp. Over the course of his career, Malek has worked on different crises in the Middle East in his capacity as a protection specialist in the areas of health, protection, food, cash, WASH, mental health, and community engagement. He has a firm commitment to knowledge transfer, voluntary work, and facilitating efforts to help people in need.

Muteeb Awad Al-Hamdan is a displaced Syrian educator and interpreter. Currently, he teaches high school students at Relief International in the Azraq Refugee Camp, Jordan. His efforts led to the establishment of Tawjeehi exams at the camp, paving the way for camp residents to access university education. He is the recipient of the Bond Humanitarian Award (2nd prize) and the first of 2,100 students who have taken

the Aptis exam on the LAZER project to receive 'C' in all skills.

Muhsen Albawab, an architect and heritage conservationist, is the Azraq Alive Project Manager and Lead Architect in CIVIC (NPO) working on urban interventions in Azraq, Jordan. His work focuses on building collaborations and supporting collectives to design contextual solutions for under-serviced urban environments.

Amani Alshaaban is an architect and participatory urban development professional with seven years of interdisciplinary experience across the fields of architecture, humanitarian work, and urban development. She is the former Secretary-General of Architecture Sans Frontières International and the co-founder of

Think-Fast: A Collective Urban Response to COVID-19. She received her Master's degree in urban design from University College London. She is currently working as a participatory and integrated development advisor in GIZ-Jordan. Her research interest lies in humanitarian corridors and emerging spaces during armed conflict in the Middle East.

Rejan Ashour is an Industrial Professor at the School of Architecture and Built Environment, German Jordanian University and co-founder of the design office Muqarnas for Design. She specializes in Arabic calligraphy in Mamluk architecture. She has published many papers on muqarnas, design education, and the pedagogy of Arabic typography. She has taught at various universities in Jordan, teaching introductory courses in design, CAD, and

زيد ماضي: مهندس معماري وباحث حضري، يمتلك خبرة واسعة في العمل على التدخلات الثقافية في سياقات اللجوء، وهو مدير Cluster Labs الذي يمثل وحدة بحث وتطوير حضري مقرها في عمّان-الأردن.

محمد عبدالله المزعل: شاب سوري لاجئ ذو شخصية قيادية، أسس في سن الخامسة عشرة مجلة مخيم الأزرق للاجئين، التي وُزعت في جميع أنحاء المخيم بعد أن كتبها وحررها لاجئون شباب. يدرس محمد حاليًا تخصص تكنولوجيا الطاقة المتجددة في كلية الخوارزمي الجامعية التقنية في عمّان-الأردن.

وتعليم التصميم وفن صياغة الحروف العربية، ودرّست في جامعات مختلفة في الأردن مواد تمهيدية للتصميم والتصميم باستخدام الحاسوب وفن صياغة الحروف، كما أجرت العديد من ورش العمل لتعليم الخط العربي لغير الناطقين بها، وهي حاصلة على درجة الماجستير في الهندسة المعمارية من الجامعة الأردنية.

د. (محمد علي) جلال ياغان: أستاذ في كلية العمارة والبيئة المبنية في الجامعة الألمانية الأردنية، ومؤسس مشارك لمكتب مقرنص للتصميم. تمتاز خبرة ياغان المعرفية بأنها متنوعة الثقافات والخلفيات من كل من الأردن والمملكة المتحدة واليابان، وهو متخصص في تعليم التصميم وفي مجال التصور الرقمي للفن الإسلامي بما في ذلك الأنماط الهندسية والمقرنصات والخط. نشر ياغان كتابين والعديد من المقالات في هذه المجالات، وابتكر برامجًا لبناء الفن الإسلامي، واخترع أنواعًا جديدة من الأنماط الإسلامية وأشكال المقرنصات الجديدة، وقدم رؤىً جديدة فيما يتعلق بأبحاث وفهم الخط العربي. درّس ياغان في عدد من الجامعات في الأردن والمملكة العربية السعودية وألمانيا والولايات المتحدة الأمريكية، كما أقام ورش عمل لتعليم الخط العربي لغير الناطقين بها.

typography. She also conducted many workshops teaching Arabic calligraphy to non-native speakers. She holds a Master's degree in architecture from the University of Jordan.

(Mohammad Ali) Jalal Yaghan, PhD, is a full professor at the School of Architecture and Built Environment in German Jordanian University and co-founder of the design office Muqarnas for Design. Yaghan's education comes from a variety of cultures and backgrounds including Jordan, the UK, and Japan. He specializes in the area of digital visualization of Islamic art (including geometrical patterns, muqarnas, and calligraphy) and design education. He has published two books and many journal articles in these areas and has created many programs for the creation of Islamic art. He has also invented new types of Islamic patterns, new muqarnas forms, and introduced new visions into Arabic calligraphy research and understanding. He has taught at universities in Jordan, Saudi Arabia, Germany, and the United States and has conducted multiple workshops teaching Arabic calligraphy to non-native speakers.

Zeid Madi is an architect and urban researcher. He has extensive experience working on cultural interventions in refugee contexts. He is the director of Cluster Labs, an urban research and development module based in Amman, Jordan.

Mohammad Abdullah Al-Mezael is a displaced Syrian youth leader. At the age of 15, he founded the *Azraq Journal,* a publication written and edited by young refugees and distributed across the camp.

أ**ماني الشعبان:** مهندسة معمارية ومتخصصة في مجال التنمية الحضرية التشاركية، تمتلك سبع سنوات من الخبرة متعددة التخصصات بما في ذلك الهندسة المعمارية والعمل الإنساني والتنمية الحضرية. شغلت الشعبان سابقًا منصب نائب رئيس شبكة Architecture Sans Frontières International العمارة بلا حدود الدولية، وهي أيضًا مؤسس مشارك لمنصة Think-Fast: A Collective Urban Response to COVID–19. حصلت الشعبان على درجة الماجستير في التصميم الحضري من كلية لندن الجامعية، وتعمل حاليًا مستشارًا للتنمية التشاركية المتكاملة في المؤسسة الألمانية للتعاون الدولي في الأردن. تكمن اهمامات الشعبان البحثية في المواضيع الإنسانية والمجتمعات الناشئة خلال فترات النزاع المسلح في منطقة الشرق الأوسط.

ريجان عاشور: أستاذ ممارس في تخصص الهندسة المعمارية والتصميم الصناعي في الجامعة الألمانية الأردنية في كلية العمارة والبيئة المبنية، ومؤسس مشارك لمكتب مقرنص للتصميم، ومتخصصة في الخط العربي في العمارة على الطراز الملوكي. نشرت عاشور عددًا من الأوراق البحثية حول المقرنصات

نقل المعرفة والعمل التطوعي وتسهيل الجهود من أجل مساعدة الفئات التي تحتاج العون.

متعب عوض الحمدان: معلم ومترجم سوري نازح، يقوم حاليًا بتدريس طلاب مرحلة الثانوية العامة في منظمة الإغاثة الدولية في مخيم الأزرق للاجئين في الأردن، وأدت جهوده لإدخال امتحان الثانوية العامة (التوجيهي) إلى المخيم، مما مهد الطريق أمام سكان المخيم لدخول الجامعات. الحمدان حاصلٌ أيضًا على جائزة Bond Humanitarian Award (المرتبة الثانية) وهو أول طالب يحصل على «C» في جميع مهارات اختبار Aptis في مشروع LAZER من أصل 2100 مشارك.

محسن البواب: مهندس معماري ومحافظ على التراث، يشغل منصب مدير مشروع الأزرق حي – Azraq Alive ومدير مشروع في منظمة NPO (CIVIC) حيث يعمل على التدخلات الحضرية في مخيم الأزرق للاجئين في الأردن. يركز البواب في عمله على بناء أوجه التعاون وتقديم الدعم للمجتمعات من أجل تصميم حلول للبيئات الحضرية التي تفتقر إلى الخدمات.

Currently, he studies renewable energy
technology at Khawarizmi University
Technical College in Amman, Jordan.

ميلينا فيليبو؛ مهندسة معمارية ومخططة حضرية،
تشغل منصب الباحثة الرئيسية ومديرة برنامج مختبر
الإرث المستقبلي (FHL) في قسم الهندسة المعمارية
في معهد ماساتشوستس للتكنولوجيا. تبحث أعمال
ميلينا في فاعلية الممارسات المكانية في توفير فرص
متكافئة في المجتمعات المحرومة، كما تعاونت مع
عدد من المنظمات والبلديات والمؤسسات الأكاديمية
في مشاريع التنمية المستدامة للمجتمعات في مخيم
الأزرق في الأردن وفي برونكس ونيويورك ولشبونة في
البرتغال. عُرضت أعمال فيليبو في معارض شهيرة، من
بينها بينالي البندقية للعمارة، وأسبوع عمّان للتصميم،
ومعرض تريانالي لشبونة، والمتحف الوطني للفن المعاصر
في أثينا (EMST). تمّ تقديم أبحاث فيليبو حول
العلاقة بين النزوح القسري والأخلاقيات والتصميم في
مؤسسات تعليمية رائدة مثل جامعة دلفت للتكنولوجيا
ومركز بارتلت في كلية لندن الجامعية (UCL)
والجامعة التقنية الوطنية في أثينا. حصلت فيليبو على
جائزة LafargeHolcim في دورتها السادسة للتصميم
المستدام في الشرق الأوسط وأفريقيا مع الدكتورة
أزرا أكشامية، وجائزة Lawrence B. Anderson
للبحث التحليلي، ومنحة صندوق Harold Horowitz

(1951)) لأبحاث الطلاب عن أطروحة الماجستير التي
قدمتها. وُلدت ميلينا فيليبو في اليونان، ونشأت في
قبرص، وهي حاصلة على شهادة تخصص في الهندسة
المعمارية من الجامعة التقنية الوطنية في أثينا–اليونان.
وتعتبر أيضًا باحثة معتمدة في قبرص، وحاصلة على
درجة الماجستير في العلوم في تخصص التخطيط
الحضري من معهد ماساتشوستس للتكنولوجيا ضمن
برنامج فولبرايت للتبادل الثقافي.

مالك عابدين؛ قائد فريق في مخيم الأزرق للاجئين،
ويمتلك خبرة لأكثر من اثني عشر عامًا في المجال
الإنساني، ويعمل مع منظمات محلية ودولية في منطقة
الشرق الأوسط. درس مالك تخصص علم النفس،
وعمل في العديد من المنظمات مثل الهيئة الطبية الدولية
ومنظمة العمل ضد الجوع وأطباء بلا حدود. منذ العام
2013، تولى عابدين قيادة فريق منظمة كير العالمية
في مخيم الأزرق في الأردن، وعمل على مدار حياته
المهنية خلال أزمات مختلفة في الشرق الأوسط بصفته
أخصائيَ حماية في مجالات الصحة والحماية والغذاءَ
والنقد والصرف الصحي والصحة العقلية والمشاركة
المجتمعية. يؤمن عابدين بأهمية الالتزام الراسخ في

نبذة عن سيرة المساهمين في الكتاب

مختبر الإرث المستقبلي (FHL): هو مختبر للأبحاث والفنون برئاسة الأستاذة الدكتورة أزرا أكشامية، ويقع في كلية الهندسة المعمارية والتخطيط في معهد ماساتشوستس للتكنولوجيا. يُسهم مختبر الإرث المستقبلي (FHL) في التصاميم الإبداعية التي هي ناتج الصراعات والأزمات، وذلك من خلال توظيف وسائل الفن والتصميم والحفاظ على الإرث والإغاثة الإنسانية. نقوم في المختبر بتصميم الأنظمة والأدوات والبنى التحتية لتحسين حياة المجتمعات المهددة بالمخاطر، كما نبحث في قدرة التصميم والهندسة المعمارية في تخفيف آثار الصراع، ونبتكر طرق جديدة للحفاظ على الإرث بمجمله، ونبني نماذج لتبادل المعرفة التعاوني في البيئات المتضررة، ونطور وسائل لإحياء الفنون والحرف التقليدية. ويتمثل هدفنا في التصدي للمحو السريع للذاكرة الثقافية في جميع أنحاء العالم، وتعزيز التفاهم بين الثقافات.

د. أزرا أكشامية: فنانة ومؤرخة معمارية، وتتولى رئاسة مختبر الإرث المستقبلي في معهد ماساتشوستس للتكنولوجيا، وتعمل كأستاذ مشارك في قسم الهندسة المعمارية في معهد ماساتشوستس للتكنولوجيا في برنامج الفن والثقافة والتكنولوجيا. تتبنى أعمال أكشامية مزيجًا من الخلفية التاريخية ونظرية الفن والعمارة، وتستكشف تأثر الحياة الاجتماعية بالتحيز الثقافي وتدهور ودمار البنية التحتية الثقافية، ضمن سياق الصراع والهجرة والنزوح القسري. قامت أكشامية بتأليف كتابين، وهما *Mosque Manifesto* الذي نشر في العام 2015، إضافة إلى كتاب -Mu *seum Solidarity Lobby* المنشور عام 2019، وكلا الكتابين منشورين من قبل ريفولفر للنشر (-Revolv er). كما قامت الدكتور أزرا أكشامية بتدقيق كتاب *Architecture of Coexistence: Building Plural- ism*المنشور في العام 2020 بواسطة. عُرضت أعمال الدكتورة أكشامية في معارض دولية بارزة، بما في ذلك بيينالي البندقية، وفالنسيا، وليفربول، ومؤسسة جنرالي في فيينا، ومعرض الفن المعاصر في لايبزيغ، ومعارض الفن المعاصر في زغرب، وبلغراد، وليوبليانا، ومعرض SculptureCenter في نيويورك، ومبنى الانفصال في فيينا، ومعرض مانيفستا 7، والأكاديمية الملكية للفنون في لندن، والمتحف اليهودي في برلين، ومتحف

كوينز للفن في نيويورك، ومهرجانات أسبوع التصميم في ميلان، واسطنبول، وآيندهوفن، وعمّان، ومعرض قلنديا الدولي. عُرضت أعمال الدكتورة أكشامية مؤخرًا في متحف كونستهاوس غراتس، ومتحف آغا خان في تورنتو، ومتحف كستنر في هانوفر، وبيينالي البندقية للعمارة 2021/2020. كما نالت جائزة آغا خان للعمارة في العام 2013، لتصميمها مُصلّى في المقبرة الإسلامية في ألتاش-النمسا، وحصلت أيضًا على جائزة الفن لمدينة غراتس في العام 2018، والدكتوراة الفخرية من كلية مونتسيرات للفنون في العام 2020.

رأفت مجذوب: مهندس معماري وفنان وكاتب ومدير الخان: الجمعية العربية لنمذجة الممارسات الثقافية The Khan: The Arab Association for Prototyping Cultural Practices، ورئيس تحرير سلسلة كتب Dongola Architecture Series ويعمل أيضًا كمحاضر في قسم العمارة والتصميم في الجامعة الأمريكية في بيروت. يسعى مجذوب من خلال أعماله لاستكشاف بناء العالم من خلال التجارب الجديدة التي ترتكز على التخلي عن فكرة الحقيقة الواحدة، وتطوير أساليب تعلم وتعليم شاملة وتعاونية. شارك مجذوب في تأسيس مجلة «The Outpost» في بيروت، ونشر فيها عملين أدبيين، وهما رواية «الروض العاطر–The Perfumed Garden» وكتاب الأطفال المصور الذي شاركت فيه الفنانة جوان باز «L'Origine(s) du Monde». نُشرت كتابات مجذوب أيضًا في مجلة Recto Verso، ومنصة Perpetual Postponement، ومجلة antiAtlas، ومجلة Contemporary Theatre Review، وجريدة الأخبار. ناقش مجذوب عددًا من الأبحاث وألقى محاضرات فنية حول بناء العالم والخيال التأملي في مركز بيروت للفن، والمدرسة الوطنية للفنون الزخرفية في باريس، ومركز الثقافة المعاصرة في برشلونة، ومسرح Kaaitheater في بروكسل. كما تم عرض أعماله في عدة معارض في بيروت، والقاهرة، والقدس، وعمّان، وبروكسل، وكامبريدج، إضافة لمشاركتِه في مشروع NSK Pavilion في الدورة 57 لبيينالي البندقية، ومهرجان الفن Drodesera XXXVII، والبرنامج العام Nature © في بروكسل.

محتويات الكتاب

*The book is designed to be read in two directions, weaving Arabic and English content side by side throughout.

Perspectives on Life at the Camp

‹ 231

Landscape

‹ 191

Intimacy

Table of Contents